THE LOST

ROLLING STONES
PHOTOGRAPHS

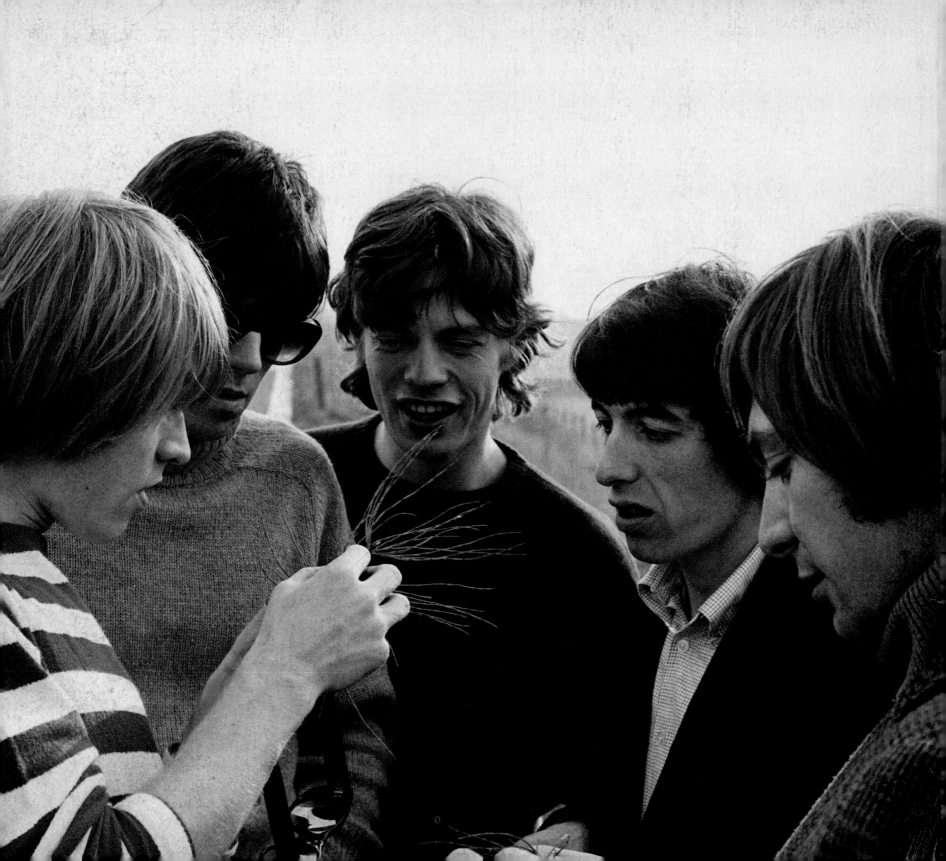

THE LOST ROLLING STONES PHOTOGRAPHS

PHOTOGRAPHS

THE BOB BONIS ARCHIVE, 1964–1966

BY LARRY MARION

FOREWORD BY CHARLIE WATTS

PHOTOGRAPHS BY BOB BONIS

itbooks

AN IMPRINT OF HARPERCOLLINS*PUBLISHERS*

For more information about these photographs and
The Rolling Stones' gear, go to www.NFAgallery.com.

HarperCollins books may be purchased for educational, business, or sales promotional use. For information please write: Special Markets Department, HarperCollins Publishers, 10 East 53rd Street, New York, NY 10022.

FIRST EDITION

DESIGNED BY PAULA RUSSELL SZAFRANSKI

Library of Congress Cataloging-in-Publication Data has been applied for.

ISBN 978-0-06-196079-6

10 11 12 13 14 ID / QGV 10 9 8 7 6 5 4 3 2 1

ALTHOUGH I WAS not born until years after these photographs were taken, I grew up with them around my home. A few of them were permanent fixtures on the walls in my house while others rotated as my father would swap them for a different one from time to time depending on his mood.

One day, when I was in my late teens, we went to a guitar expo together and afterward went for dinner at a restaurant in Manhattan. When we asked for a table the host remarked that we had chosen a good day to visit the restaurant because Mick Jagger was dining there with David Bowie. Several times throughout the meal I noticed Mick and my dad exchanging glances. Finally my father got up and went over to them and asked Mick, "Do you have a moment for an old tour manager?" Mick leapt from his seat and gave my father a big embrace. He insisted that we join them, and the staff quickly rearranged the tables so that we were seated with them. Dad and Mick exchanged memories and laughed about the good times they had on the tours. As we left the restaurant, he turned to me and said with a smirk, "I told you I knew them," as if I had any doubt.

Dad had a deep love for photography and his camera was always within reach. He was very fortunate to be in the right place at the right time and now we can all benefit from his talent for capturing the excitement of The Rolling Stones' first United States tours.

I hope you enjoy these unseen photographs, and take pleasure in the memories and excitement he captured that have remained hidden and unpublished until now.

It is with great pride that I dedicate *The Lost Rolling Stones Photographs: The Bob Bonis Archive, 1964–1966* to my father, who introduced me to the British invasion, and to my mother, Phyllis, who was the primary rocker of the family.

Alex Bonis
September 2010

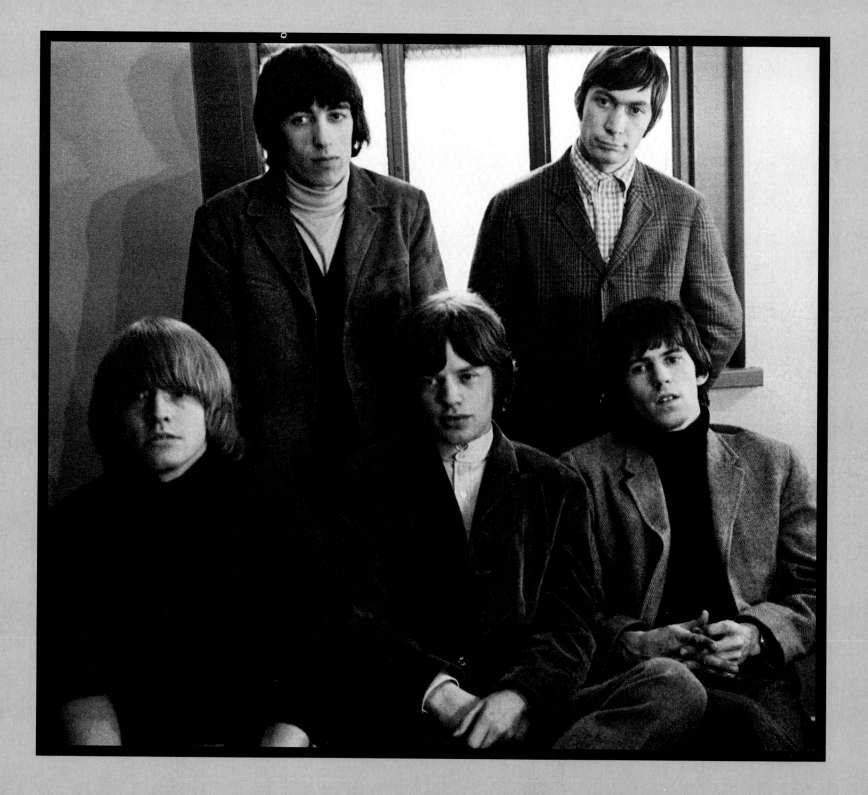

CONTENTS

This book would not have been possible without and
is also dedicated to:

Brian Jones,

Ian "Stu" Stewart,

Mick Jagger,

Keith Richards,

Bill Wyman,

Charlie Watts,

Andrew Loog Oldham

FOREWORD BY CHARLIE WATTS

Almost a year and a half after I joined The Rolling Stones we embarked on our first tour of America. We were already successful in England but America was a new and important frontier.

On June 1st 1964, just after we released our first LP in America, we flew to New York to begin a tour. When we arrived we were met by Bob Bonis. Bob took great care of us and got us wherever we had to be on time and with little or no problems. He was a great guy and shared my love of jazz. Before he was hired to manage our tour he had an agency that handled jazz performers.

And through Bob I was fortunate enough to be introduced to Bob Cranshaw (Sonny Rollins's long-time bass player), which was a great honour.

Bob always seemed to have his trusted camera with him and we were happy to have him take photographs. More than forty years after they were taken, seeing ourselves recording at Chess Studios, or rehearsing for the T.A.M.I. show, brings back so many fond memories.

I considered Bob a friend and it was an honour to know him.

Charlie Watts

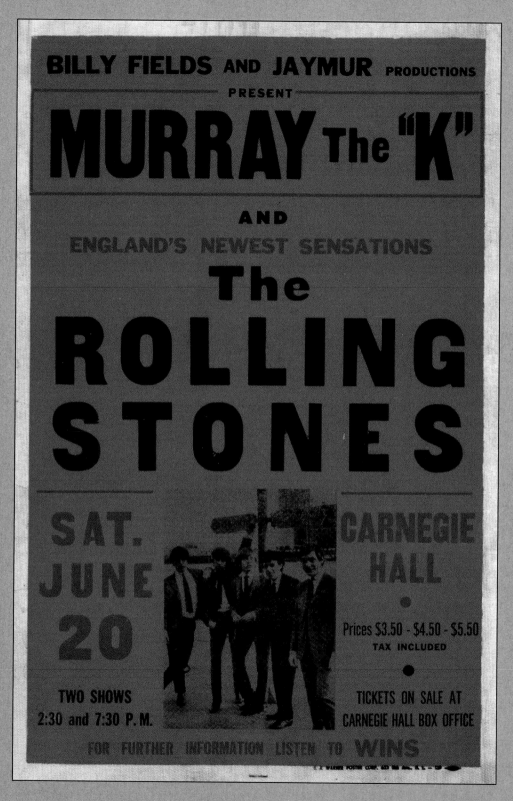

An extraordinarily rare poster for The Rolling Stones "sold out" 1964 concert at Carnegie Hall during their first U.S. tour.

PREFACE

BOB BONIS is a name that might escape even the most hard-core Rolling Stones or Beatles fan. Although he held a significant position in both of these bands' histories, he preferred to remain anonymous throughout his life. From 1964 through 1966, spanning The Rolling Stones' first five U.S./North American tours and all three of The Beatles' U.S./North American tours, Bob served as tour manager for the two most important bands in the history of rock 'n' roll.

An avid photographer, Bob always traveled with his Leica M3 camera, taking beautiful and intimate photographs of the people and the places he encountered. While working with The Beatles, The Stones, and several other musicians in the rock, pop, and jazz fields, he had the opportunity to exercise his passion for photography. Thus he captured more than five thousand candid photographs of the bands and musicians with whom he worked. During his lifetime he allowed only a handful of these images to be published, in teen magazines.

On the twentieth anniversary of the Beatles' arrival in America, Bob granted a handful of interviews with regional newspapers. He consistently rebuffed offers to publish the photos or to write his memoirs, feeling that it was a privilege to have had such an experience. Bob did not want to appear to capitalize on his good fortune, or to exploit the relationship that he held with these iconic acts.

Bob passed away in 1992. Fifteen years later, his son, Alex, decided it was time for other people to enjoy the memorabilia and photographs his father had saved. Through his pursuit to find the best means to achieve this feat, he eventually met me, Larry Marion. At the time I was working with several auction houses as a specialist in rock and music memorabilia. The items Bob had saved (some are pictured in this book) were sold at auction sometime later. The slides, negatives, and their copyright were acquired by a company dedicated to honor Bob's life, his career, and his extraordinary talent with a camera. Alex and I are two of the founding partners of this company, 2269 Productions, Inc. Not Fade Away Gallery (NFAgallery.com) was created in New York City to release, show, and exclusively represent these phenomenal images, and to make them available for fans and collectors around the world.

We are proud to present the photographic legacy of Bob Bonis. We hope you enjoy viewing these rare and wonderful images that are presented here for the first time since they were preserved on film more than forty years ago. It is with great pride that we present *The Lost Rolling Stones Photographs: The Bob Bonis Archive, 1964–1966.*

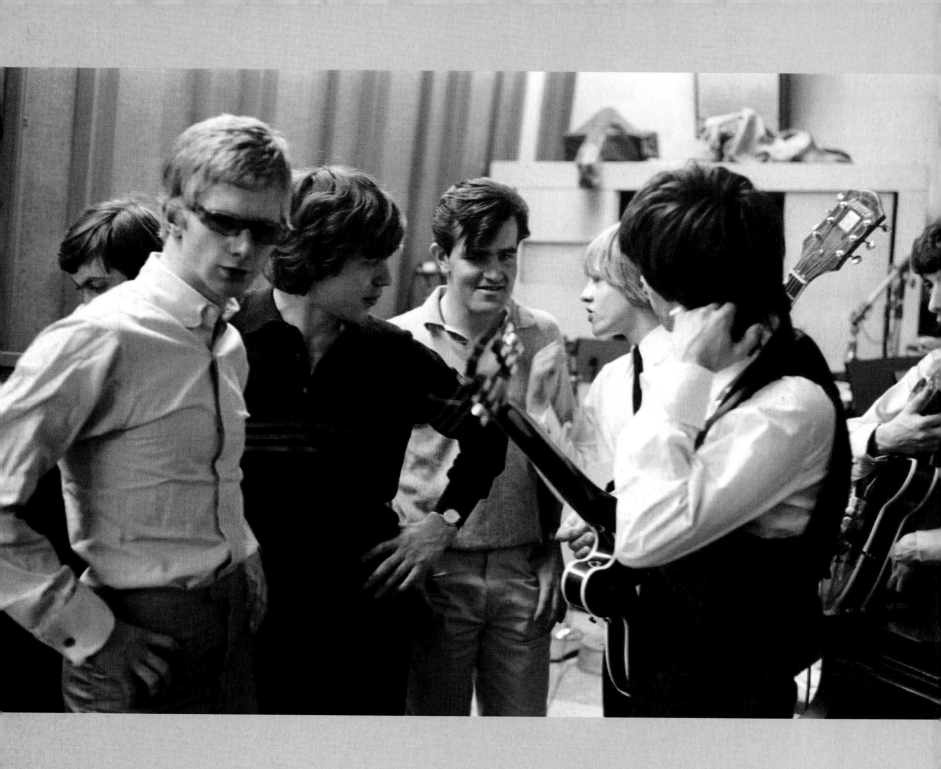

ABOUT THE PHOTOGRAPHS

AT THE TIME THESE photographs were taken, The Rolling Stones were a different band than how they are viewed today. Here you will find the lineup that existed when the band came to America and first became famous: Brian Jones, Mick Jagger, Keith Richards, Bill Wyman, and Charlie Watts.

The Rolling Stones were originally formed by Brian Jones and Ian "Stu" Stewart, who later brought in the other members who would go on to become the most famous of the band. A few years later, when Andrew Loog Oldham took over as manager and producer of The Stones, things began to change under his guidance. Stu became a behind-the-scenes player, performing in the studio. He was allowed to remain with The Rolling Stones but was no longer considered a member of the band. However, his role in creating the band and its style is critical. ALO, as Andrew is often referred to today, steered the band away from being a blues and R&B cover band to *Top of the Pops*. Recognizing that Brian's songwriting skills were not going to propel the band to stardom, ALO literally forced Mick and Keith to start writing songs together by locking them in a room. His influence greatly affected their look and style, and he had the idea to position them as the "bad boy" answer to The Beatles. Where The Beatles had a squeaky-clean image, dressed in identical outfits, and sang songs about love—"I Wanna Hold Your Hand," "I Saw Her Standing There," "She Loves You," etc.—Oldham created the image of troublemakers by dressing them in leather and getting them arrested for public urination, and they recorded songs about the other side of relationships—"Heart of Stone," "Play with Fire," "(I Can't Get No) Satisfaction," etc. Bob's photographs reveal members of the Stones exposing themselves, flipping the bird, and mugging for the camera.

When they first came to America in June 1964 The Rolling Stones had existed for only two years. They had released only one single: "Not Fade Away" (the Buddy Holly song) backed with "I Wanna Be Your Man" (written for The Stones by John Lennon and Paul McCartney), neither of which were written by The Stones, on March 6, 1964. On May 29, 1964, just one week before beginning their first U.S. tour, they released their first LP in America, *England's Newest Hit Makers: The Rolling Stones*. It

featured one song, "Tell Me," written by Mick Jagger and Keith Richards; a song called "Little by Little" (credited to Phelge/Spector); "Now I've Got a Witness" (credited to Nanker/Phelge); and nine cover songs. Between 1963 and 1965 the Stones would use the pseudonymous credit Nanker/Phelge or some variant to indicate a song that was written or cowritten by the entire band of Mick Jagger, Keith Richards, Brian Jones, Bill Wyman, Charlie Watts, and Ian Stewart. "Phelge" was taken from the name of an old friend and roommate of The Stones, Jimmy Phelge, and "Nanker" was the word used to describe a revolting face made by pulling down your eyelids while pulling up your nostrils and making an inhuman noise. The Stones, especially Keith and Brian, were fond of "pulling a nanker," as they called it.

They came to America almost completely unknown to U.S. audiences and often played on bills with a variety of other artists, not necessarily as the headliner and often to lukewarm receptions. Many of these earliest U.S. shows did not sell out.

Television and film were a means to expose the Rolling Stones to a wider audience from the beginning. Bob Bonis captures a few of these appearances and behind-the-scenes moments, including *The T.A.M.I. Show* movie, the TV show *Hullabaloo*, and the dressing room before their 1966 *Ed Sullivan Show* appearance. (See Television and Movie section)

Bob's color photographs of *The T.A.M.I. Show,* which was filmed in black and white, are the only known color images of this legendary concert film. *The T.A.M.I. Show* concert movie was filmed on October 28 and 29, 1964, at the Santa Monica Civic Auditorium in California, just a few dates into their second U.S. tour.

The Rolling Stones performed in *The T.A.M.I. Show* along with an all-star lineup of performers. The idea of the film was to mix U.S. and British acts as well as black and white acts. Teens were buying a wide variety of music but had never seen what the performers looked like. The watershed concert film was emceed by Jan and Dean, who performed along with The Barbarians, The Beach Boys, Chuck Berry, James Brown and The Famous Flames, Marvin Gaye, Gerry and The Pacemakers, Lesley Gore, Billy J. Kramer and The Dakotas, Smokey Robinson and The Miracles, and The Supremes.

The performances of James Brown and The Famous Flames and The Rolling Stones are considered their finest moments ever captured on film. After a brief release in theaters, The Beach Boys' segment of the film was removed due to rights complications. Eventually the entire film was withdrawn, and remained unavailable for more than forty years.

On the first day of the show, The Stones rehearsed and recorded all their tracks with the exception of the closing jam, which was filmed on the second day. The Stones performed five songs plus the finale: "Around and Around," "Off the Hook," "Time Is on My Side," "It's All Over Now," "I'm Alright," and "Get Yourself Together" (closing jam with other performers). The Stones also rehearsed "Not Fade Away," "Tell Me," and "2120 South Michigan Avenue," but they were not used in the film.

There have been varied reports of controversy over who should close the show: The original plan was for James Brown and The Famous Flames to close, since their manager proclaimed that no one could follow James Brown. While he already was an established star in the black community and had radio and record success with white listeners, he was not yet performing in venues patronized by white audiences. Executive producer Bill Sargent wanted The Rolling Stones to close out the show. The Stones were understandably concerned about following James Brown, until Marvin Gaye comforted them backstage and told them to just go out and do their thing. The Stones did just that.

Keith Richards has been quoted as saying that following James Brown was the worst mistake of their career. Regardless, there is no doubt that it was *the* definitive early performance by the original lineup of The Rolling Stones.

There have been many reports that James Brown was upset that The Stones would close the show, but after their set James shook their hands and congratulated them. And a week later when Mick, Keith, and Andrew Oldham went to see James at the Apollo Theater in New York he brought them onstage to take a bow.

In *Creem* magazine, Patti Smith, who covered rock music for a few rags in the late 1960s and early '70s, commented on how the Motown acts and James Brown were the saving grace of *The T.A.M.I. Show* and that The Stones themselves were responsible for the sexual awakening of confused American teenage girls: "On that silver screen they were bigger than bed. My head spun, my pussy dripped, my pants were wet and The Rolling Stones redeemed the white man forever" (January 1973).

In the years that Bob photographed them they went from unknowns to one of the most prominent bands in the world. Documented in these photos is this seminal period when The Stones made their transformation into the world's greatest rock 'n' roll band.

Where The Beatles' public image was sweet and innocent, The Rolling Stones represented S-E-X. This was Andrew's vision brought to fruition. By the time The Stones came back to America in 1965, girls were throwing underwear at the stage with salacious and explicit notes attached and hiding in the shower of the hotel rooms where The Stones stayed. According to Bill Wyman some performed sex acts on security guards to gain access.

During the time these photographs were taken Bob Bonis was The Rolling Stones' U.S. tour manager, beginning with their first U.S. tour in June 1964 and continuing through their fifth U.S. / North American tour in 1966. In addition to serving as tour manager for their U.S./North American tours, Bob Bonis accompanied The Rolling Stones on their five-day tour of West Germany in September 1965. Because of Bob's unique access, he was able to capture images, angles, and perspectives unlike any other photographer. Through these photographs we get a rare view into the dynamics and characters of the band members, as well as those of several important supporting people:

BRIAN JONES—founding member, multi-instrumentalist

Born Lewis Brian Hopkins-Jones on February 28, 1942, Brian Jones was twenty-two years old when The Stones first came to America in June 1964.

On March 17, 1962, he attended an engagement of Alexis Korner's Blues Incorporated at the Ealing Jazz Club in West London and gave Alexis a tape of three songs he'd recorded with his friend Paul Jones. The following week Alexis introduced "Elmo Lewis" (a name Brian made up in tribute to blues great Elmore James). Charlie Watts was the drummer in Blues Incorporated at the time. Mick Jagger and Keith Richards and their band Little Boy Blue and the Blue Boys attended a show of Alexis Korner's Blues Inc. on April 7, 1962, and the slide guitarist who called himself Elmo Lewis was also performing. Mick and Keith were blown away and talked with him after the show.

In May Brian placed an ad looking for musicians to form his own R&B group. Ian "Stu" Stewart responded.

IAN "STU" STEWART—founding member, keyboard player, tour support

Ian Andrew Robert Stewart, born on July 18, 1938, was twenty-six years old when The Stones first came to America.

In May 1962, when Brian Jones placed an advertisement in the *Jazz News* looking for other musicians with which to form his own R&B group, "Stu" was the first to answer and the seeds of The Rolling Stones were planted. Brian and Stu started rehearsing and looking for other members to form a band. The journey to the formation of The Rolling Stones had begun.

On May 8, 1963, almost nine months after The Stones played their first gig, Stu was informed by Andrew Oldham, who had signed The Rolling Stones to a management contract two days prior, that he would no longer be a front-line member of The Rolling Stones. Instead he was offered the position of road manager and he agreed to stay on. He was told that he didn't have the right image and that six names were too hard for fans to remember.

He played on all the albums they released through 1983 with the exception of *Beggar's Banquet*. A blues purist to the end, he refused to play on the track "Wild Horses" because minor chords offended him aesthetically.

MICK JAGGER—founding member, lead vocalist, harmonica and guitar player

Michael Philip Jagger, born on July 26, 1943, was twenty-one years old when The Stones first came to America.

Mick and Keith Richards were classmates back in 1950 but lost touch in the midfifties when they went to different schools. They met again in October 1961 when Mick ran into his old mate at the Dartford, Kent, train station. Mick had an armful of rare R&B records that he had mail-ordered from Chess Records. Keith shared a musical interest in the Muddy Waters and Chuck Berry records, and a renewed friendship followed.

In November 1961 Keith joined Mick's band Little Boy Blue and the Blue Boys. They never played a live club gig, but this was the beginning of the journey to become "the greatest rock 'n' roll band in the whole world," as stage manager Sam Cutler would introduce them on their 1969 U.S. tour. The title has stuck to this day.

KEITH RICHARDS—founding member, guitar player, vocalist

Keith Richards was born on December 18, 1943, and was also twenty-one years old in 1964.

On May 25, 1962, Mick and Keith attended one of Brian and Stu's rehearsals and were invited to join.

On July 12, 1962, The Rollin' Stones, as they were called after a line in the Muddy Waters song "Mannish Boy," played their first gig. The band included Mick, Keith, Brian (listed as Elmo Lewis), Stu, Dick Taylor on bass, and Tony Chapman on drums.

In 1963 Andrew Oldham suggested that Keith drop the *s* in Richards to appear more "pop," but Keith replaced the *s* in the late 1970s, having never legally changed the spelling. It is spelled both ways on various records from this time.

BILL WYMAN—bass player

Born William George Perks on October 24, 1936, the oldest member of The Rolling Stones was twenty-eight years old when they first came to America.

When bassist Dick Taylor quit to return to art school, Tony Chapman told the others that he knew a bass player who also had his own amp. On December 9, 1962, Wyman brought his monster amp along and auditioned for The Rolling Stones. He

had a lot of experience, having played with The Cliftons, a South London band. Wyman himself said that it was probably his amp that got him asked back again to play with the impoverished band. On December 15 they played their first gig together at the Youth Club, St. Mary's Church Hall, Putney, London.

In January 1963 William Perks assumed the modified name of an army buddy, Lee Whyman. A month later he substituted his own first name and in July 1964 changed it legally to Bill Wyman.

Although you might expect it to be Mick, Keith, or Brian, it was actually Bill who was the girl hound in the early years, having reportedly bedded more than two thousand women.

CHARLIE WATTS—drummer

Charles Robert Watts was born on June 2, 1941, and was twenty-three in 1964. He was interested in jazz, so his parents bought him his first drum set in 1955. In 1961 he met Alexis Korner, who invited him to join Blues Incorporated. He was the drummer in the band on April 7, 1962, when Mick and Keith attended and first met Brian Jones, and left Blues Inc in June.

After sitting in as the drummer on several gigs to fill the frequently vacant drummer's slot, Charlie was asked to join The Stones and played his first gig with them on January 17, 1963.

ANDREW LOOG OLDHAM (ALO)—manager and record producer

Andrew Loog Oldham was born on January 29, 1944. He started his music career as a press agent and then did some PR work for Brian Epstein with The Beatles. On April 13, 1963, based on a tip by journalist Peter Jones, ALO attended the Crawdaddy Club gig of The Rolling Stones at the Station Hotel in Richmond. Believing that the time was ripe for an alternative to The Beatles, he and Eric Easton signed the band to a management contract soon afterward.

Andrew would prove to be a very shrewd mananger and remade The Rolling Stones to fit his vision. He also became their record producer. He would guide them from being an R&B cover band to *Top of the Pops* and worldwide fame.

DAVE HASSINGER—engineer at RCA Studios in Hollywood, California, who would help to shape and define The Rolling Stones' sound

JACK NITZSCHE—arranger and support musician on many of their early recordings

One of Bob's gifts was his ability to render sensitive and revealing portraits of his subjects. The chapters for the individual members of the band and Andrew Loog Oldham demonstrate his ability to portray the true nature of the person's personality.

Unfortunately, Bob Bonis did not leave notes referencing the dates or locations of the scenes he captured. We have done our best to provide accurate information wherever possible. If you can provide missing information or corrections, we would love to hear from you. Please write to info@nfagallery.com.

Nov 4, 1964

Received from Bob Bonis $100⁰⁰ Bill Wyman

Bill Wyman

Receipt from Bob Bonis $100⁰⁰ Brian Jones

Brian Jones

Received from Bob Bonis $100⁰⁰ Charlie Watts

Charlie Watts

Received from B Bonis $100⁰⁰/100 K Richard

K Richard

Receipt from B Bonis $50⁰⁰/100 Mick Jagger

Mick Jagger xxx

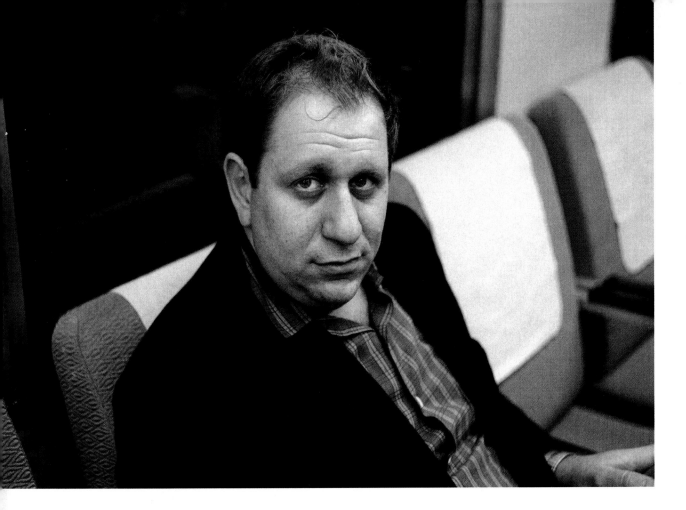

BOB BONIS

BOB BONIS (1932–1992) began his career in the music business as a talent agent at MCA in New York City in the late 1950s. He would go on to hold an extraordinary position at a pivotal time in rock history, as tour manager for both The Beatles and The Rolling Stones during their first U.S. tours in 1964, 1965, and 1966. Bob captured extraordinary, unguarded photographs seen here for the very first time.

When MCA dissolved its talent agency, Bob started a jazz management firm working with a variety of jazz and big band performers including Benny Goodman, Count Basie, Harry Belafonte, Gerry Mulligan, and others. Standing six foot one and weighing more than two hundred pounds, Bob cut an intimidating figure and earned a reputation for being able to deal with the wise guys who ran a lot of the jazz clubs.

Because of this ability and The Stones' reputation for being hard to control, he was tapped to serve as The Rolling Stones' tour manager for their first-ever U.S. tour. According to Bill Wyman in his book *Stone Alone: The Story of a Rock 'n' Roll Band*, when Bob was asked to go on the tour, his initial reaction was that he didn't want to go out on the road anymore—and that he wasn't a fan of rock 'n' roll. But according to Wyman, when he saw the famous article from *Melody Maker* titled "Would You Let Your Sister Marry a Rolling Stone?" Bob responded, "That's a great sales pitch," and agreed to manage the tour.

Bob did a great job of getting The Stones where they needed to be on time; quite a feat considering that the "bad boys" of the British Invasion worked hard to cultivate their reputation for trouble. His personal experience with them was quite the opposite, and he developed a great friendship with them that lasted long after his role as their tour manager ended. His success with The Stones led the band's management in England to recommend him to Brian Epstein for the same role with The Beatles; a job he would hold for all three of The Beatles' U.S. tours.

The combination of a gifted eye for composition and unequaled access to some of the most significant performers of the twentieth century yielded a truly remarkable archive that includes intimate and iconic images of both The Rolling Stones and The Beatles, never before published or seen by the public. In addition to more than 3,500 photos of The Beatles and The Stones, Bob photographed Simon & Garfunkel, The Hollies, Cream recording in the studio, The Lovin' Spoonful, Buddy Rich, Frank Sinatra, and many of the jazz greats with whom he worked over the years.

The Bob Bonis Archive includes thousands of candid and posed photos of The Rolling Stones in concert, backstage, rehearsing, tuning up, waiting to go on, clowning around, dressing and relaxing, on vacations, en route to shows or cities, getting their hair cut, bowling, recording in the studio, at press events, and just hanging around being themselves. The unguarded nature of these images reflects Bob's close friendship with the band and offers a private, behind-the-scenes look into the early days of the British Invasion era of rock 'n' roll.

A private man, Bob never sought publicity and had no aspirations to publish his photos or to write a book about his experiences with the two greatest, most important bands in the history of rock 'n' roll. He never participated in the fan culture or went to any of the conventions. He allowed a handful of his photographs to be published in teen magazines in the sixties, but after that, he wasn't interested in pursuing attention based on his past exploits.

For more than forty years, the negatives and slides have been safely stored away unbeknownst to anyone but his wife, son, and friends. Almost all of the photographs in this book are being seen here for the very first time.

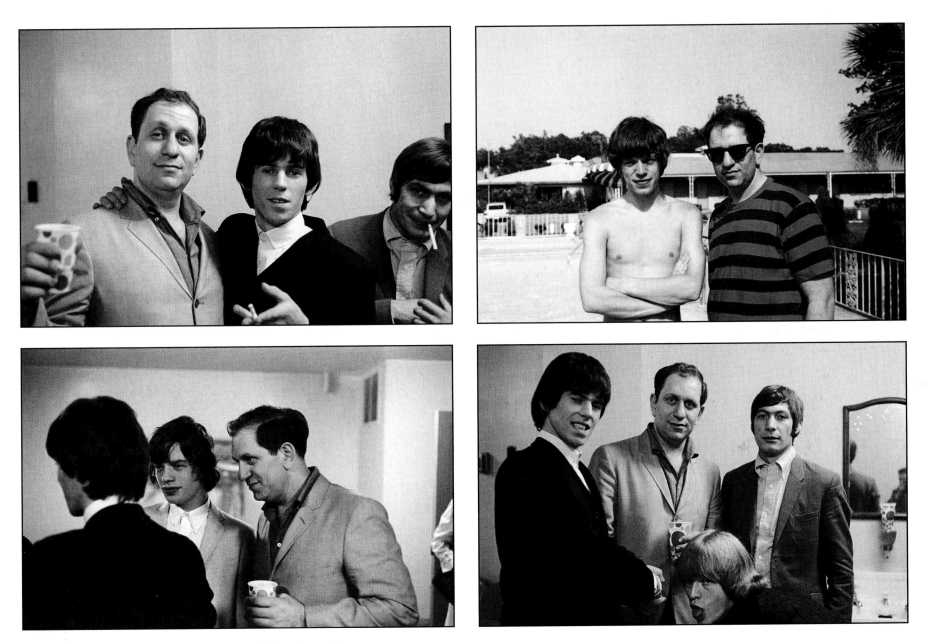

Bob Bonis on tour with The Rolling Stones in America 1965.

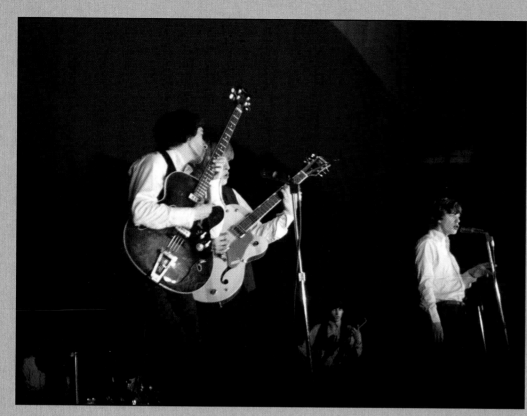

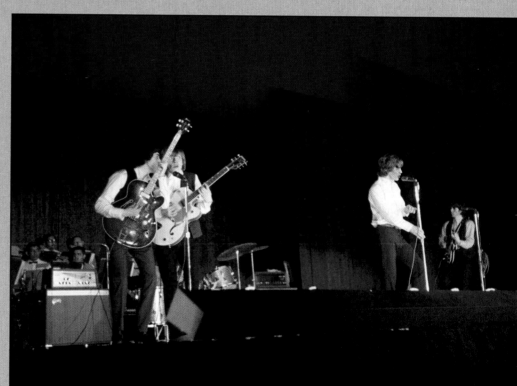

IN CONCERT

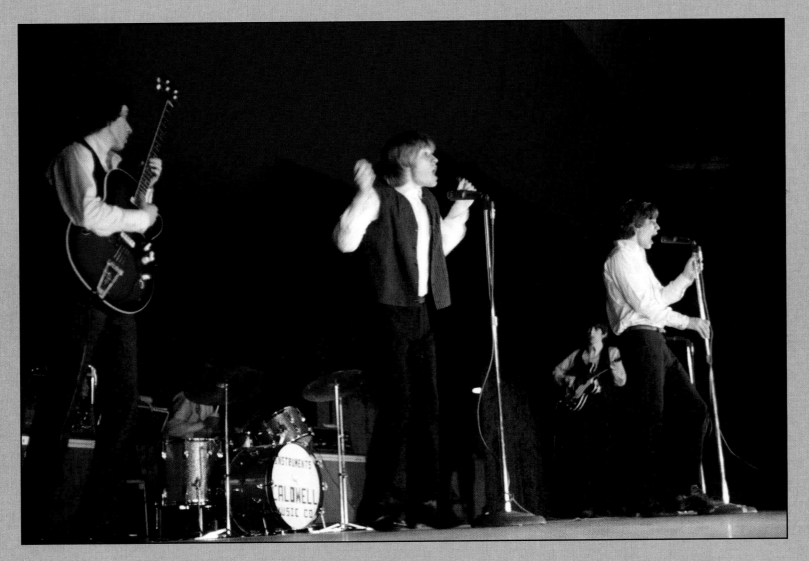

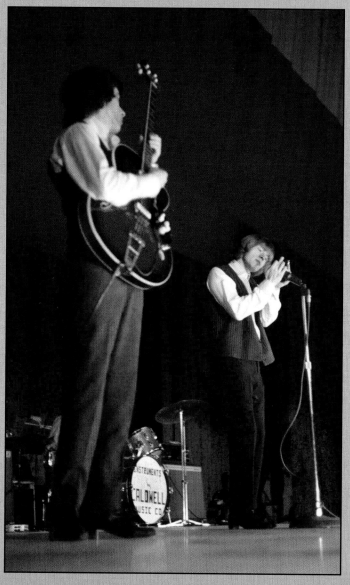

San Antonio Teen Fair, San Antonio, Texas, June 6–7, 1964.

This is The Rolling Stones' second ever show in America. Note that Charlie Watts is playing rented drums. The photographs document The Rolling Stones at this pivotal point in their career, coming to and conquering America.

On this day The Stones met saxophone player Bobby Keys, who was playing in the opening act, Bobby Vee's band. Other acts on the bill included George Jones, chimpanzee and elephant acts, and western acts. This meeting would lead to a career-long relationship, and Keys would go on to play on many of The Stones' later recordings—including the famous sax solo on 1971's "Brown Sugar"—and toured with them from 1970 to the present. Keys was filmed with Keith throwing a television set out a hotel room window on the 1972 American tour, an act that was filmed for the movie *Cocksucker Blues*. Incidentally, Bobby Keys shares a birthday with Keith Richards.

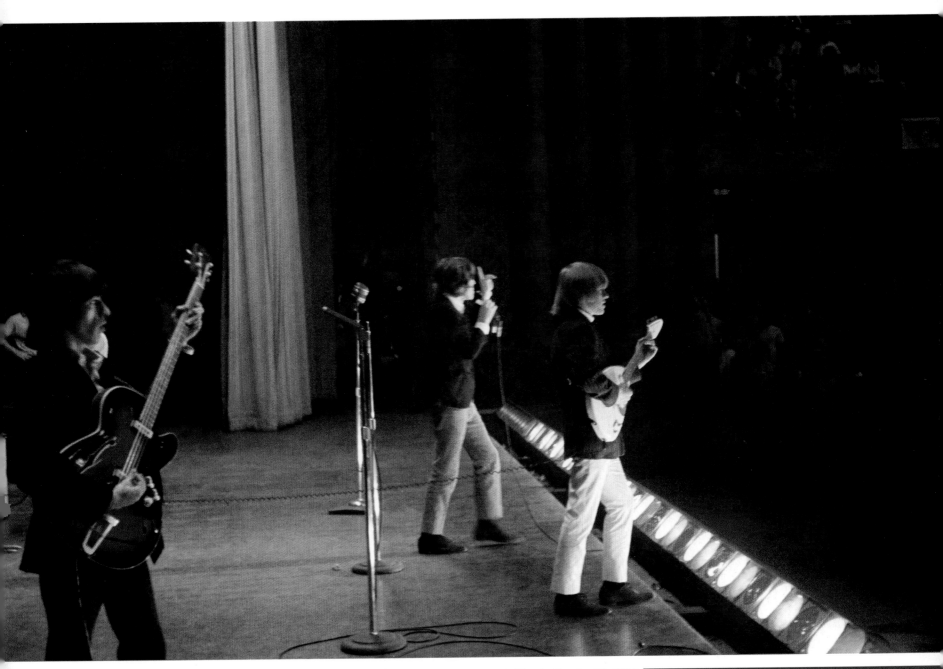

Second show of the second U.S. tour: Sacramento Memorial Auditorium, Sacramento, California, October 26, 1964.

A typical set list from this tour included: "Not Fade Away," "Walking the Dog," "If You Need Me," "Carol," "Time Is on My Side," "Around and Around," "Tell Me," "It's All Over Now," "High-Heel Sneakers," "You Can Make It If You Try," "I'm a King Bee," and "I'm Alright."

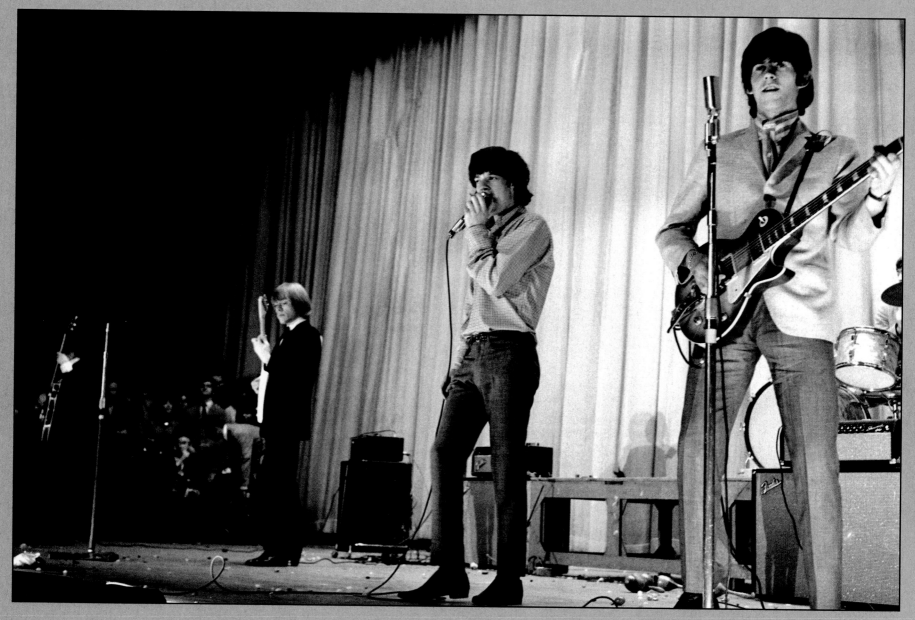

Third U.S. Tour: April–May 1965.

Keith Richards plays his 1959 Les Paul Standard guitar with a Bigsby vibrato tailpiece, a device designed by Paul Bigsby in the 1940s that allows guitarists to bend a note or whole chord with their pick hand for various effects.

A typical set list on this tour would include: "Everybody Needs Somebody to Love," "Around and Around," "Off the Hook," "Little Red Rooster," "Time Is on My Side," "I'm Alright," "Pain in My Heart," and "The Last Time."

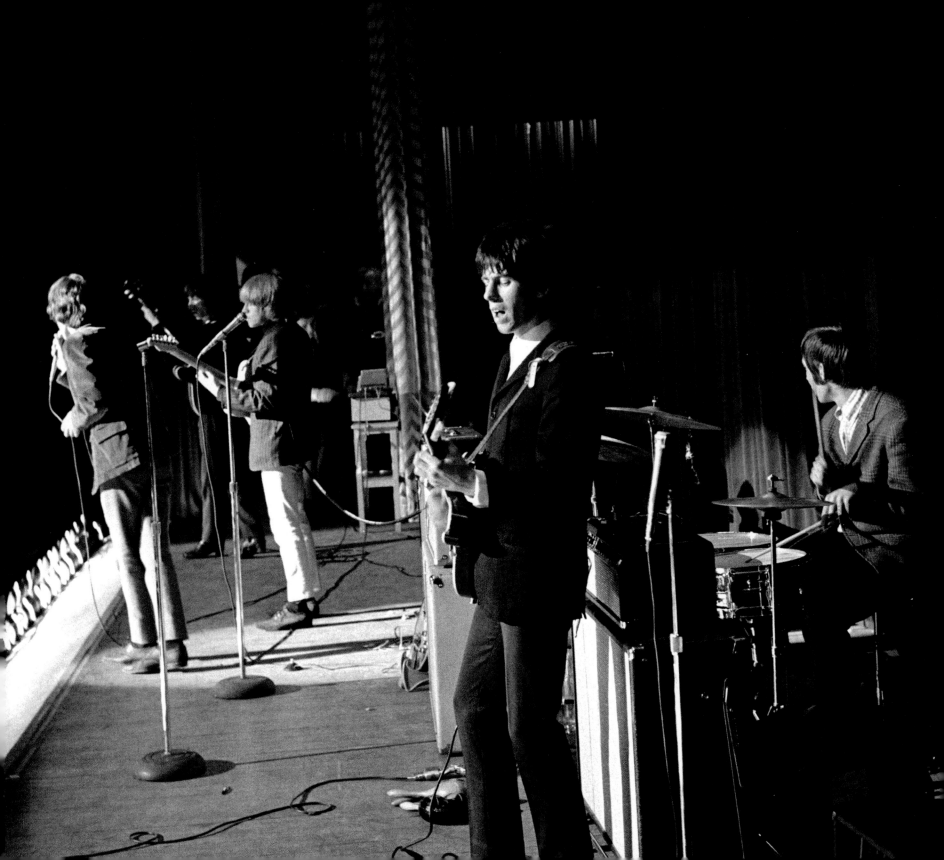

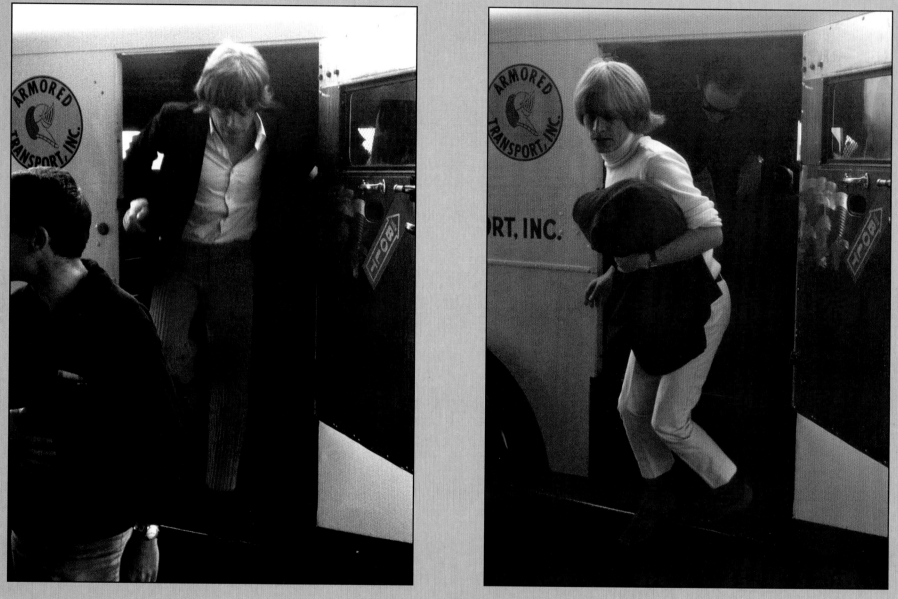

Ratcliffe Stadium, Fresno, California, May 22, 1965.

Opening act: The Byrds. Four thousand people attended this afternoon show. They played another show in Sacramento that evening.

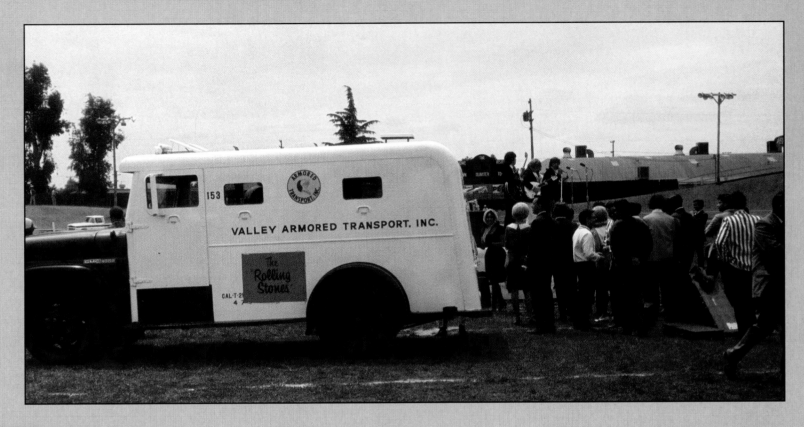

Because the stage was in the center of a football stadium, The Stones arrived in an armored car with a sign saying THE ROLLING STONES taped to the side. Bob had hired the car to transport them.

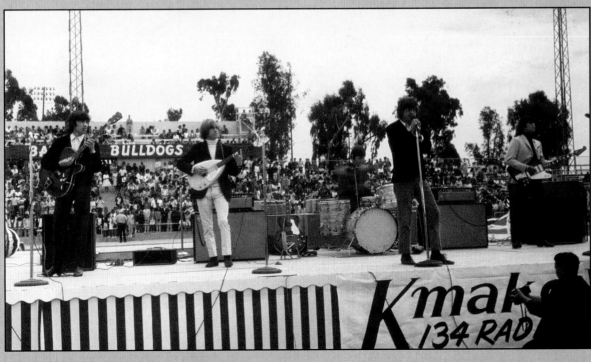

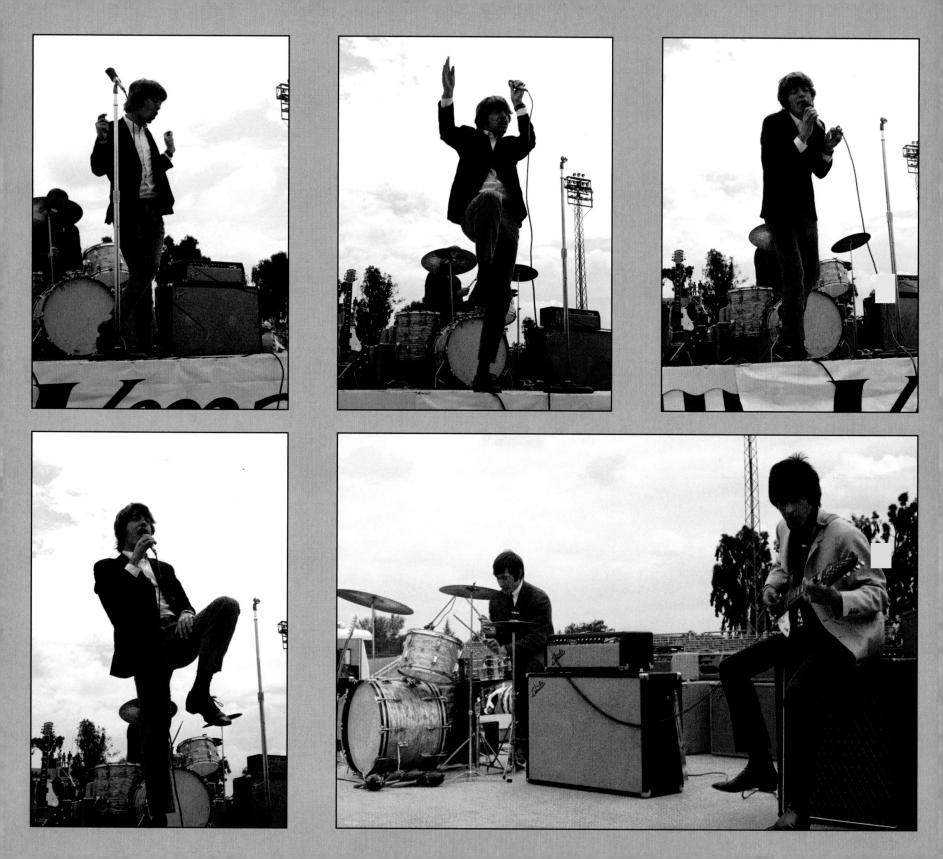

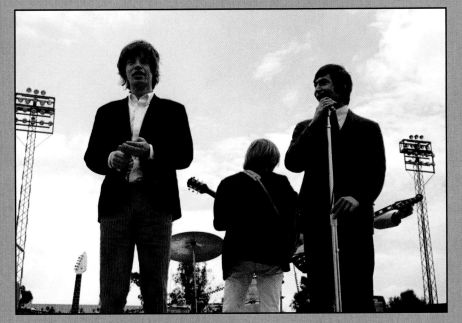

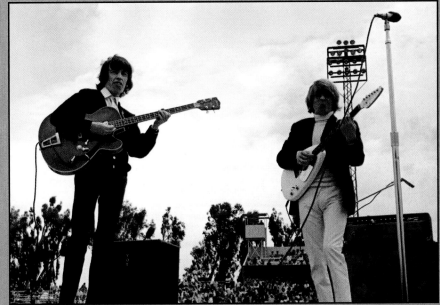

Charlie Watts introduces a song.

Brian plays the Vox Mark VI "Teardrop" guitar that was given to him by Vox in July 1964. His white Vox Mark VI was the prototype for this model.

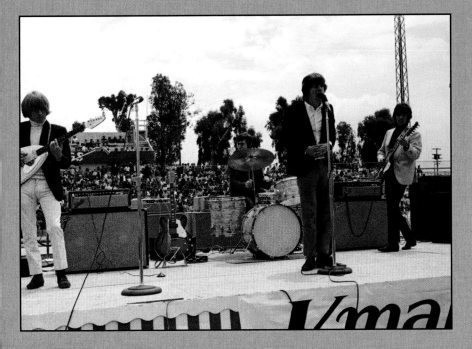

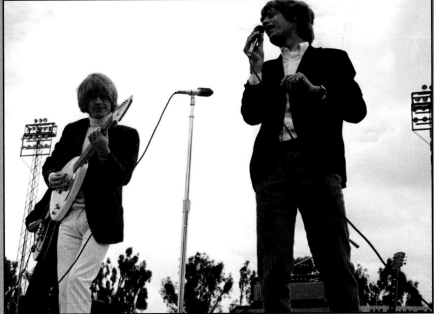

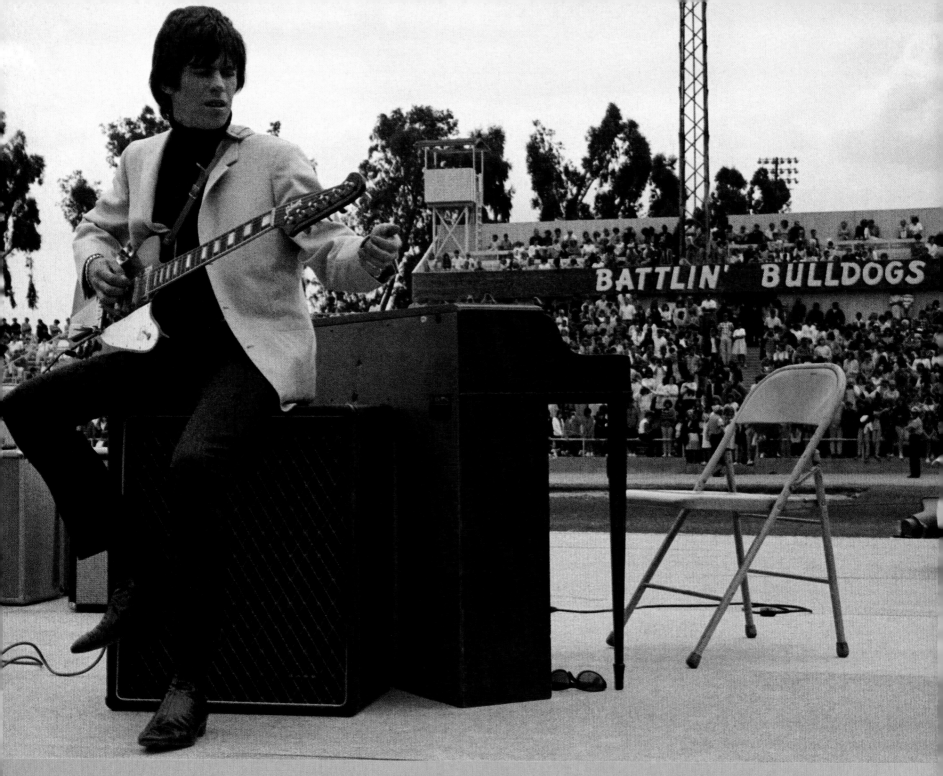

Keith sits on a bass amp and tunes his Gibson Firebird VII reverse guitar. Behind him you can see a banner for the Fresno State football team, the Bulldogs, known to fans as the "Battlin' Bulldogs."

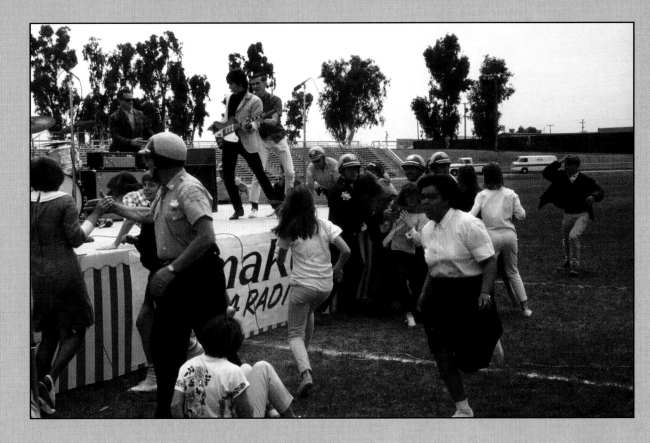

Halfway through the closing song some overzealous female fans broke out of the stands and rushed the stage, causing the Fresno police to spring into action to protect Keith Richards and the rest of the band from the teenage girls gone wild.

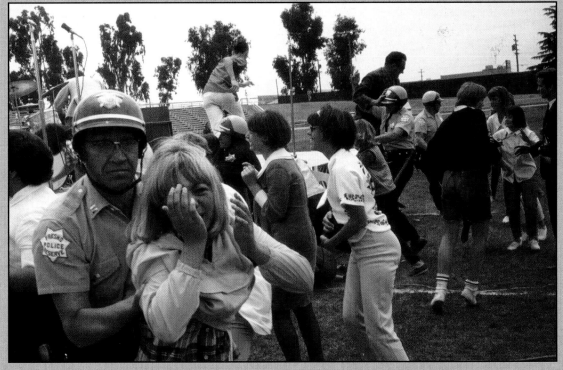

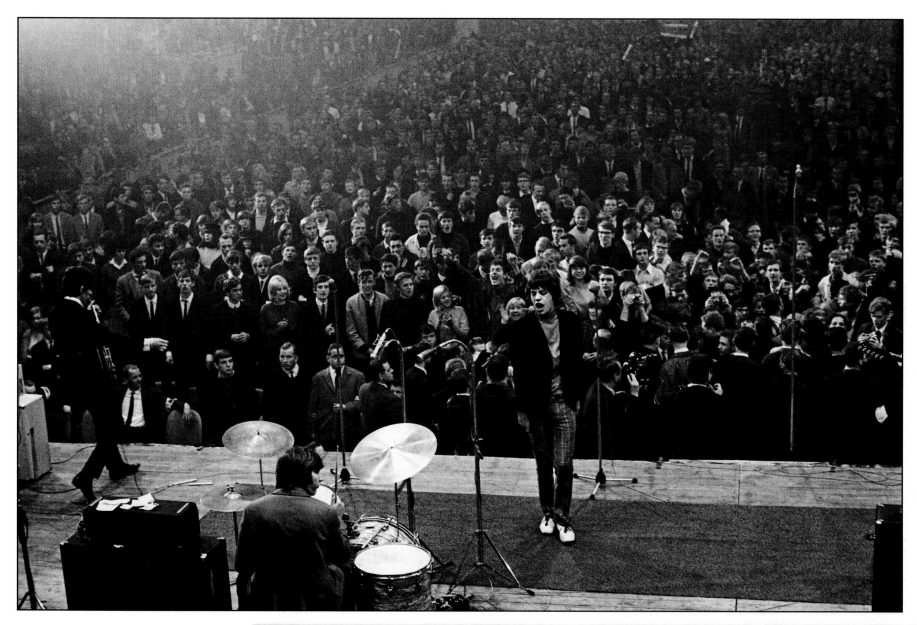

West German Tour, September 1965

Muensterland Halle, Muenster, West Germany, September 11, 1965.

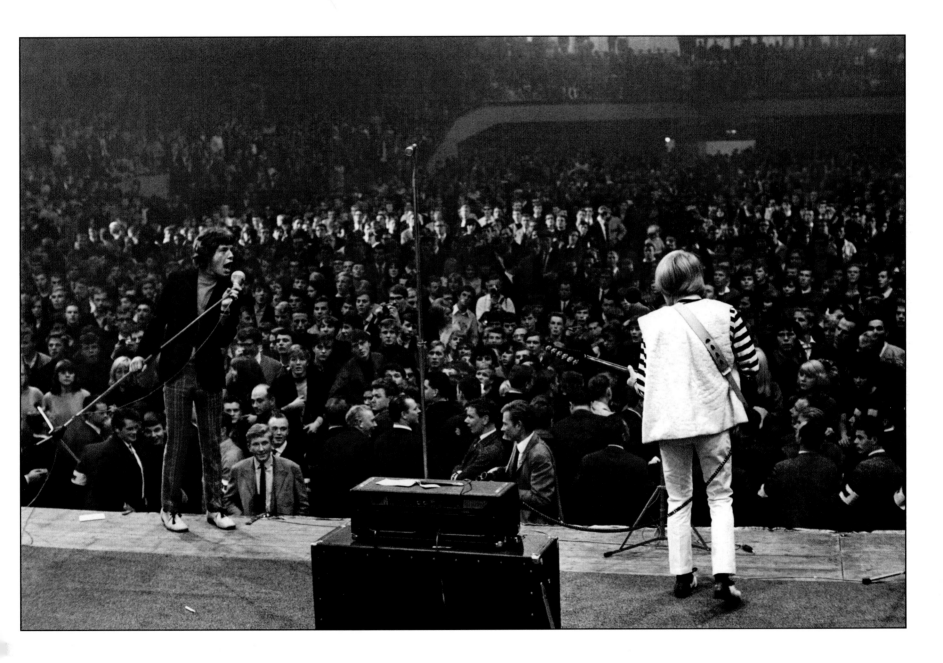

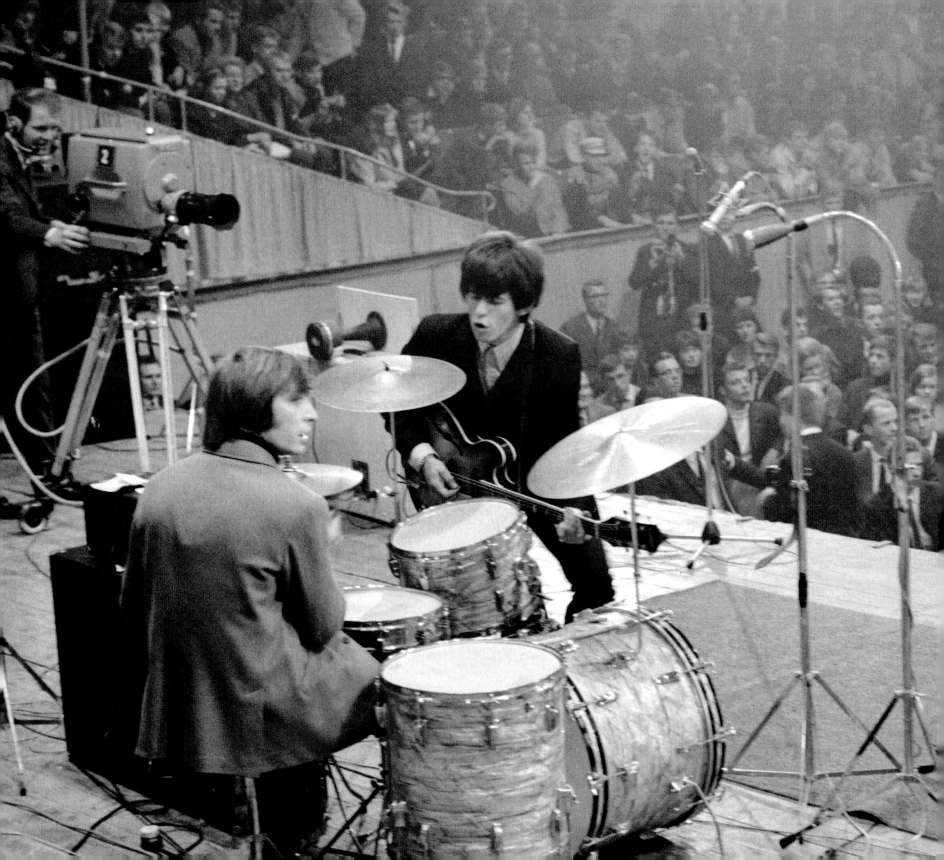

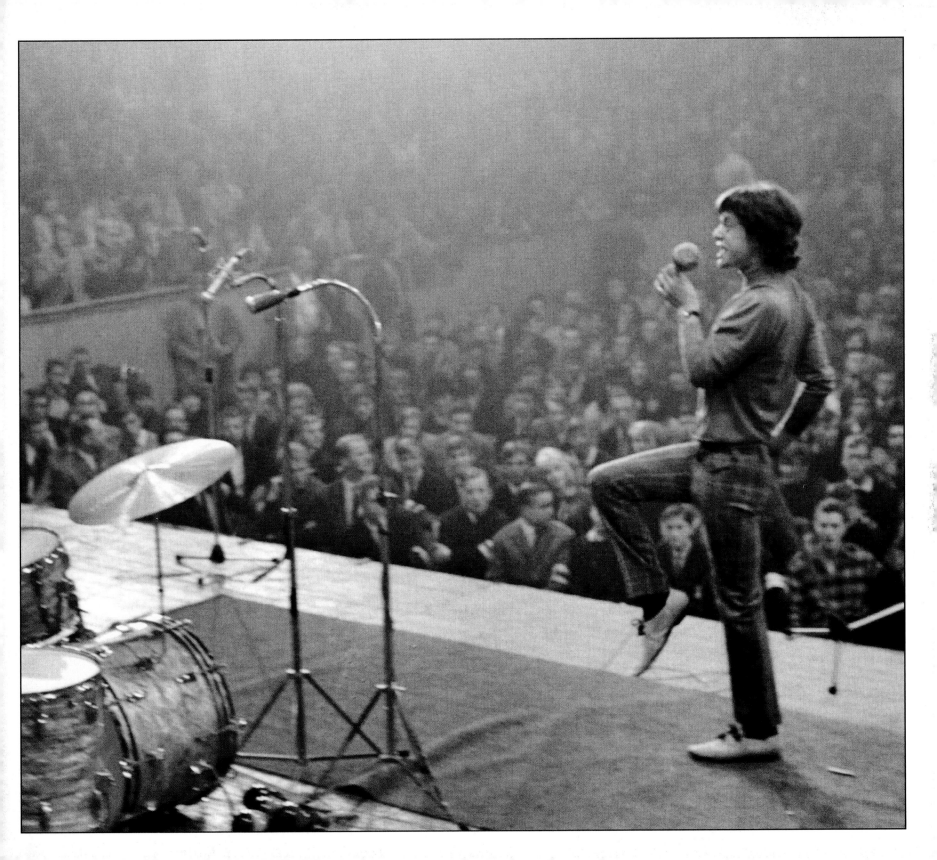

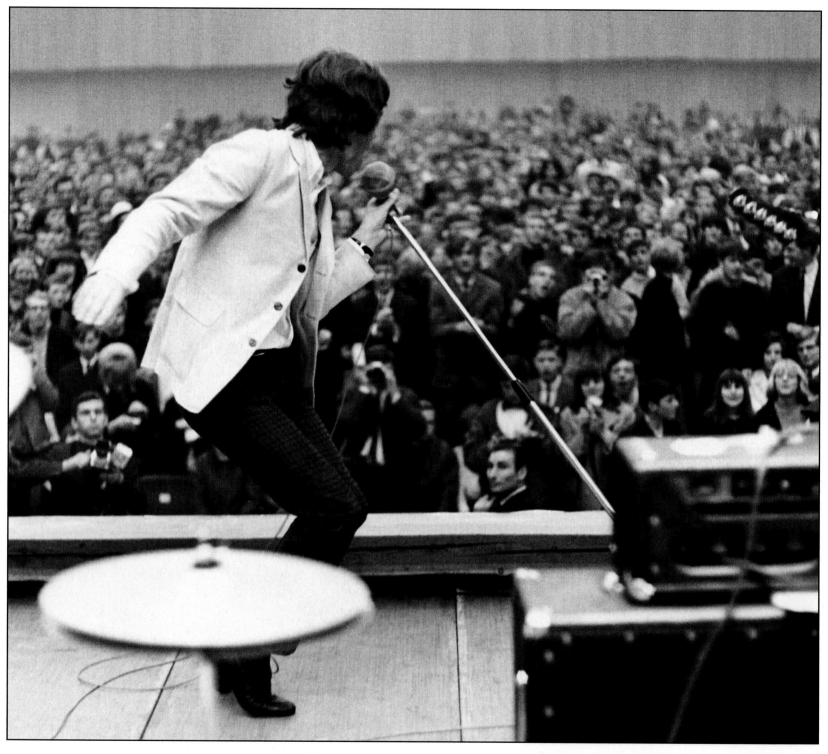

West German Tour

Grugahalle, Essen, West Germany, September 12, 1965.

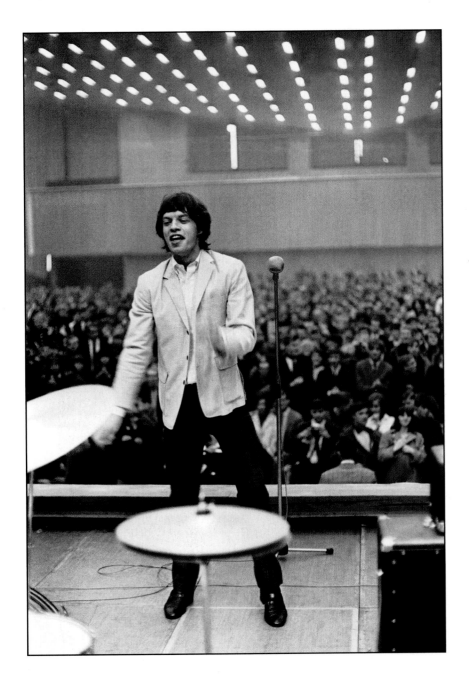
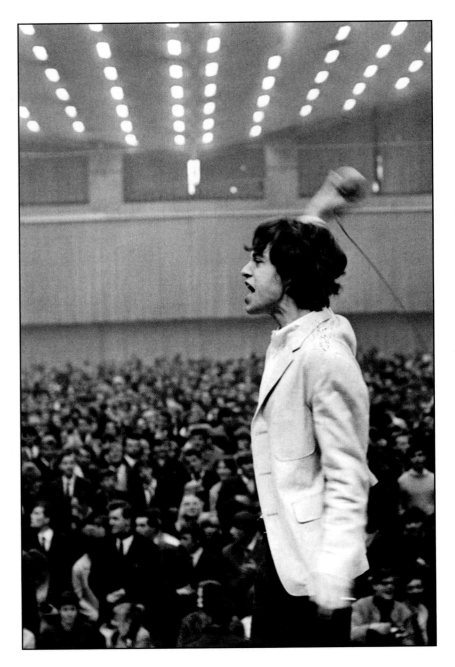

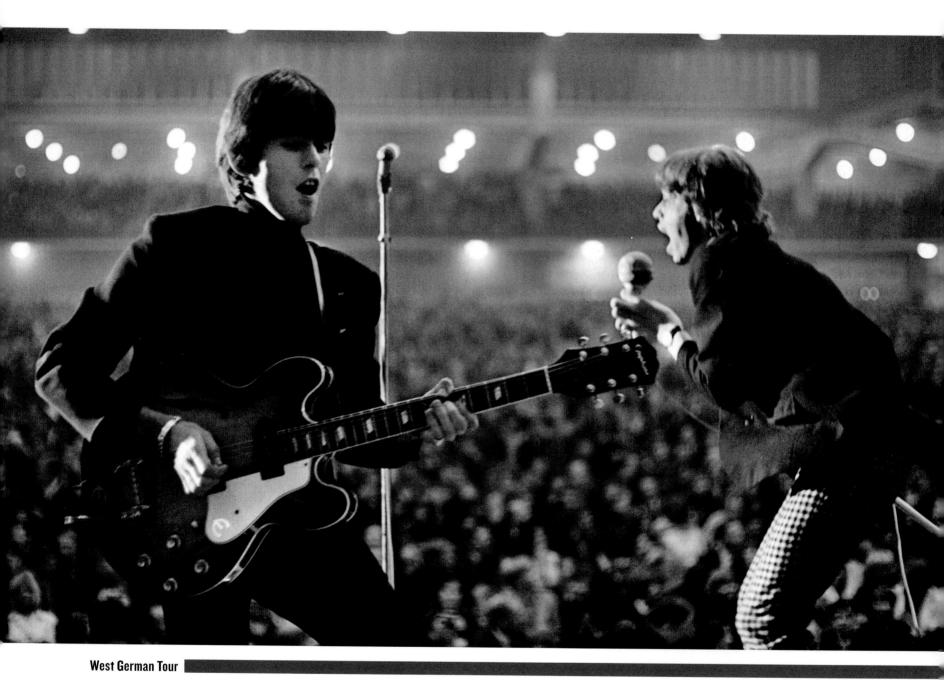

West German Tour

Ernst-Merck-Halle, Hamburg, West Germany, September 13, 1965.

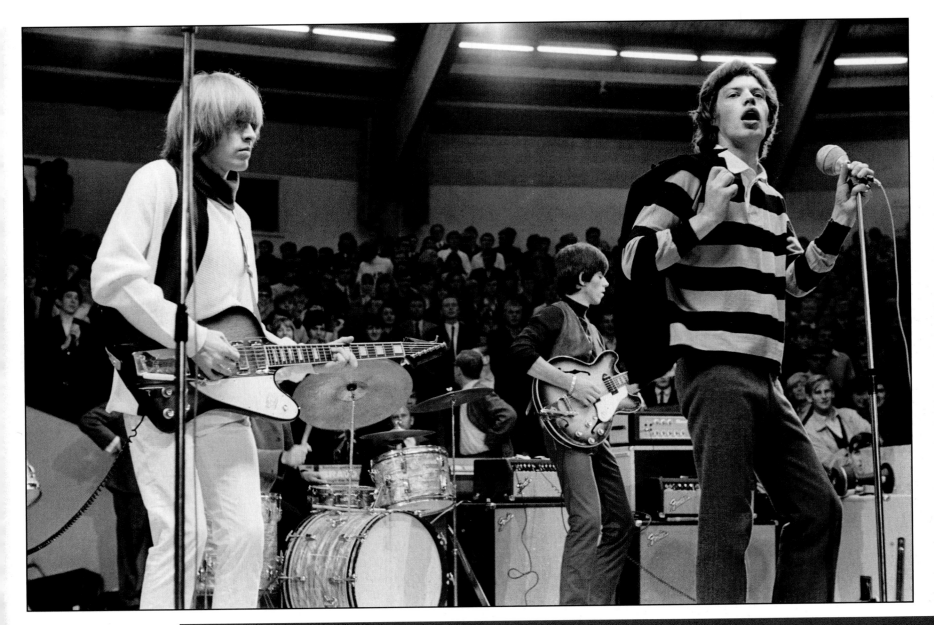

West German Tour

Zirkus Krone-Bau, Munich, West Germany, September 14, 1965.

Backstage at this concert Anita Pallenberg, who was in town on a modeling assignment, approached photographer Bent Rej and asked if he would introduce her to The Stones. He obliged, and Brian took a liking to her. They dated for two years until 1967, when while in Morocco, she left Brian for Keith Richards. She and Keith had three children (Marlon, Angela, and Tara, who died at ten weeks old) before they split up in 1981. She is also credited with singing background vocals on "Sympathy for the Devil."

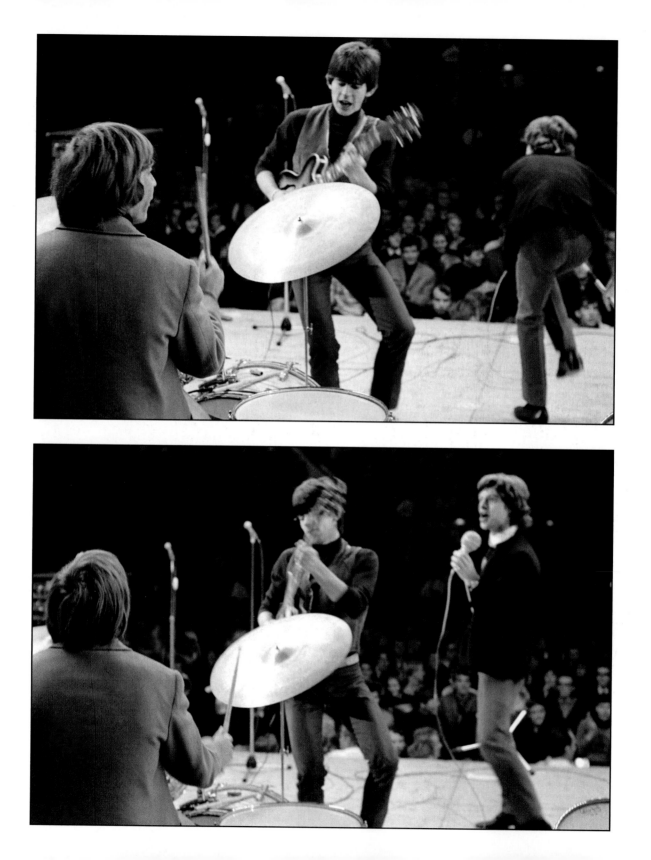

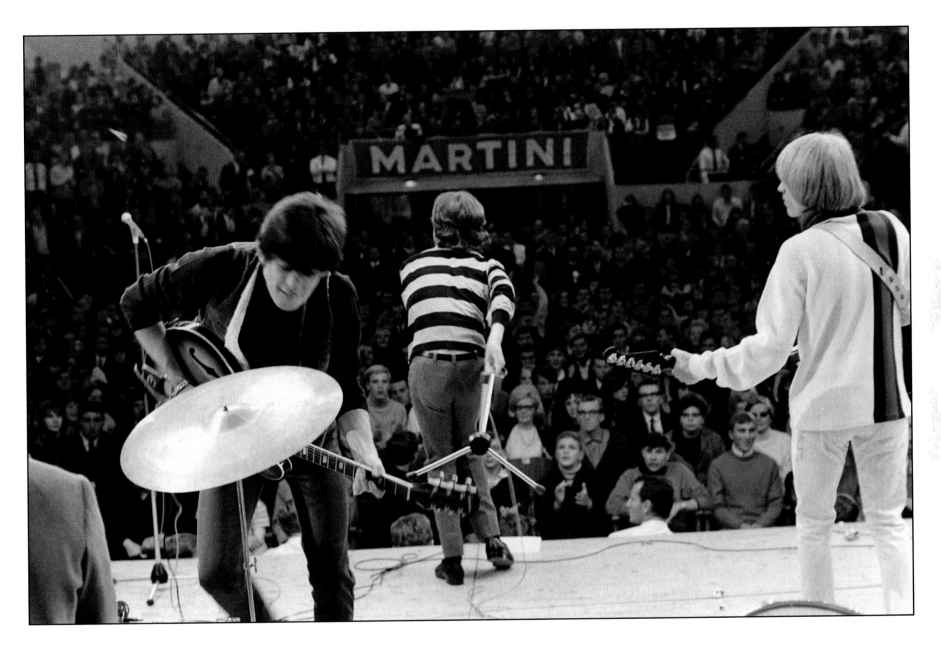

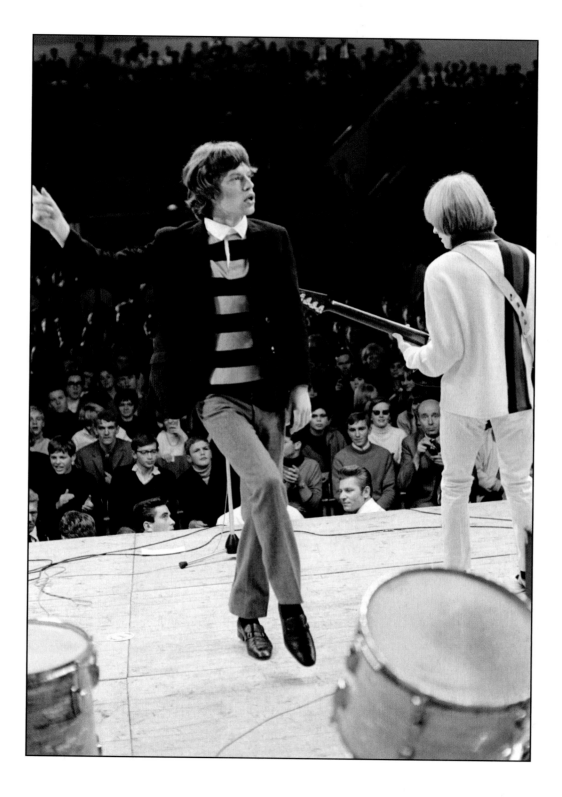

22

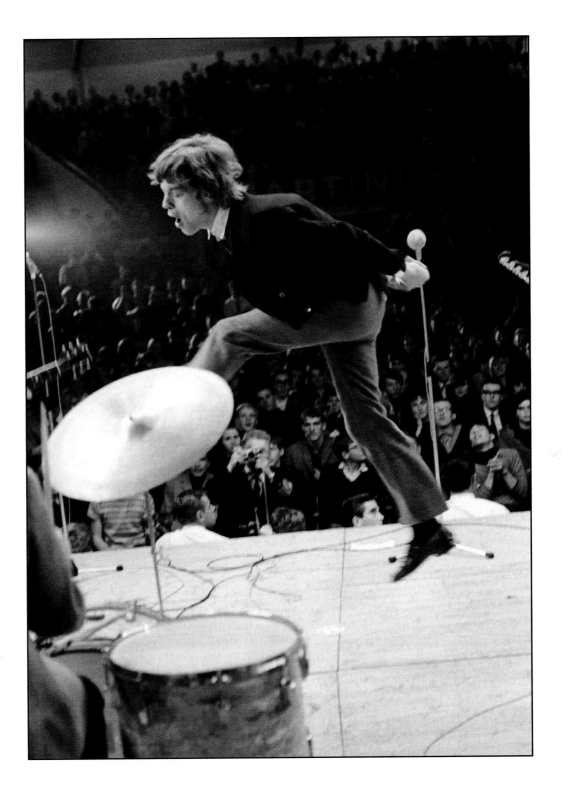

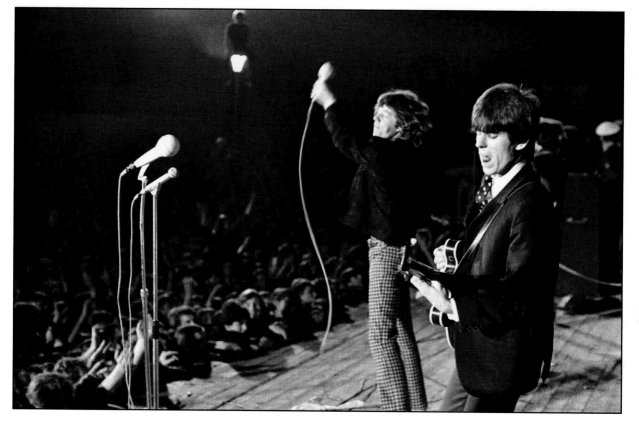

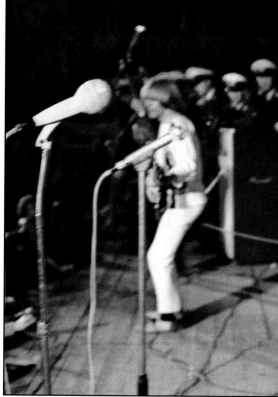

West German Tour

Waldbühne, West Berlin, West Germany, September 15, 1965.

The West German tour in September 1965 was marked by occasionally violent clashes between the fans and the police. At several of the shows fans who were unable to obtain tickets threw eggs, tin cans, and tomatoes at the police, who responded with force. The majority of the fans in West Germany were male, as much as 70 to 80 percent, a far greater percentage than in the U.K. or America. The Stones' music and their stage performances were known to incite riots at concerts before, but this was on a much greater scale.

The final show of the West German tour was marred by violence *inside* the venue. The Waldbühne had been the site of several of Hitler's speeches. Andrew Loog Oldham had suggested that Mick Jagger goose-step on stage, and Brian joined in with a Nazi salute, prompting the crowd to riot. The band was forced to retreat to an underground bunker while 400 policemen restored order and then the show resumed. After the show ended, 4,000 of the 21,000 fans who attended this open-air venue again rioted, causing a considerable amount of damage. Twenty thousand seats were destroyed, 300 arrests were made, 77 fans were injured, 28 fans and 6 police were hospitalized, 15 train cars were damaged, and several automobiles were overturned.

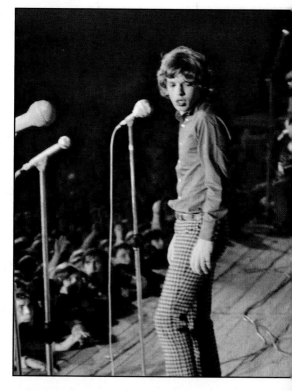

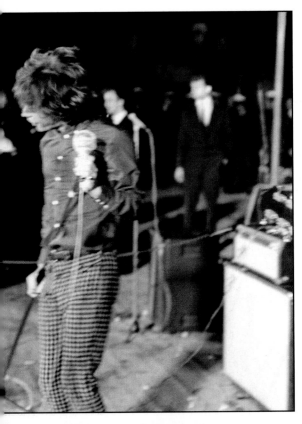
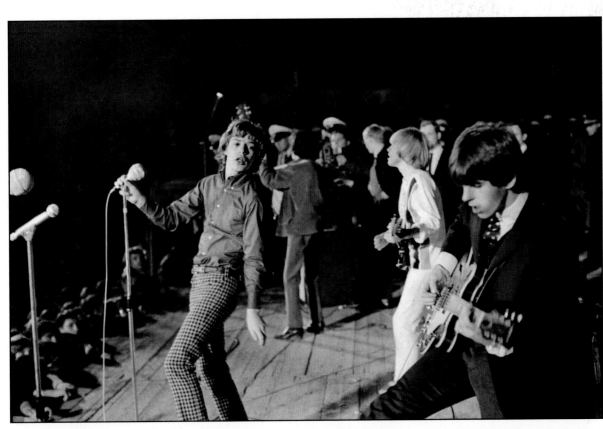
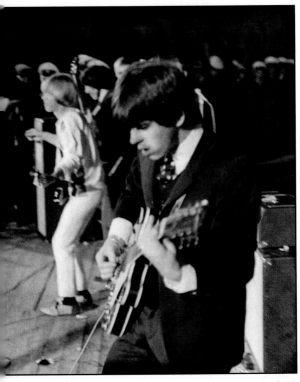
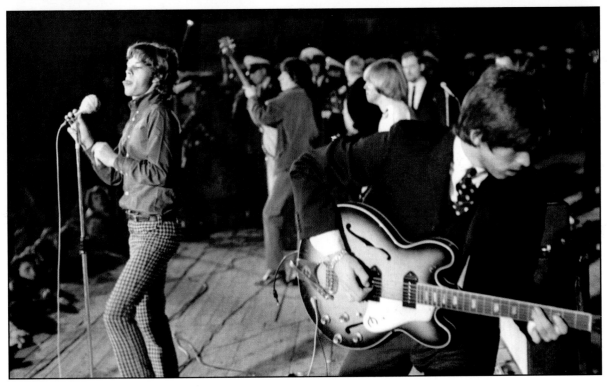

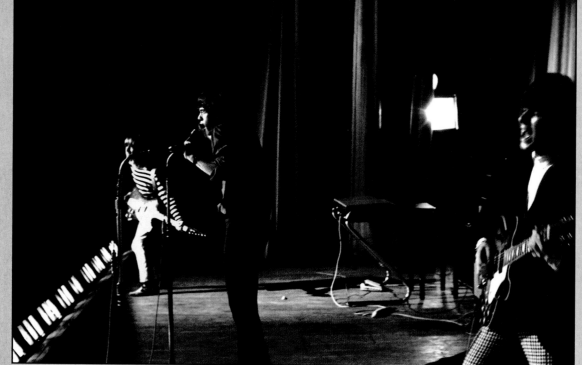

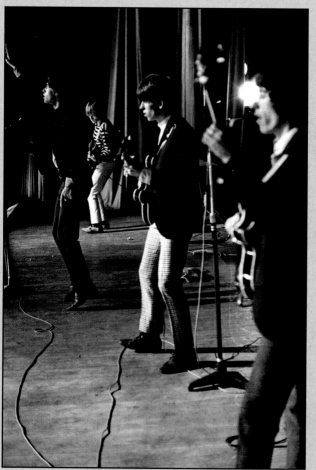

**Fourth North American Tour
October 29–December 6, 1965**

A typical set list on this
tour would include:

"She Said Yeah"
"Hitch Hike"
"Heart of Stone"
"Mercy, Mercy"
"That's How Strong My Love Is"
"Play with Fire"
"The Last Time"
"Good Times"
"Oh Baby (We Got a Good Thing Goin')"
"Get Off My Cloud"
"Moving On"
"(I Can't Get No) Satisfaction"

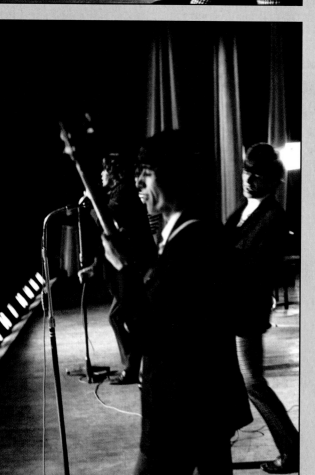

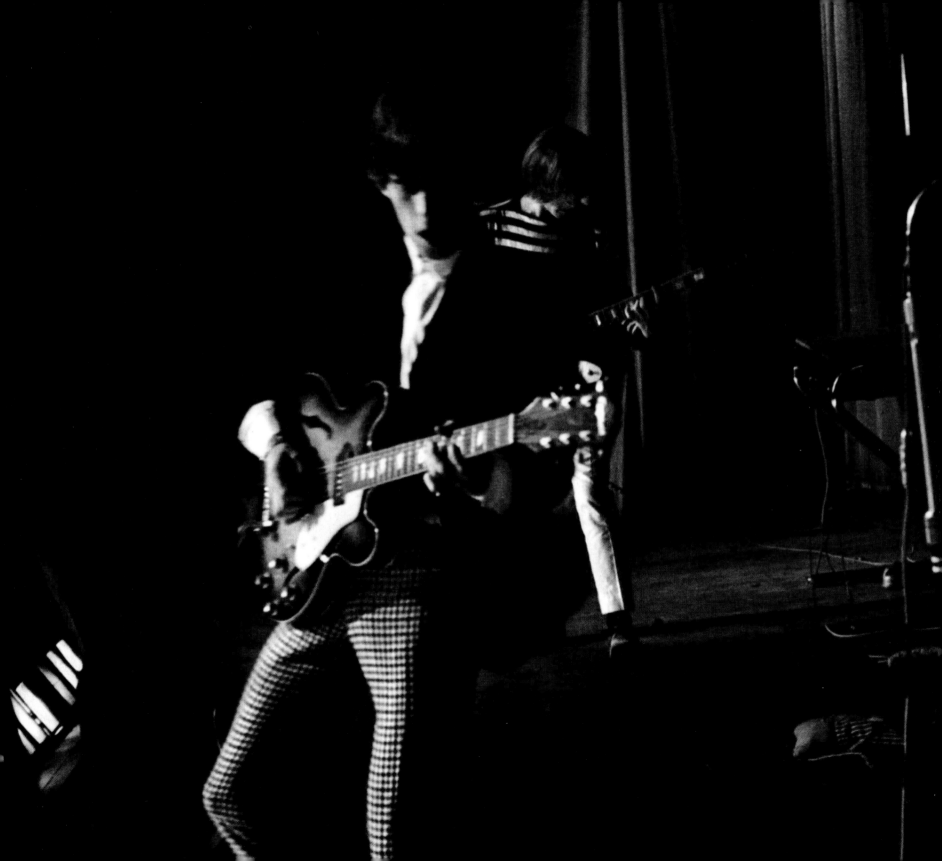

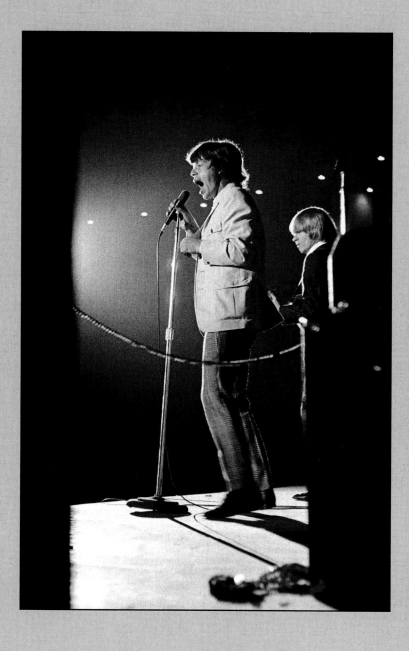
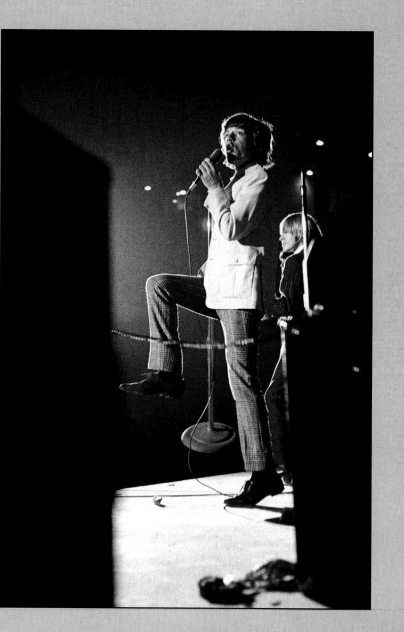

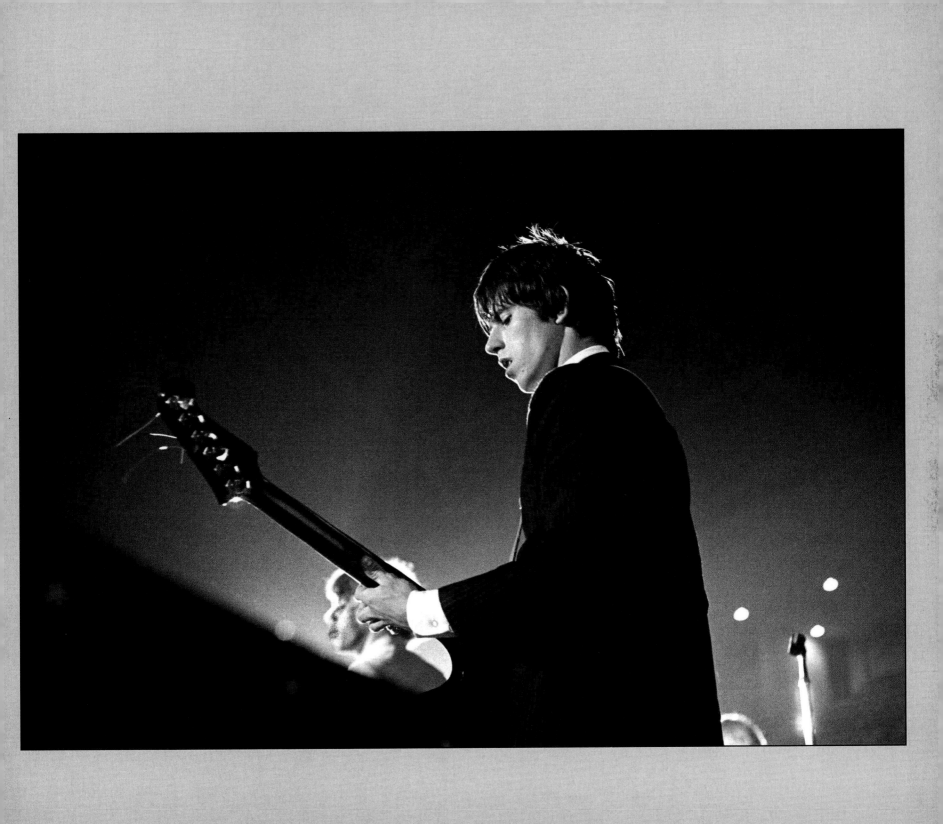

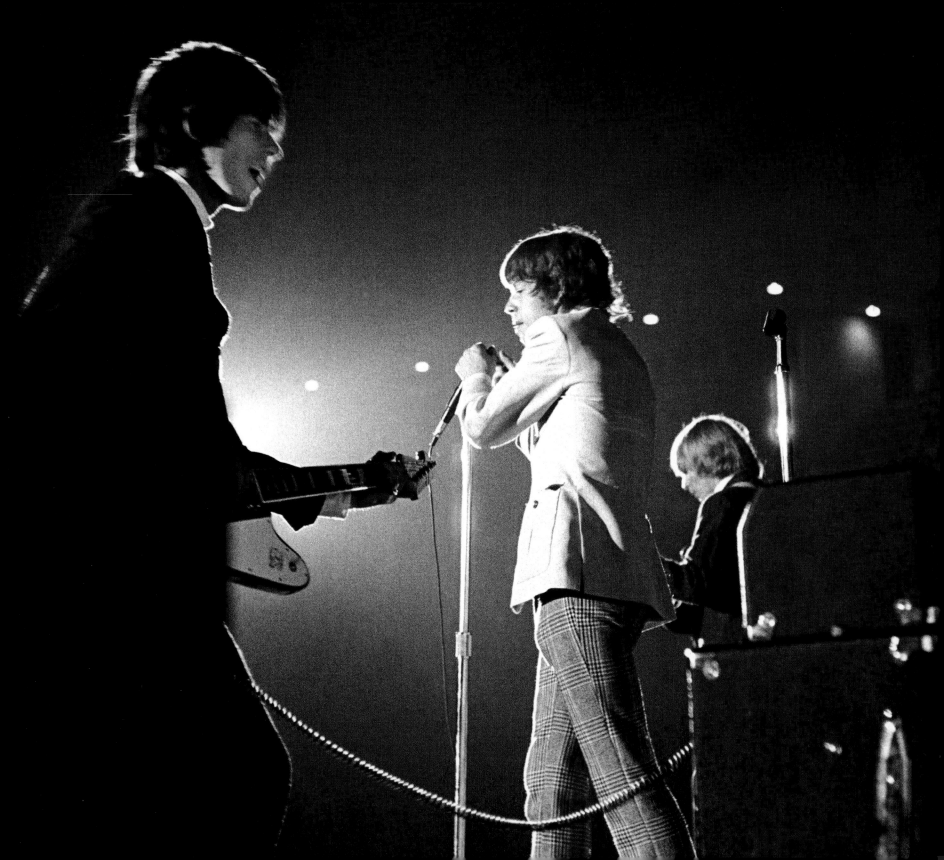

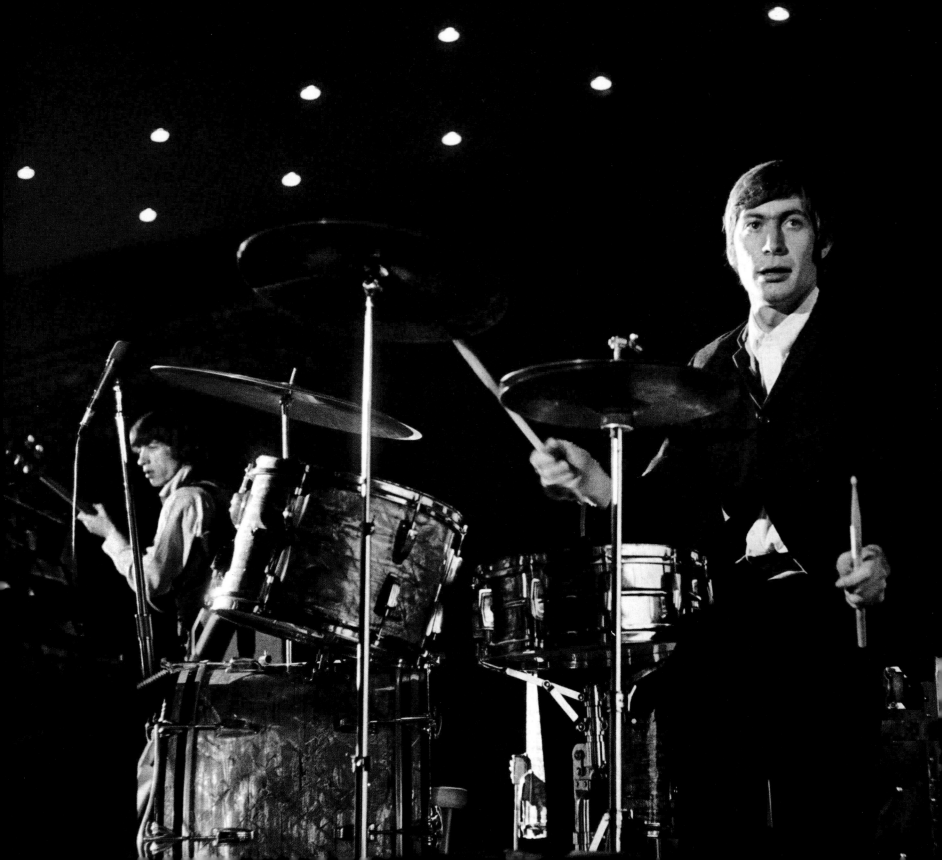

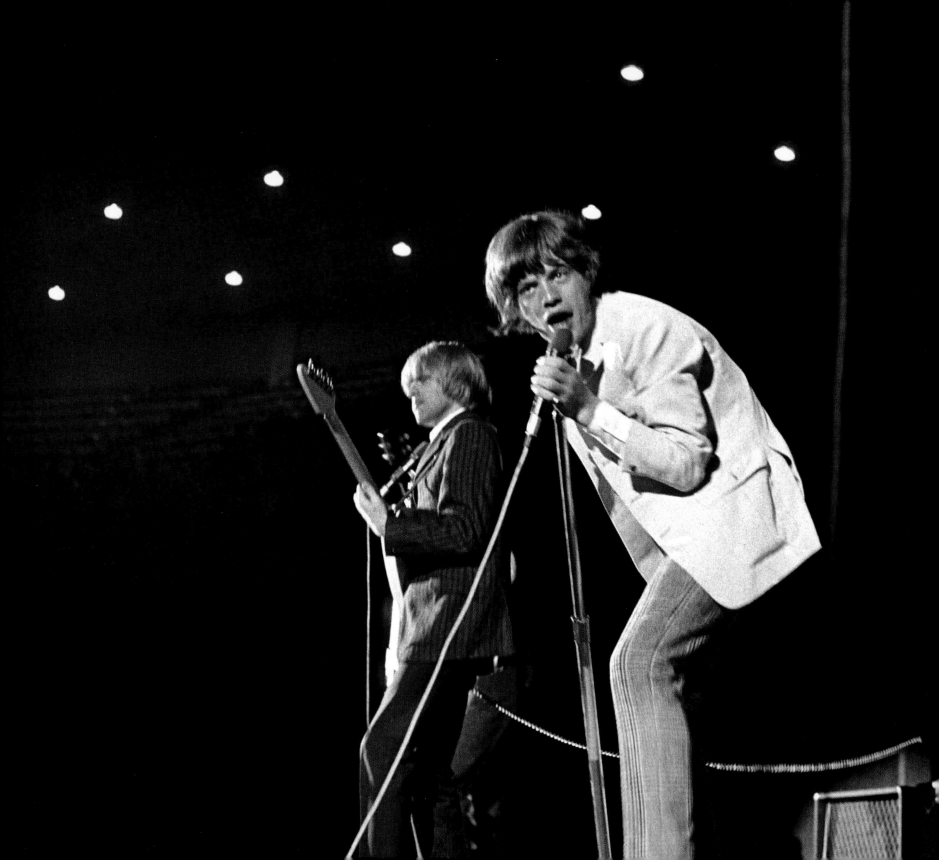

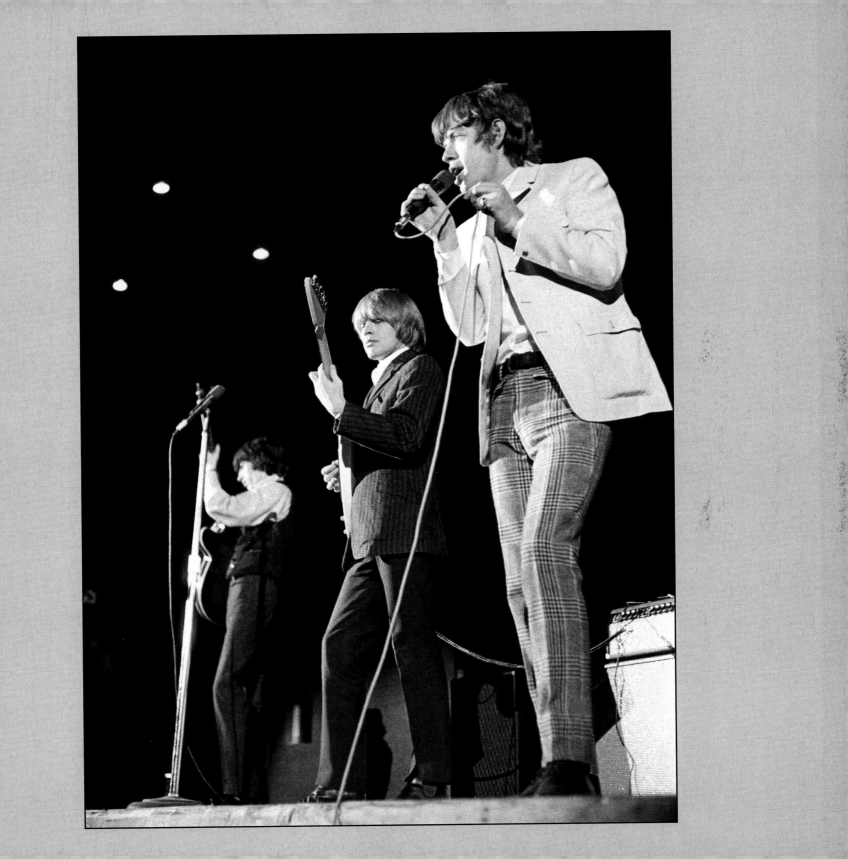

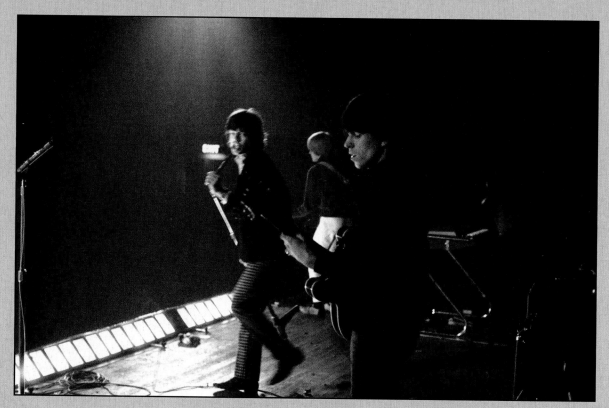
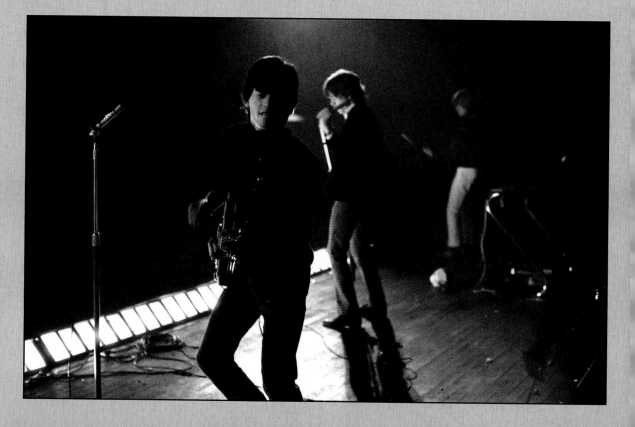

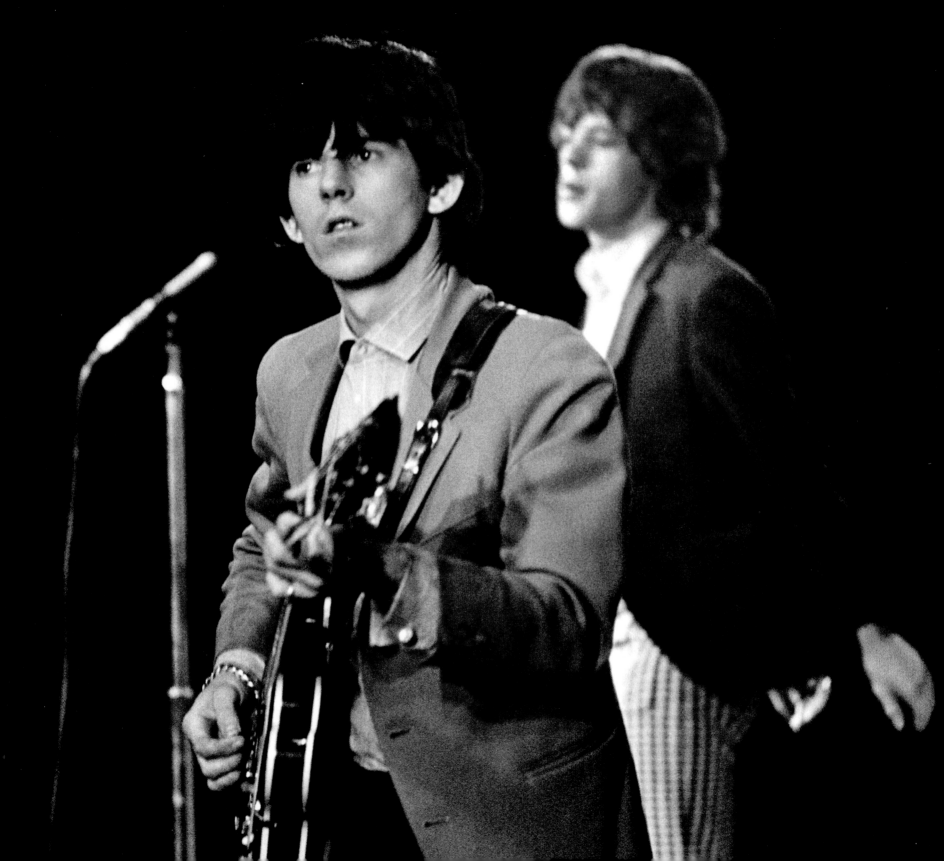

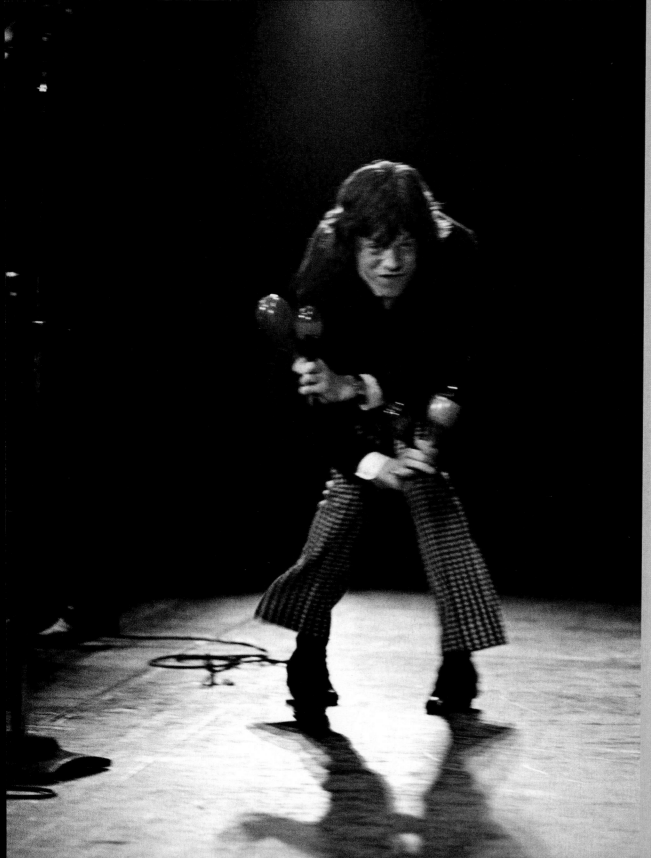

Mick demonstrates his fancy footwork, with
a tip of the hat to James Brown. The Stones
followed James Brown when they appeared
on *The T.A.M.I. Show* (Teenage Awards Music
International) film, and in their performance
Mick shows what a great influence James
had on his stage moves.

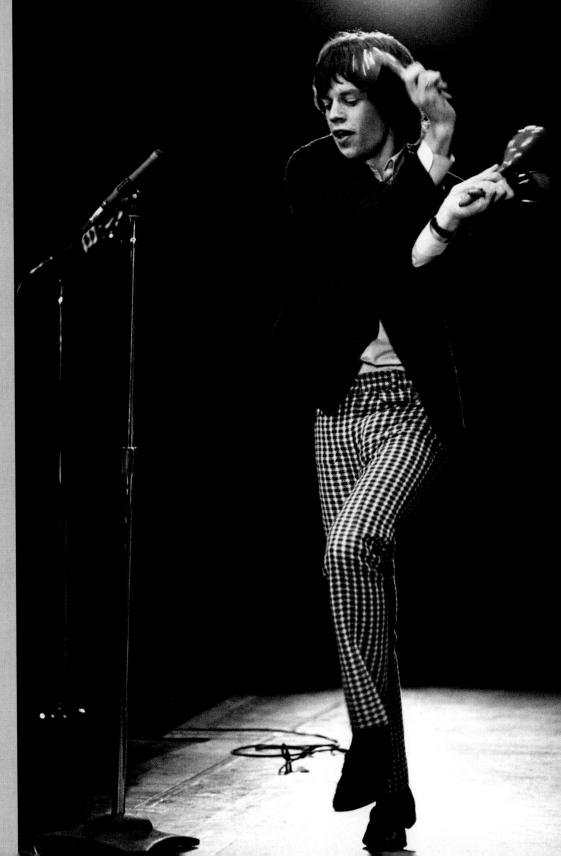

Mick plays the maracas as The Stones perform "Not Fade Away" (the first single released in the United States).

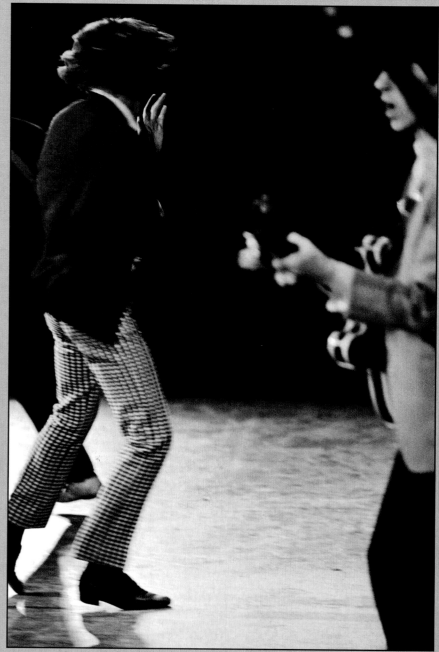

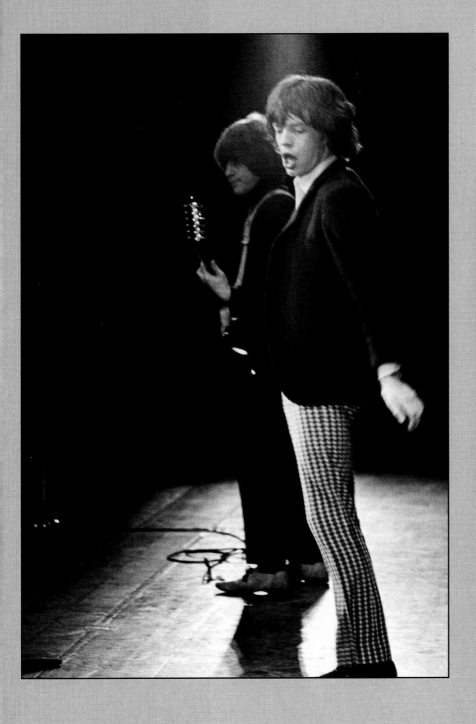
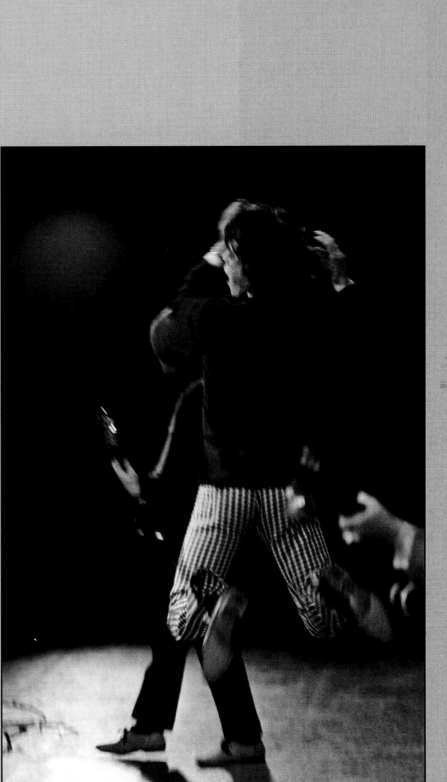

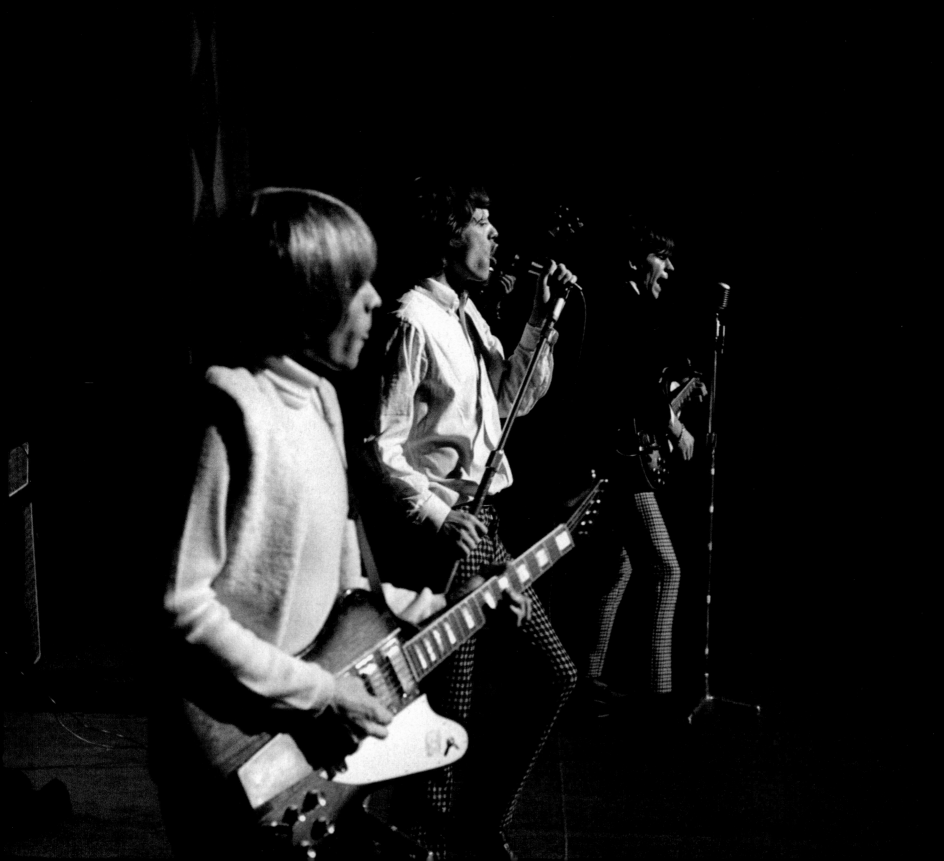

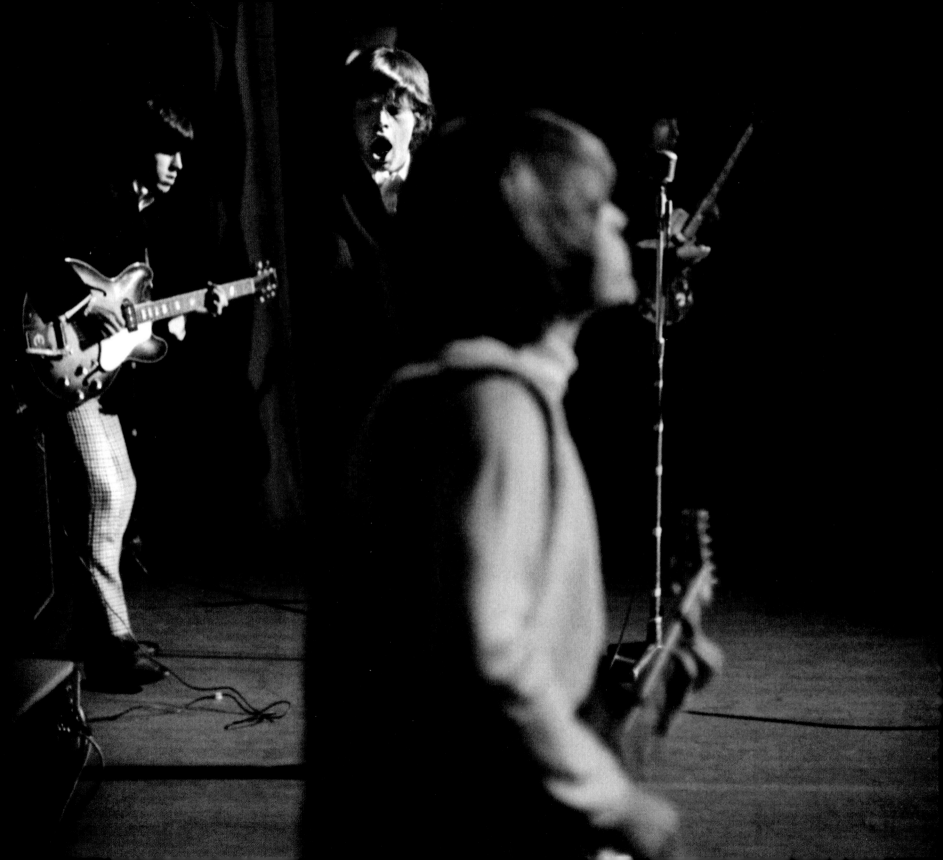

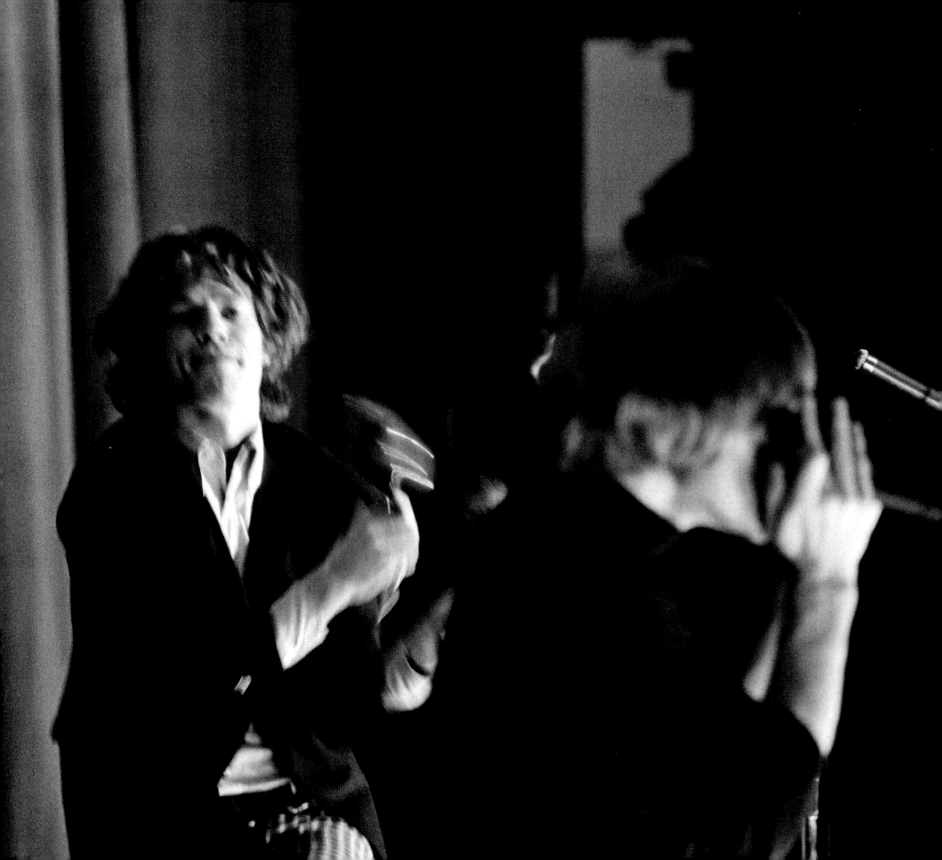

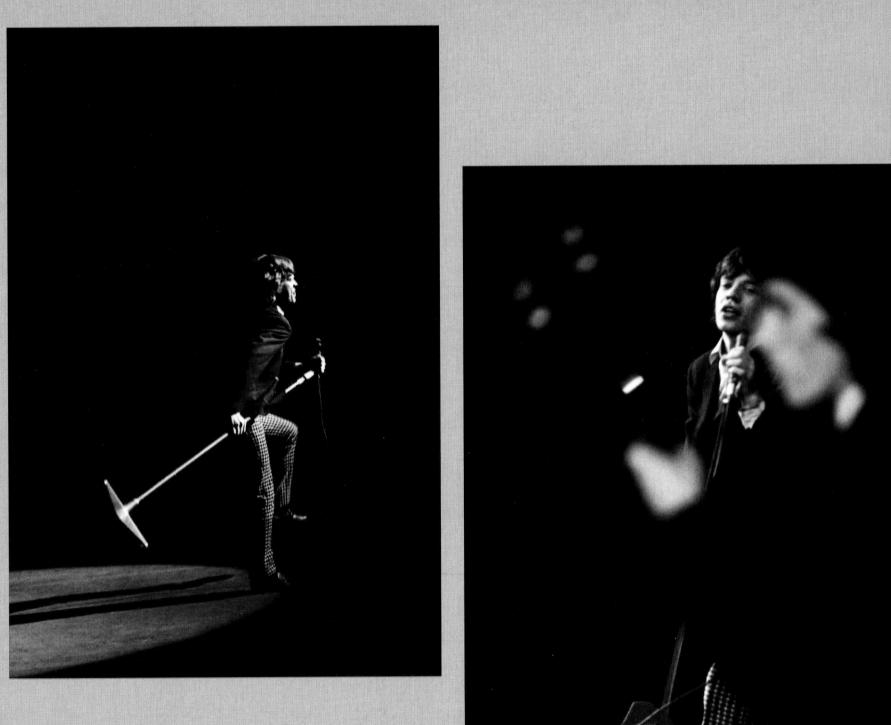

Mick would often use the microphone stand as a stage prop to great effect.

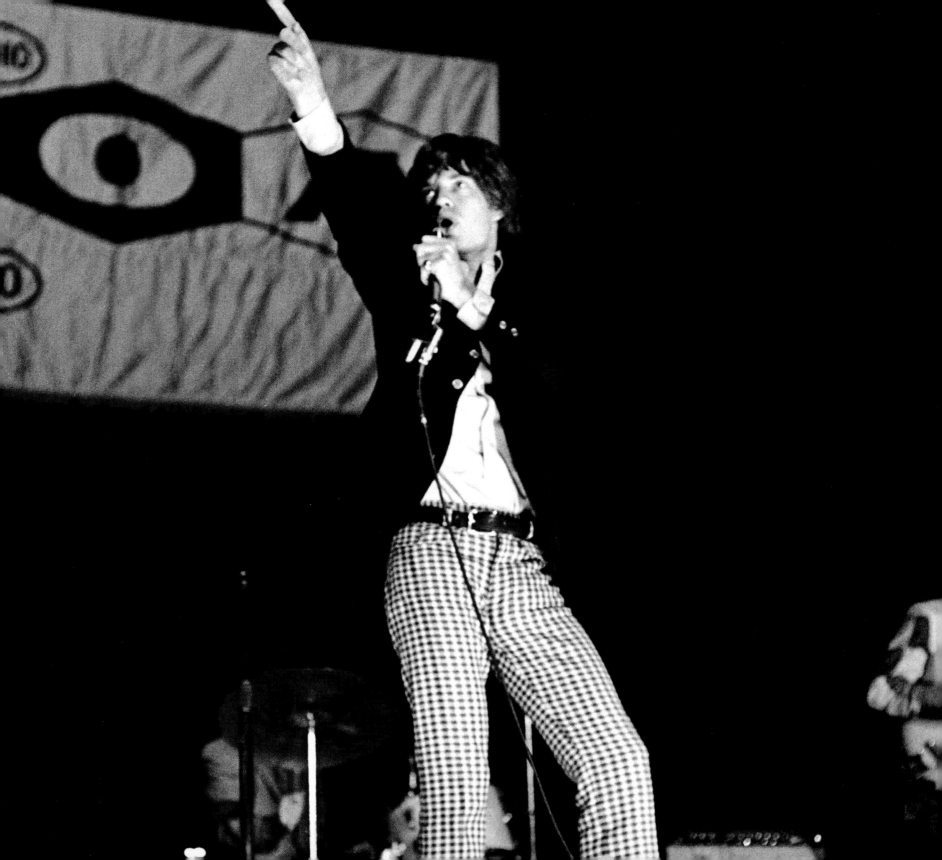

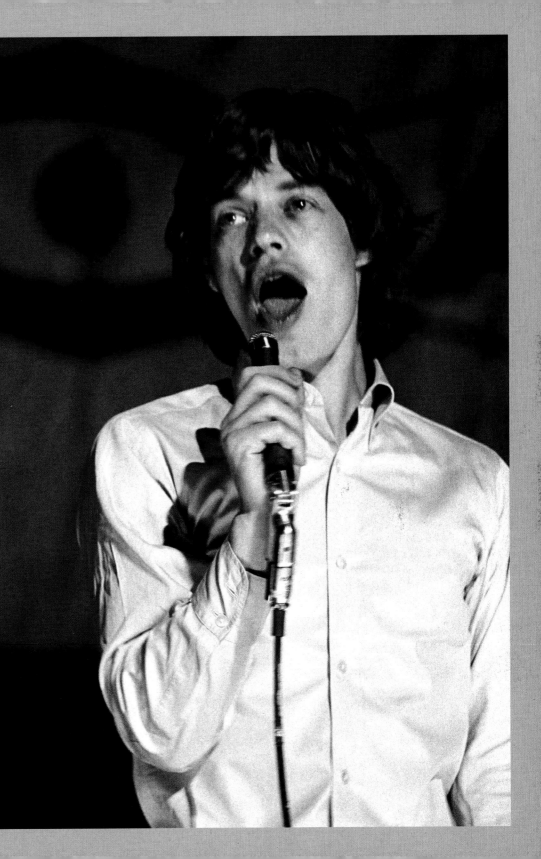

**Sacramento Memorial Auditorium,
Sacramento, California,
December 3, 1965.**

Sponsored by radio station KXOA, the show was opened by
Rockin' Ramrods and Patti LaBelle and the Bluebelles.

Late into the concert Keith accidentally touched his guitar
to an ungrounded microphone stand and was electrocuted,
knocking him unconscious. Keith would later say about the
incident, "I woke up in the hospital an hour later. The doctor
said [electric shock victims] come around or they don't."

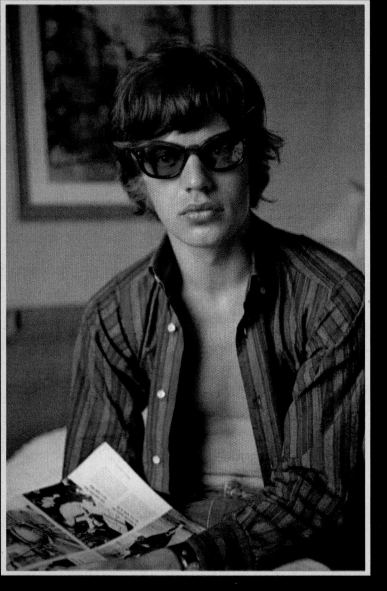
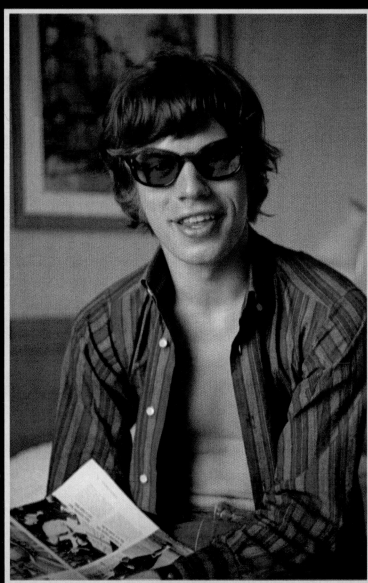

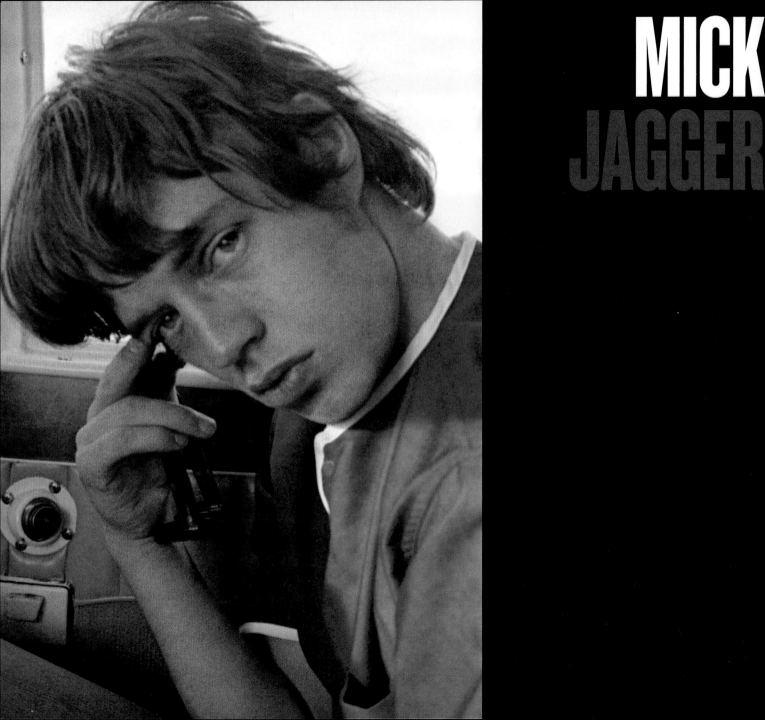

MICK
JAGGER

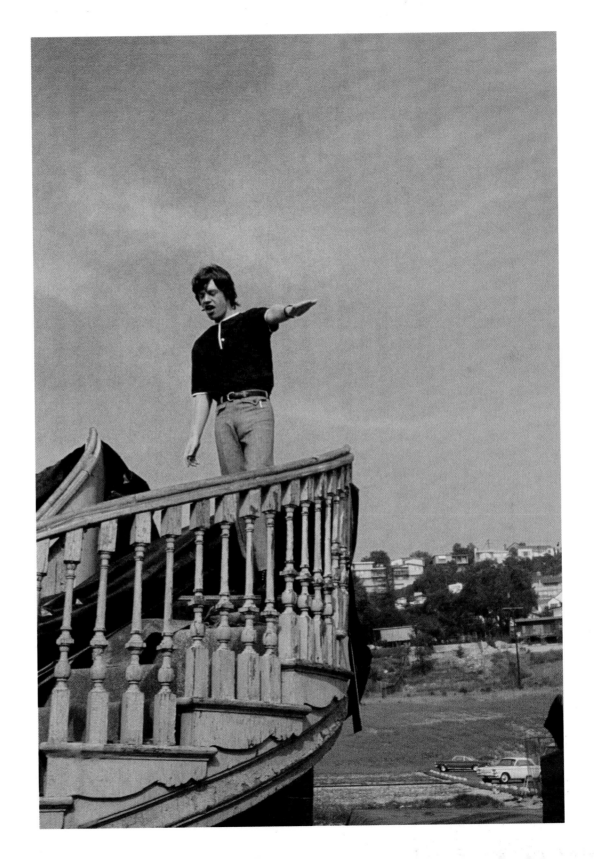

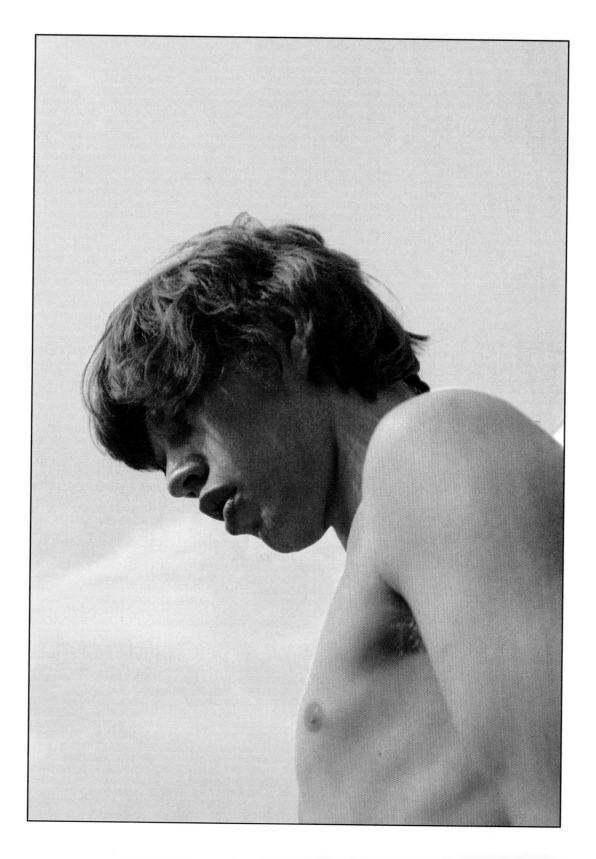

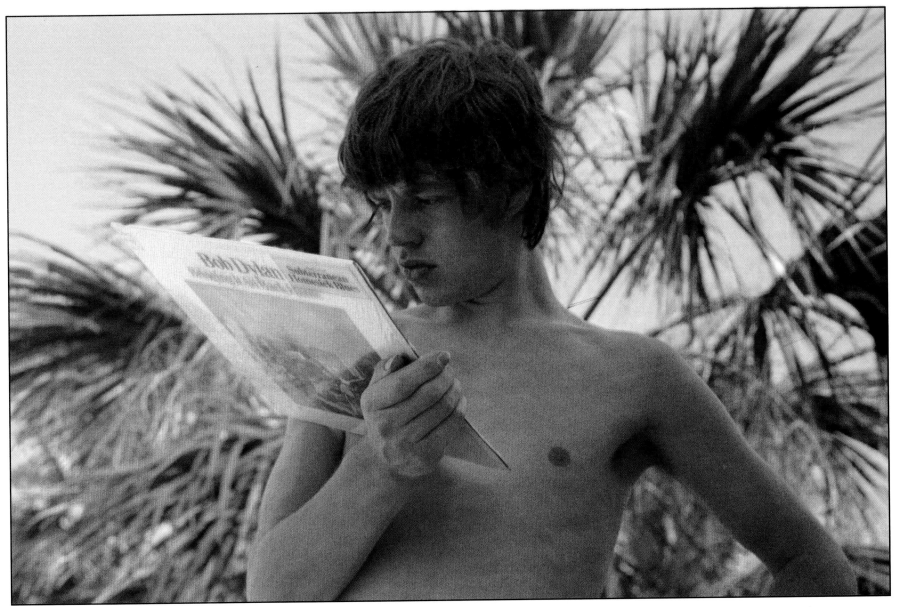

A very engrossed Mick Jagger sizes up the competition as he reads the liner notes of Bob Dylan's newest LP *Bringing It All Back Home.* This album came out at the beginning of The Stones' third U.S. tour, in May 1965. It marked a change in direction for Dylan, a move away from the folk and protest songs of his previous recordings to a more rock 'n' roll electric sound. The Stones had met Bob Dylan at the final show of their first U.S. tour, on June 20, 1964, at Carnegie Hall in New York City.

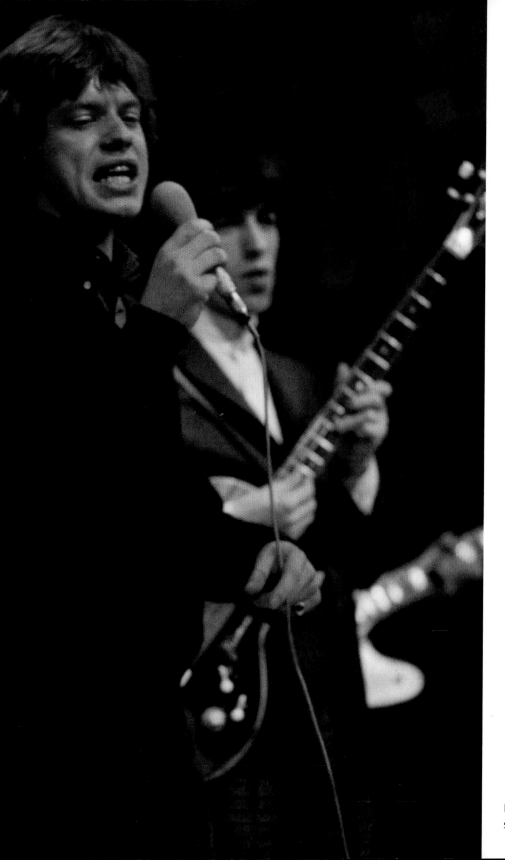

Mick, with Bill Wyman behind him, performs on the TV
show *Hullabaloo* in November 1965.

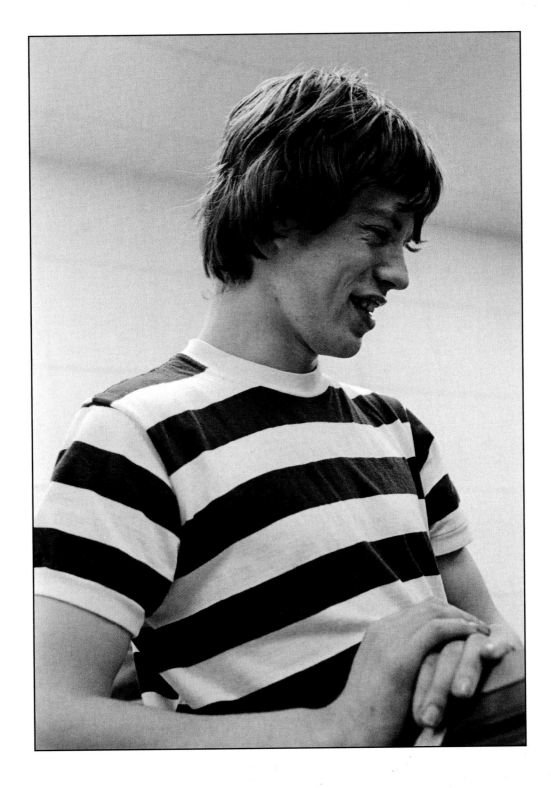

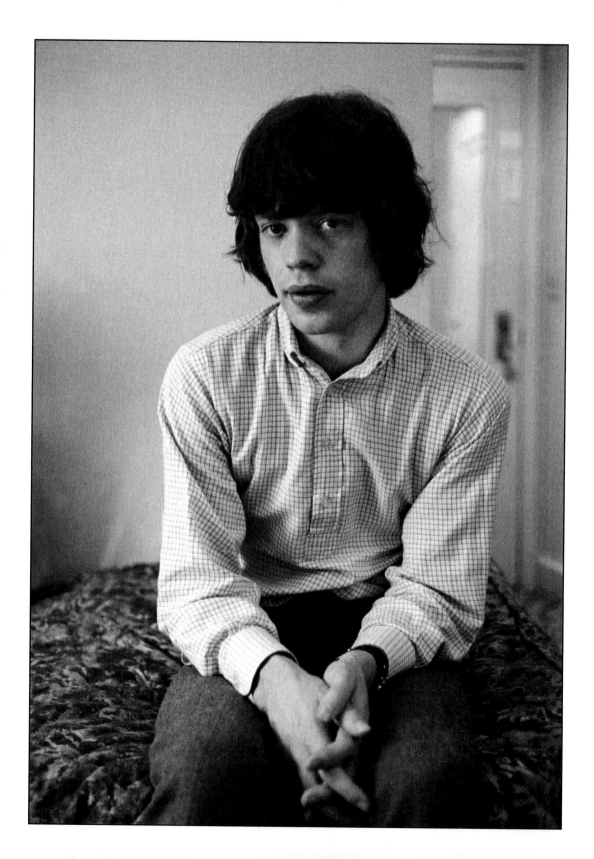

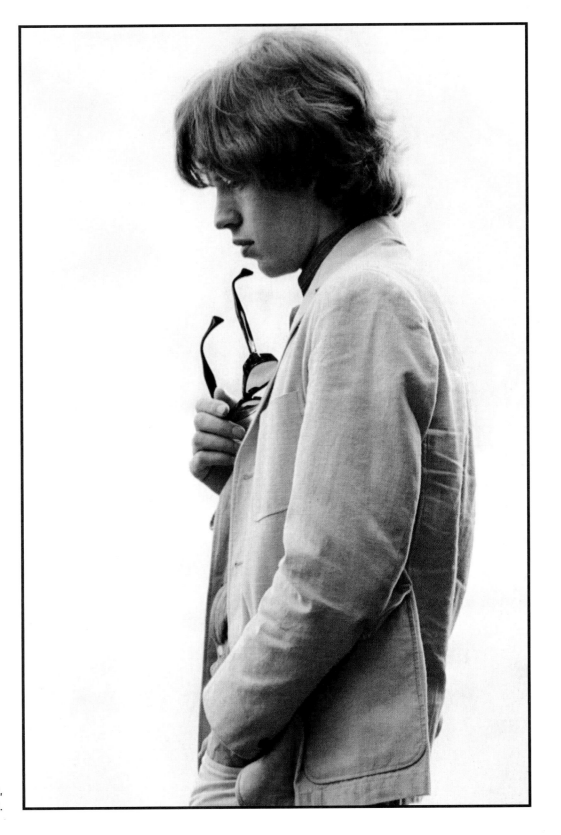

Los Angeles, California,
December 1965.

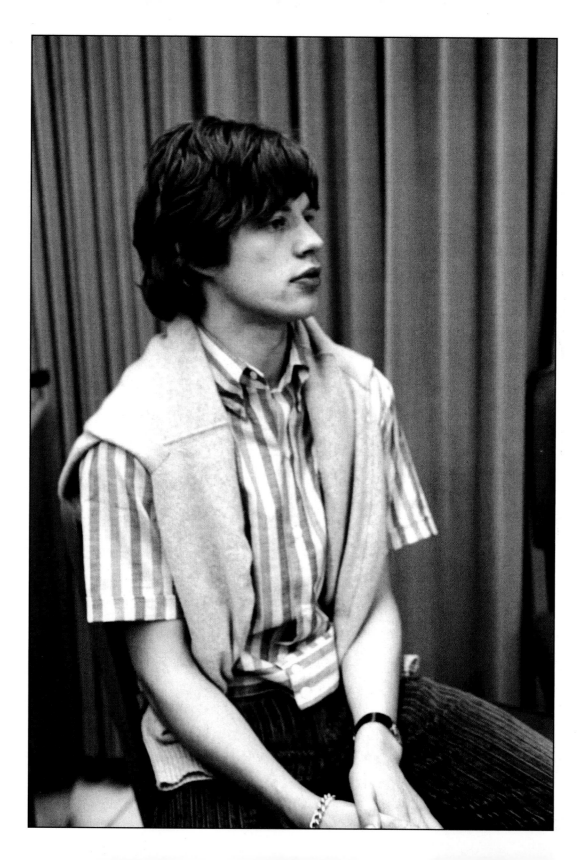

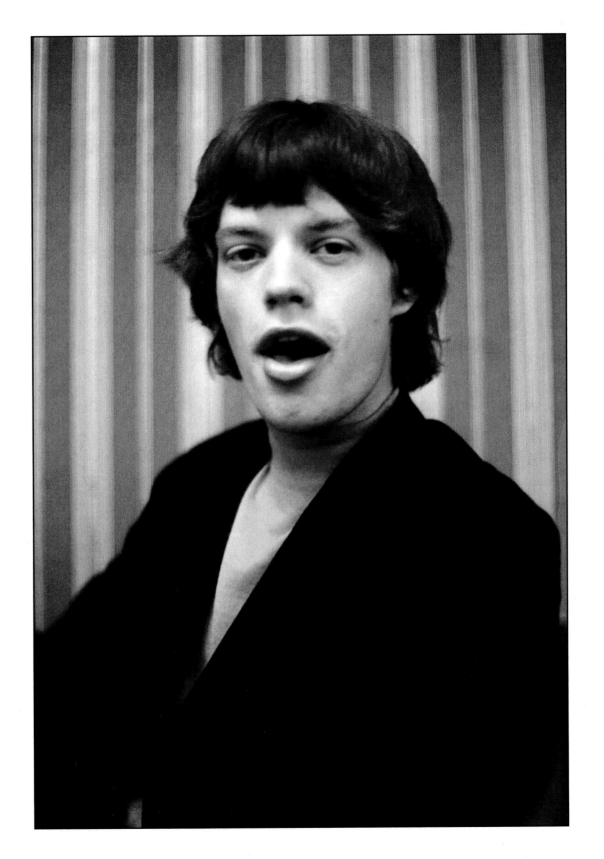

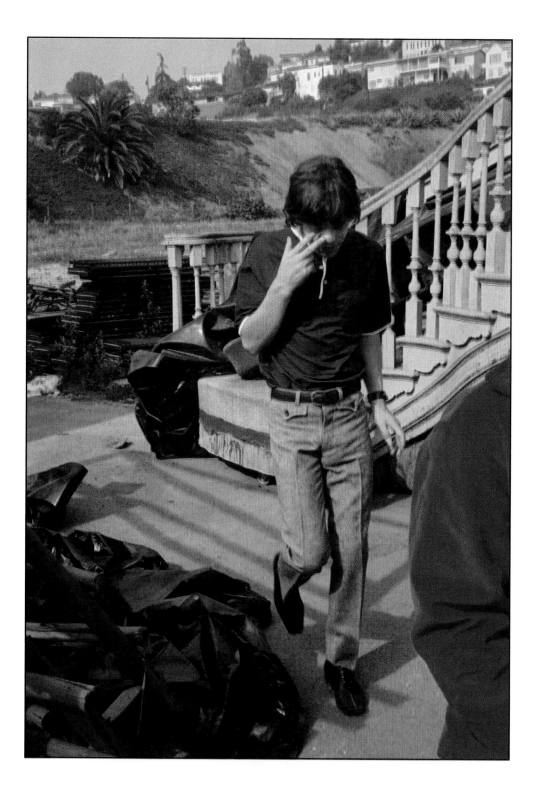

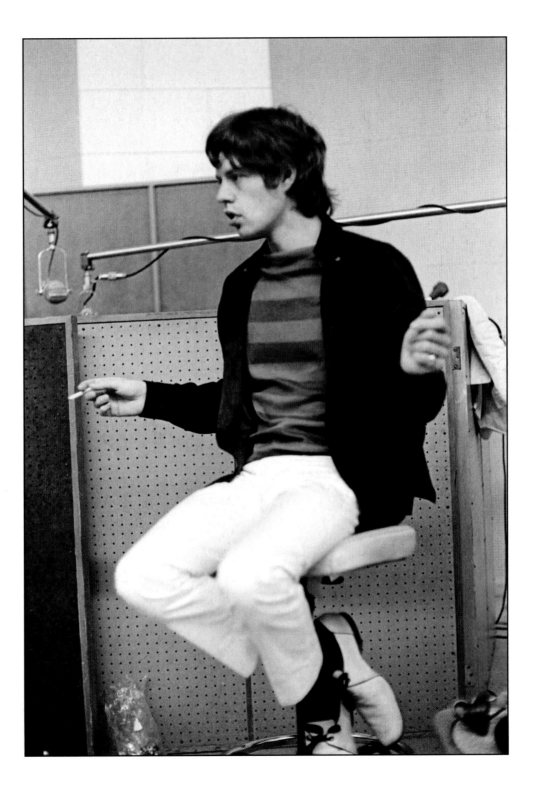

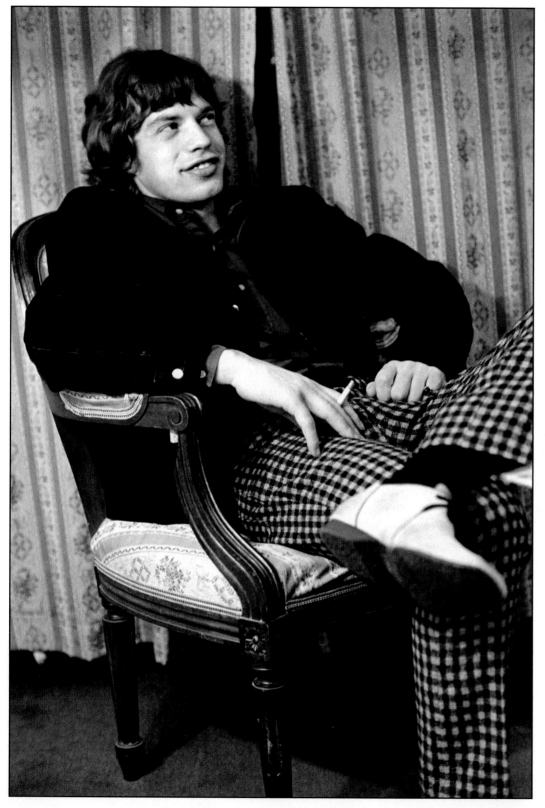

Backstage at Waldbühne, West Berlin, West Germany,
September 15, 1965.

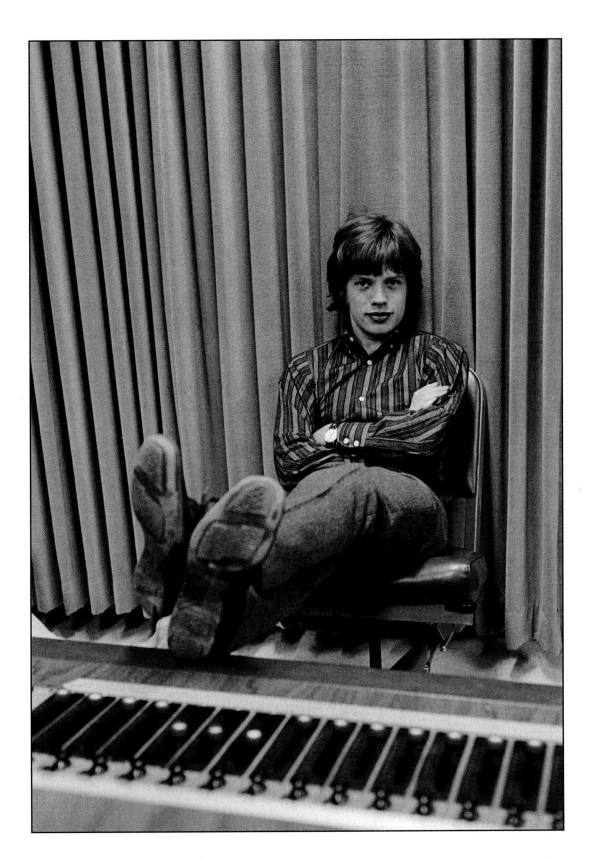

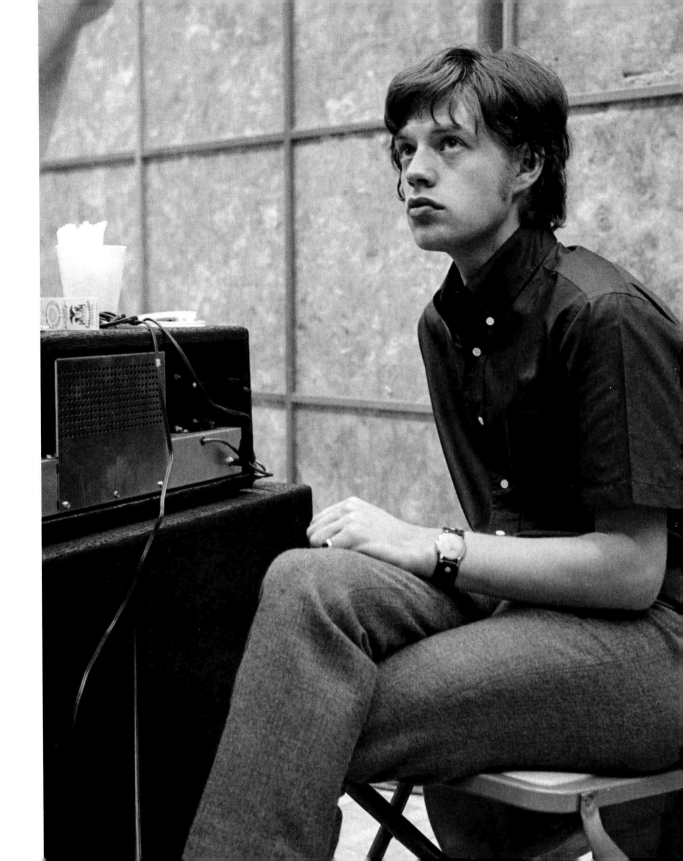

RCA Studios, Hollywood, California,
September 6–7, 1965.

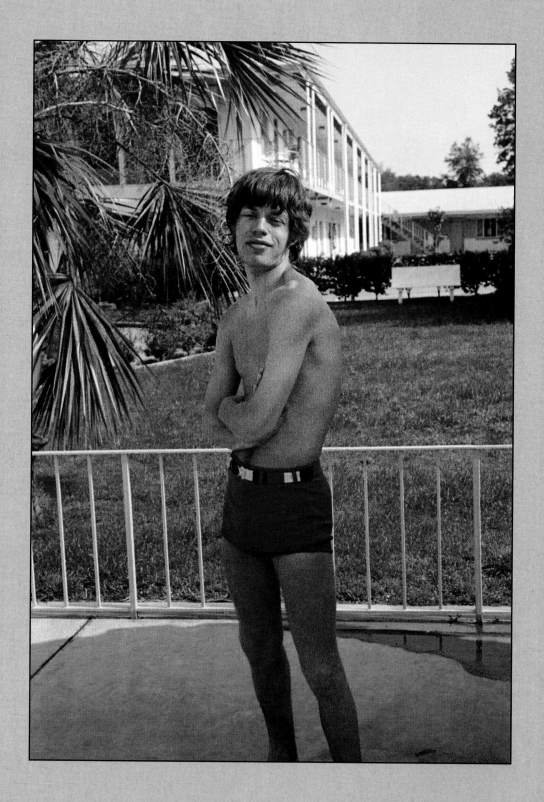

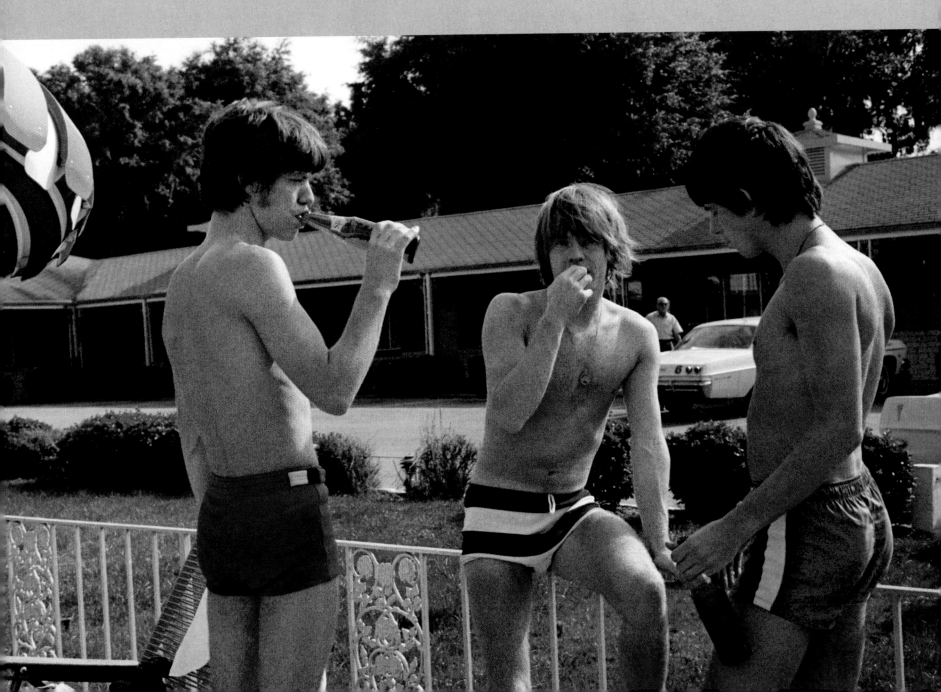

PERSONAL TIME

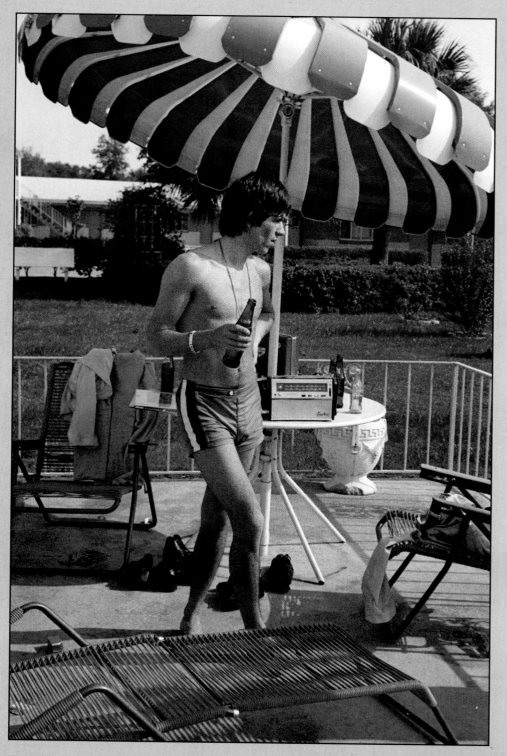

The Manger Town and Country Motor Lodge, Savannah, Georgia, May 1965.

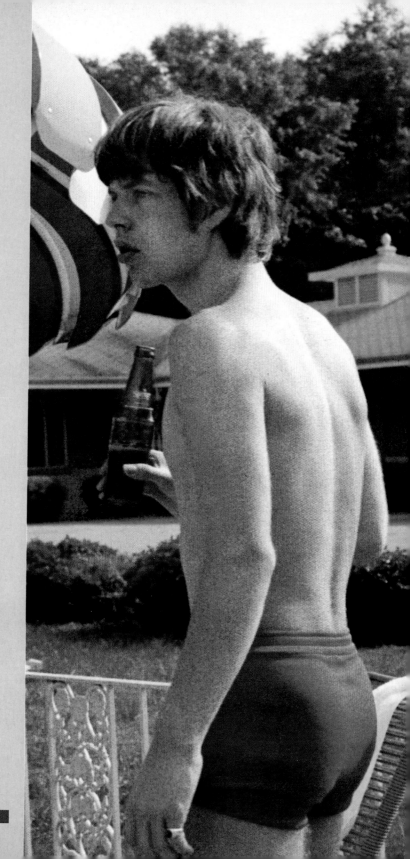

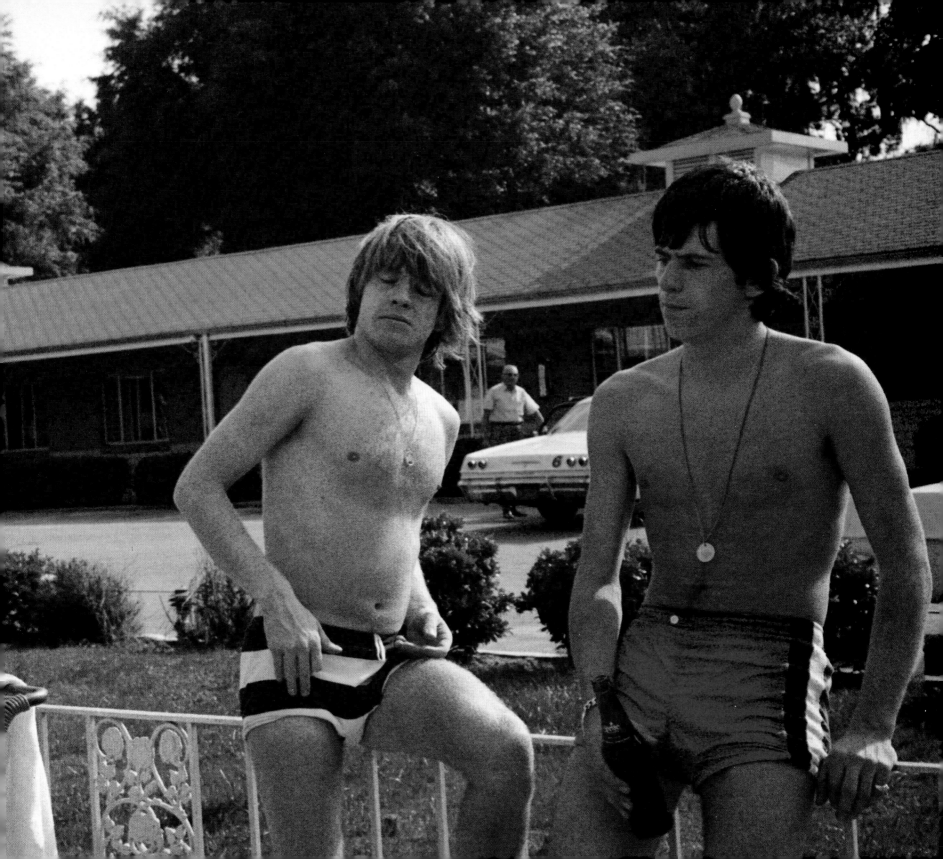

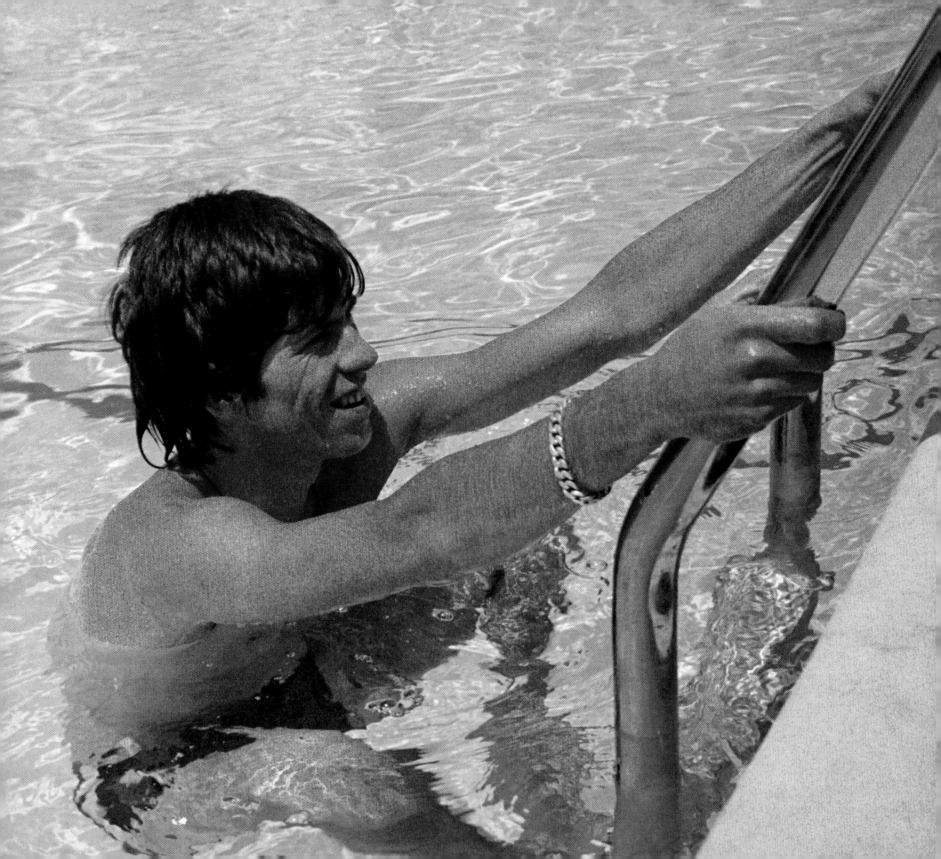

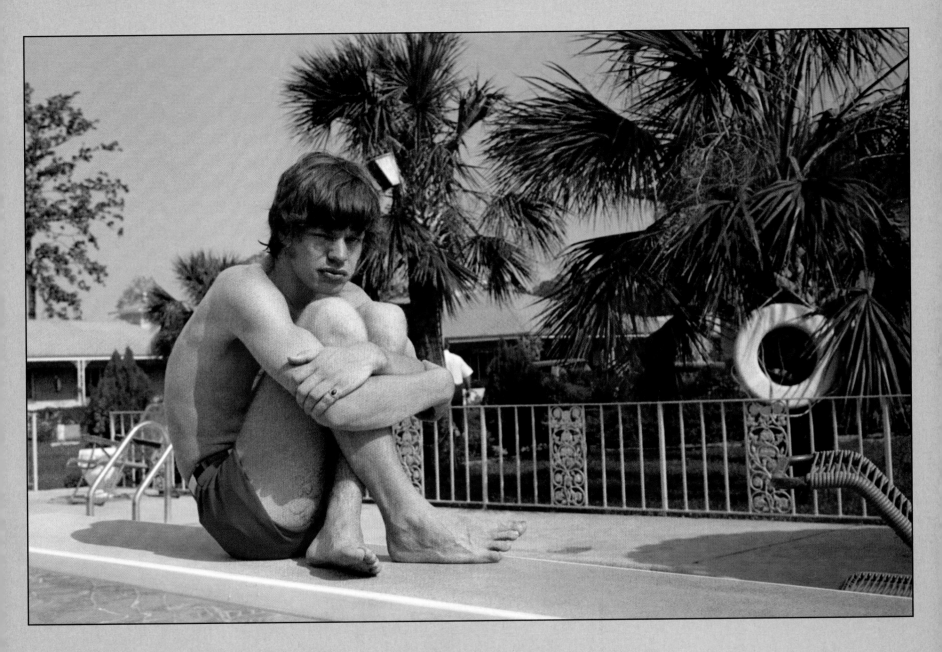

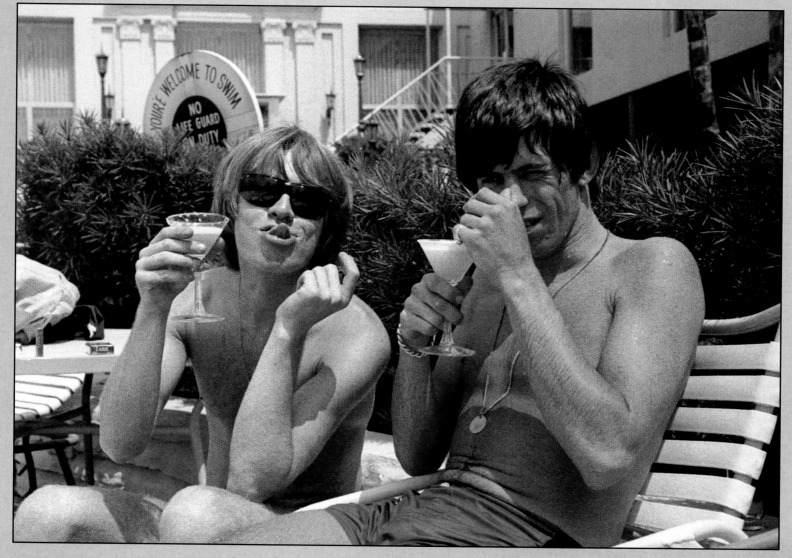

The Fort Harrison Hotel, Clearwater, Florida, May 7, 1965.

Today this building is home to the headquarters of the Church of Scientology. In the wee hours of the morning that these were taken Keith awoke with a riff in his head. He grabbed his cassette recorder and laid down what *Newsweek* magazine called "five notes that shook the world" and the lyric "I can't get no satisfaction." Keith awoke to hear "2 minutes of 'Satisfaction' and 40 minutes of me snoring," as he had forgotten to turn off the tape before falling back asleep.

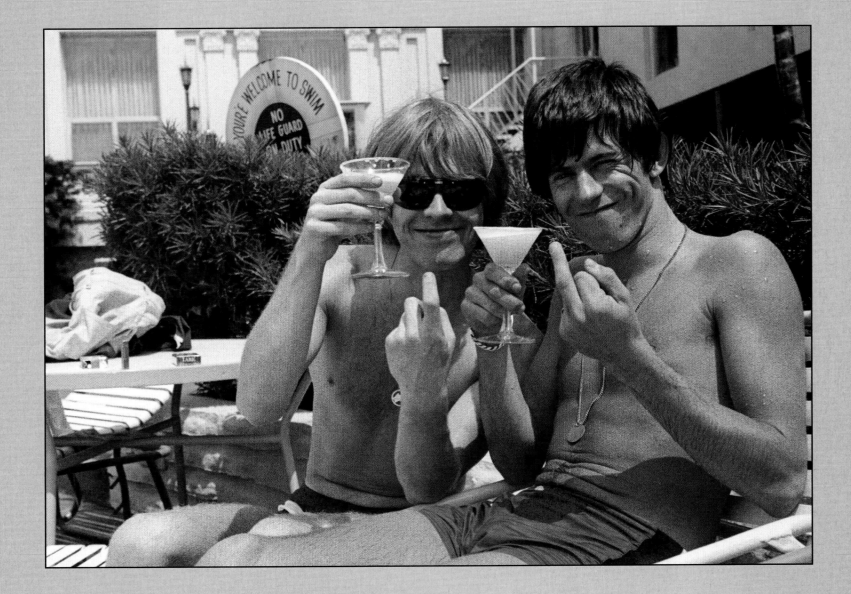

"You can do some of your best writing in hotel rooms," Keith once said. "I woke up with the riff in my head and the basic refrain and wrote it down." According to several accounts, Keith also came up with the lyrics "I can't get no satisfaction" the next morning, but never thought the song was particularly good. He wanted it done with a horn section instead of the fuzzy-sounding guitar. "The record still sounded like a dub to me," he once said. "I couldn't see getting excited about it. I'd really dug it that night in the hotel, but I'd gone past it."

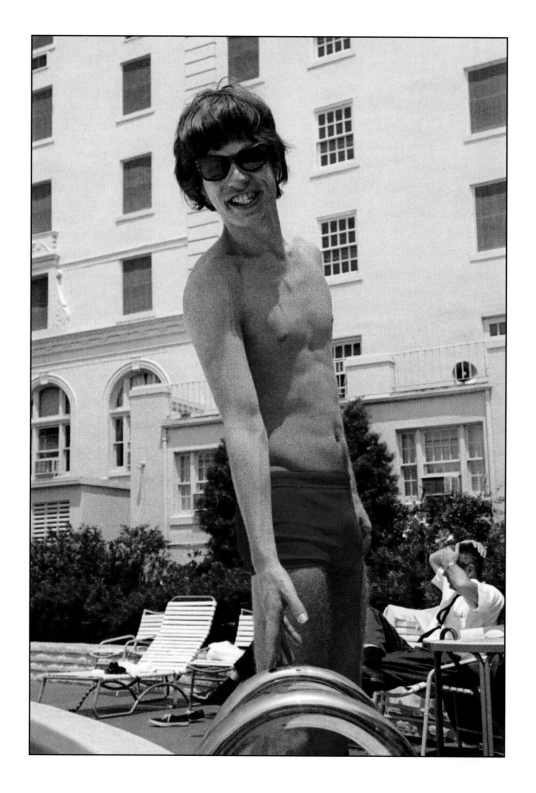

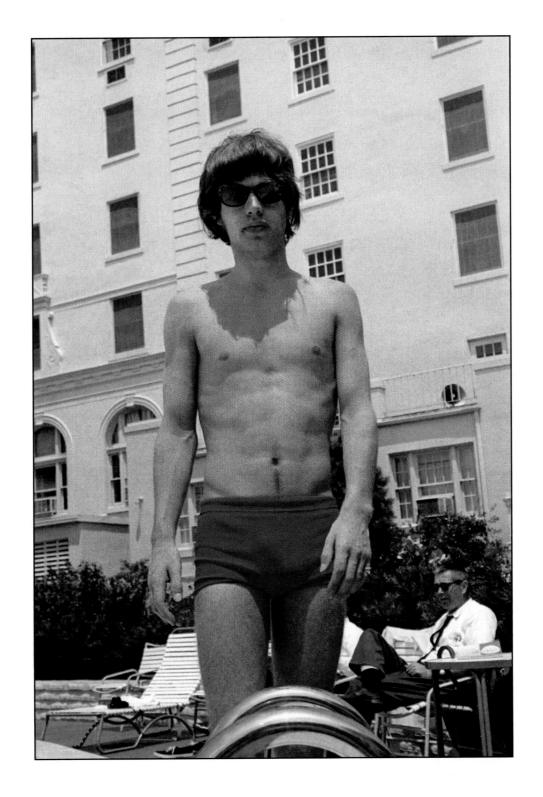

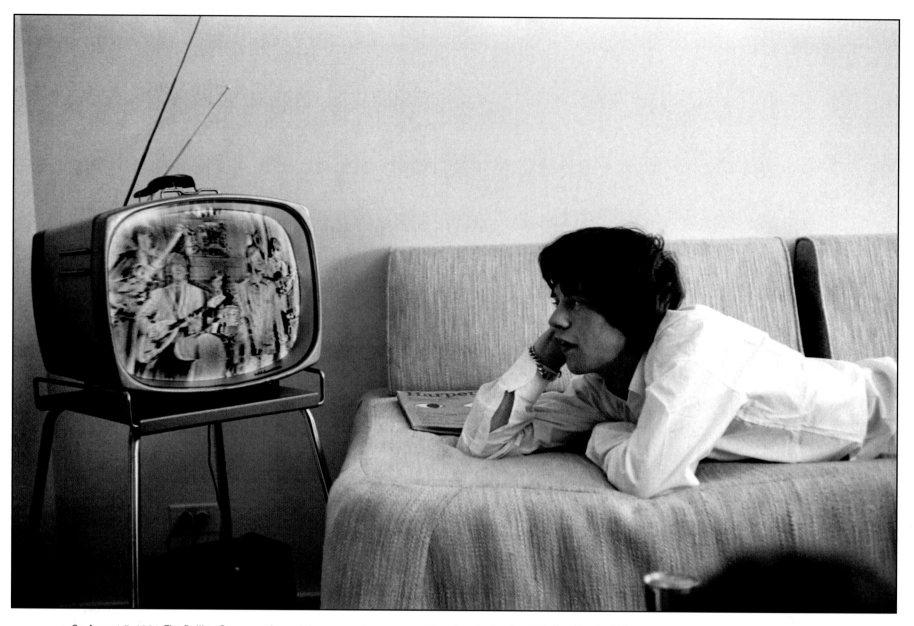

On August 5, 1964, The Rolling Stones performed three songs for a segment filmed at the London Palladium for the U.S. television show *The Red Skelton Hour*. It aired on September 22, but The Stones were not in the United States at the time and therefore were unable to see the show.

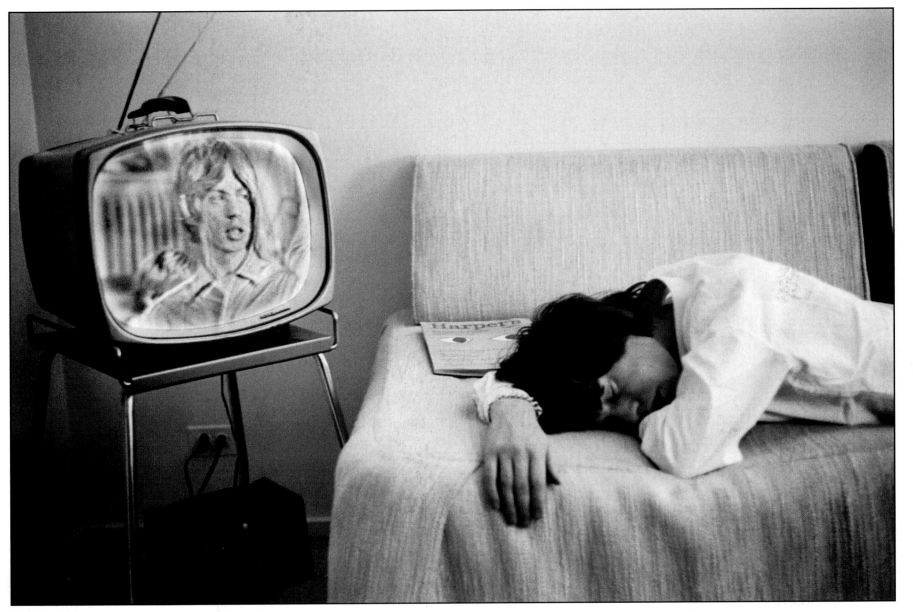

It was rebroadcast on November 10, when The Stones were in the midst of their second U.S. tour, and Mick watched the show in his hotel room. He feigned sleeping when he appeared on screen.

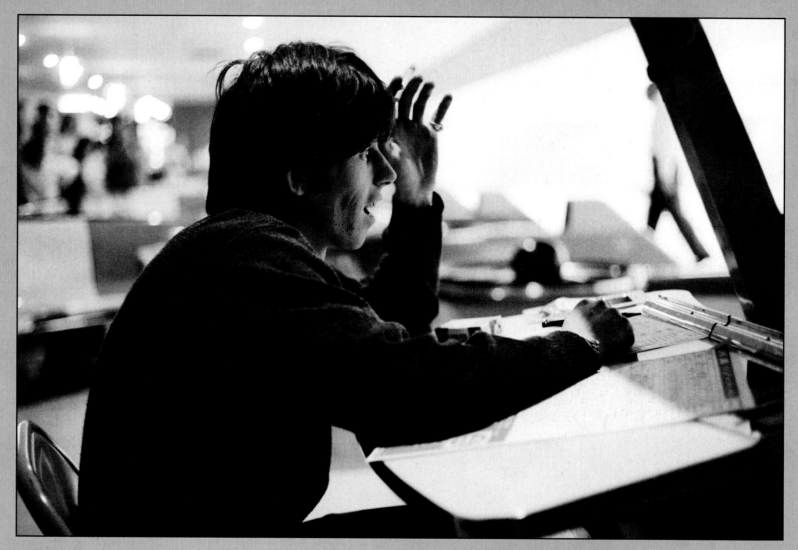

The Rolling Stones take a break at a bowling alley. Keith keeps score.

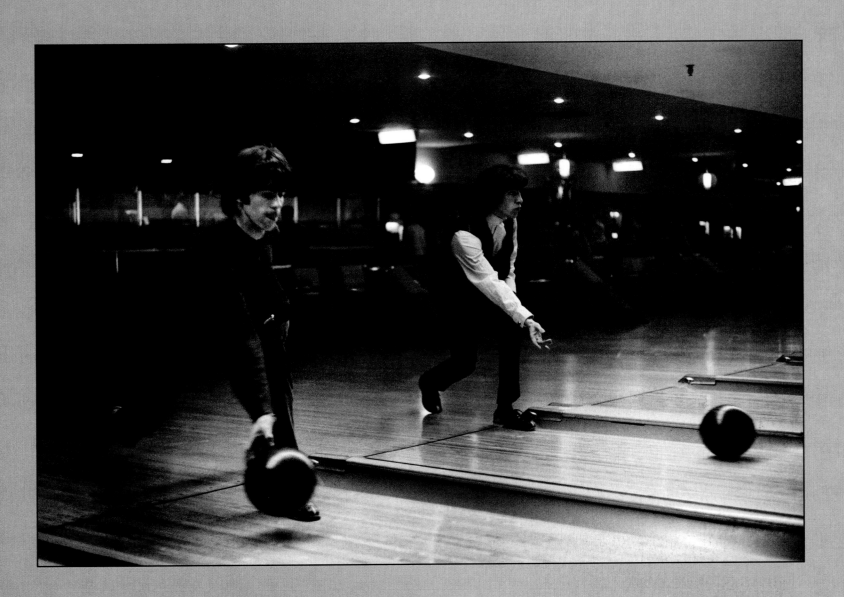

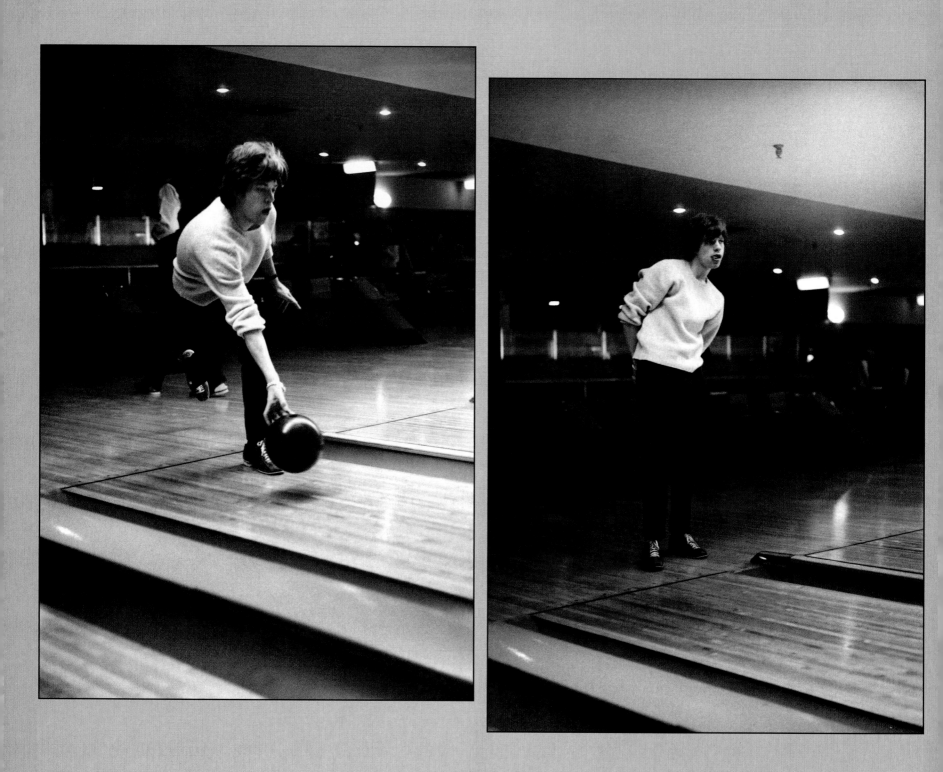

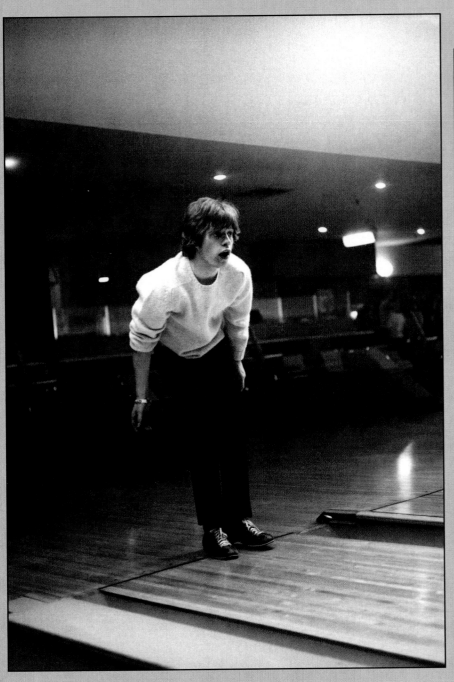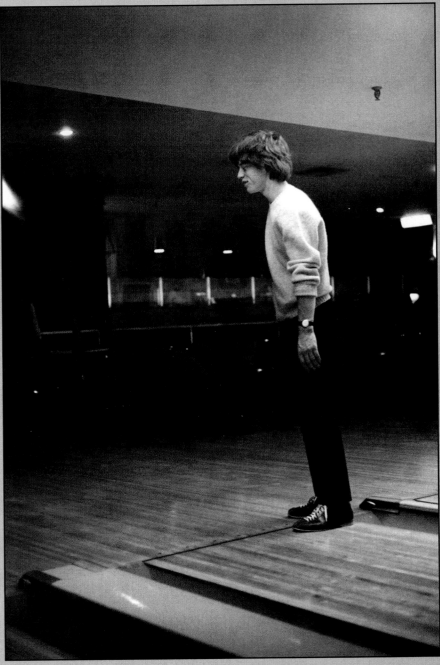

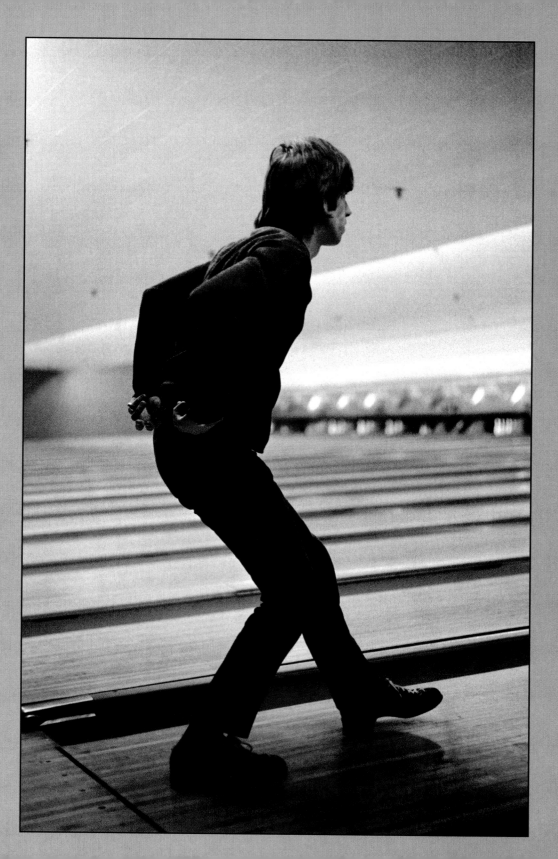

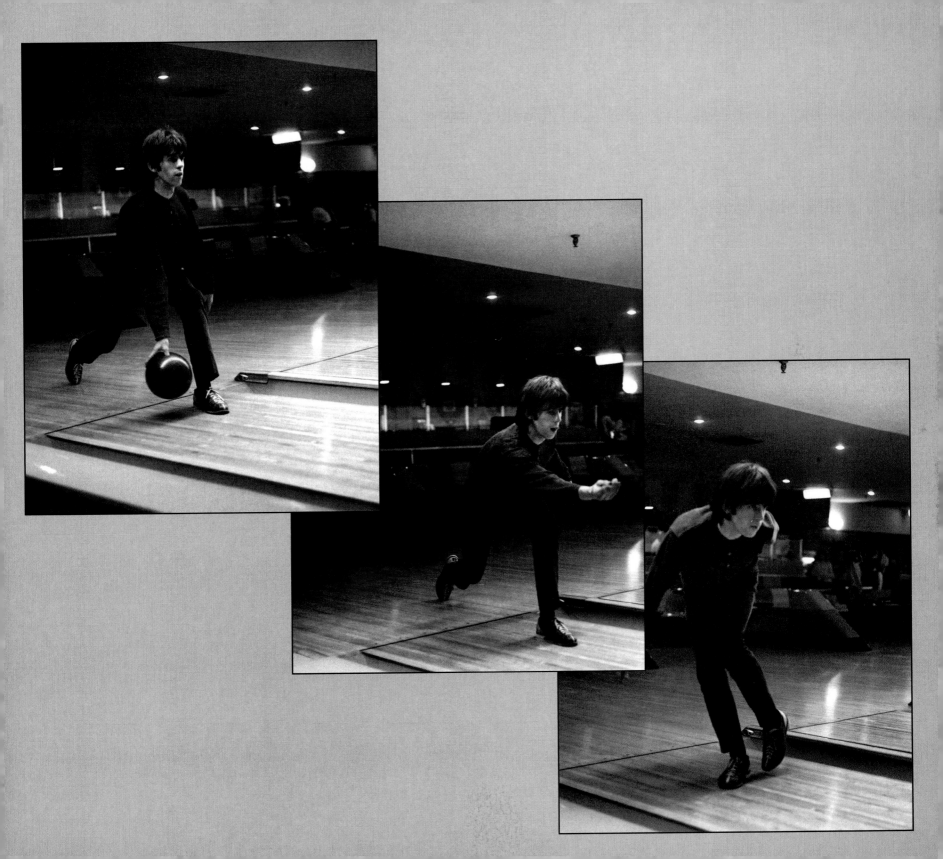

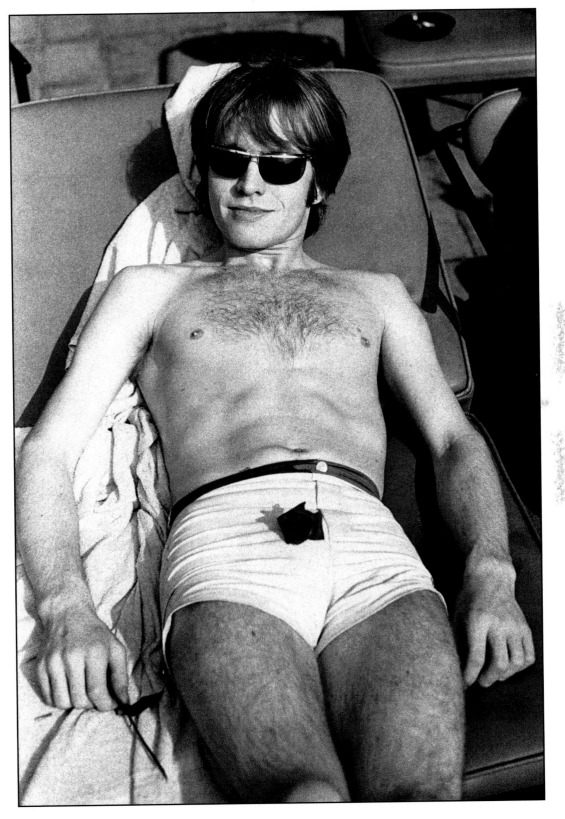

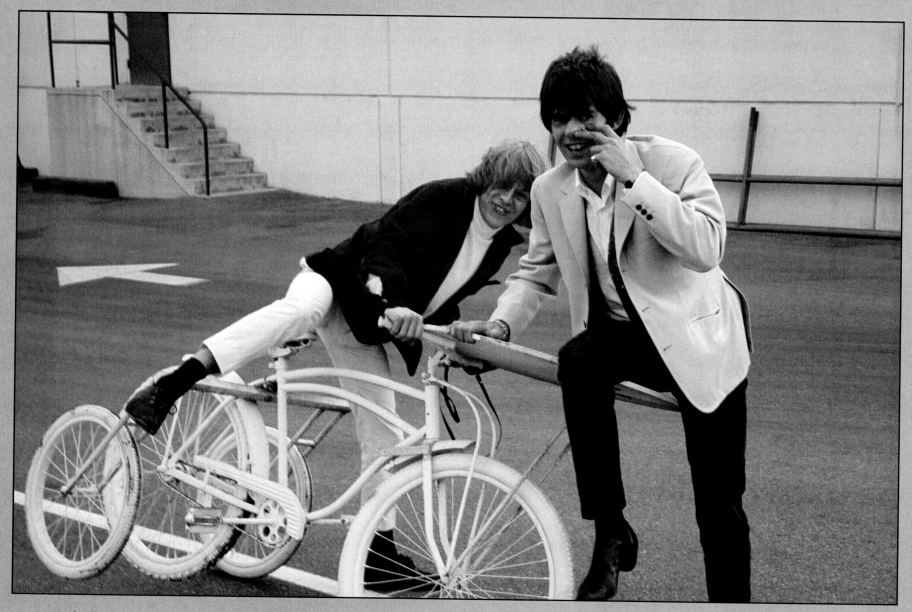

At a lot full of props in Los Angeles in 1965 Brian rides a strange tricycle and Keith pulls a half-nanker.

A "nanker" is when you make a face by turning up your nostrils and pulling your eyelids down, while making inhuman noises. The Stones, especially Keith, were quite fond of this.

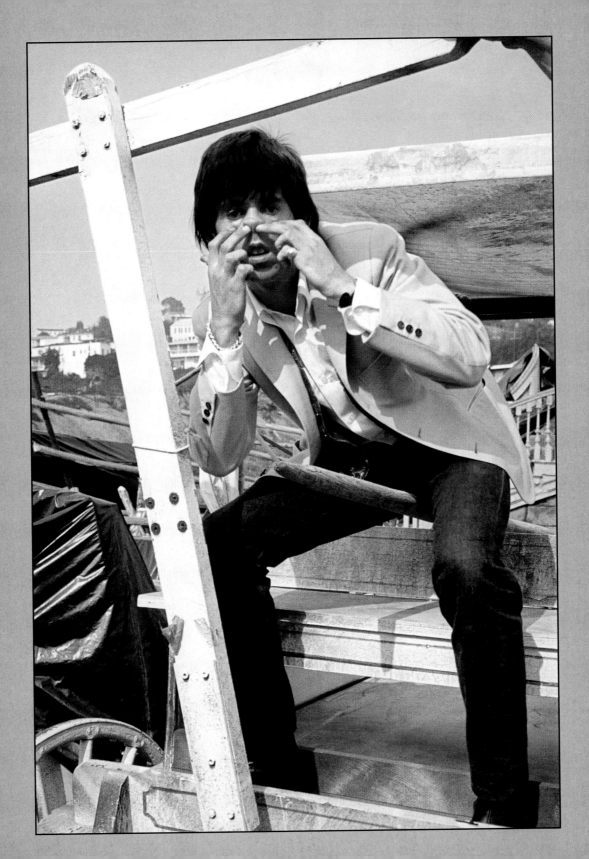

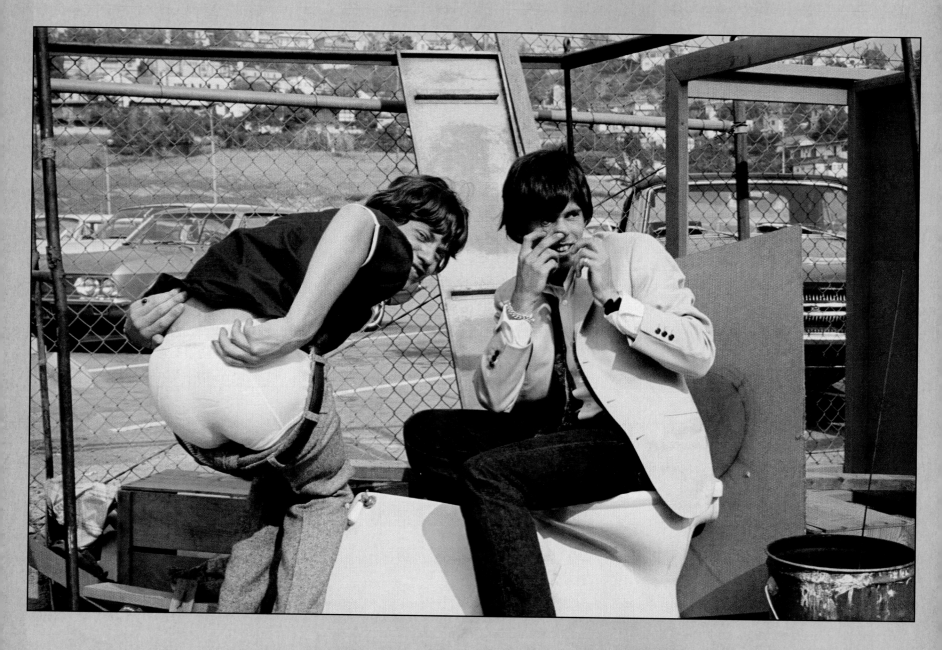

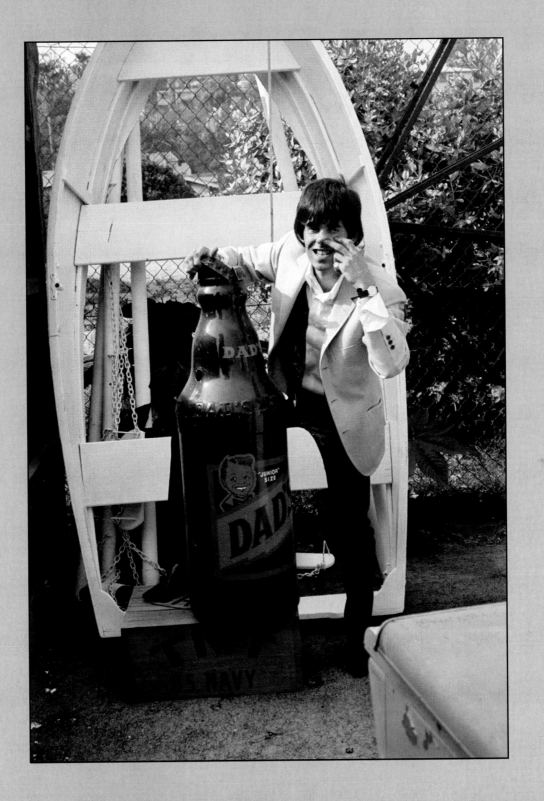

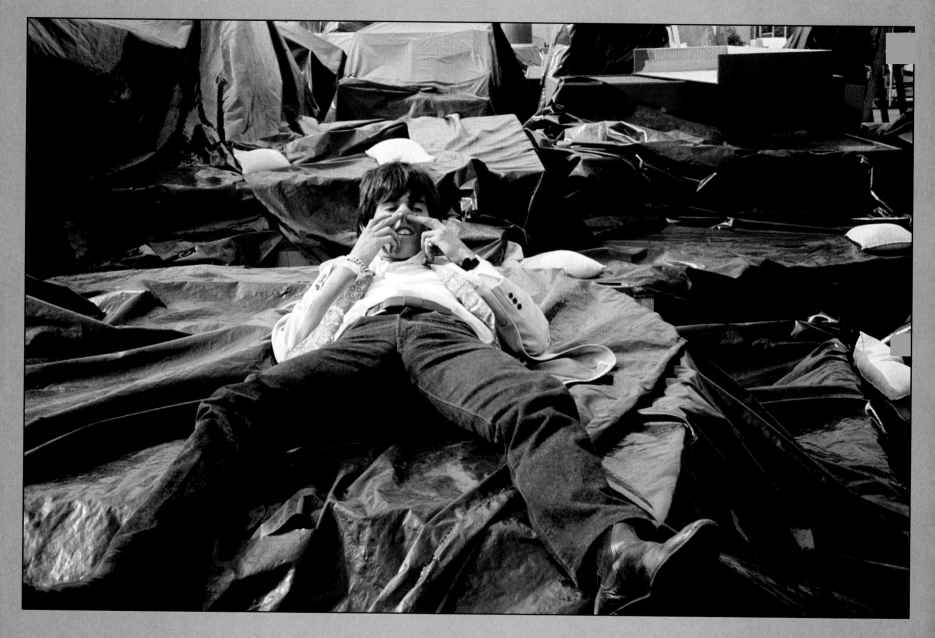

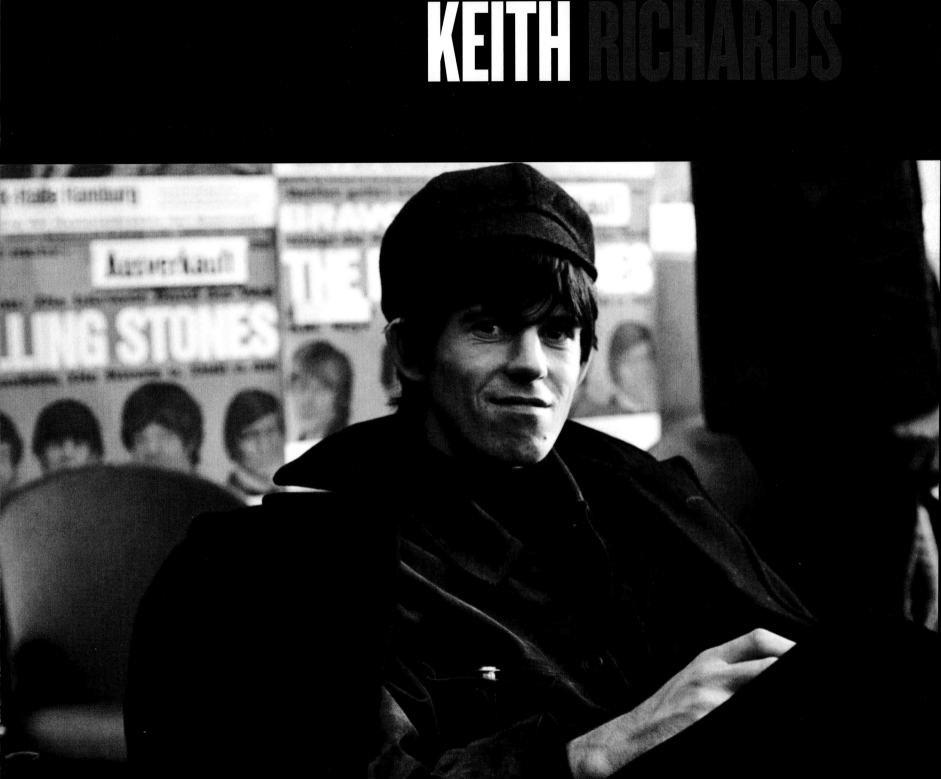

KEITH RICHARDS

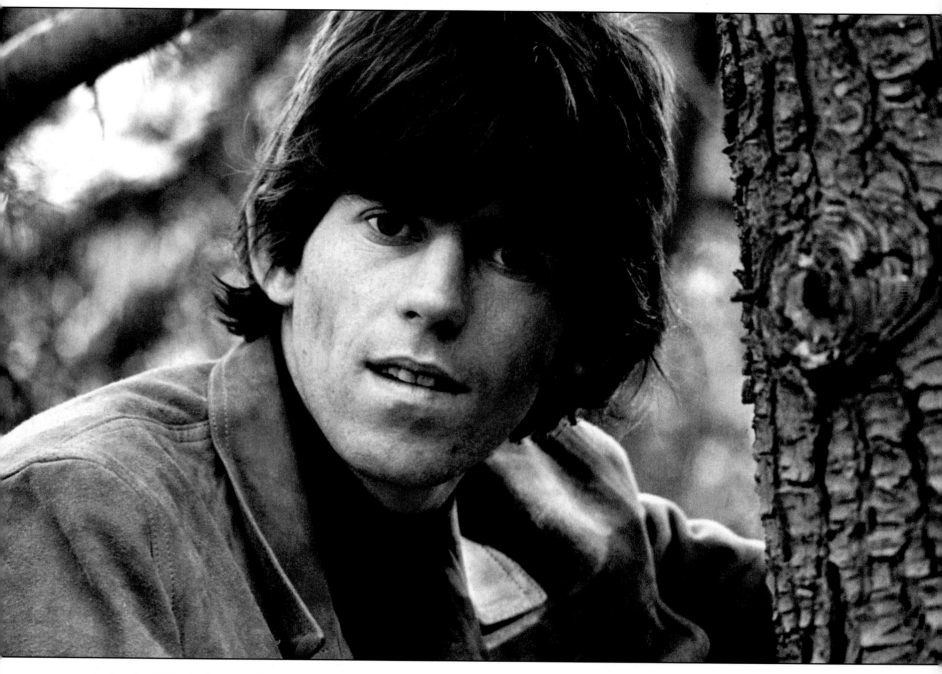

Los Angeles, California, December 1965

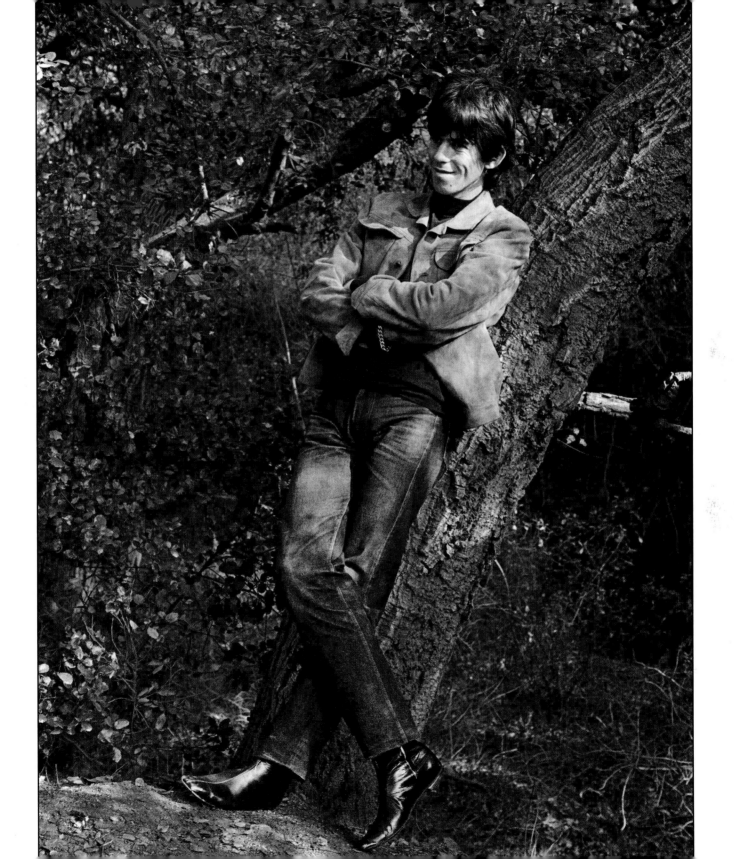

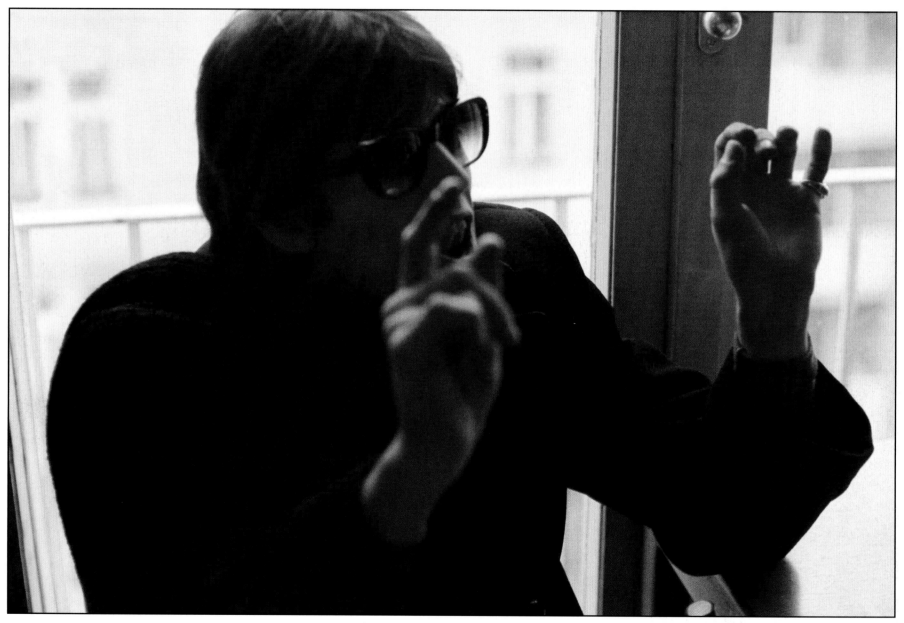

West German tour, September 1965.

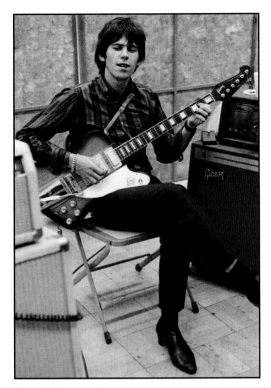

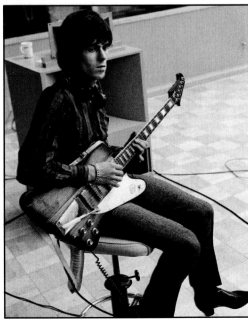

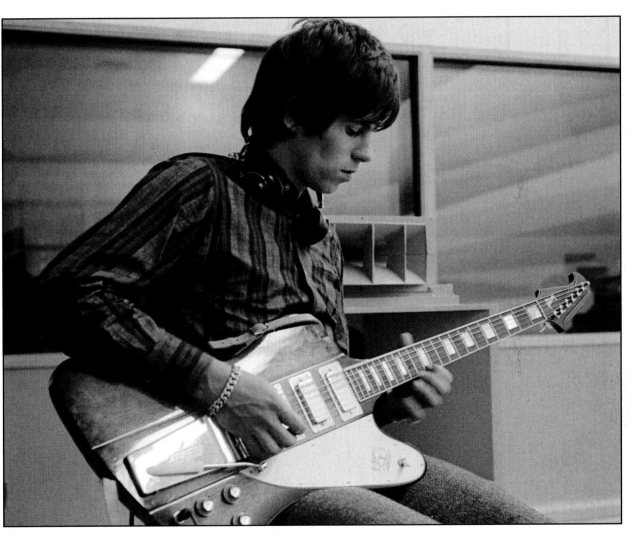

RCA Studios, Hollywood, California, September 6–7, 1965.

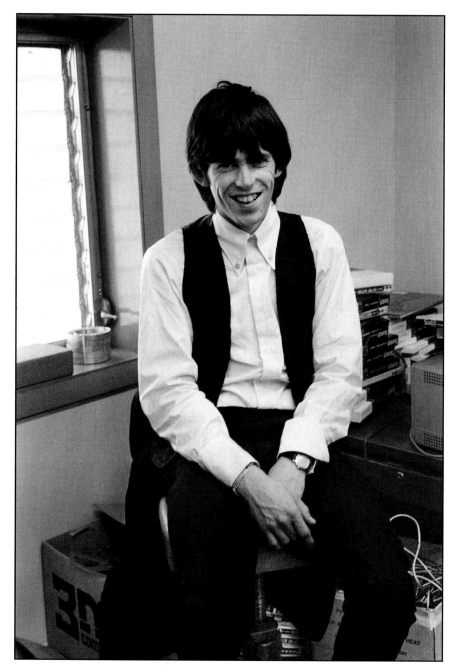

Chess Studios, Chicago, Illinois, June 1964.

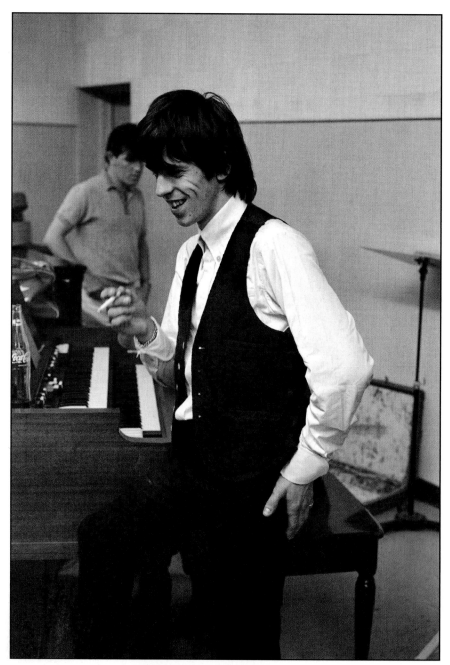

Keith pulls a nanker during a break at Chess Studios.

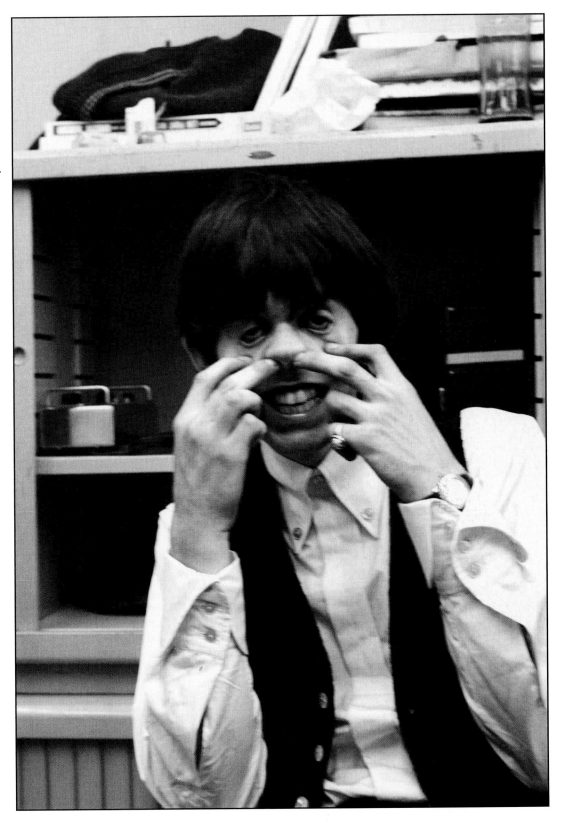

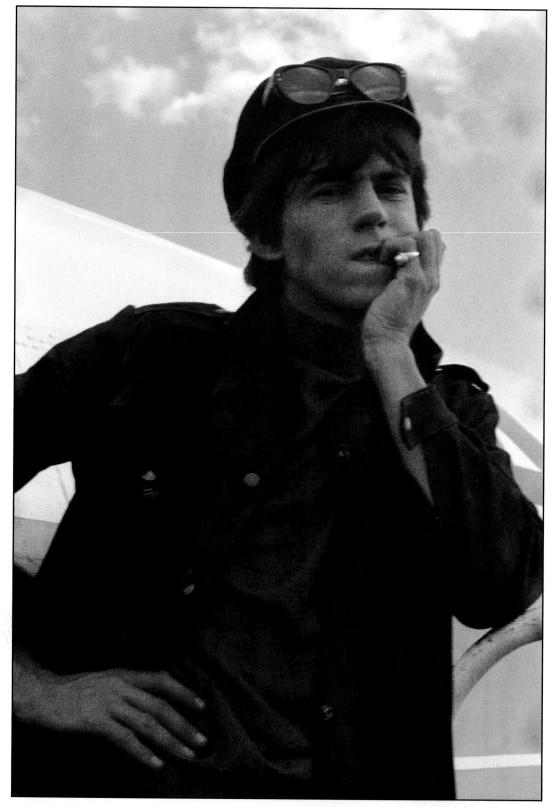

Keith poses as he exits the plane when The Stones land
in Munich, West Germany, September 14, 1965.

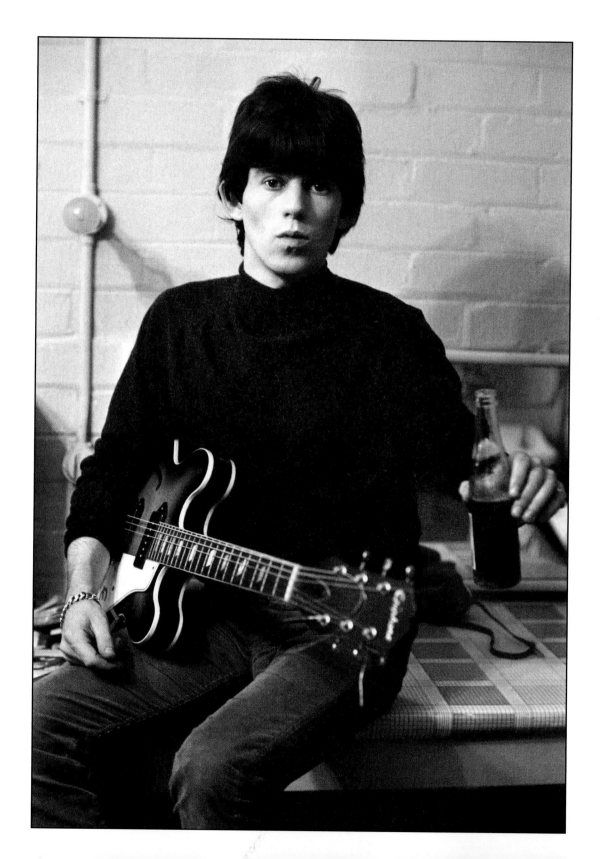

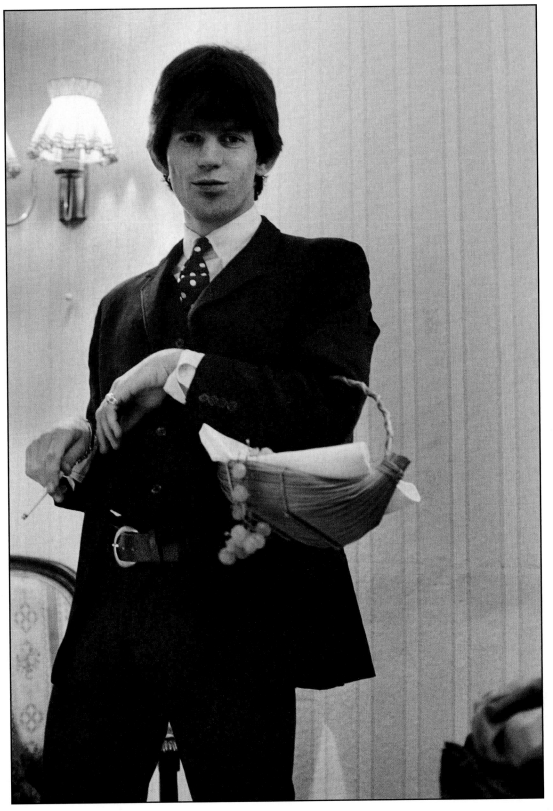

Backstage at Waldbühne, West Berlin, West Germany,
September 15, 1965.

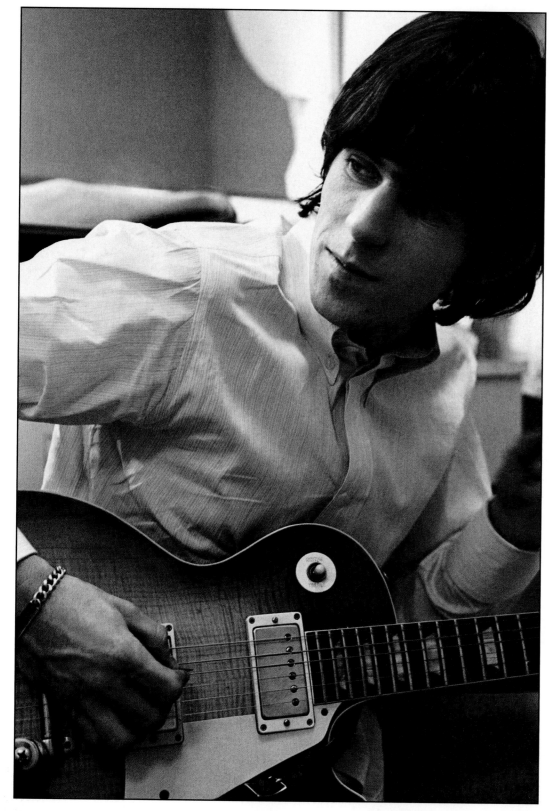

Backstage in Santa Monica, California, October 1964, at *The T.A.M.I. Show*.

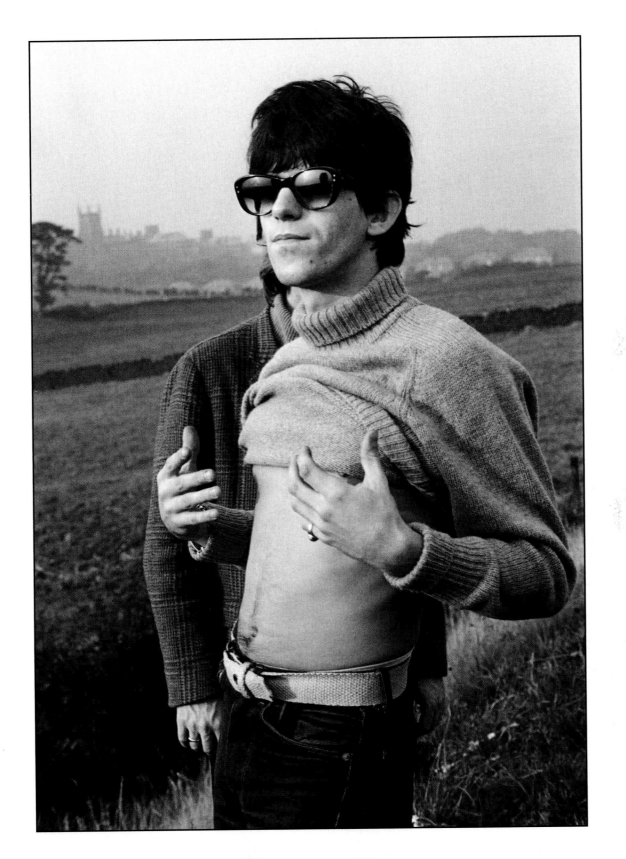

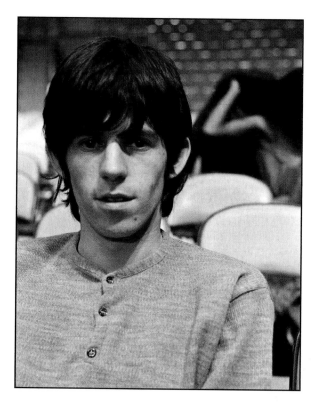
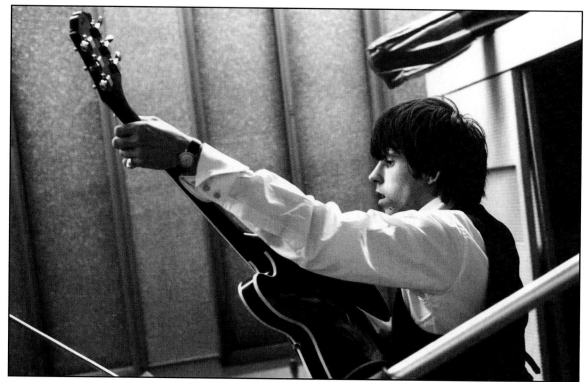
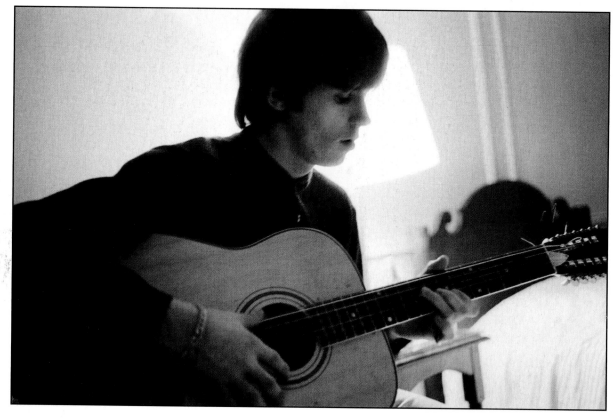

Keith with a hair accessory, perhaps foreshadowing his current preference for wearing objects in his hair.

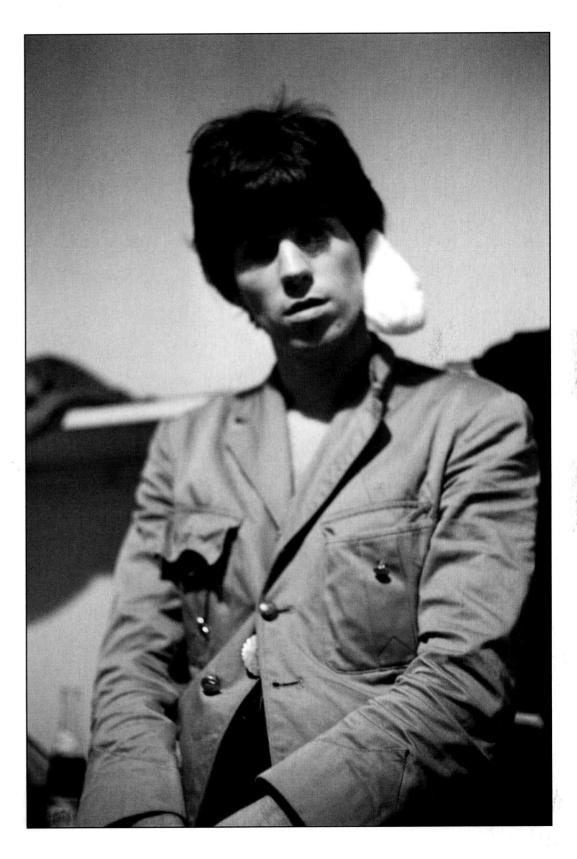

Top left: The T.A.M.I. Show rehearsal, October 28, 1964.

Top right: Chess Studios, June 1964.

Bottom left: Keith playing a Harmony H1270 Sovereign jumbo twelve-string acoustic guitar.

Bottom right: New York, November 1965.

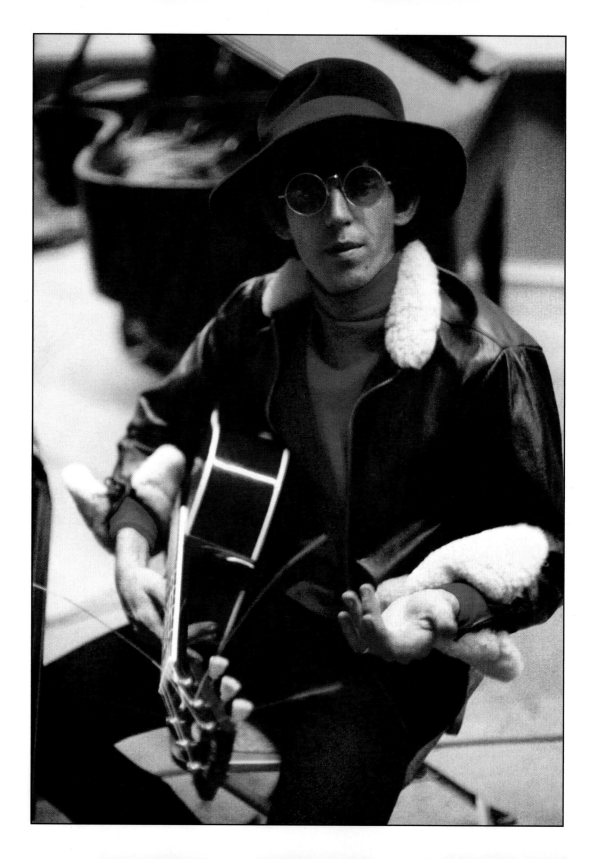

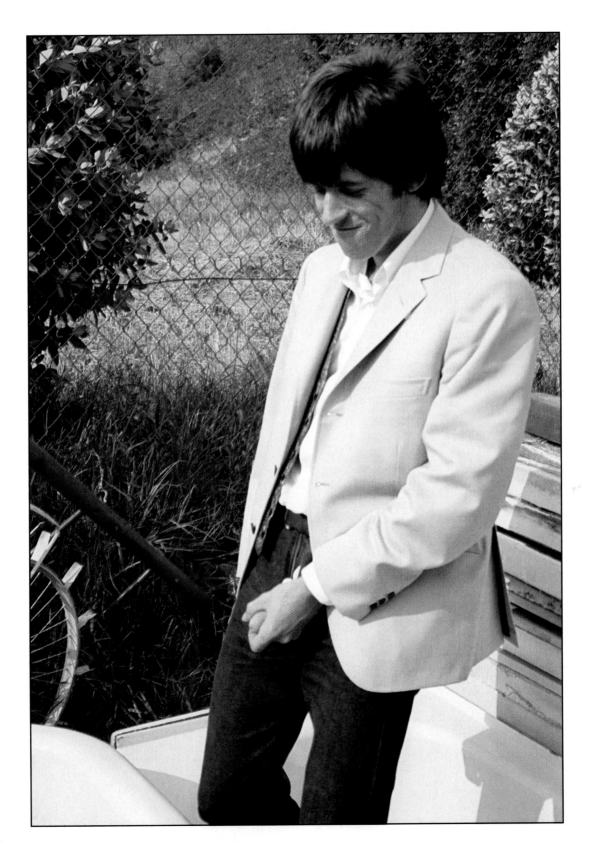

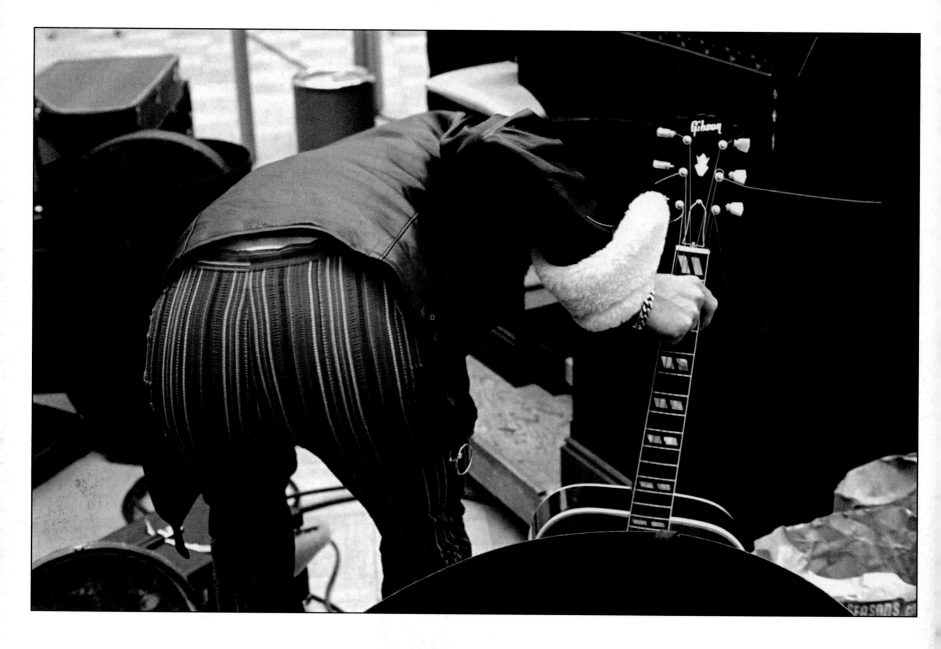

STUDIO AND REHEARSALS

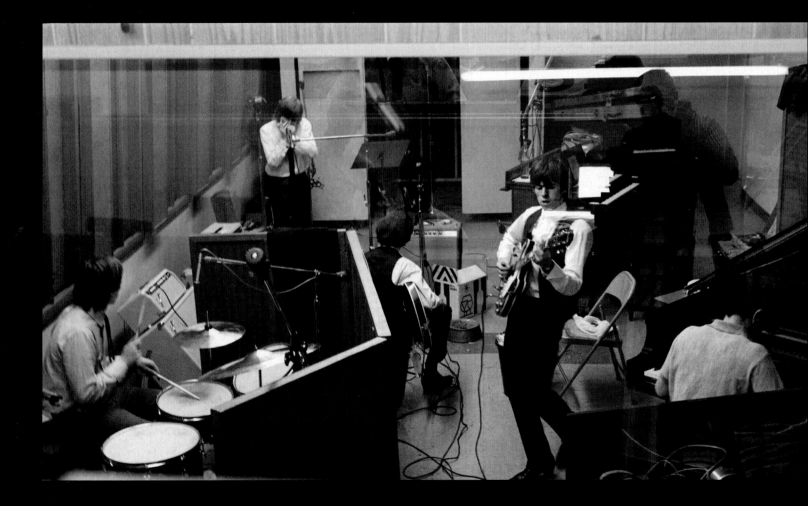

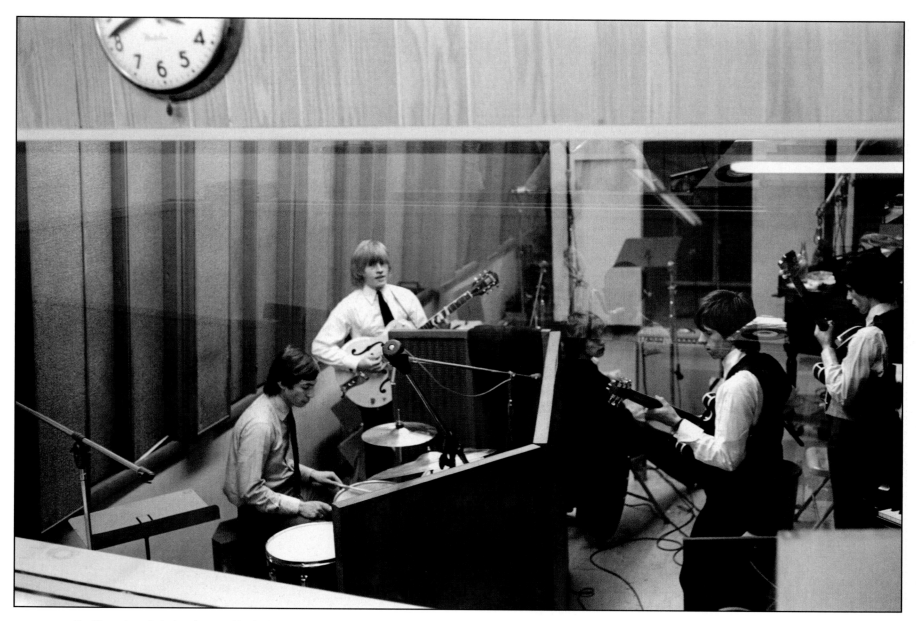

The Stones' music is deeply rooted in the blues. As they were enthusiastic fans of Muddy Waters, Chuck Berry, Willie Dixon, and the like, they were especially thrilled to be able to record at the legendary Chess Studios. They recorded there on June 10 and 11 and November 8, 1964, with engineer Ron Malo. On the first visit they met Muddy, Chuck, and Willie. These photos are among the only known photographs of The Rolling Stones recording at Chess Studios. While in America The Rolling Stones took several opportunities to lay down some tracks in a studio. In the States they finally found engineers who could obtain that authentic blues and R&B sound they had tried to re-create. In these early days the band would record live in the studio with all members playing at once.

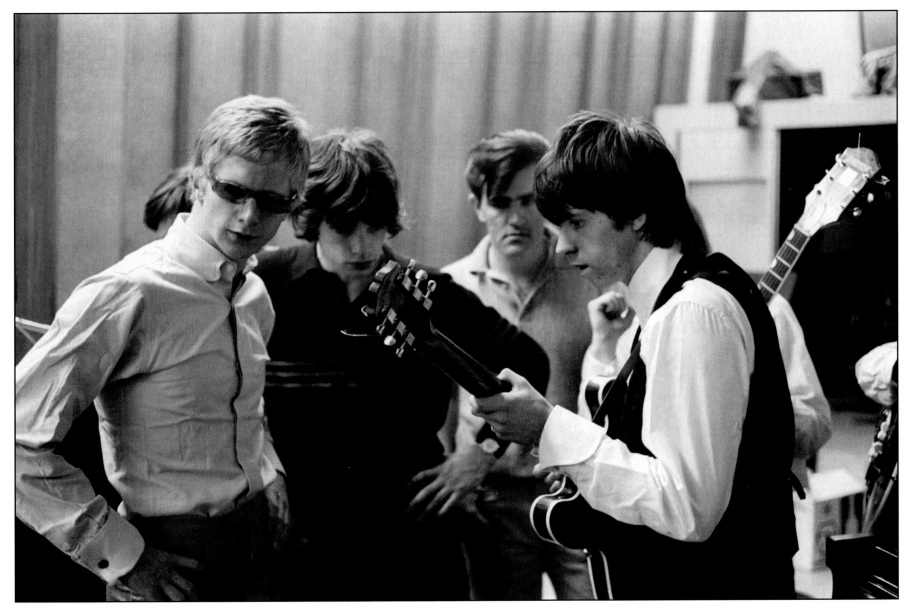

The Stones plus manager/producer Andrew Loog Oldham and Ian "Stu" Stewart discuss one of the songs at Chess.

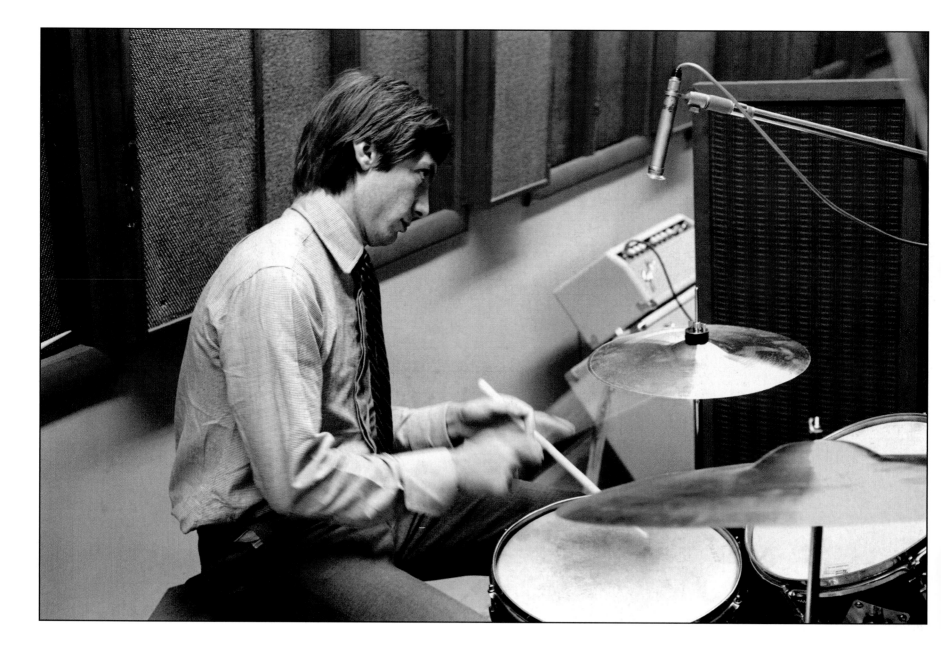

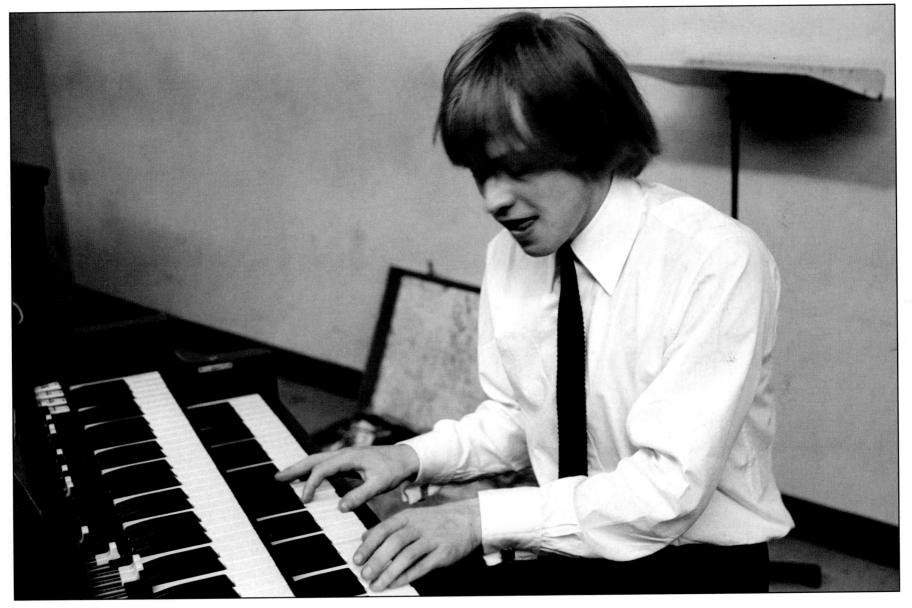

Brian plays a Hammond B3 organ at Chess Studios, recording the first version of "Time Is on My Side."

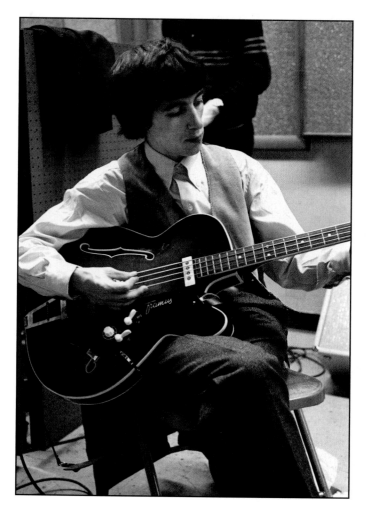

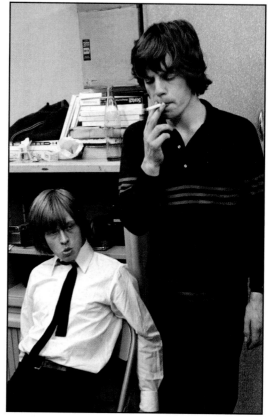

Ian "Stu" Stewart

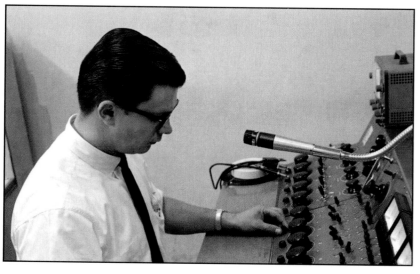

Sound engineer Ron Malo

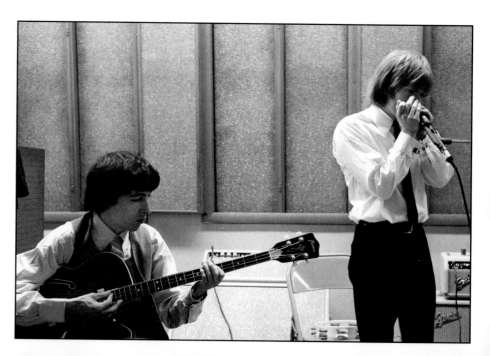

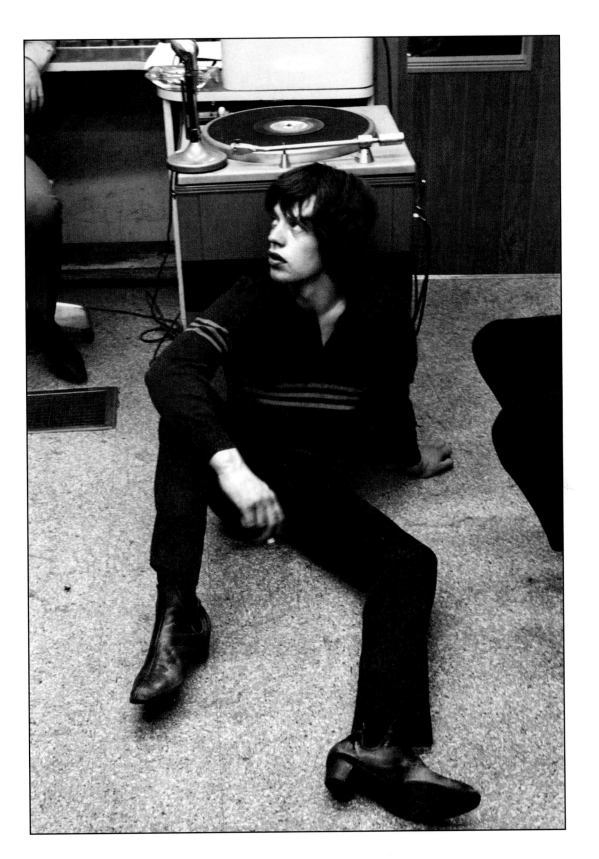

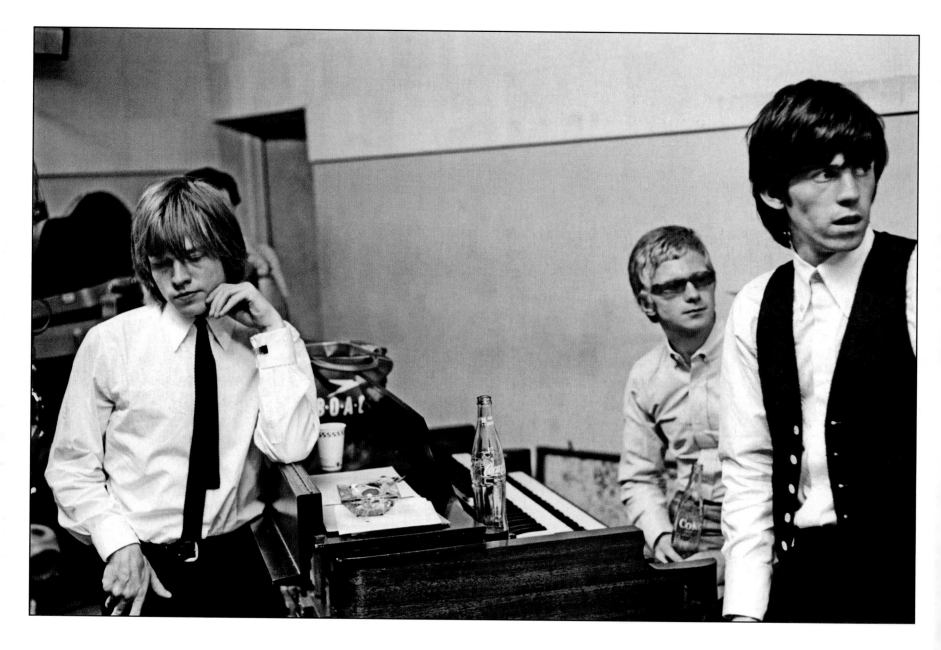

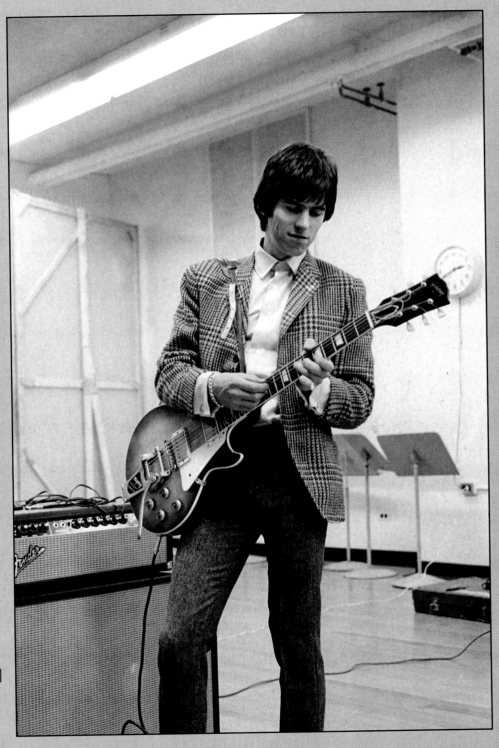

RCA Studios, Hollywood, California.

Keith with his 1959 Gibson Les Paul Standard flame top equipped with a Bigsby vibrato. Keith was the first British guitarist to popularize the use of the flame top Les Paul.

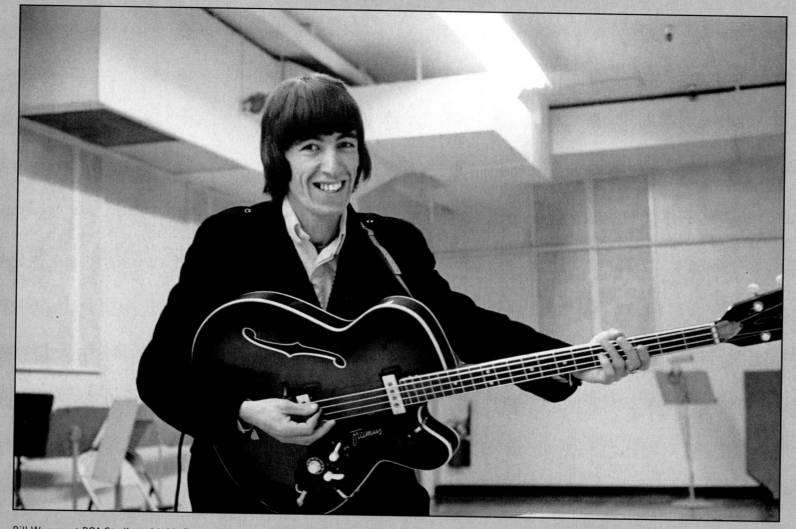

Bill Wyman at RCA Studios with his Framus Star bass model F5/150 that he bought on September 2, 1963, at the Art Nash music shop in Penge, U.K. He had sold his old bass cabinet to Tony Chapman (who played drums in the earliest lineup of The Stones) and amp to help pay for the purchase. Bill later endorsed Framus basses.

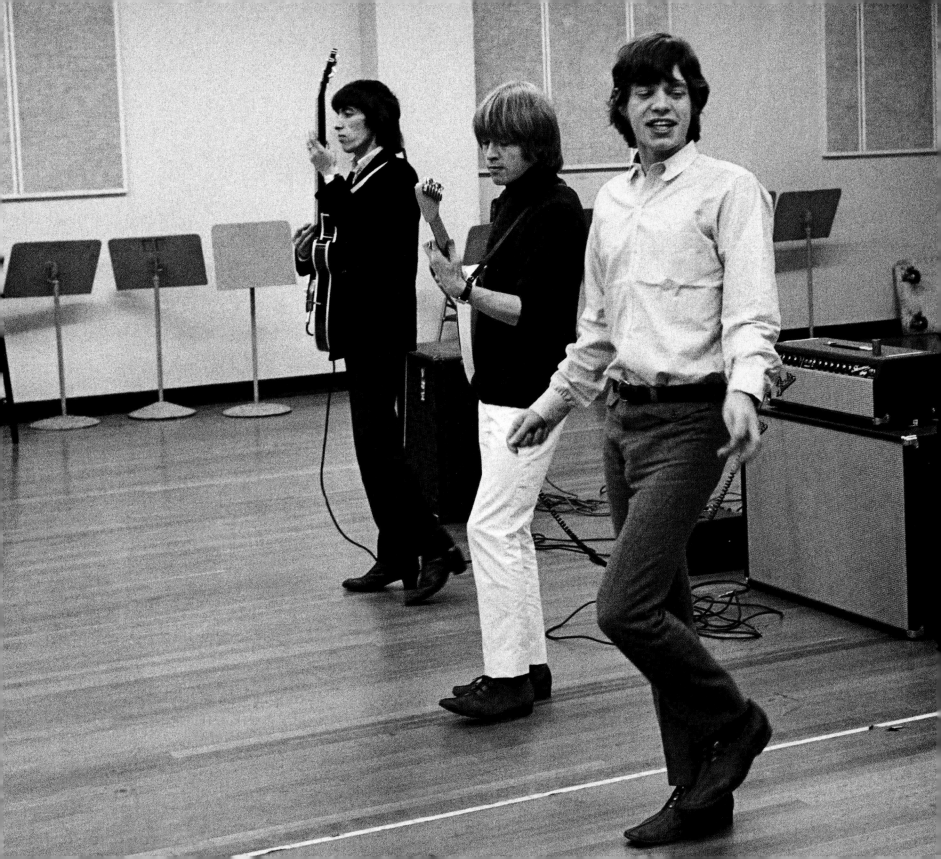

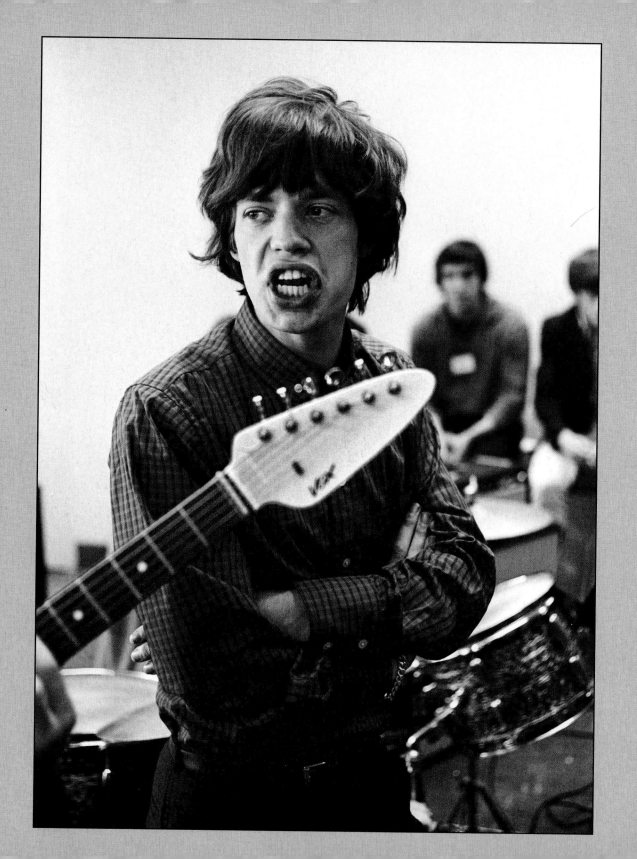

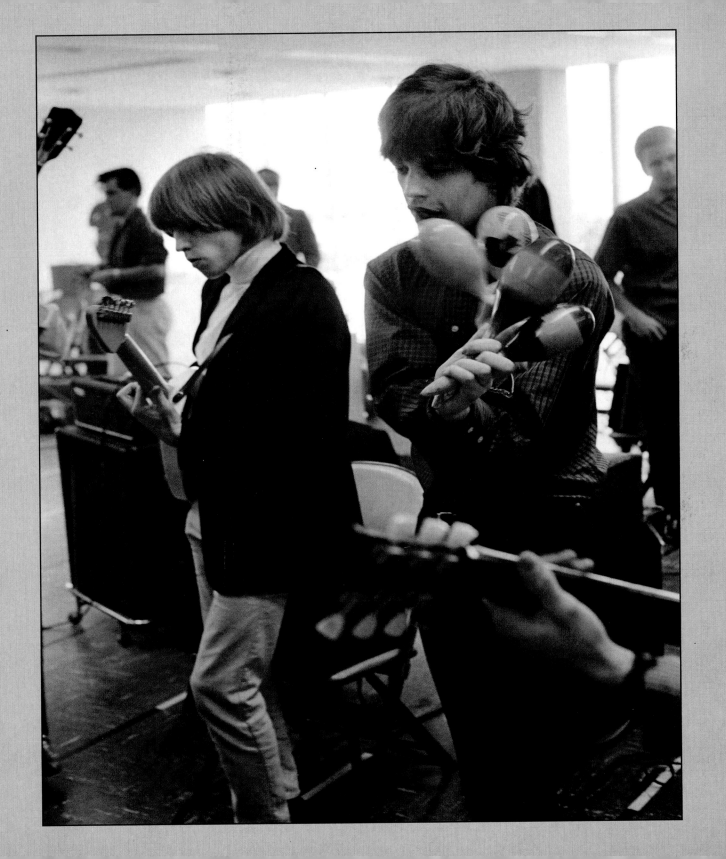

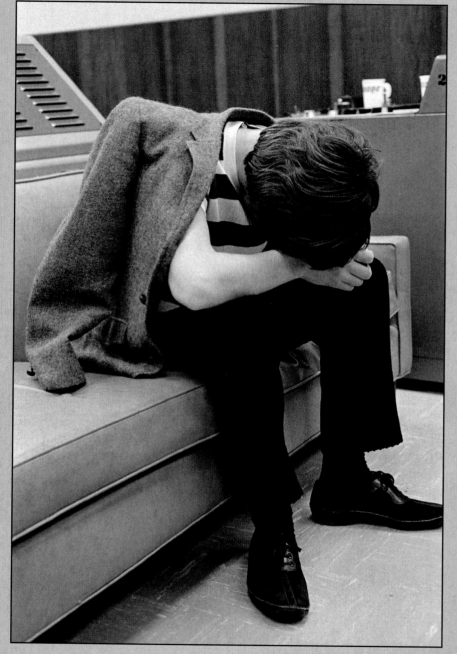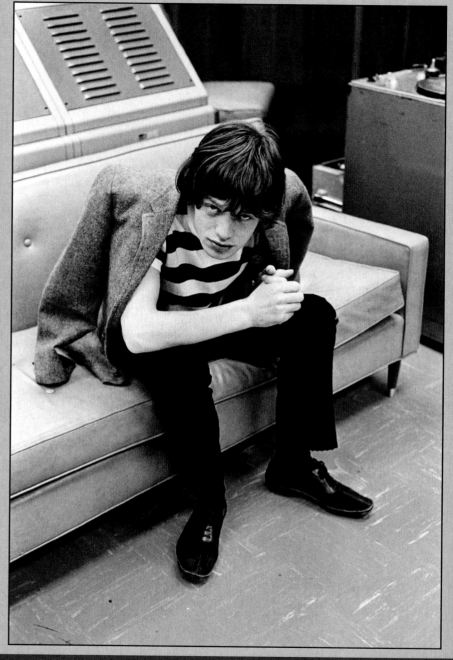

RCA Studios, Hollywood, California, September 6–7, 1965.

An exhausting day of recording takes its toll on Mick.

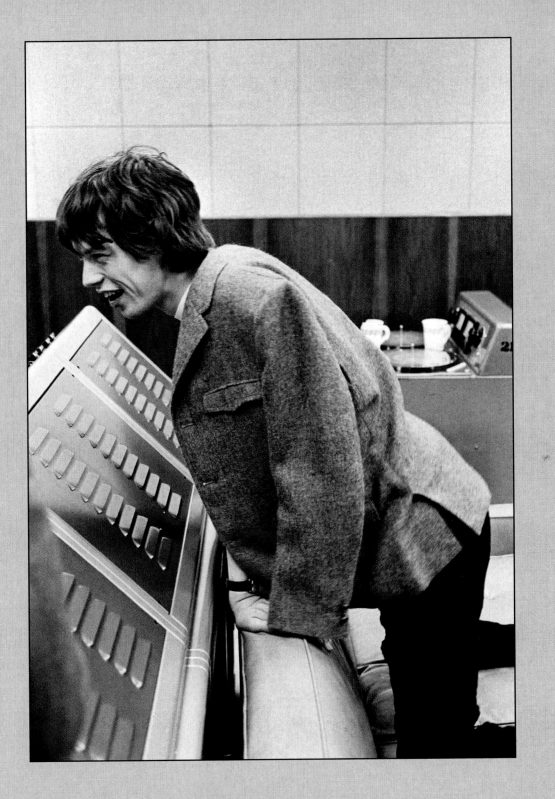

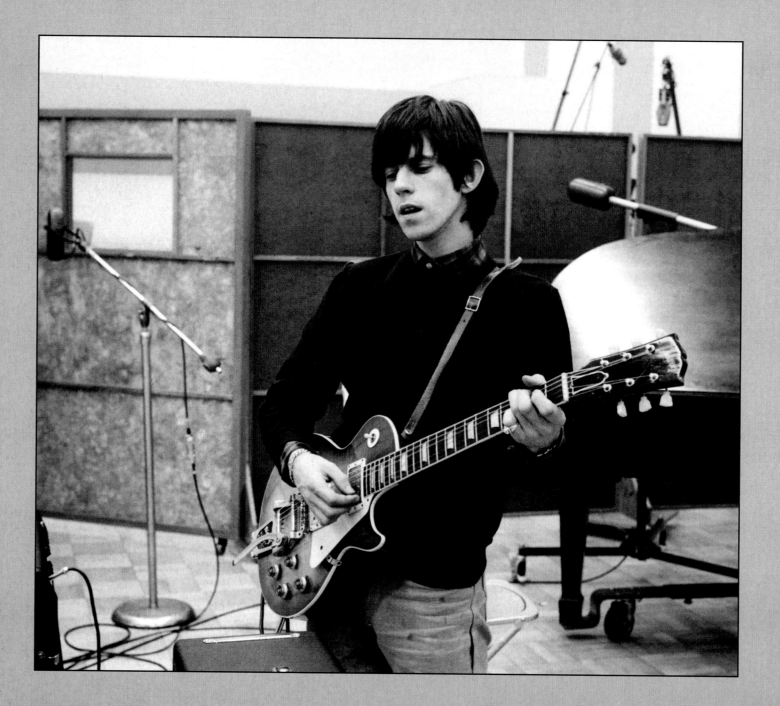

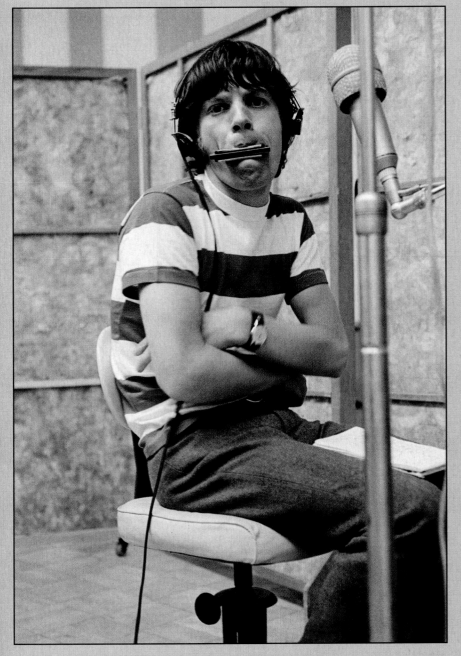

Most people think of Mick as only a vocalist but he is also a very accomplished harmonica player.

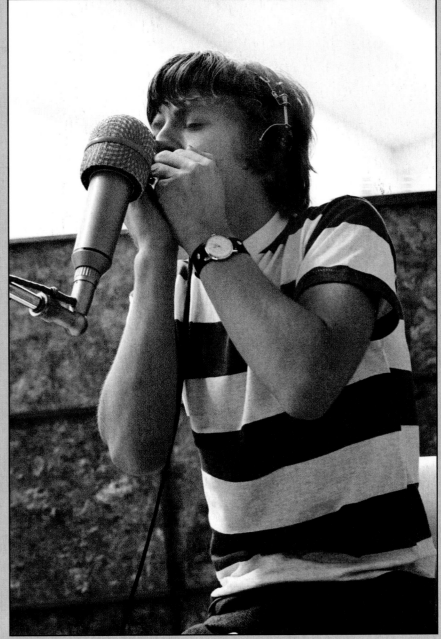

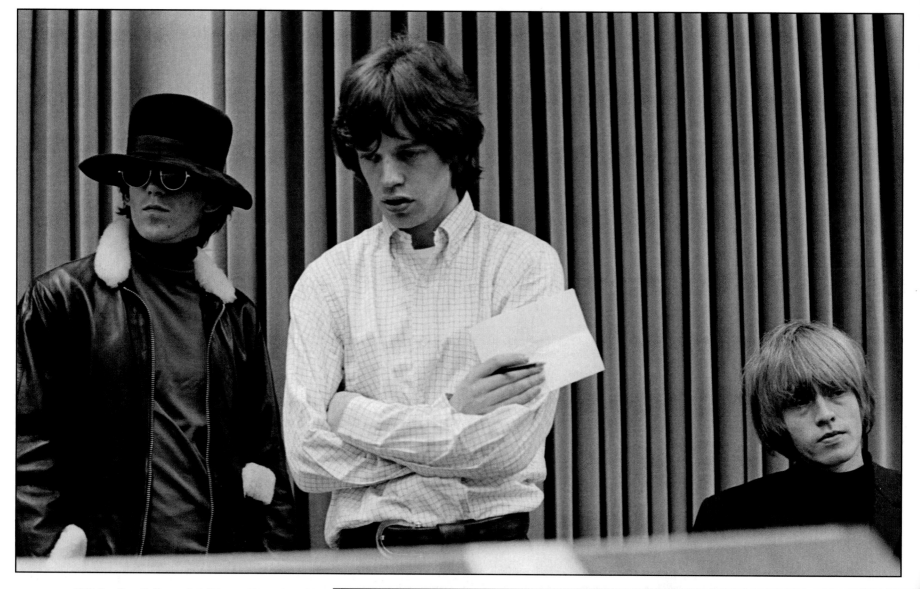

RCA Studios, Hollywood, California, December 1965.

Recording the LP *Aftermath*. Considered by many to be their defining album, *Aftermath* was the first Rolling Stones LP with songs written by only Jagger and Richards.

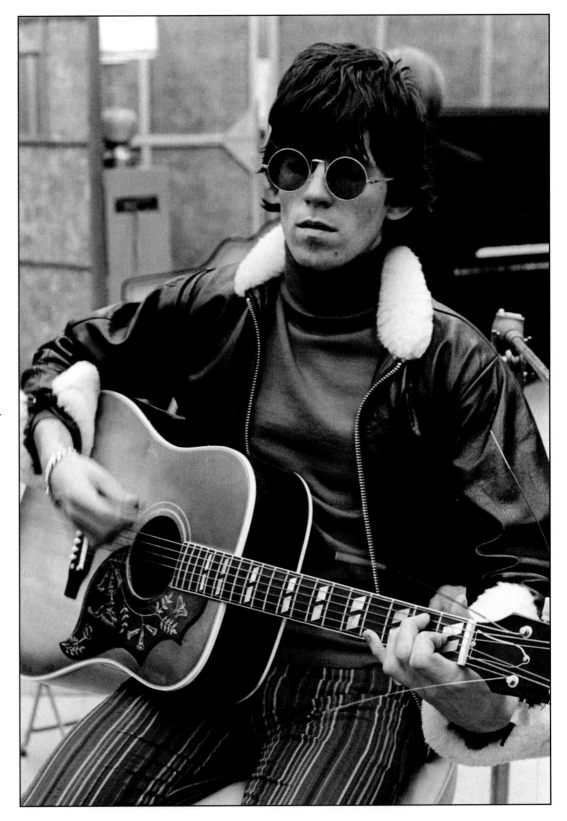

Keith playing a Gibson Hummingbird acoustic guitar.

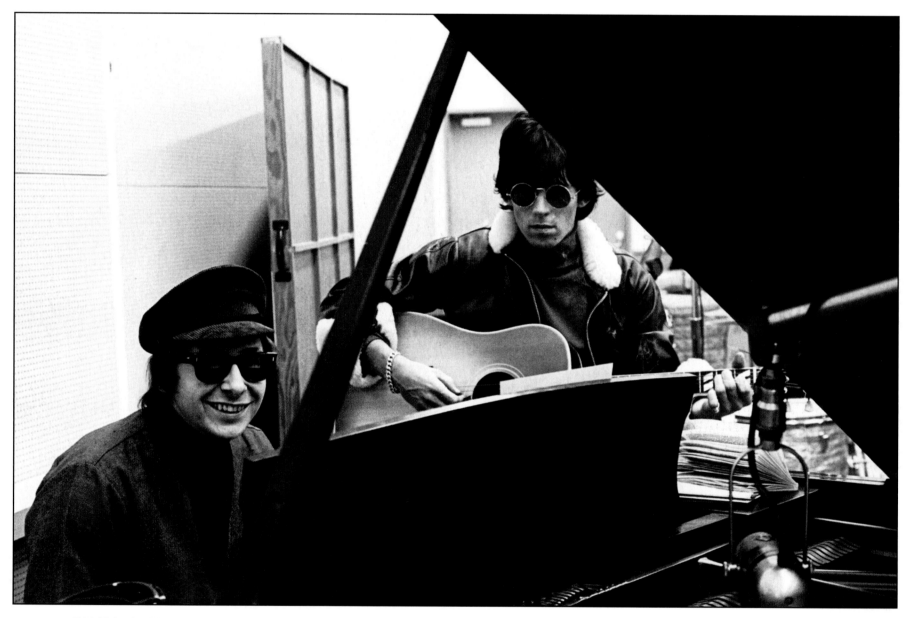

Keith Richards with arranger and musician Jack Nitzsche.

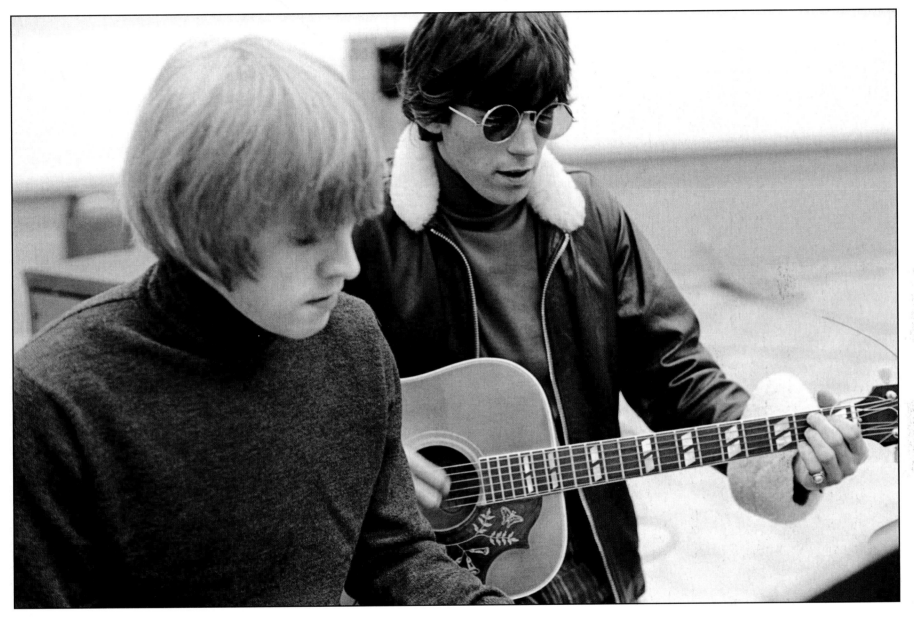

Keith plays a Gibson Hummingbird guitar in accompaniment with Brian on piano.

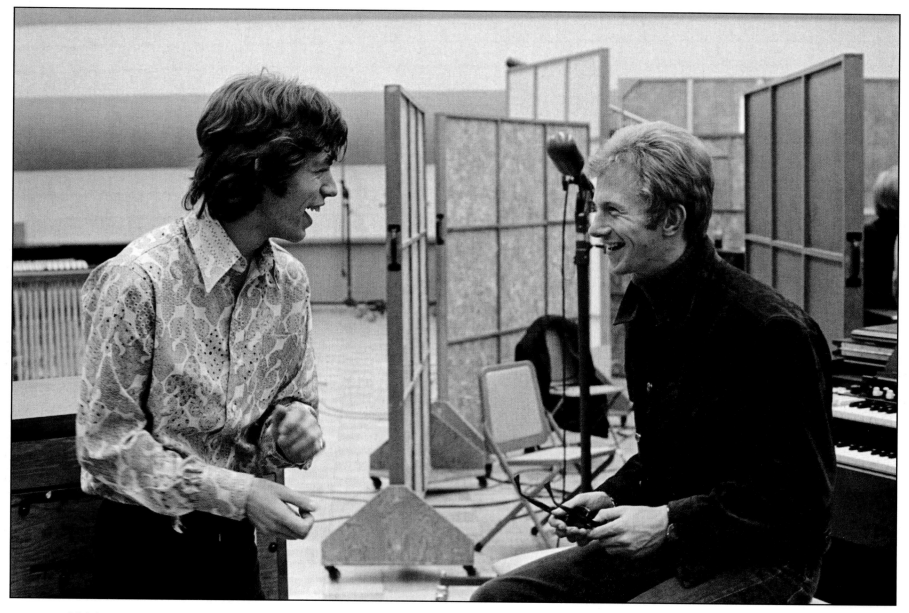

Mick Jagger and Andrew Loog Oldham share a laugh.

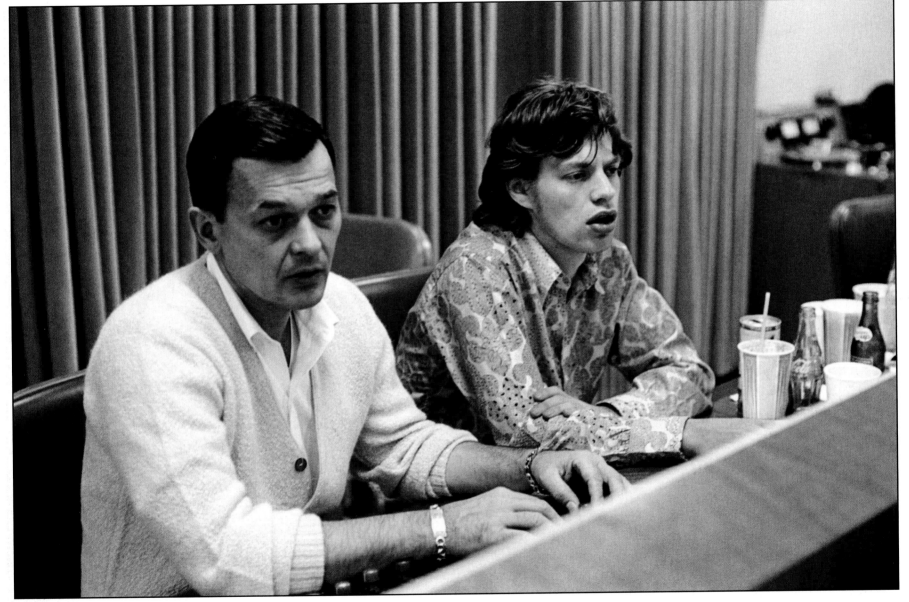

Mick Jagger with sound engineer Dave Hassinger, a staff engineer at RCA studios who became The Stones' main engineer from November 1964 through August 1966. He was a pivotal person in helping to create The Stones' sound on record, working on *The Rolling Stones, Now!; Out of Our Heads; December's Children (and everybody's);* and *Aftermath* (he wrote the liner notes for that watershed LP).

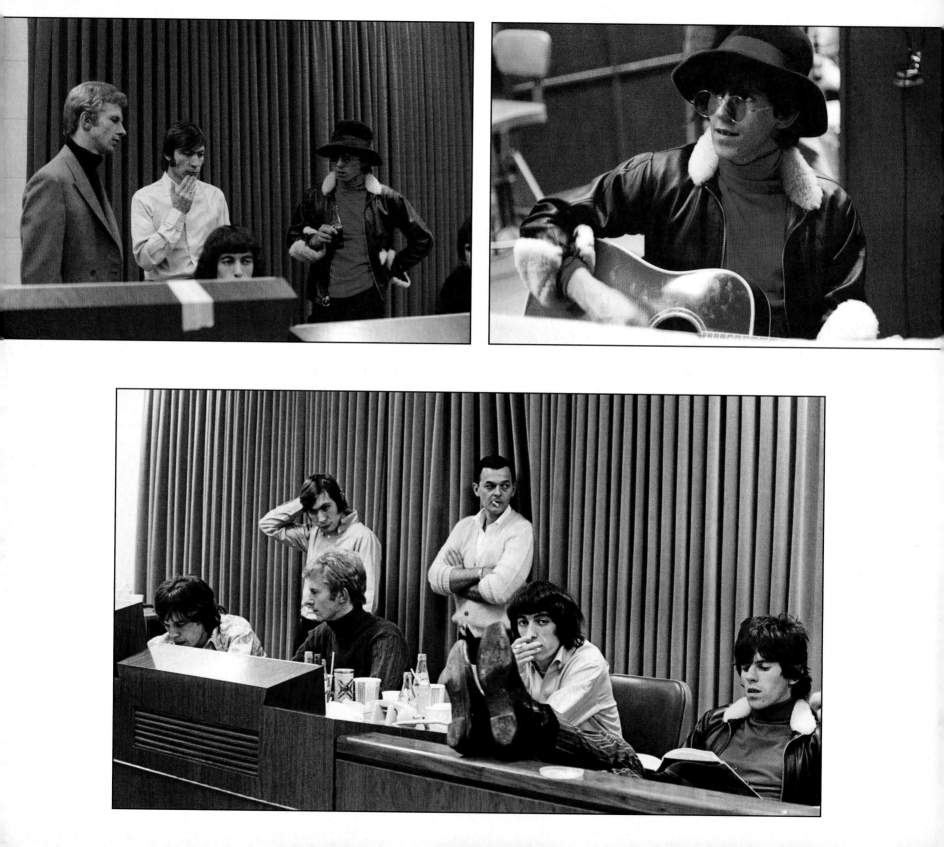

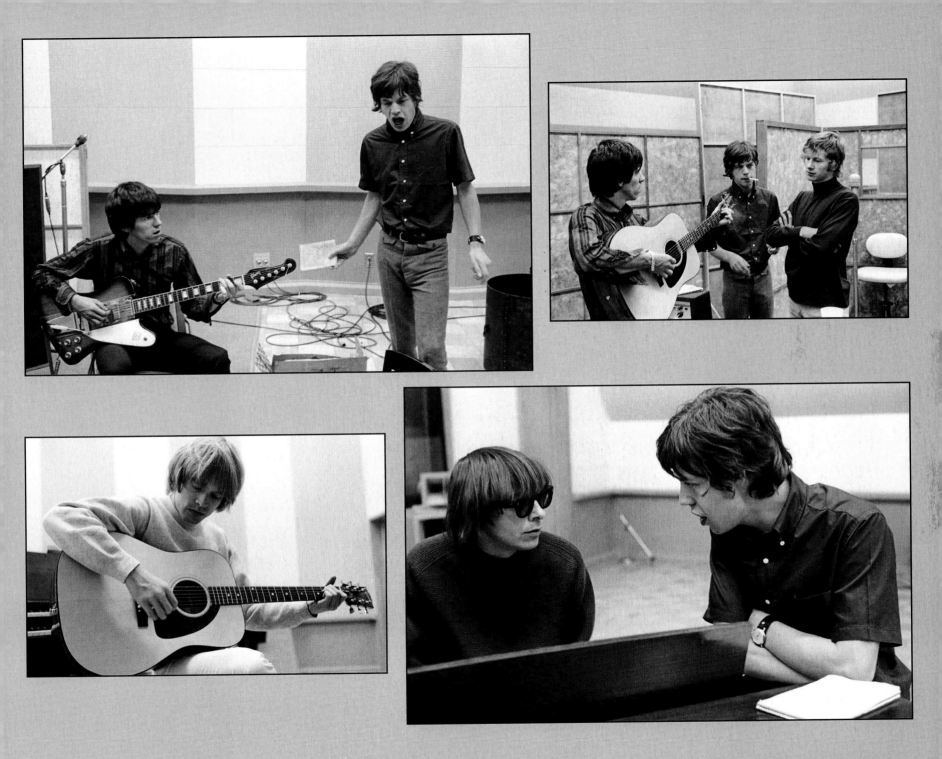

RCA Studios, Hollywood, California, September 6–7, 1965.

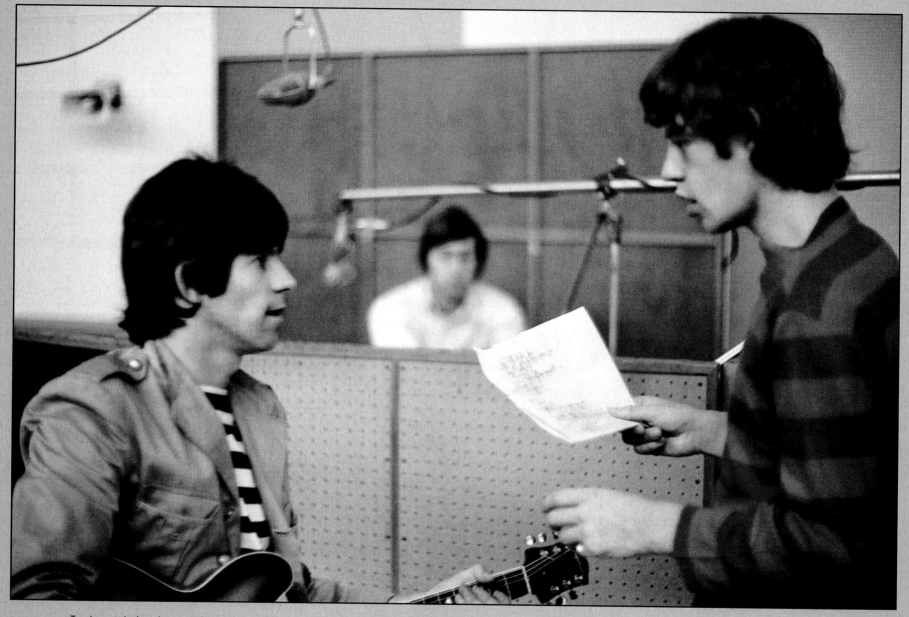

Tracks cut during these sessions included "Get Off My Cloud," "I'm Free," "The Singer Not the Song," "She Said Yeah," "Gotta Get Away," and "Blue Turns to Grey" (the version used on *December's Children*). Mick and Keith working on "Get Off My Cloud."

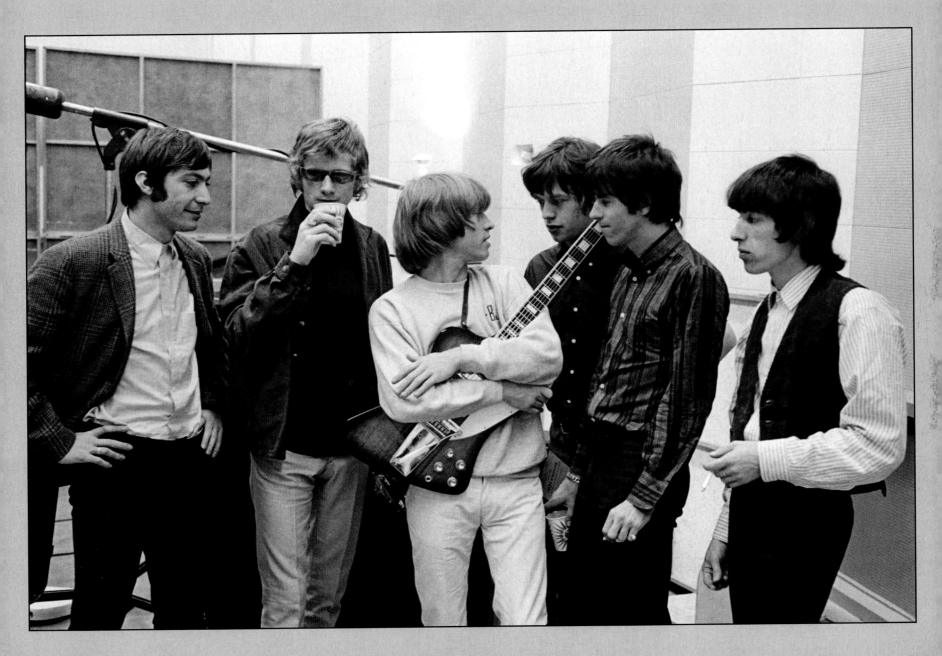

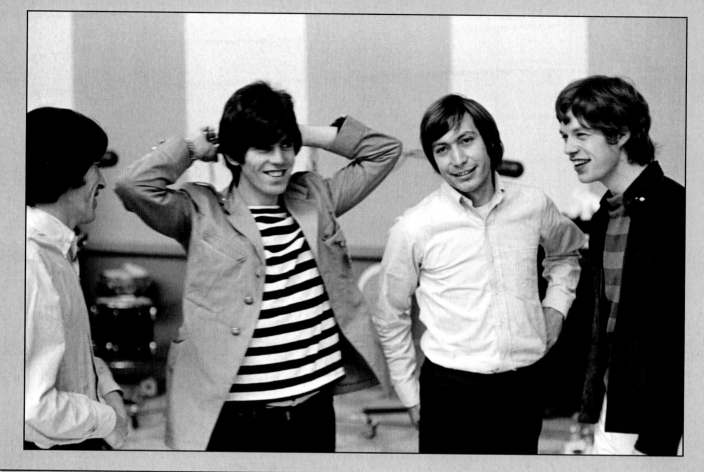

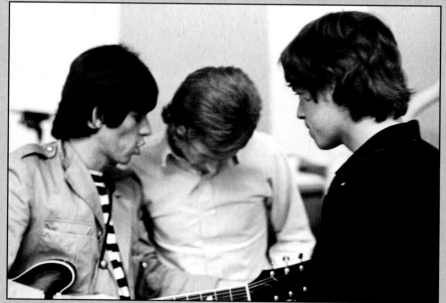

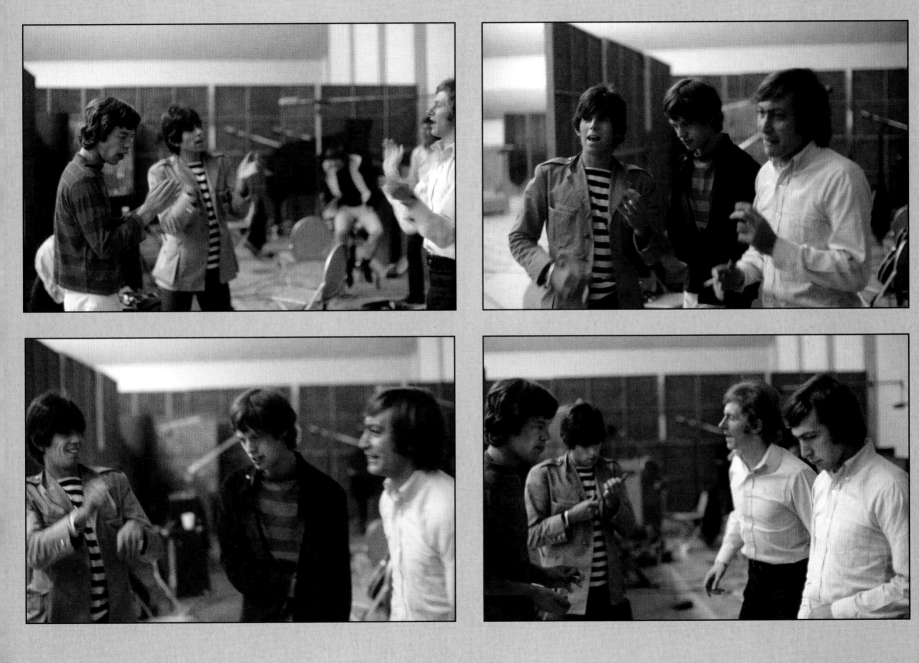

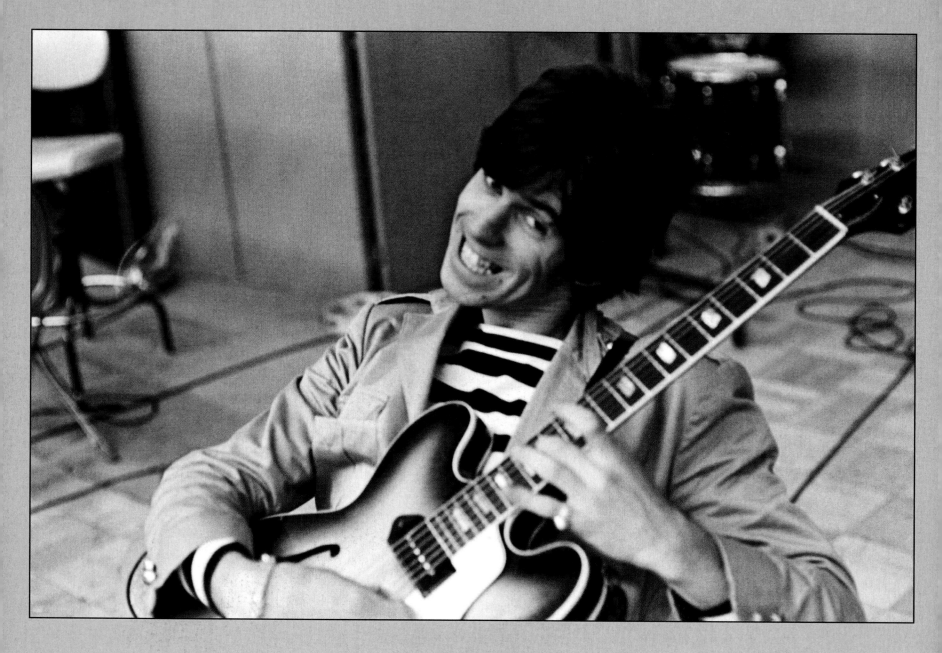

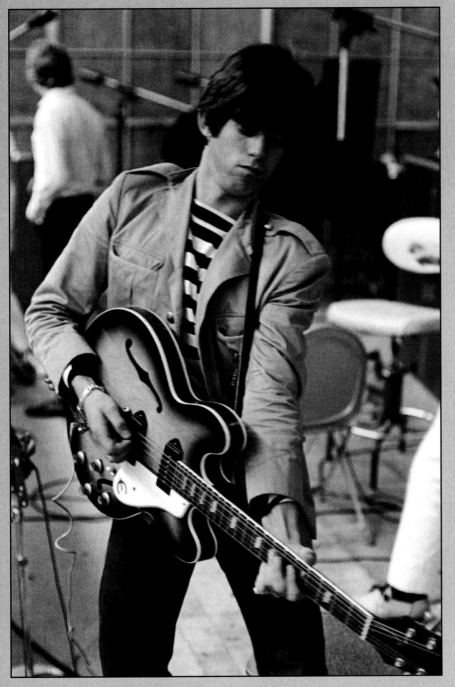

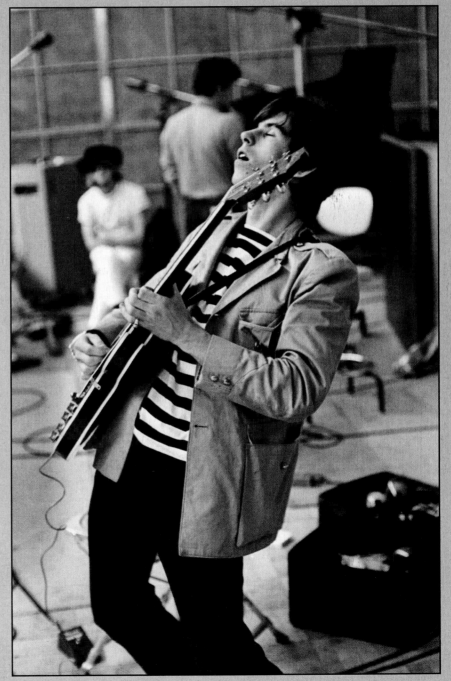

Keith used this Epiphone Casino guitar with a Maestro Fuzz-Tone model FZ-1A effect to record the classic fuzz riff on "(I Can't Get No) Satisfaction" when The Stones recorded it in May 1965 at RCA Studios.

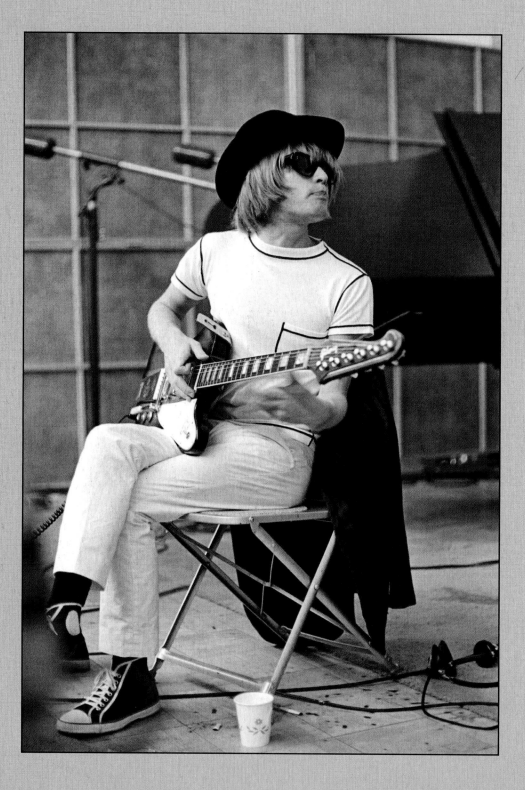

19A →20 →20A →21 →21A →22 →22A →23

25A →26 →26A →27 →27A →28 →28A →29

31A →32 →32A →33 →33A →34 →34A →35

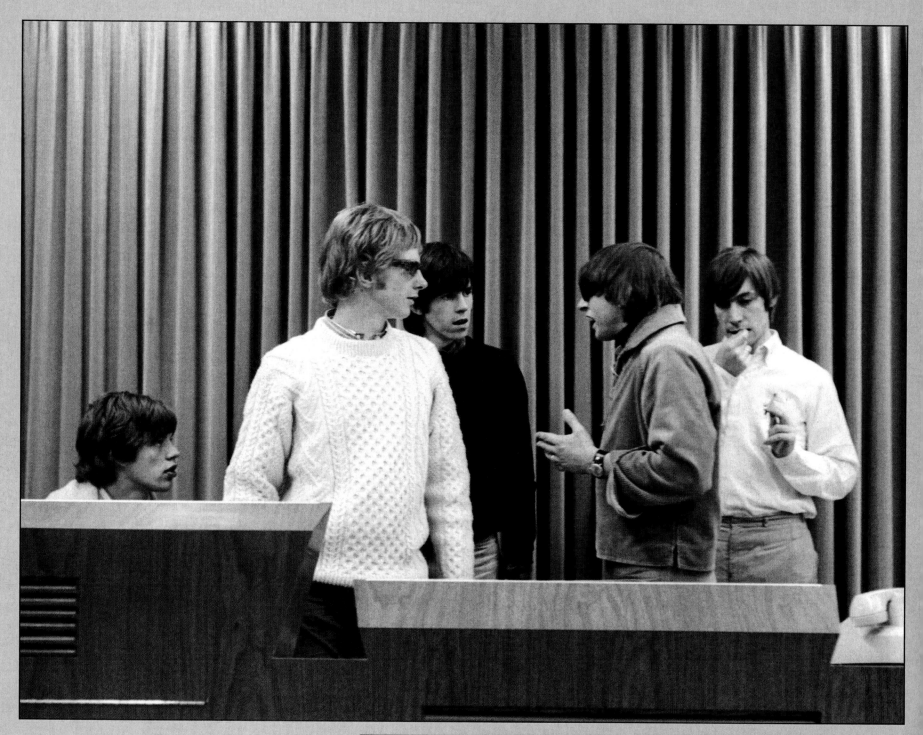

RCA Studios, Hollywood, California, September 6–7, 1965.

Jack Nitzsche makes a point to Mick, Keith, Charlie, and Andrew.

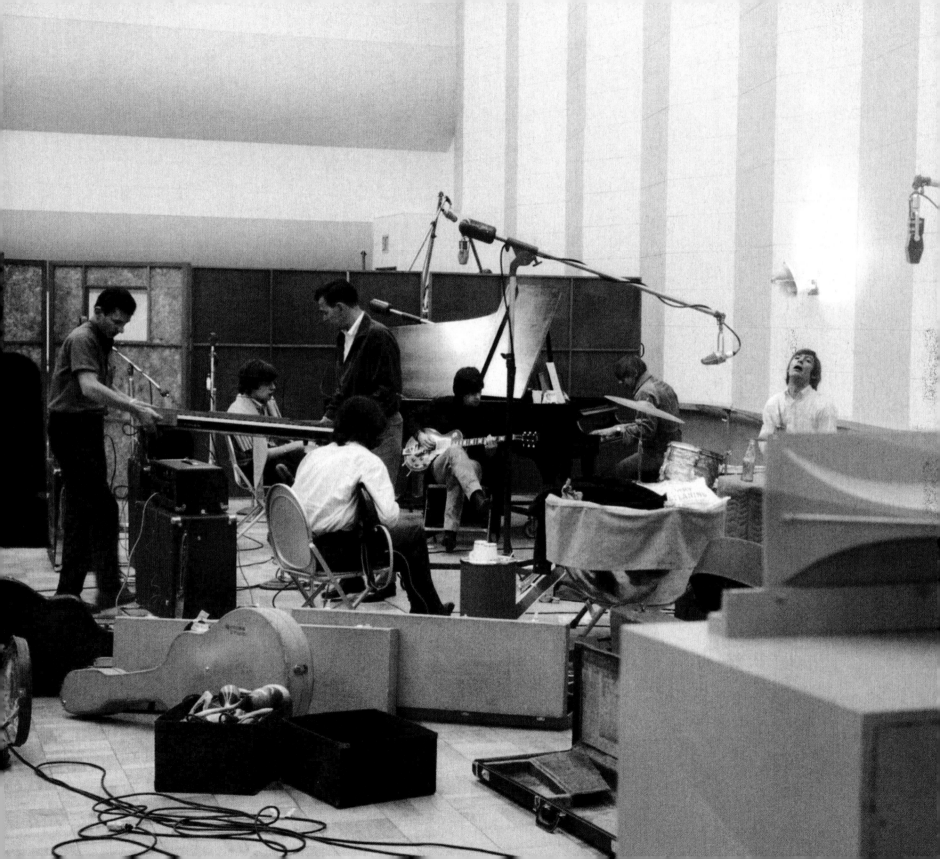

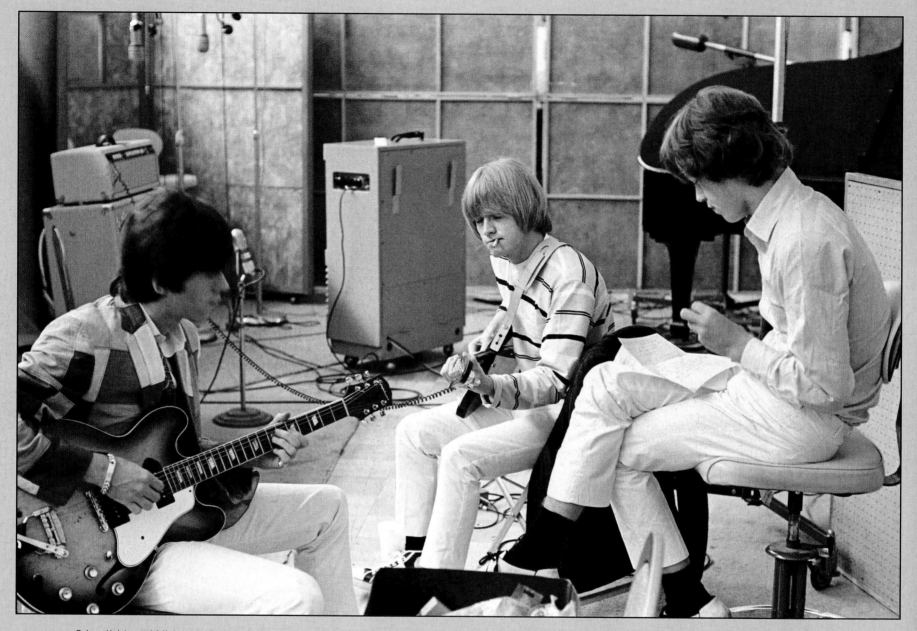

Brian, Keith, and Mick recording tracks for the albums *Out of Our Heads* (U.K.) and *December's Children (and everybody's)* (U.S.). Tracks recorded at these sessions include "She Said Yeah," "Gotta Get Away," "Get Off My Cloud," "I'm Free," "The Singer Not the Song," and "Blue Turns to Grey."

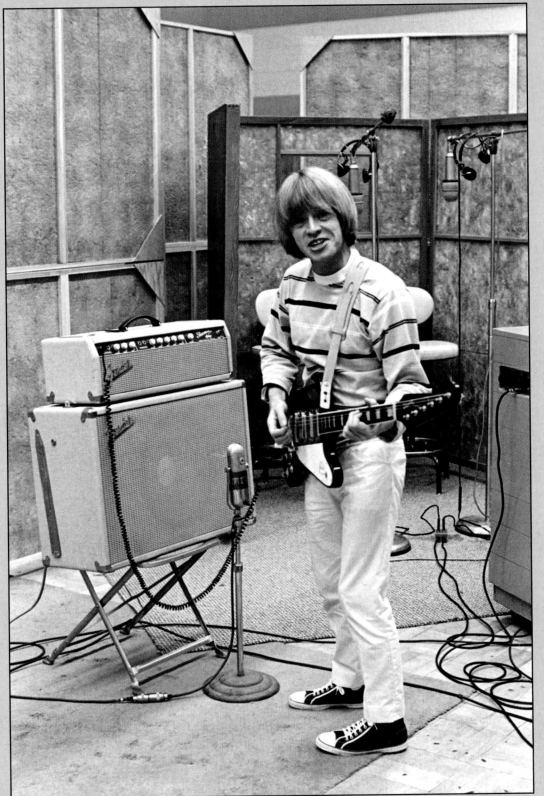

Brian plays his Gibson Firebird VII Reverse guitar through a piggyback Fender Showman amp with a single 15" bottom.

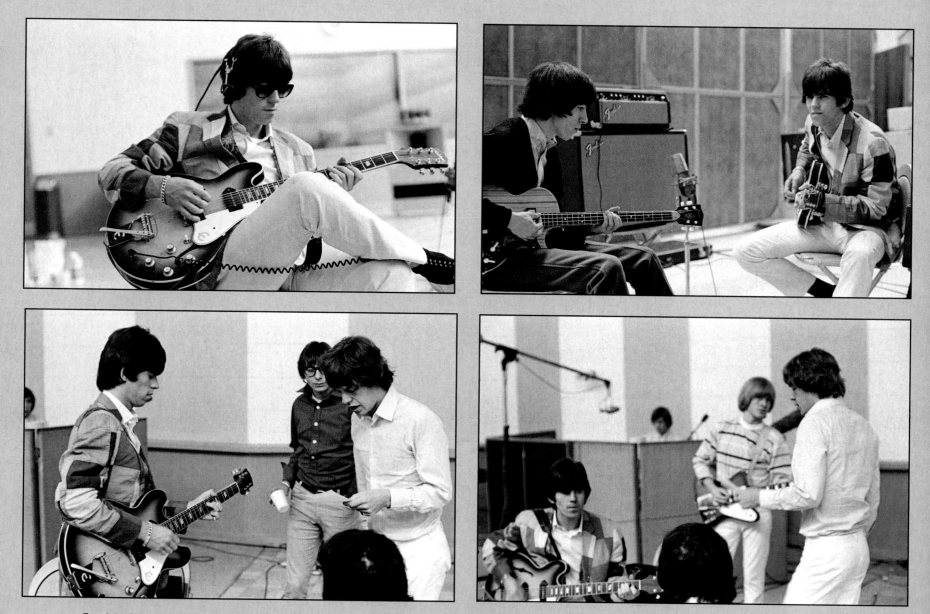

Top right: Bill with his custom-made Framus F5/150 "Humbug" bass, which he received in November 1964. It was nicknamed the "Humbug" bass after its striped finish that resembled a type of striped English candy.

Bottom left: Jack Nitzsche looks on as Mick and Keith go over a song.

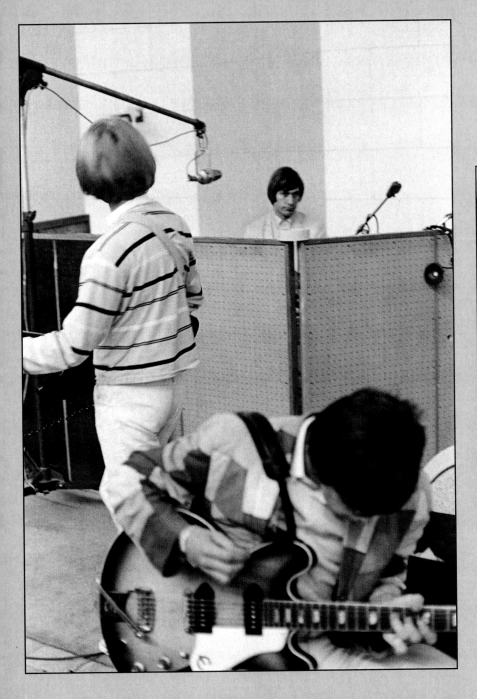
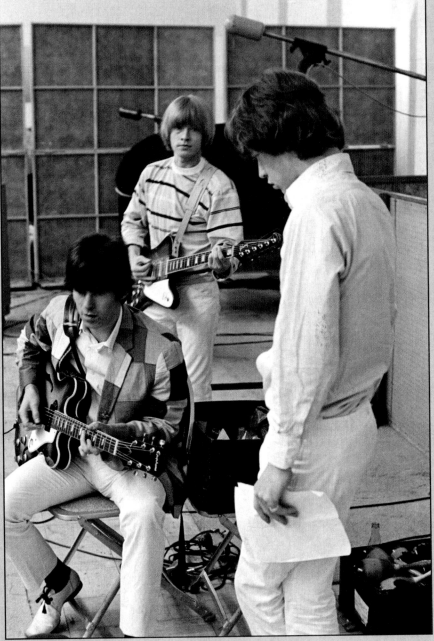

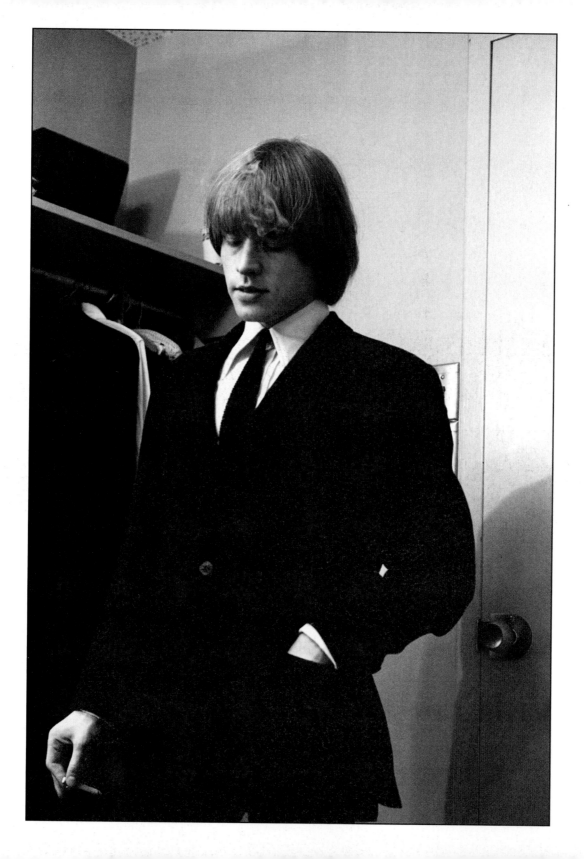

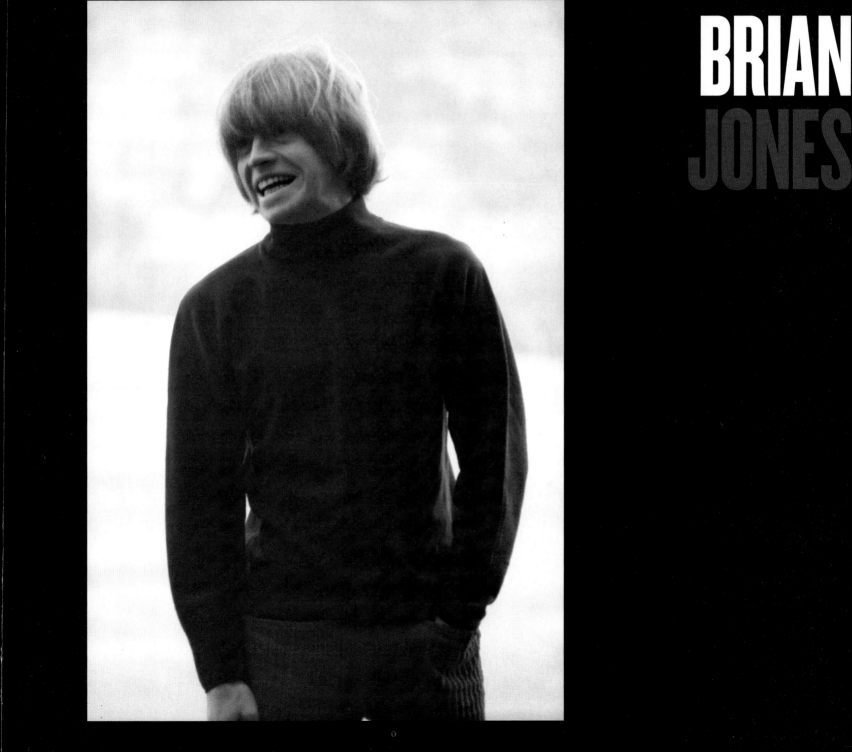

BRIAN
JONES

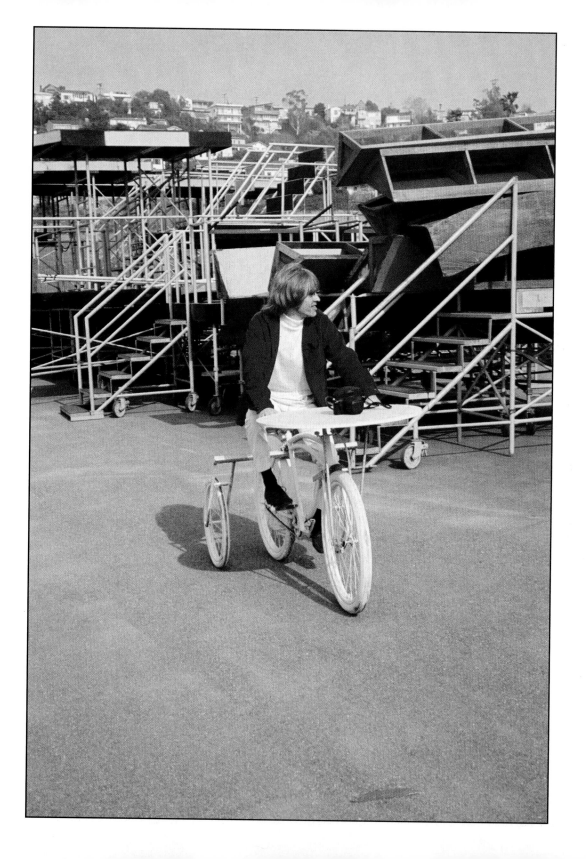

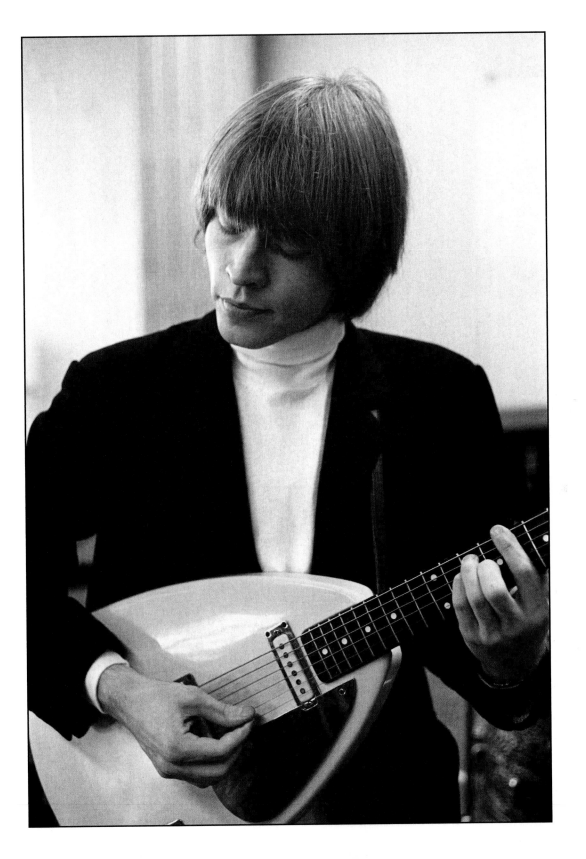

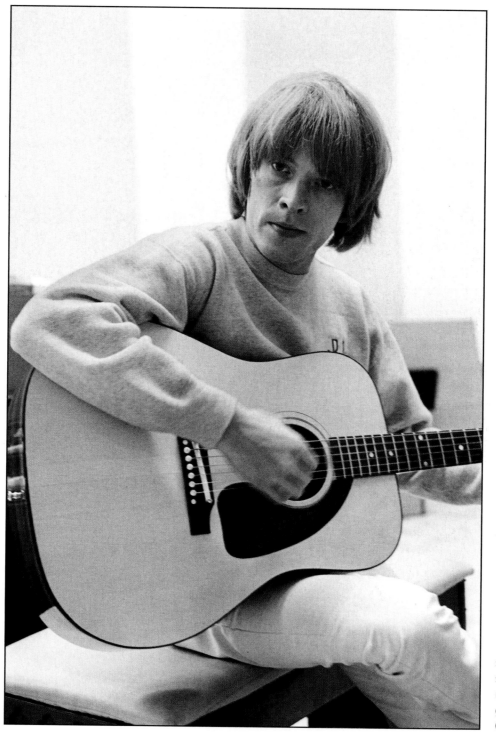

Brian with his new Gibson
Heritage acoustic square
shoulder jumbo with
spruce top and Brazilian
rosewood back and sides,
given to The Stones by
Gibson in May 1965.

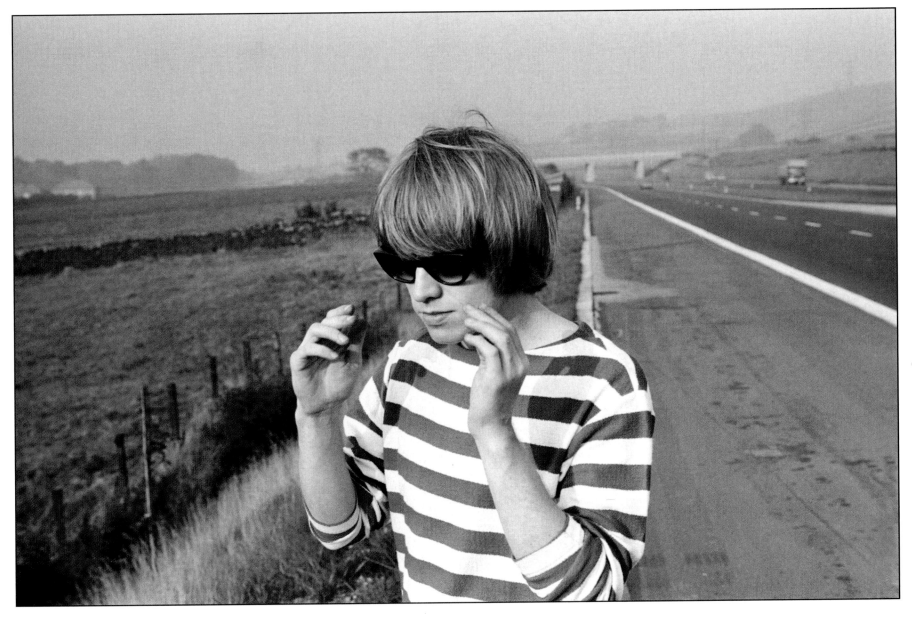

On the M1 in northern England, October 1965.

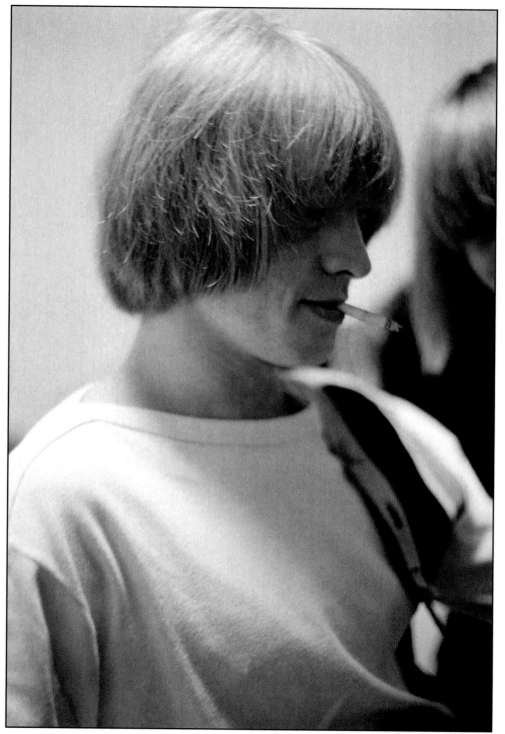

Backstage at Waldbühne, West Berlin,
West Germany, September 15, 1965.

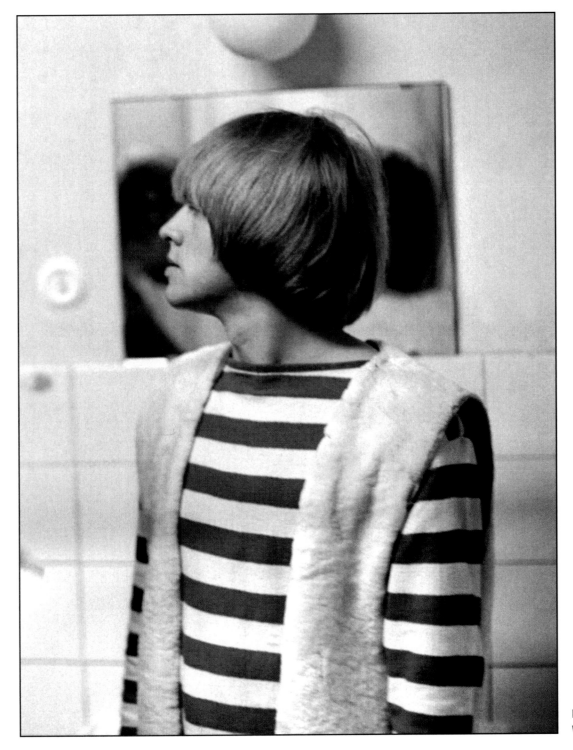

Backstage at Grugahalle, Essen,
West Germany, September 12, 1965.

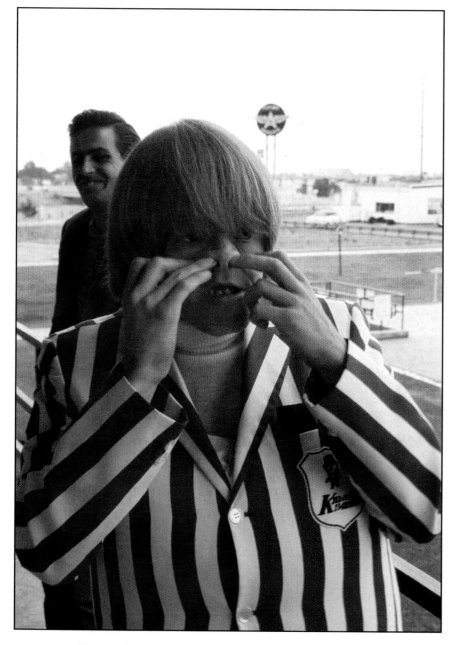

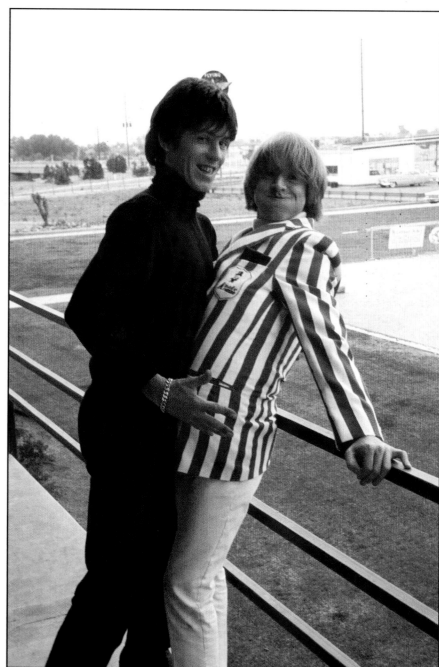

Above: Brian pulls a nanker.
Right: Brian does his impression of Bob Bonis.

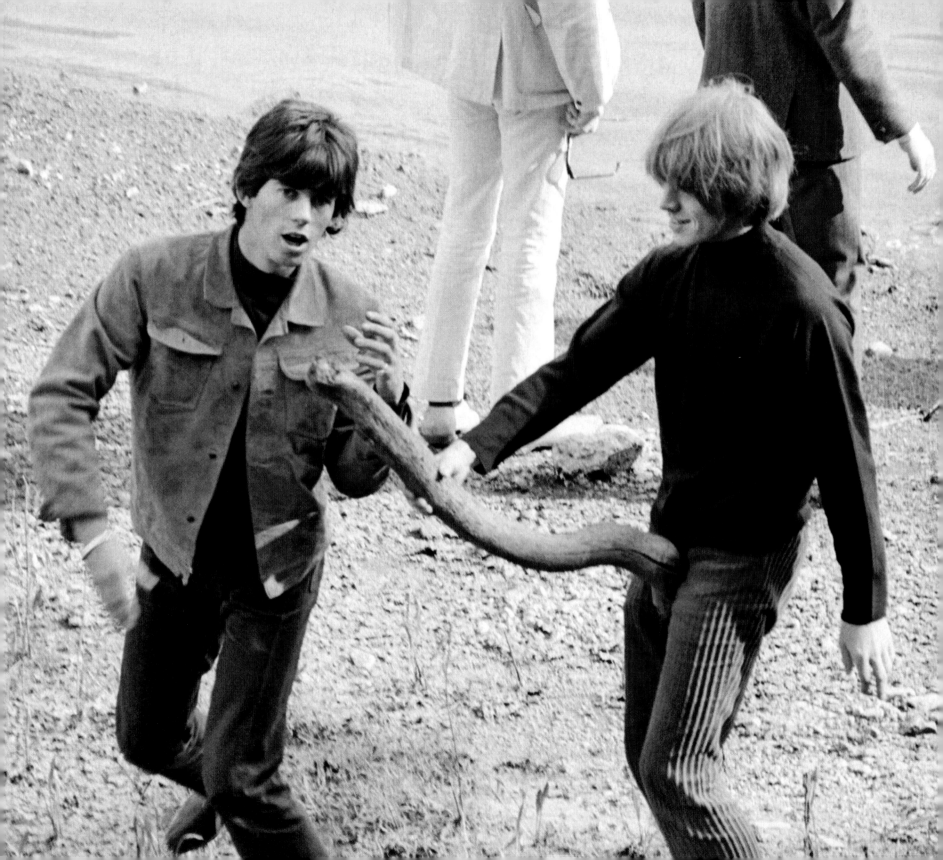

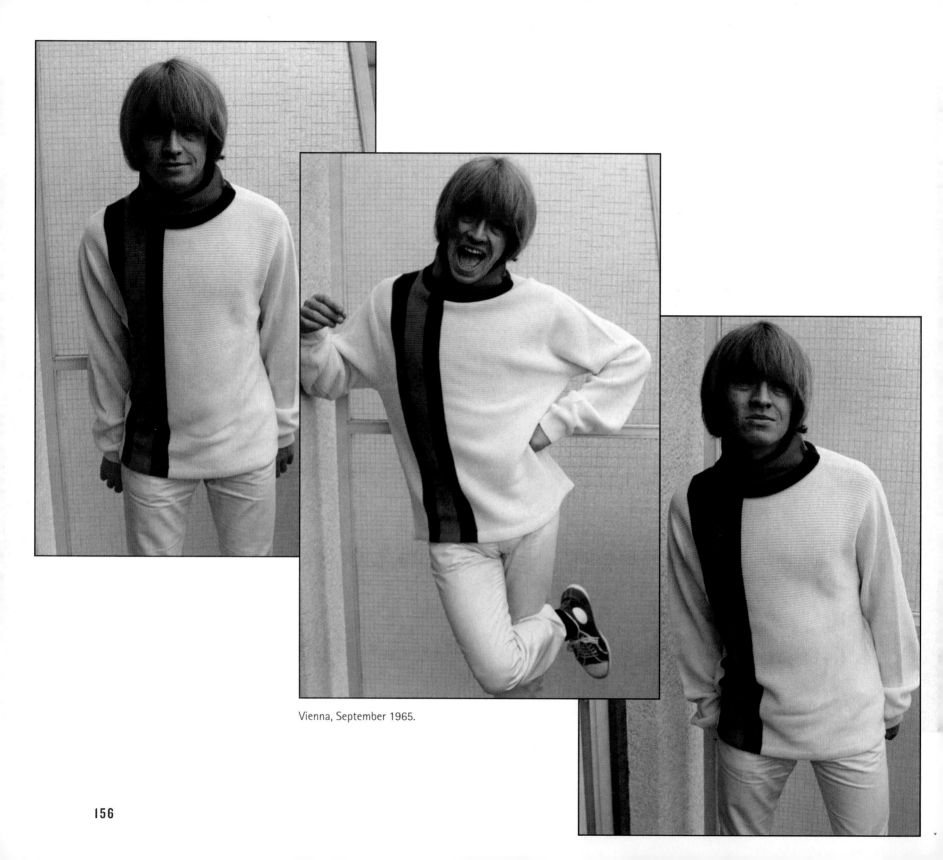

Vienna, September 1965.

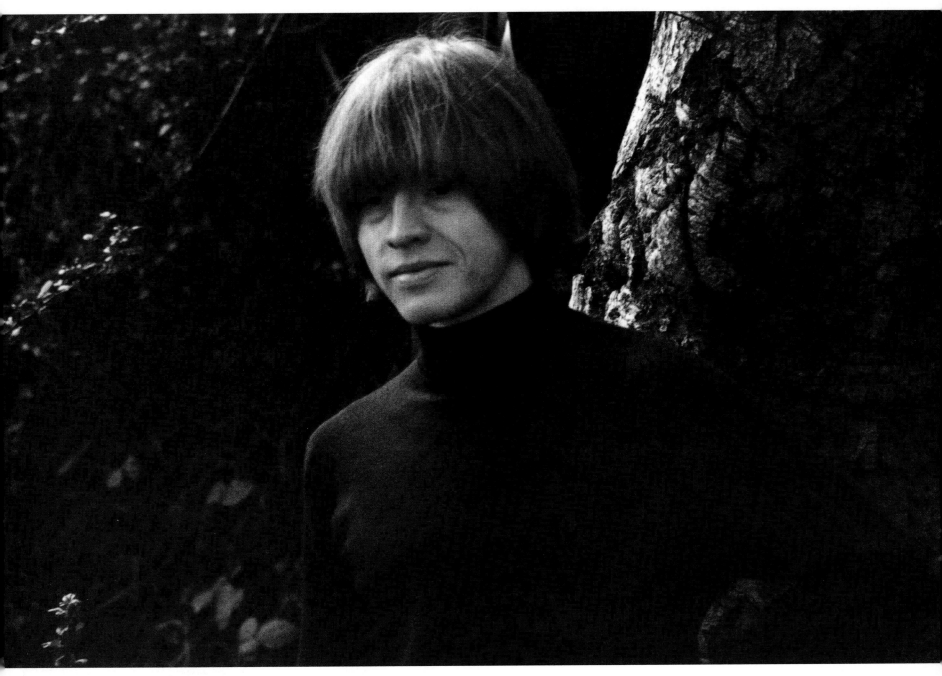

Beverly Hills, California, December 1965.

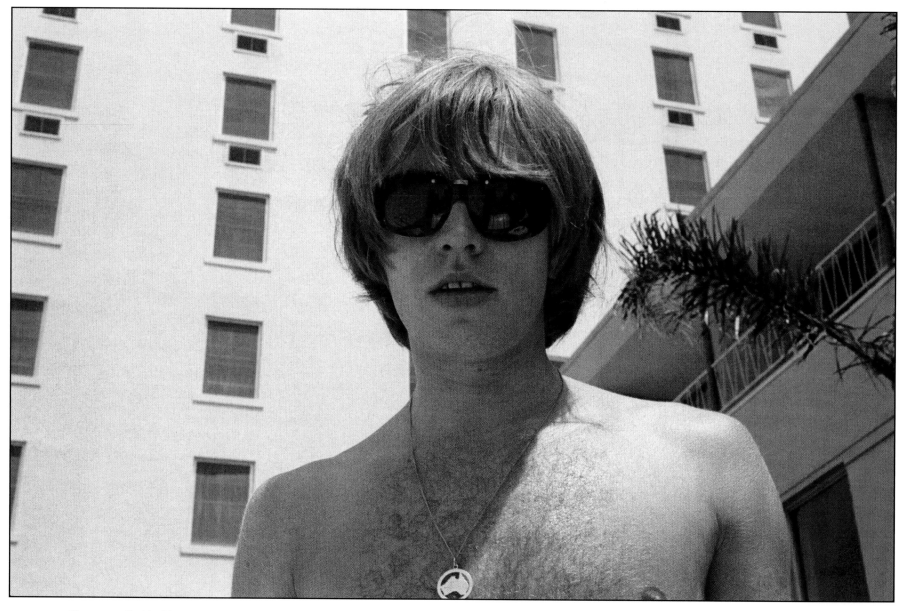

Clearwater, Florida, May 6, 1965.

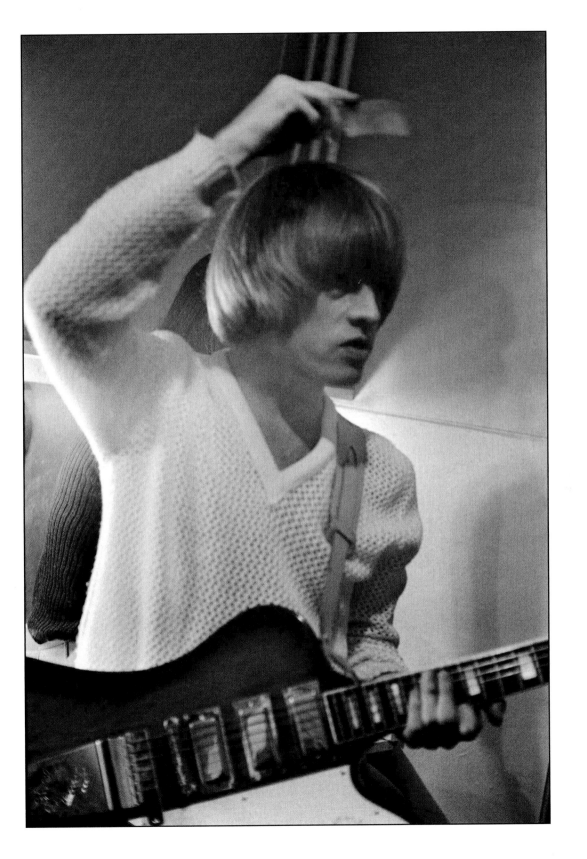

159

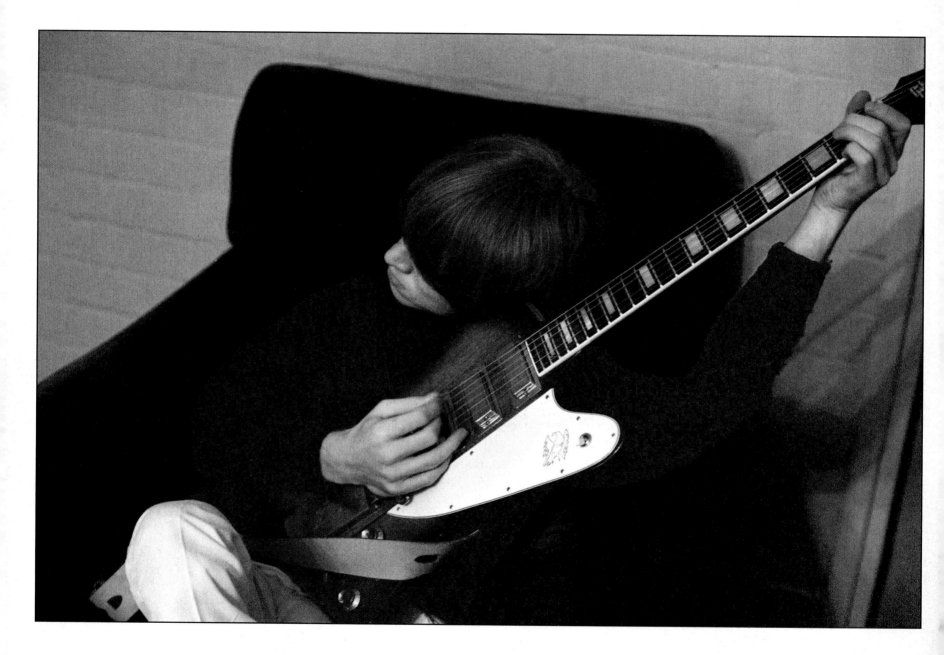

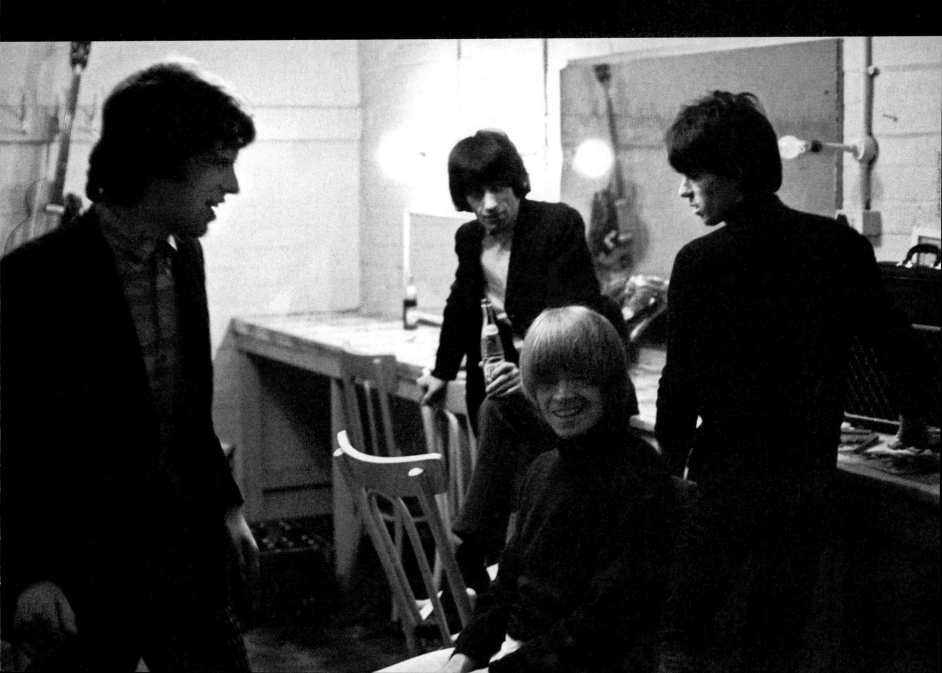

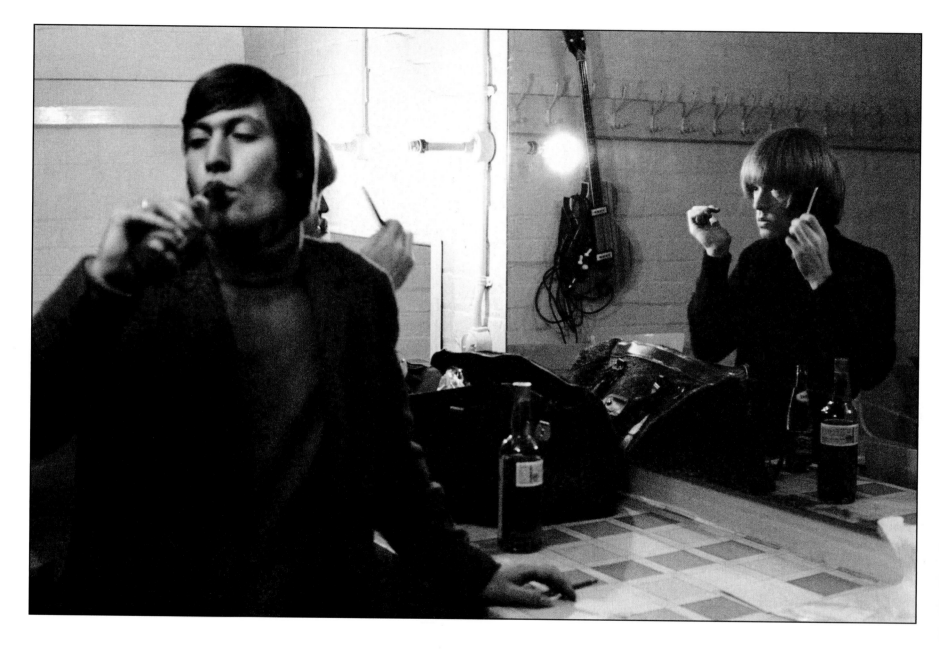

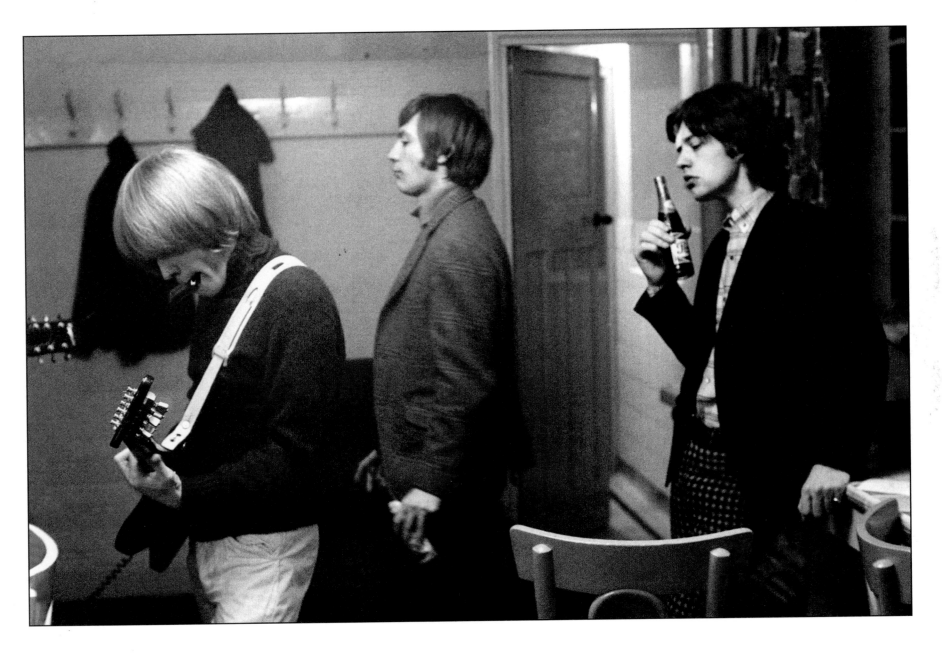

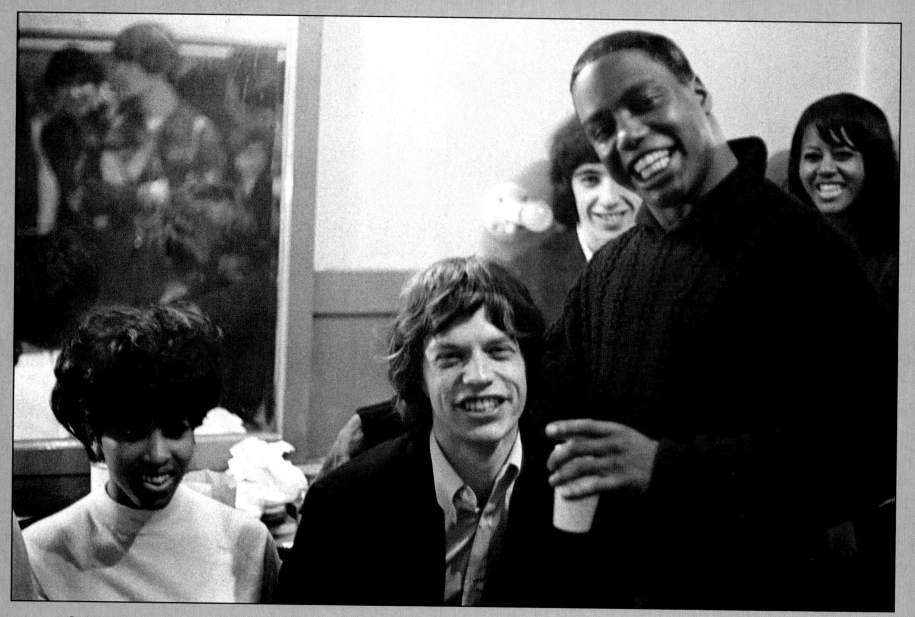

Backstage with Nona Hendryx and members of Patti LaBelle and the Bluebelles, November 1965.

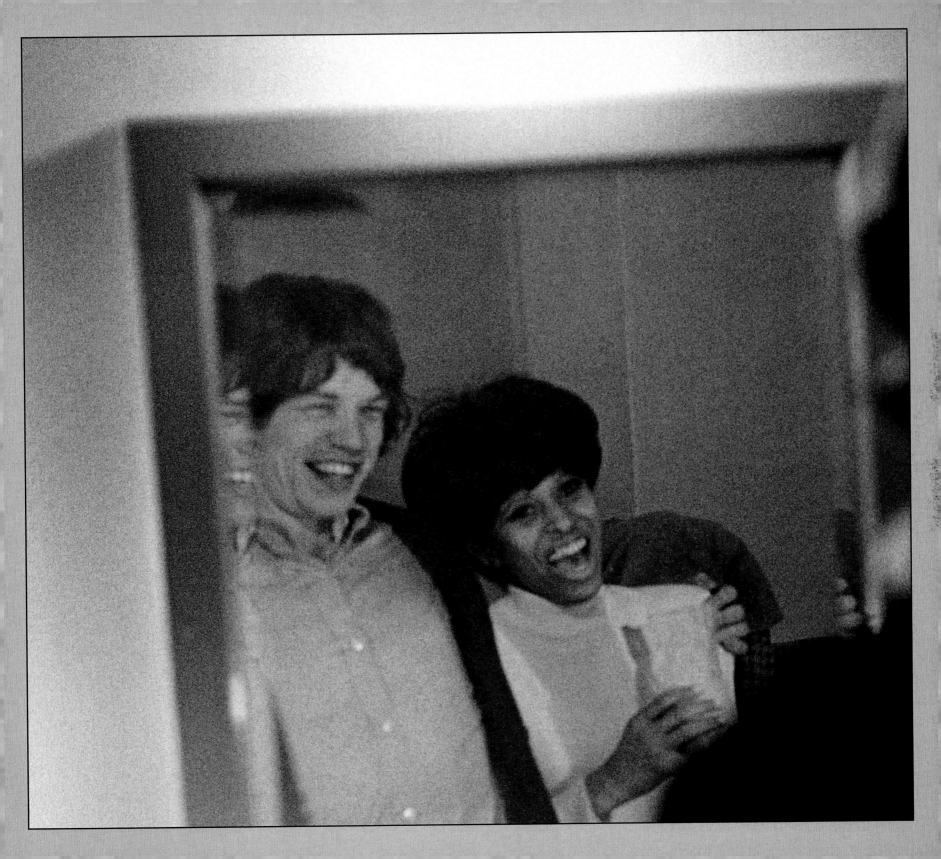

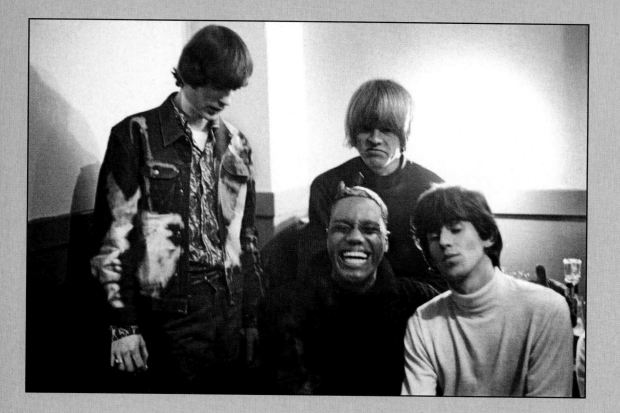

With members of opening acts including Sarah Dash *(right)* of Patti LaBelle and the Bluebelles, November 1965.

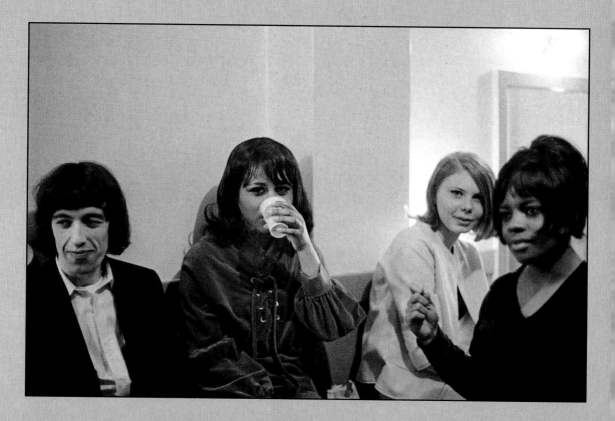

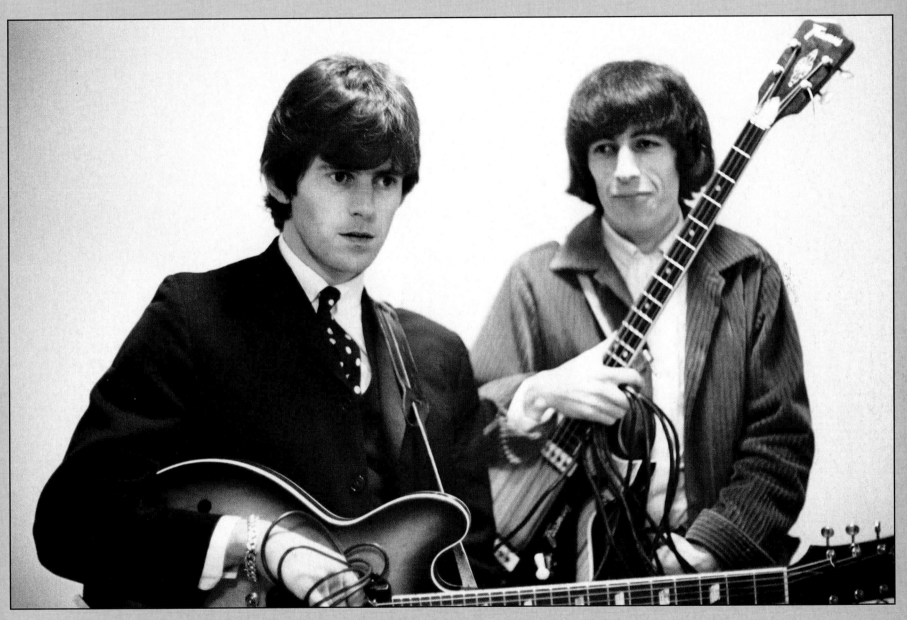

Backstage at Waldbühne, West Berlin, West Germany, September 15, 1965.

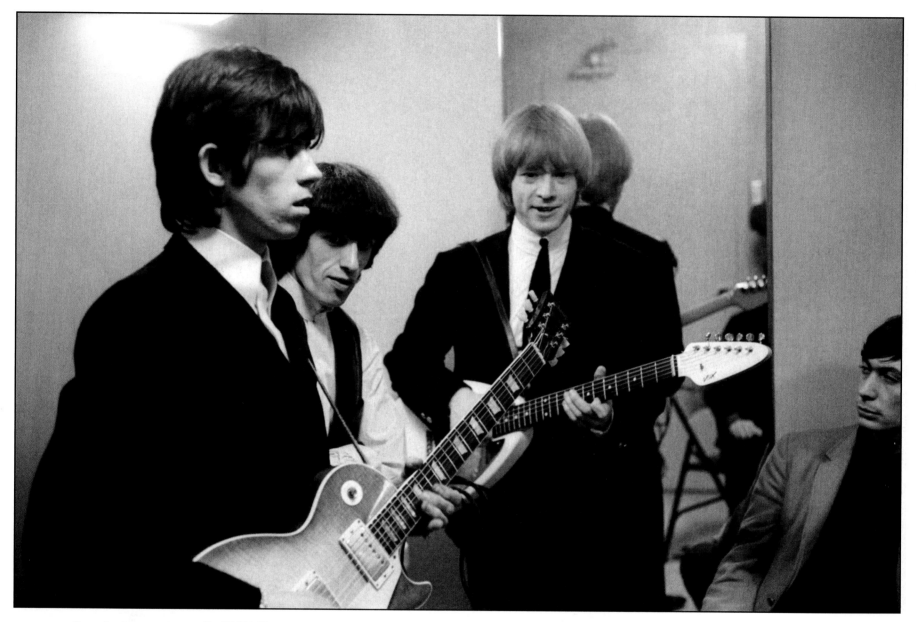

Preparing to go onstage at *The T.A.M.I. Show* at the Santa Monica Civic Auditorium in California, October 29, 1964.

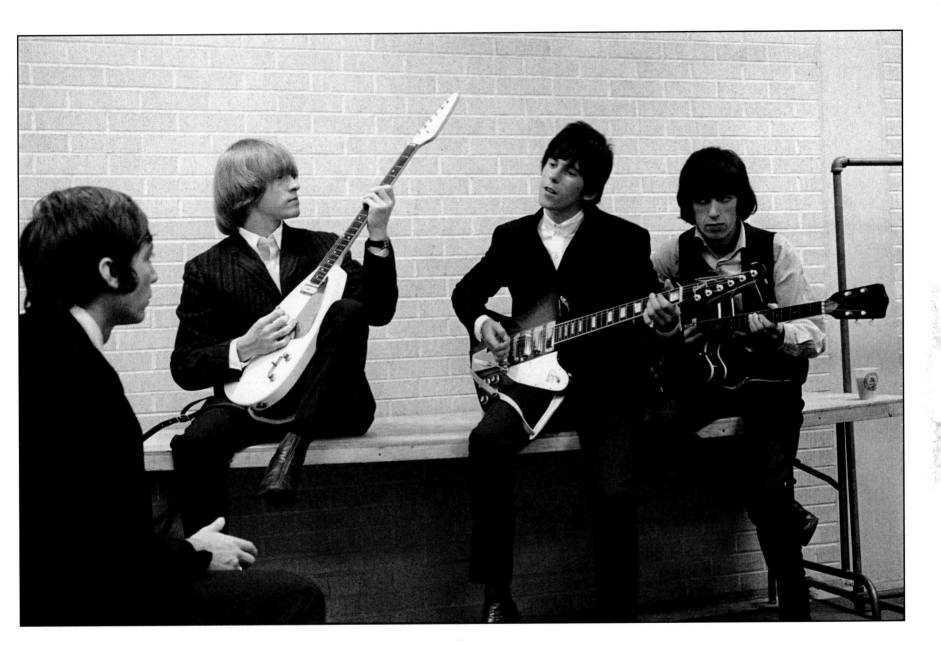

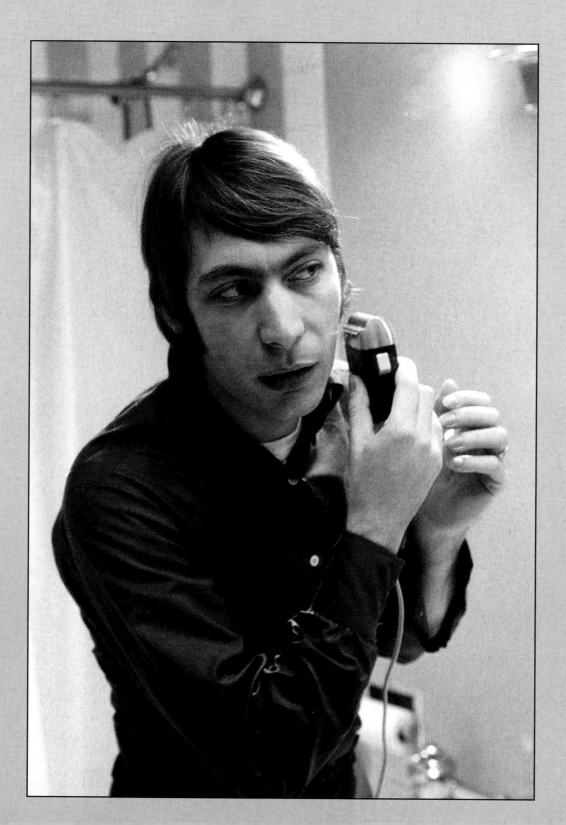

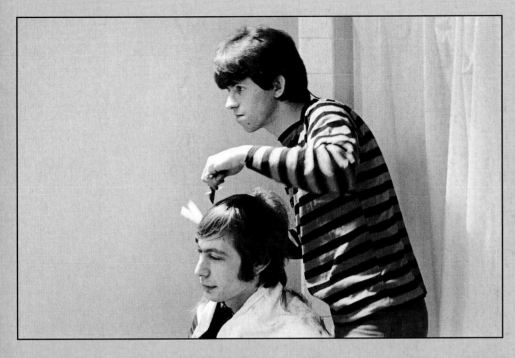

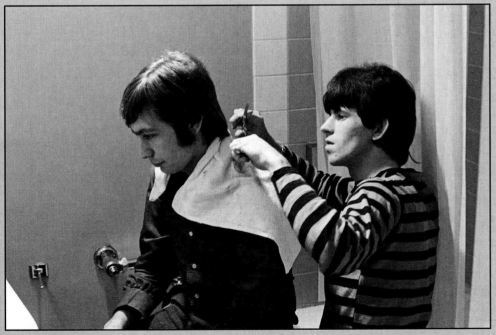

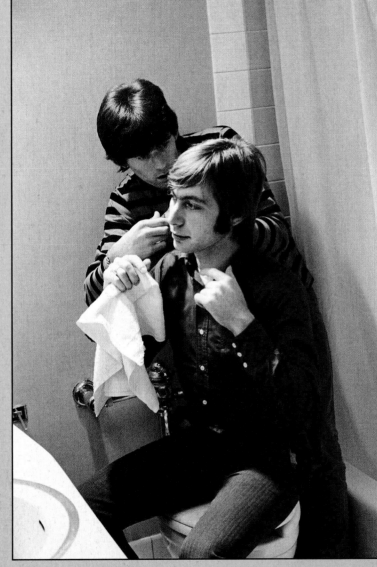

Backstage before their appearance on *Hullabaloo*, Charlie shaves (*opposite*) and Keith gives him a trim.

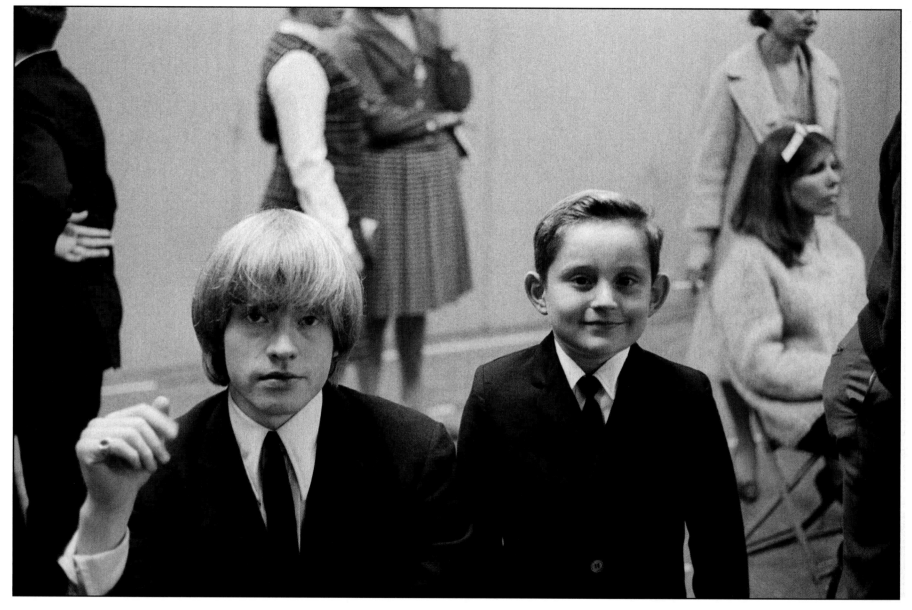

Celebrities are often called upon to pose with fans, guests, and the children of important people. Brian and Mick pose with an unidentified child, probably the son of an executive, promoter, or other VIP.

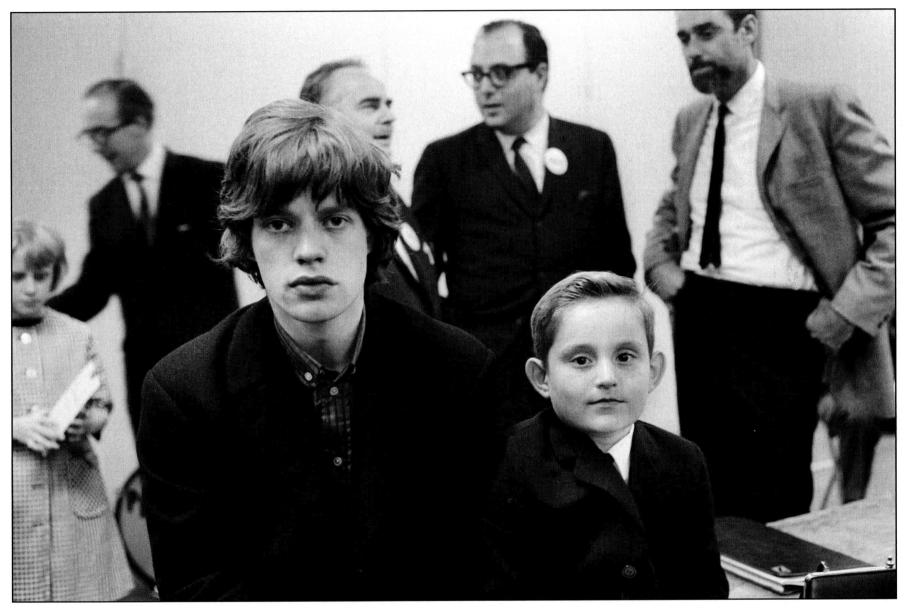

Chrissie Shrimpton, sister of model Jean Shrimpton and Mick Jagger's girlfriend until 1966, relaxes backstage before a concert. Mick wrote the songs "Under My Thumb," "Stupid Girl," and "19th Nervous Breakdown" about Chrissie.

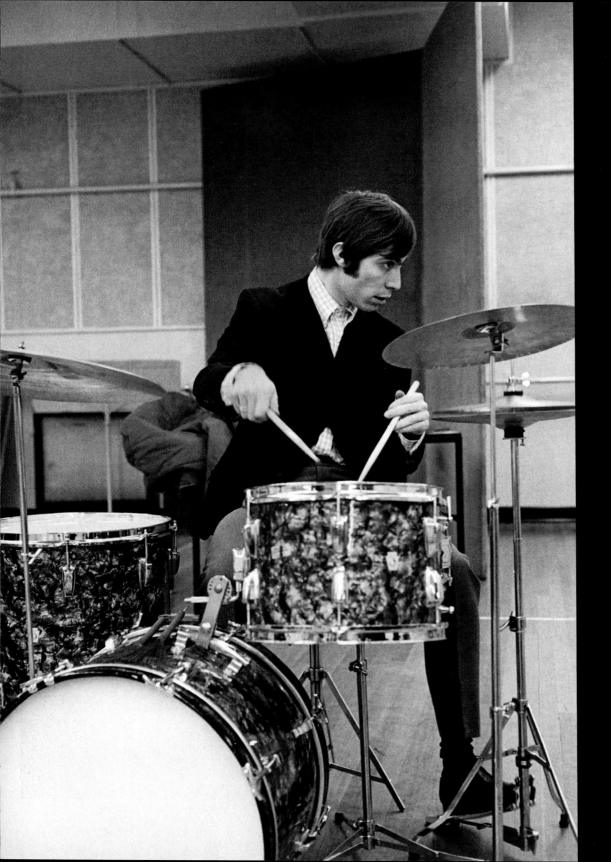

CHARLIE
WATTS

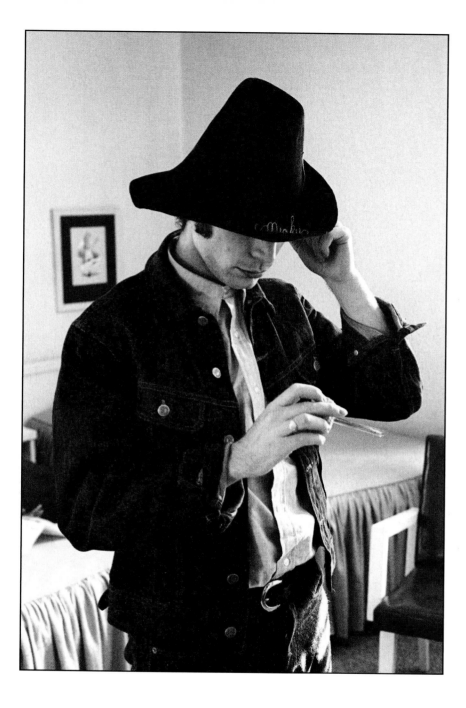

On October 14, 1964, shortly before the beginning of The Stones' second U.S. tour, Charlie Watts secretly married Shirley Ann Shepherd, to whom he is still married today. Shirley traveled with The Stones in the United States.

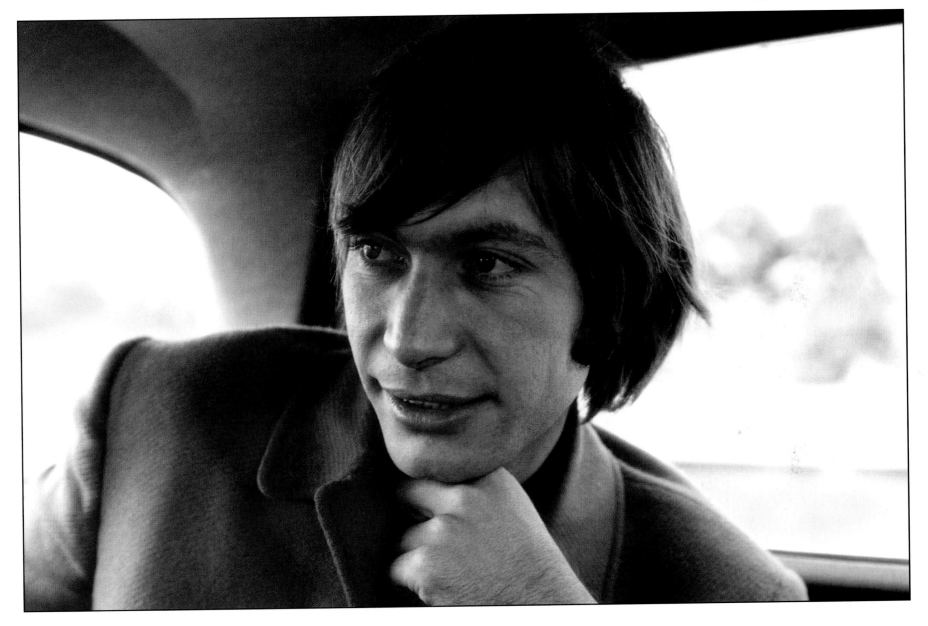

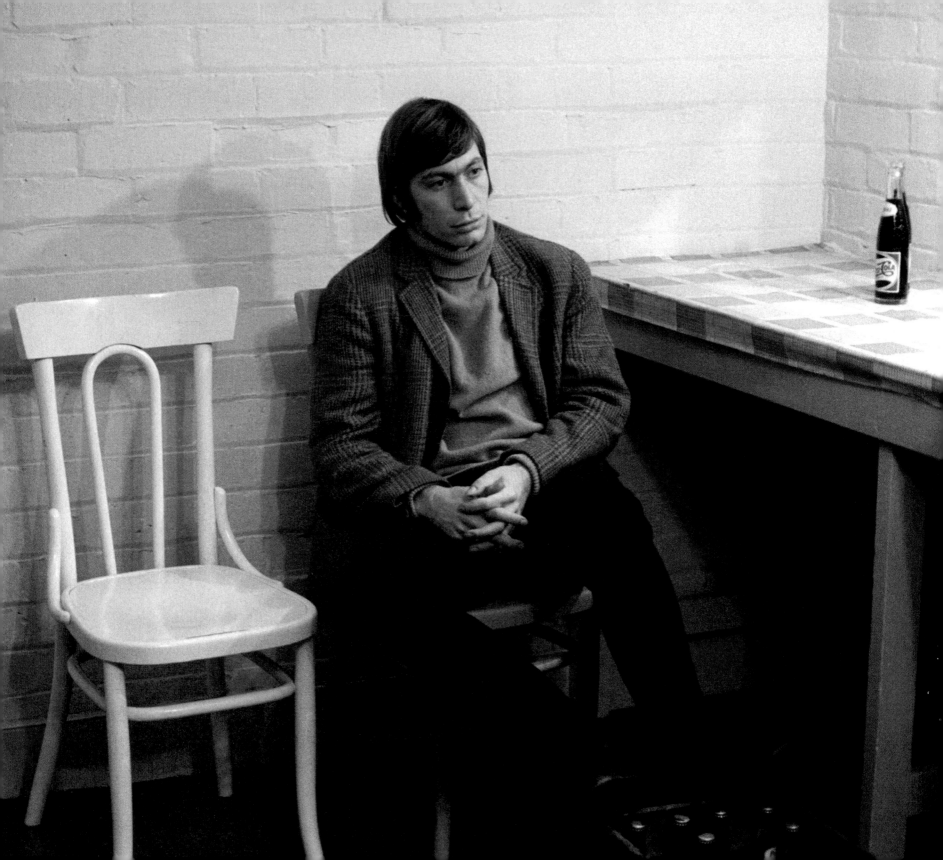

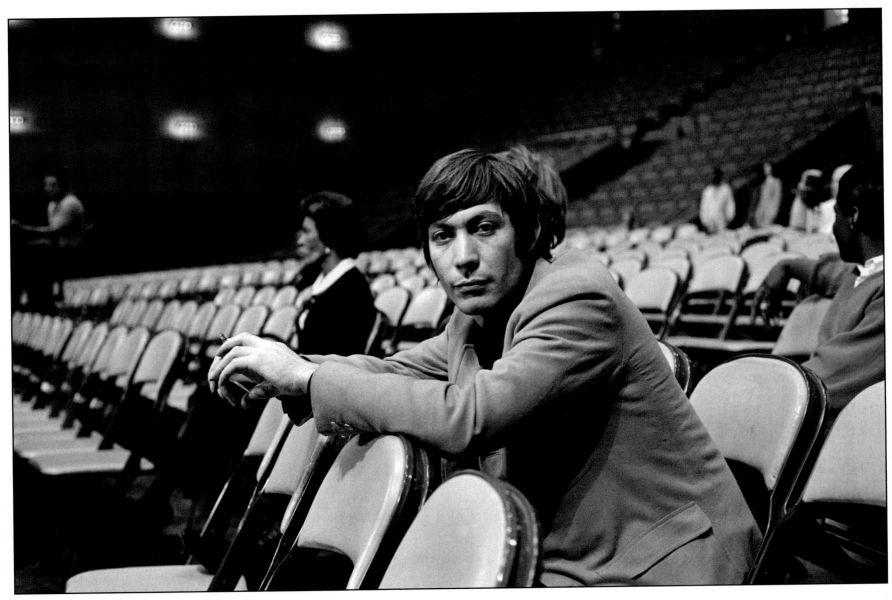

Santa Monica, California, October 1964, *The T.A.M.I. Show.*

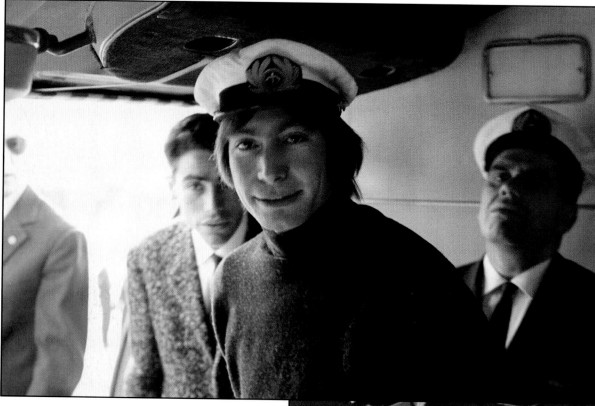

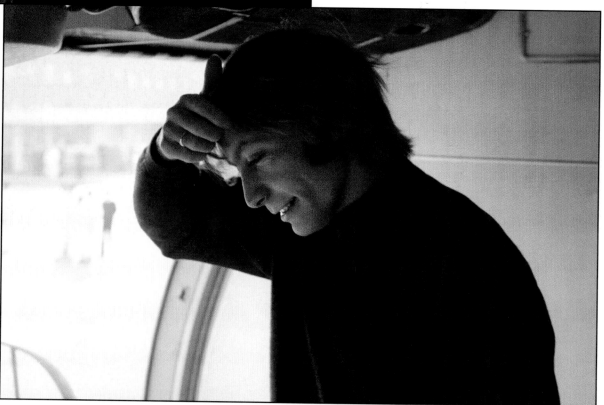

En route to Munich, West Germany,
September 14, 1965.

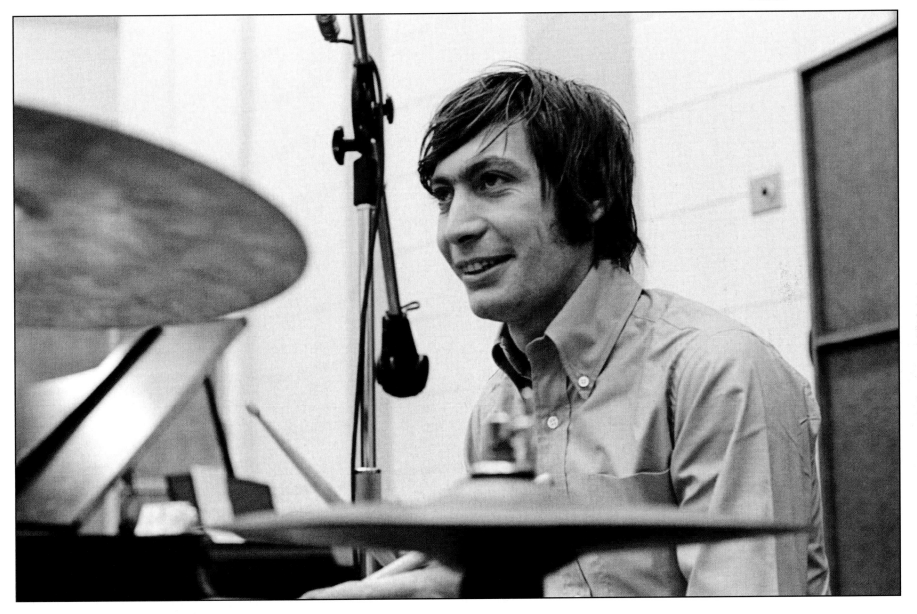

RCA Studios, Hollywood, California, December 1965.

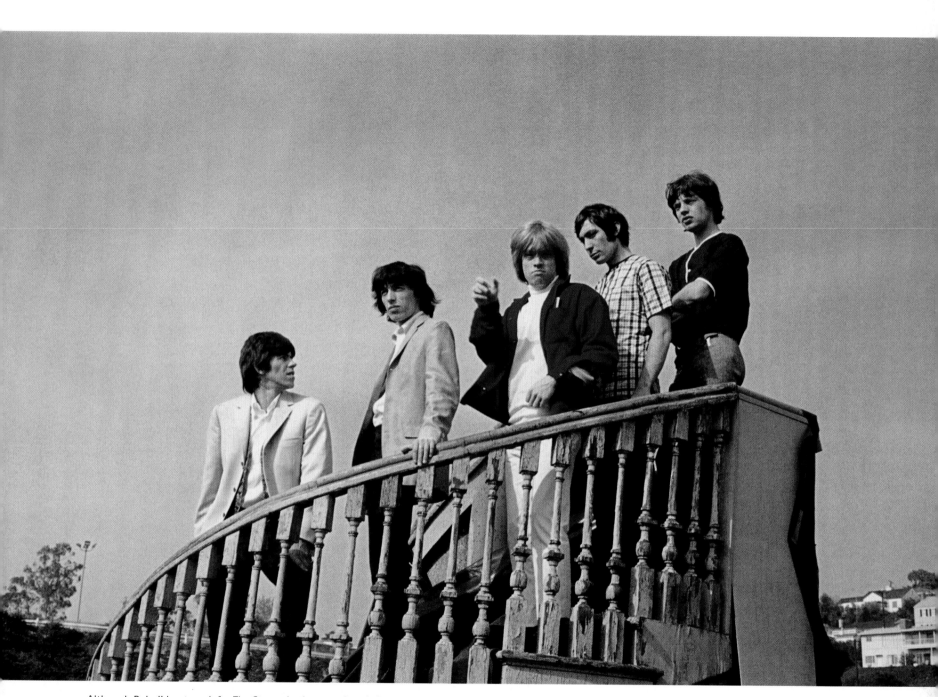

Although Bob did not work for The Stones in the capacity of photographer, he would go with them to promotional shoots and take his own photographs. Bob and The Stones ventured out to a prop facility in the Hollywood Hills near Los Angeles and spent the day taking a variety of photographs.

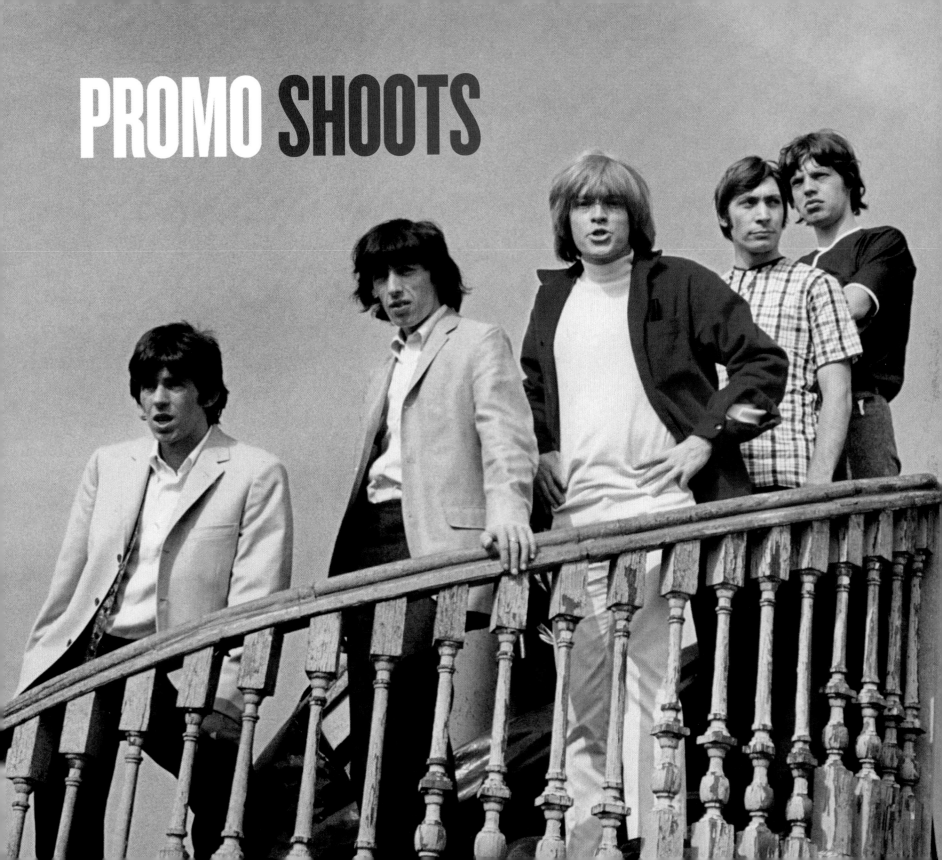

PROMO SHOOTS

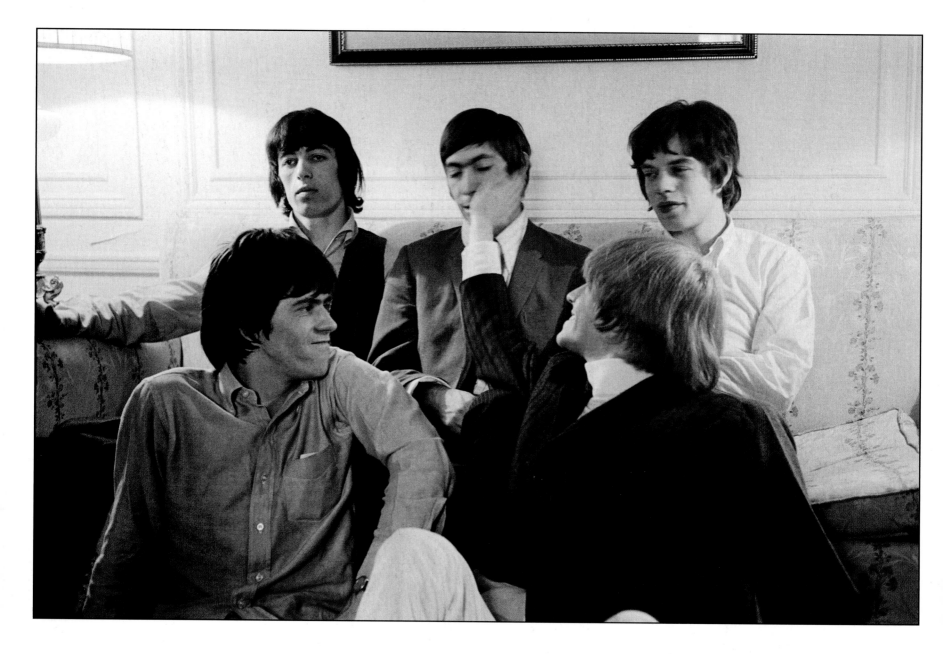

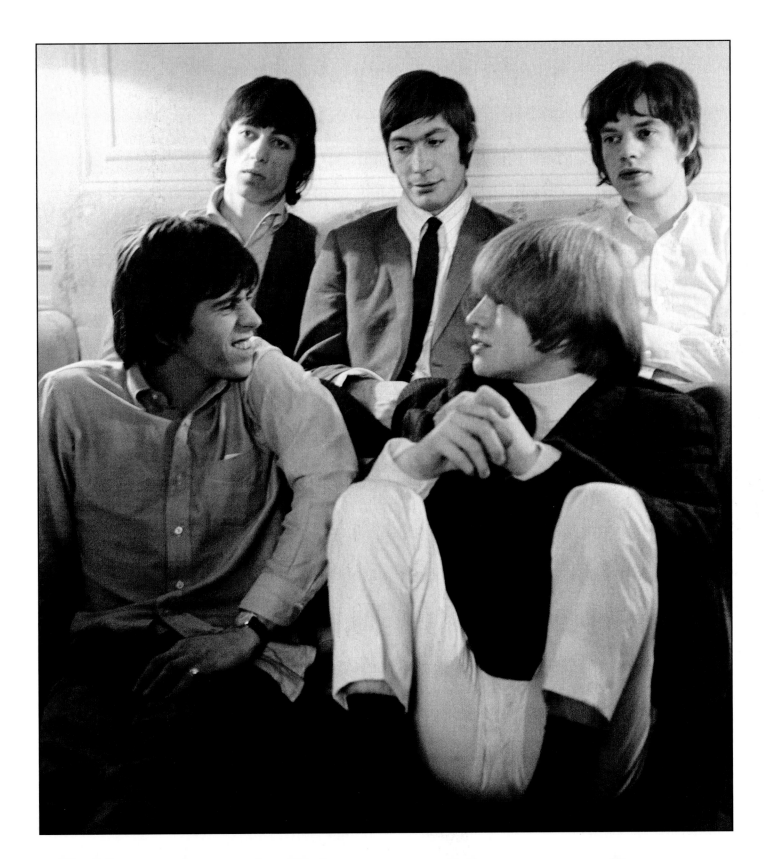

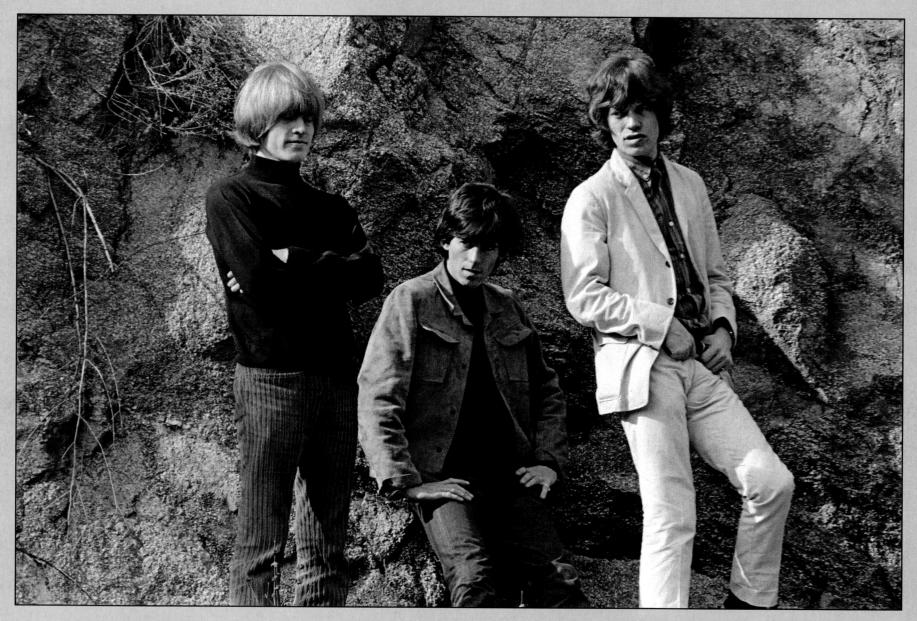

Bob accompanied The Rolling Stones and photographer Guy Webster on a trip to a reservoir on Beverly Drive in Beverly Hills, California, for a cover shoot for an LP that was to be called *Could You Walk on the Water?* and took his own photographs. After the controversy that stemmed from John Lennon's comments about The Beatles being more popular than Jesus, Decca Records refused to put out a record with that title. The album was renamed *Aftermath* and Guy's photos were instead used for the greatest hits LP *Big Hits (High Tide and Green Grass)*.

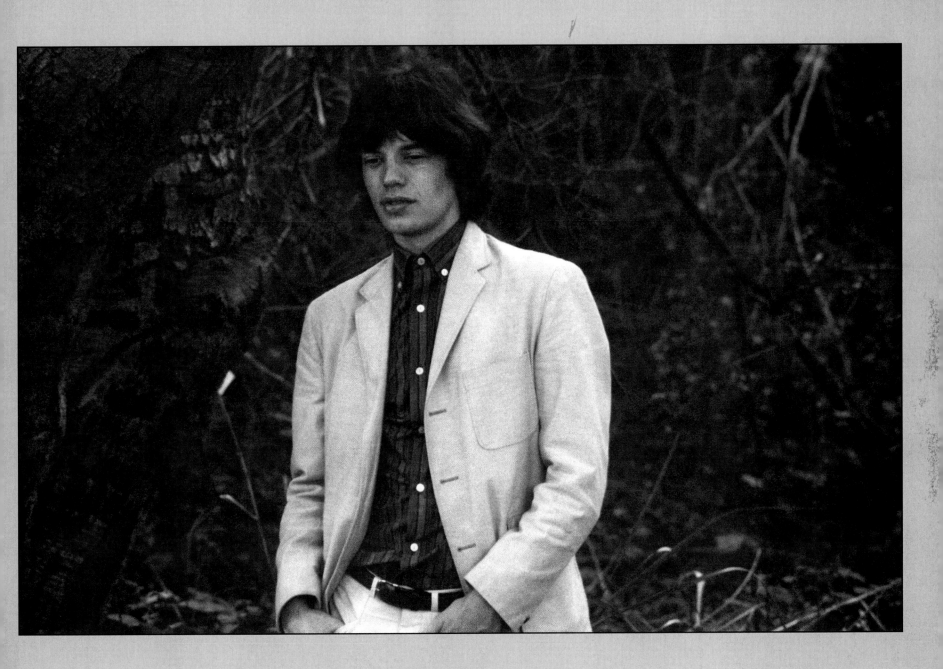

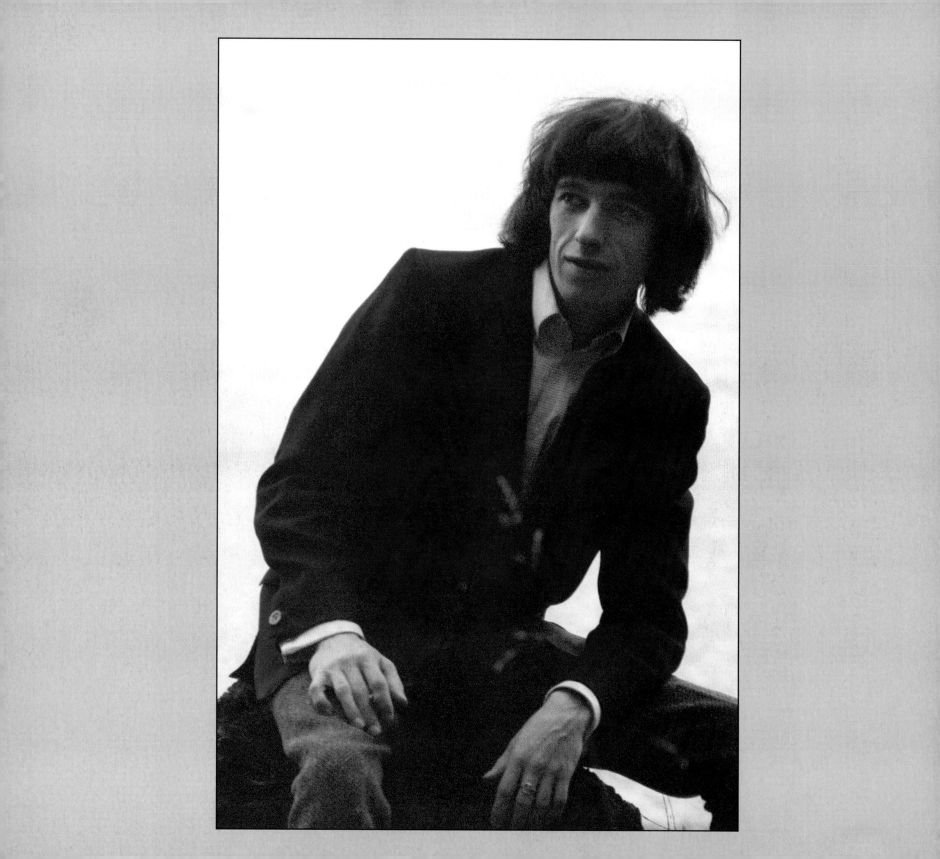

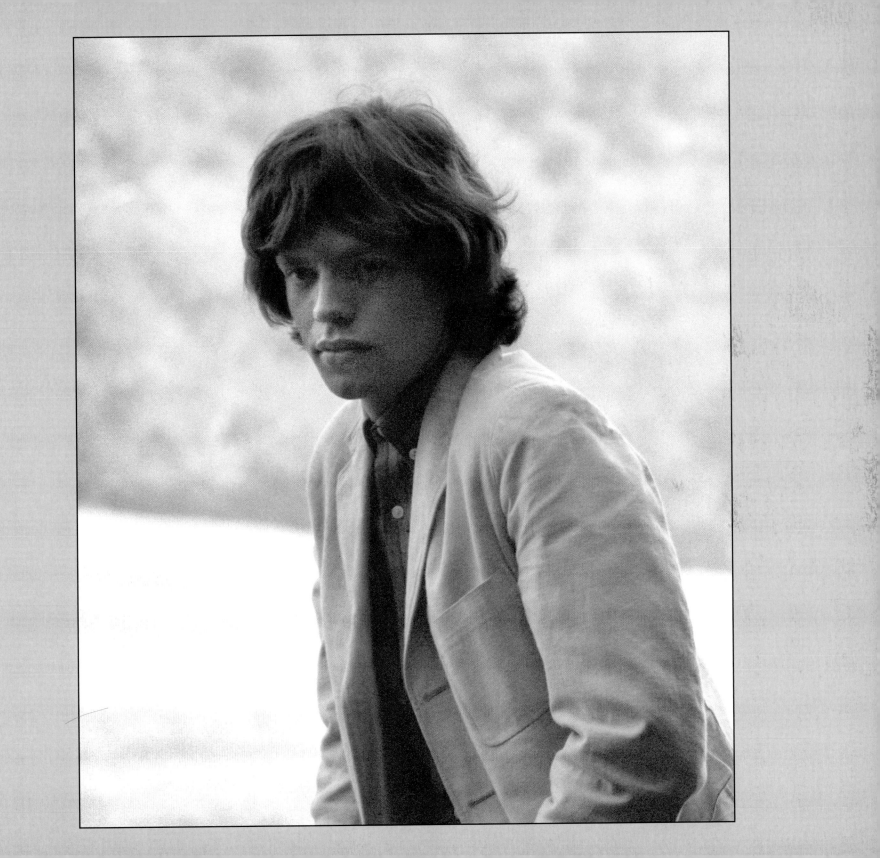

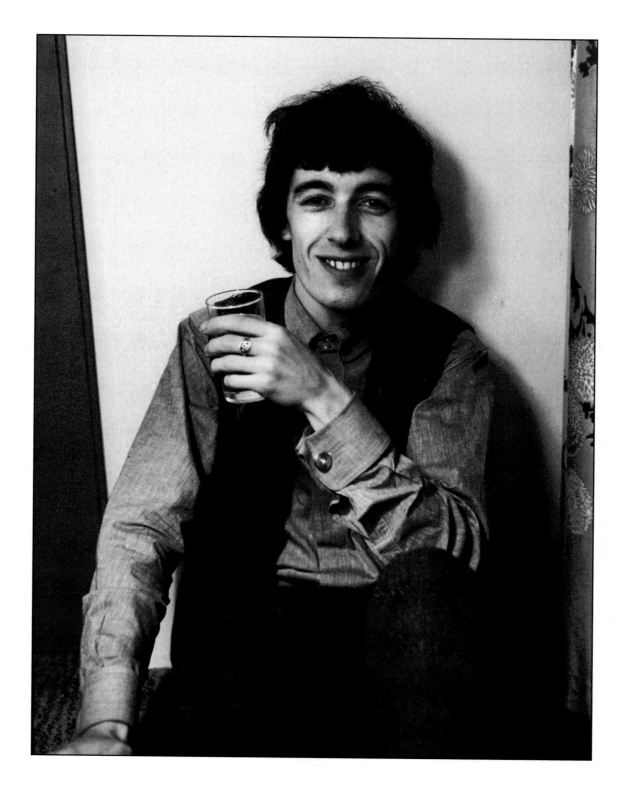

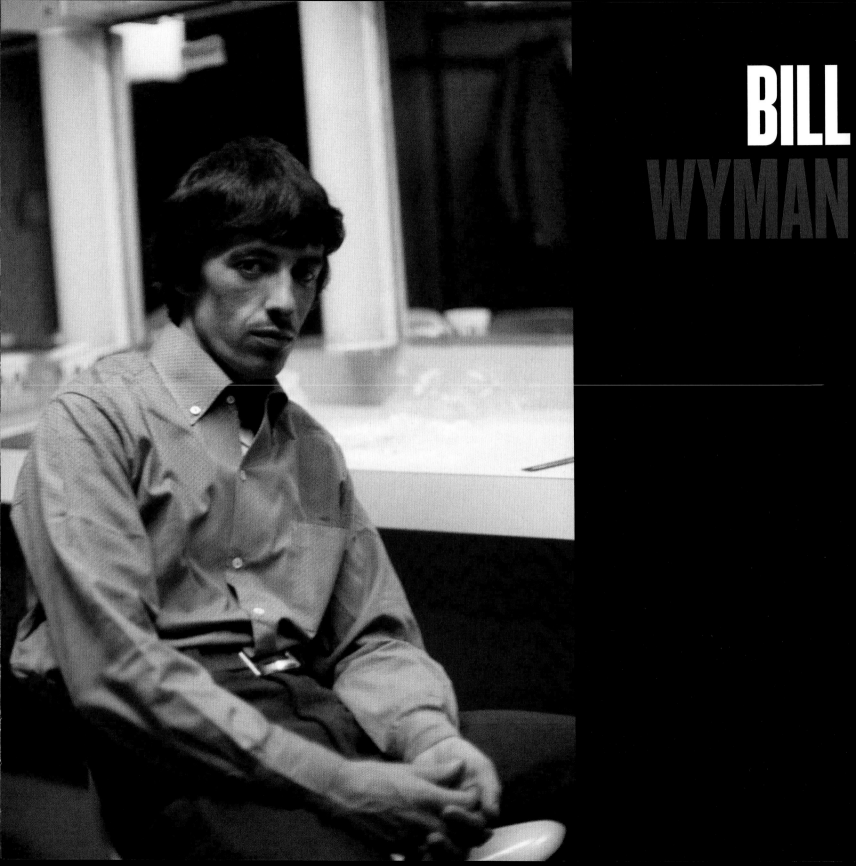

BILL
WYMAN

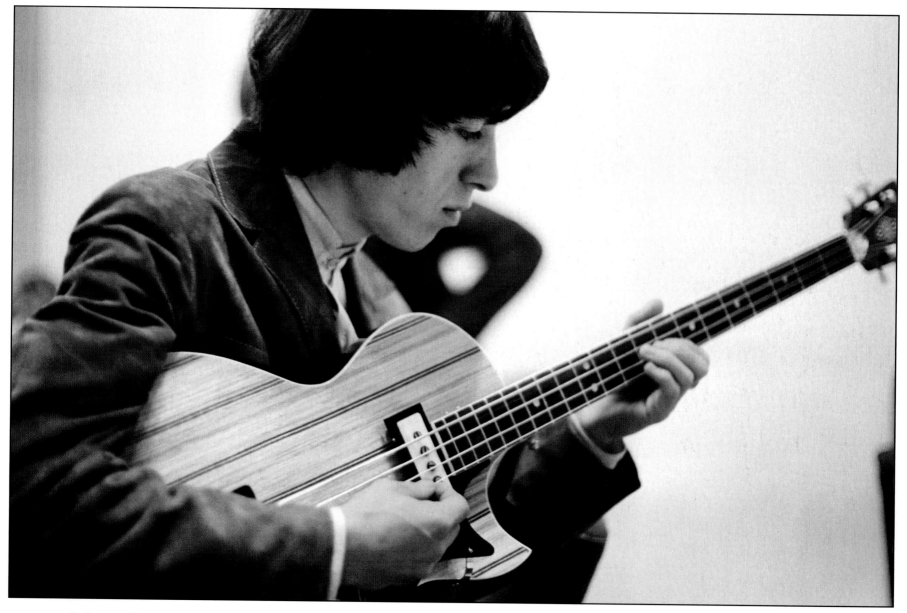

Backstage at Ernst-Merck-Halle, Hamburg, West Germany, September 13, 1965.

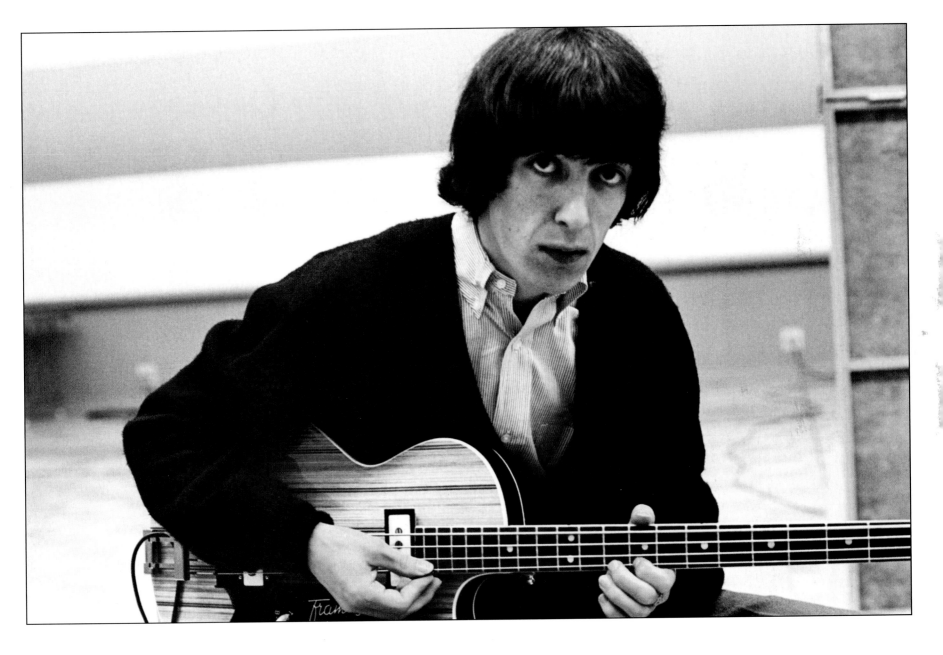

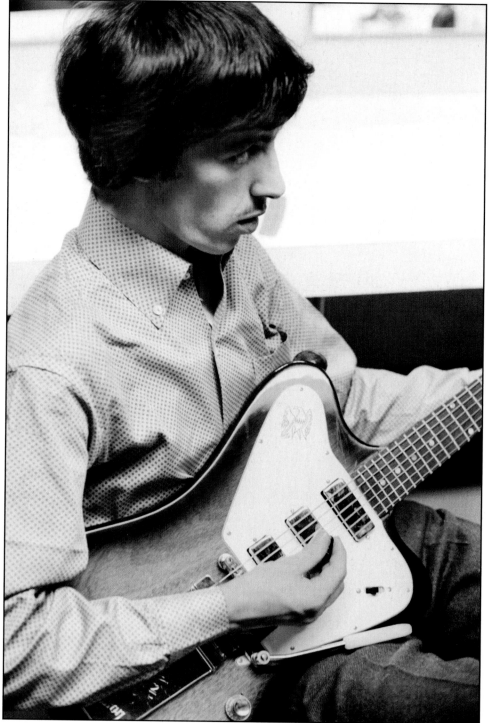

The Ed Sullivan Show dressing room, New York City, September 11, 1966. Bill is playing Brian's Gibson Firebird VII nonreverse guitar that Brian used on the show that night.

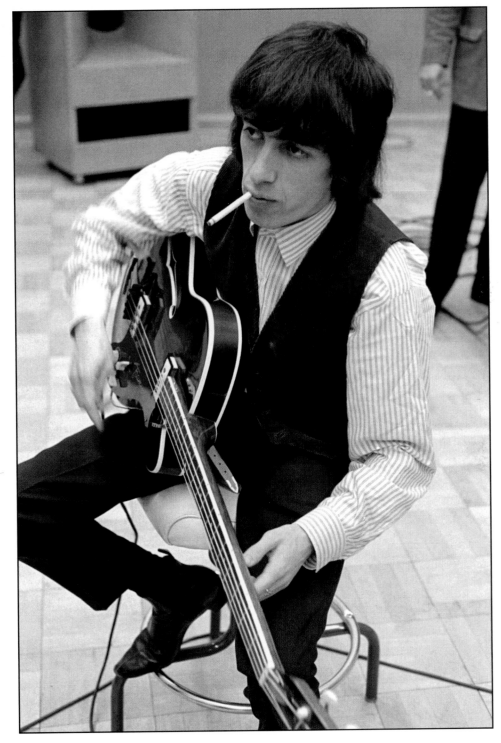

RCA Studios, Hollywood, California, September 6–7, 1965.

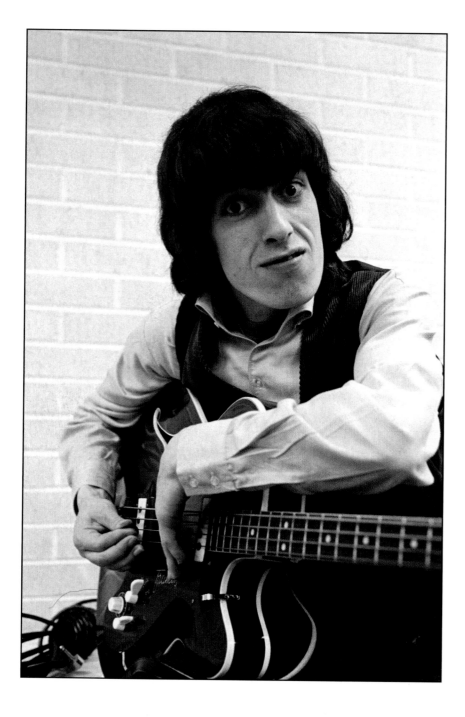

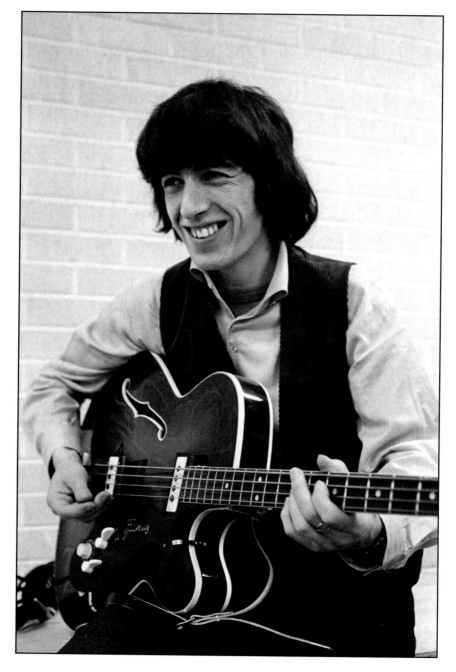

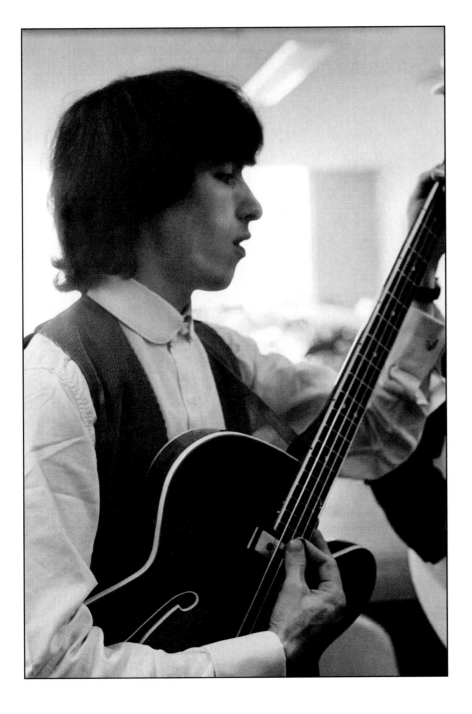

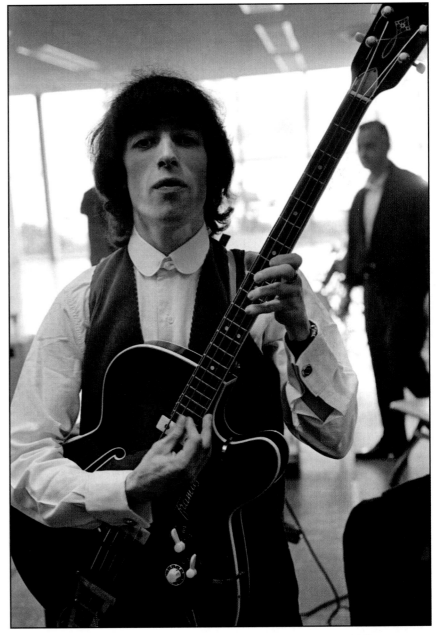

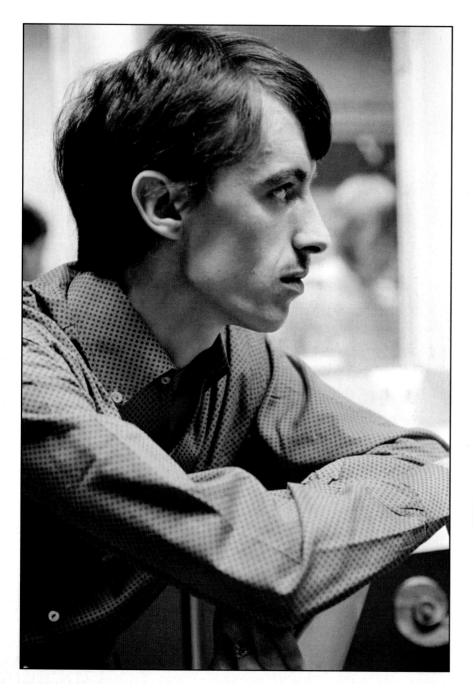

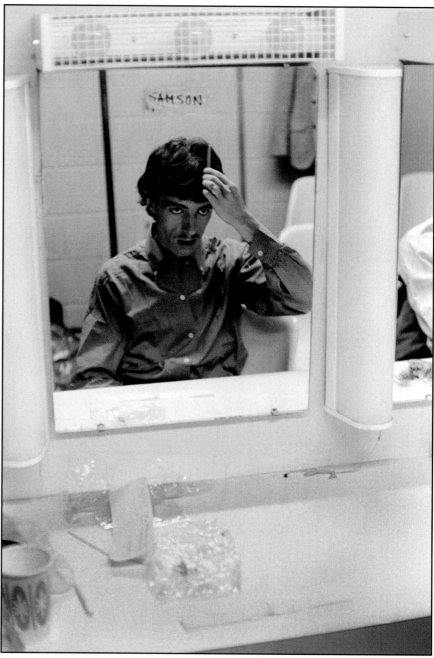

The Ed Sullivan Show dressing room, September 11, 1966.

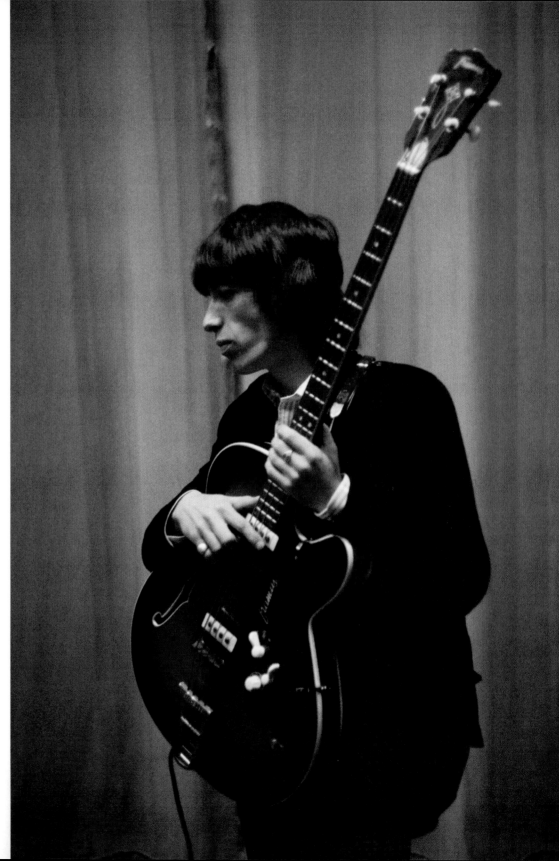

Sacramento Memorial Auditorium, Sacramento, California,
October 26, 1964.

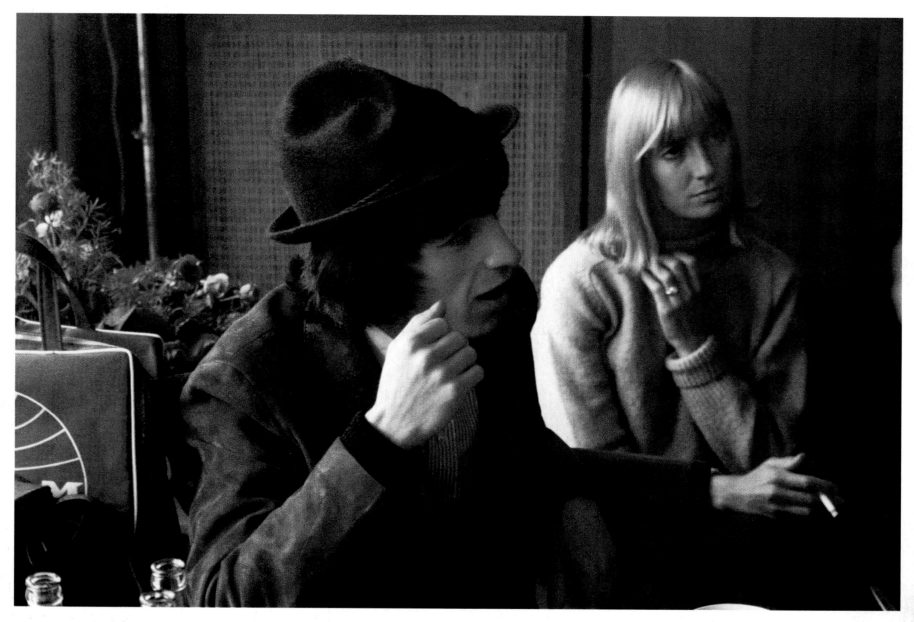

Munich, West Germany, September 14, 1965.

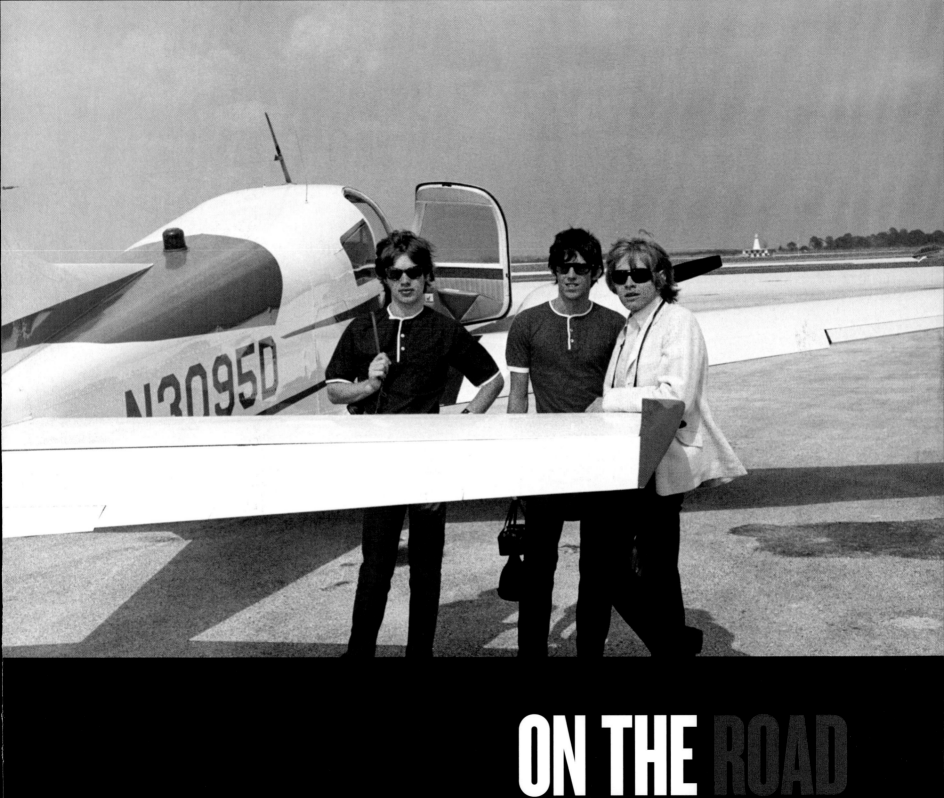

ON THE ROAD

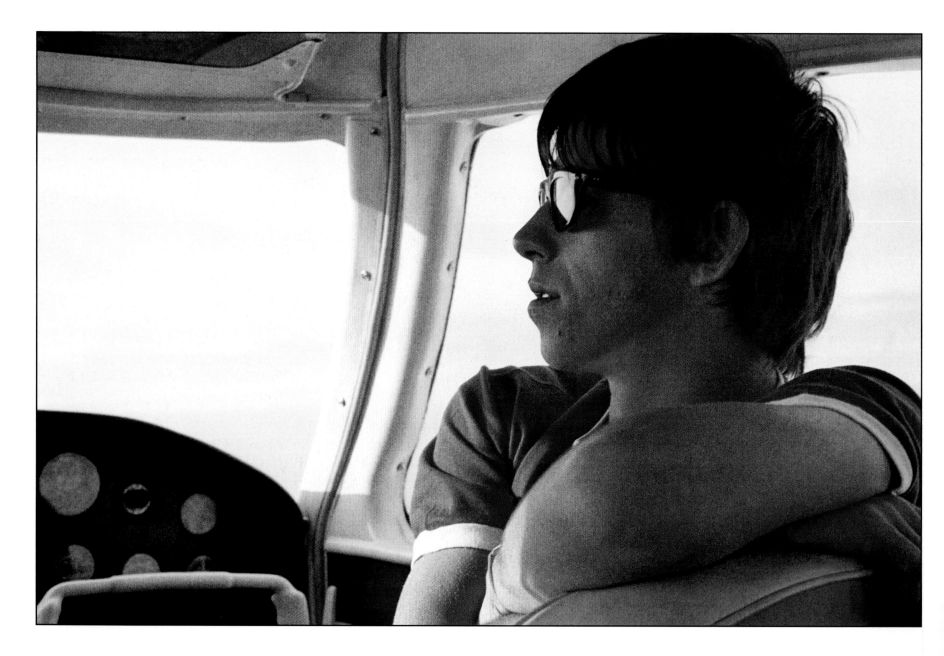

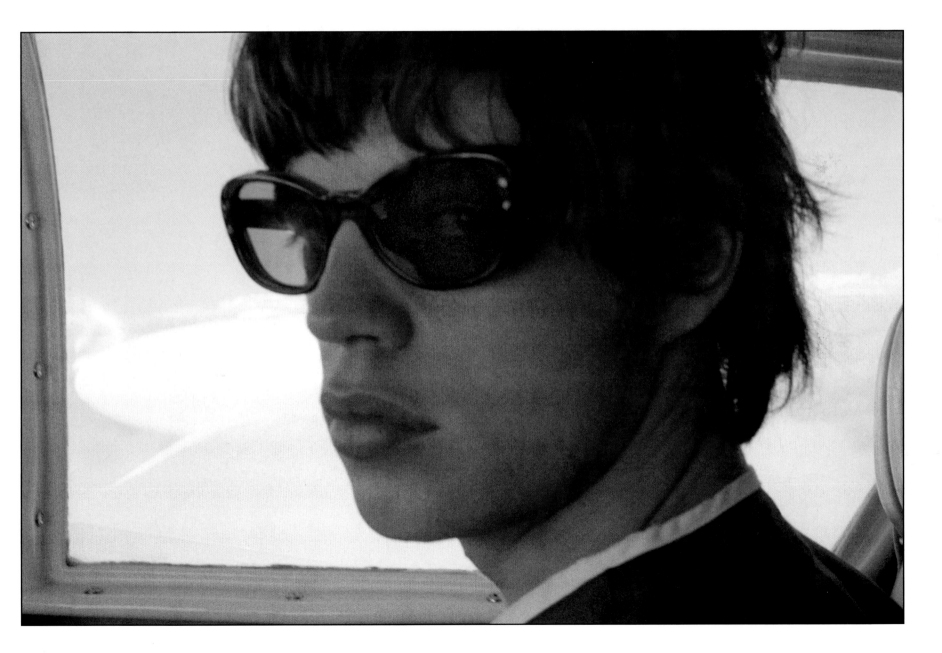

In stark comparison to how they travel in recent years with a convoy of semis and private planes, this is how The Rolling Stones toured the United States in 1964.

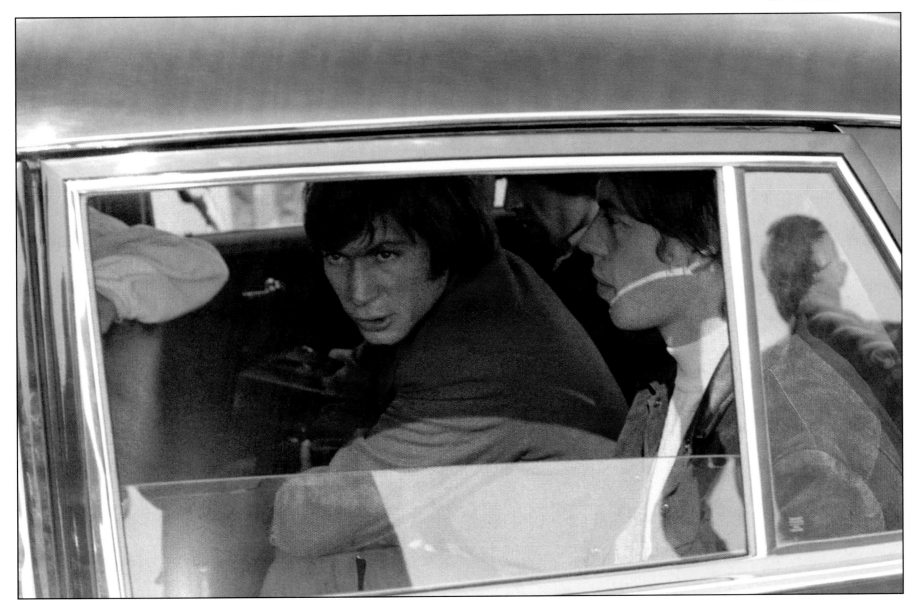

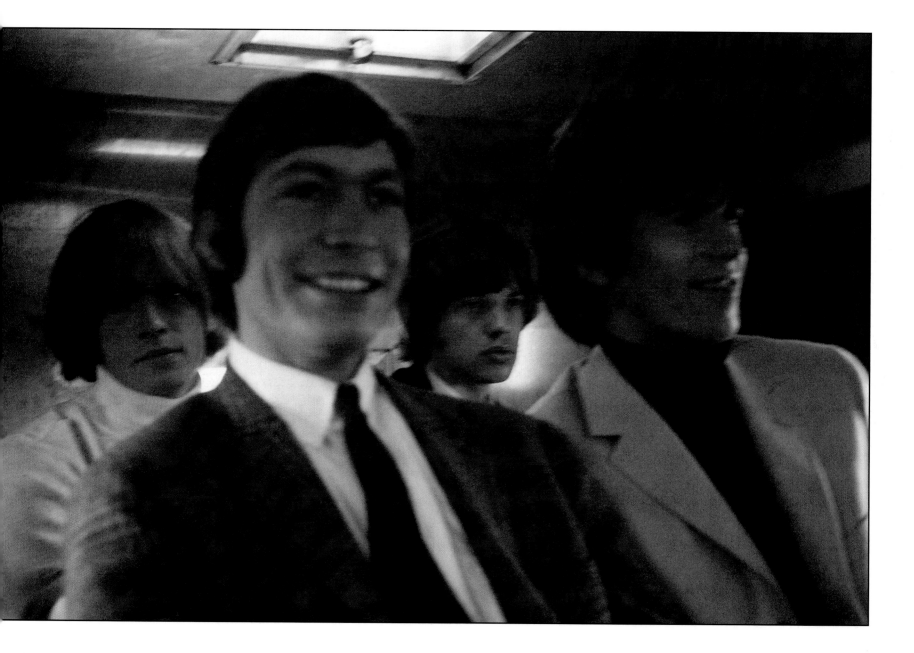

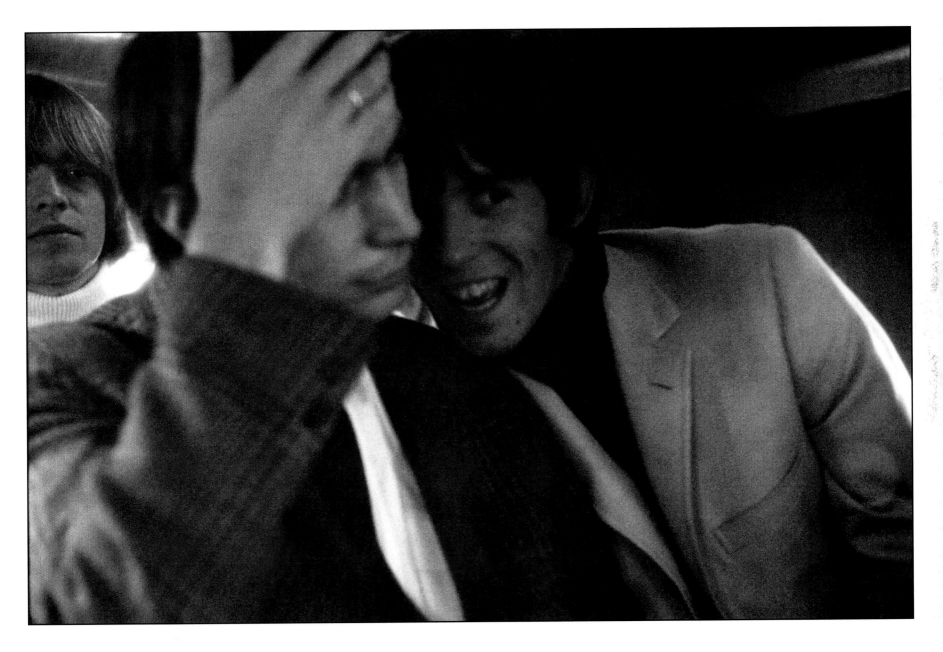

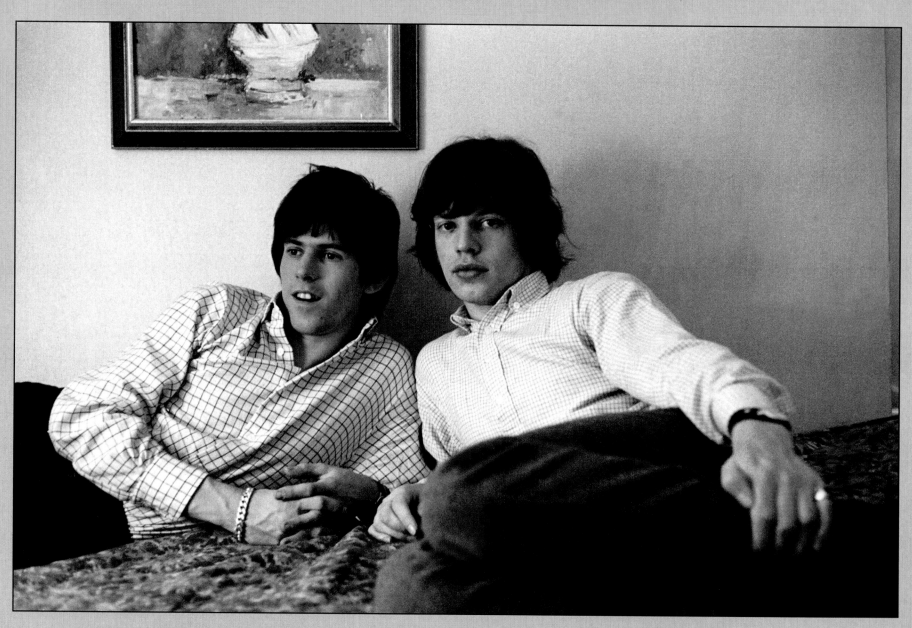

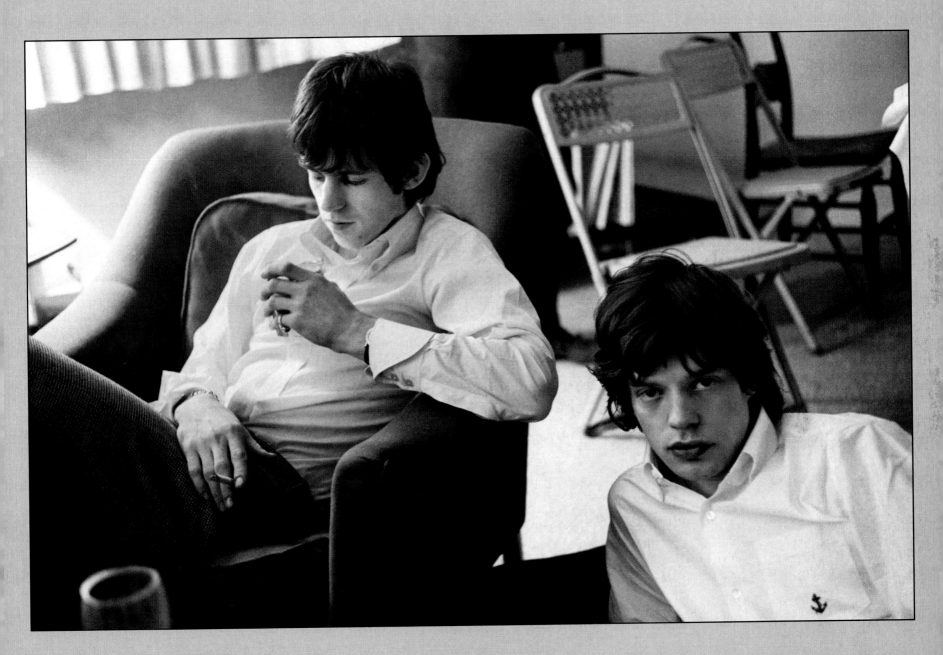

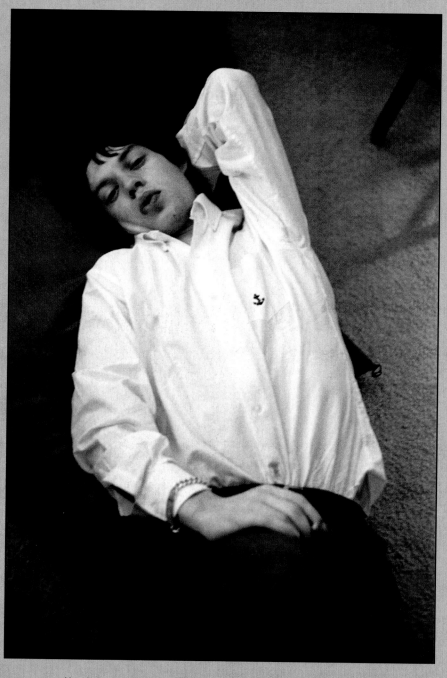

Hotel room, November 1964.

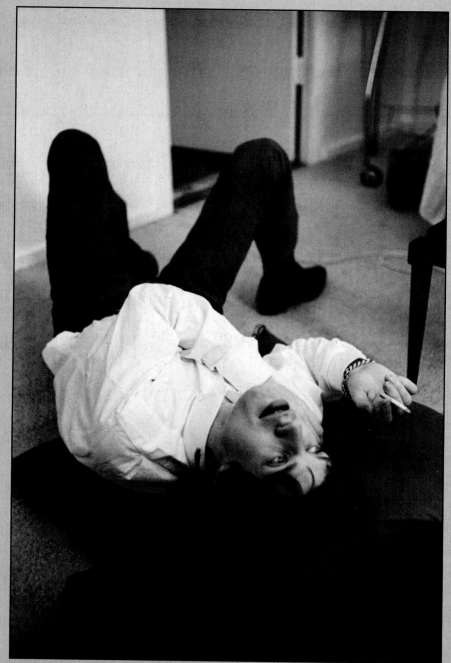

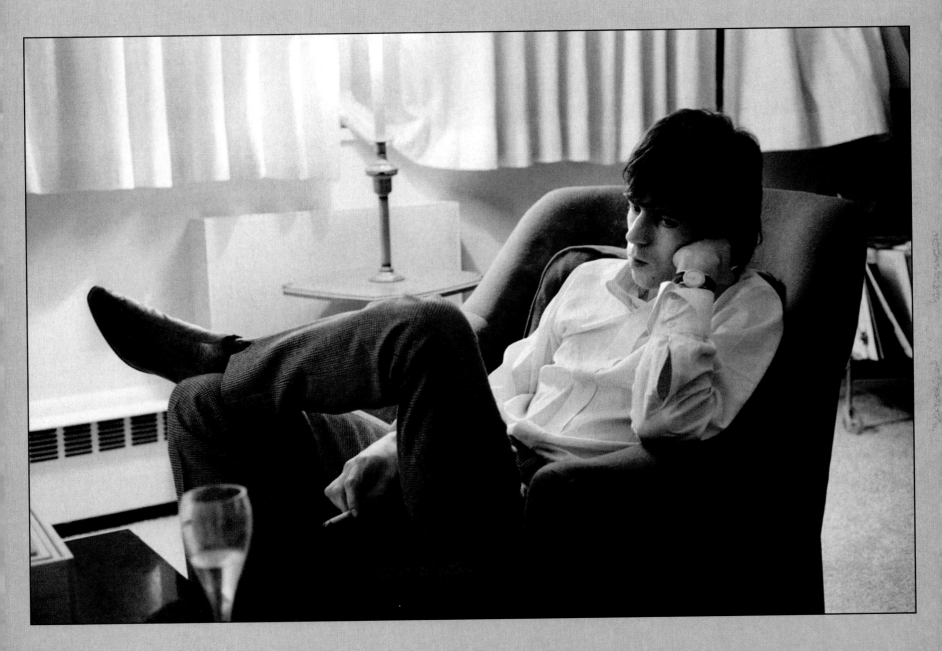

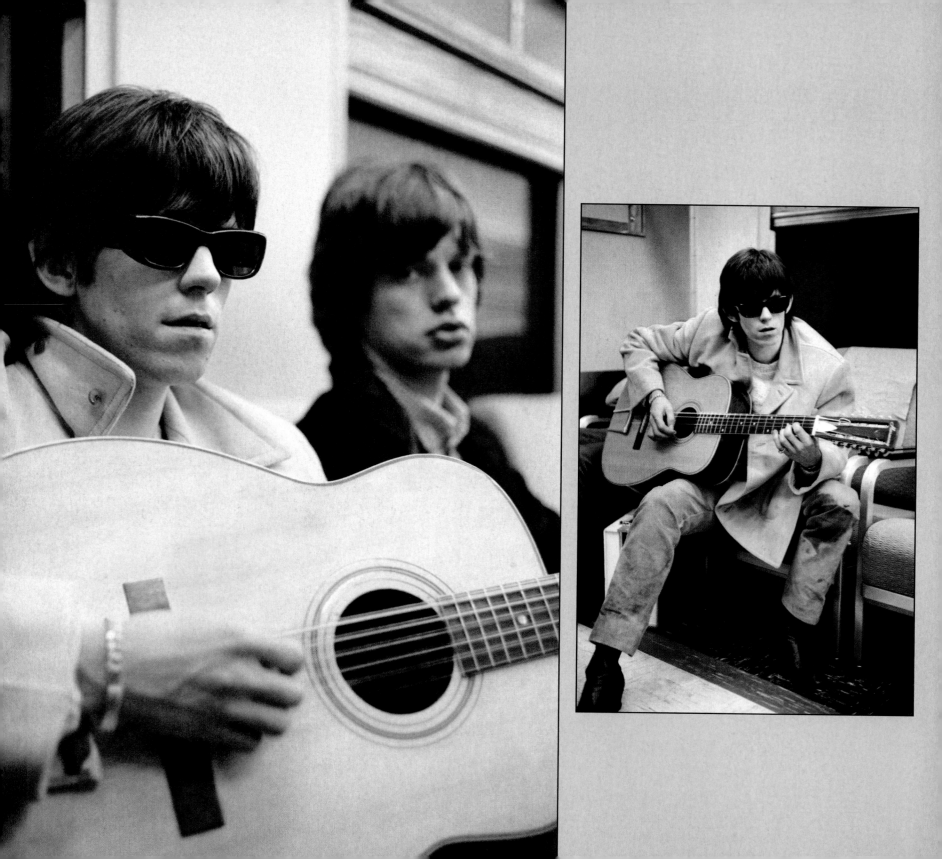

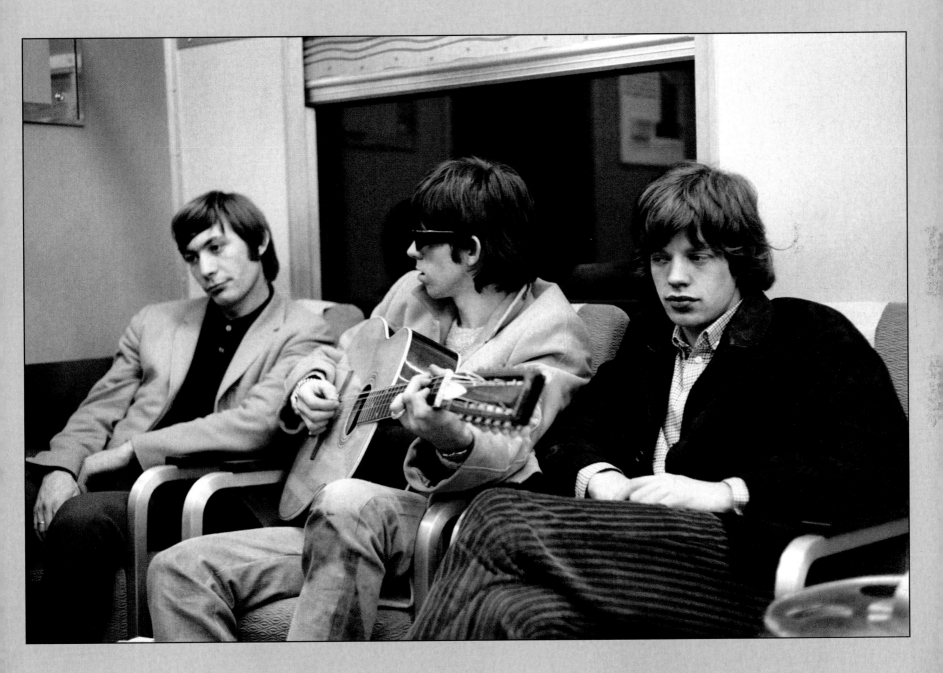

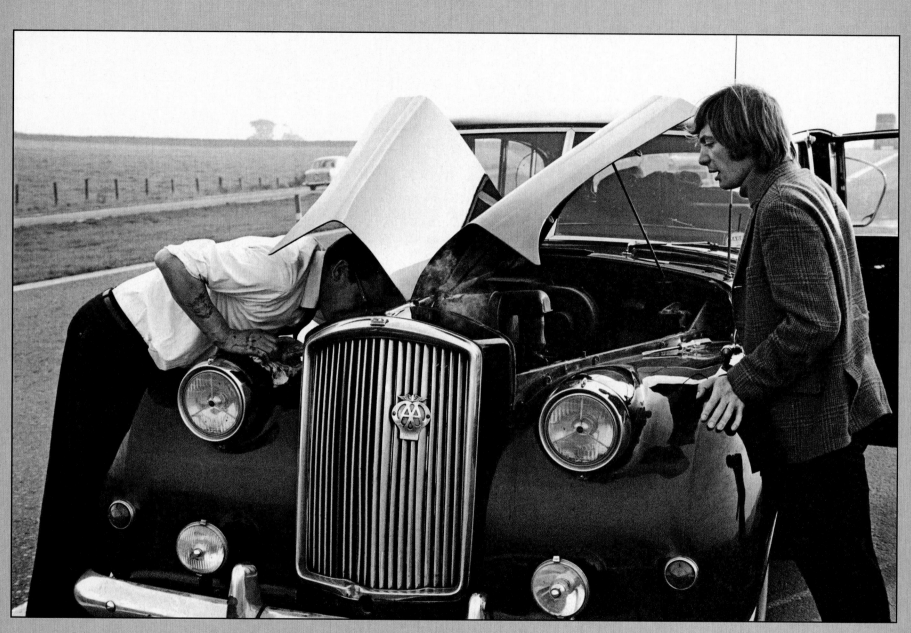

Bob visited and traveled with The Stones briefly in England in 1965. On this particular day the vehicle they had hired broke down on the M1 en route to a show. The boys entertained themselves roadside while the chauffeur fixed the car and Bob took photos.

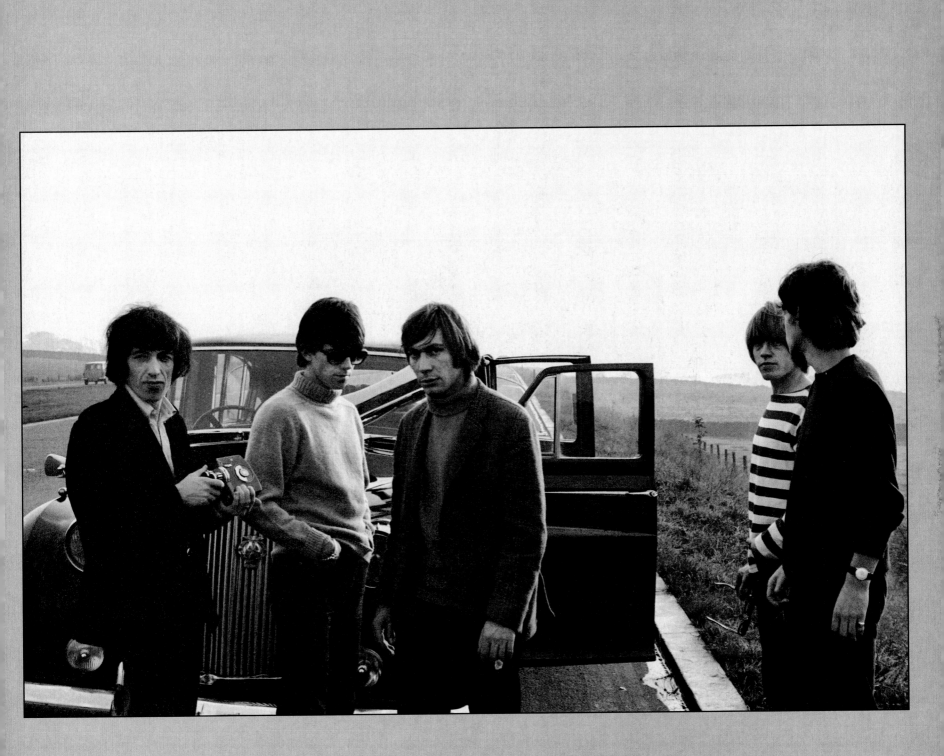

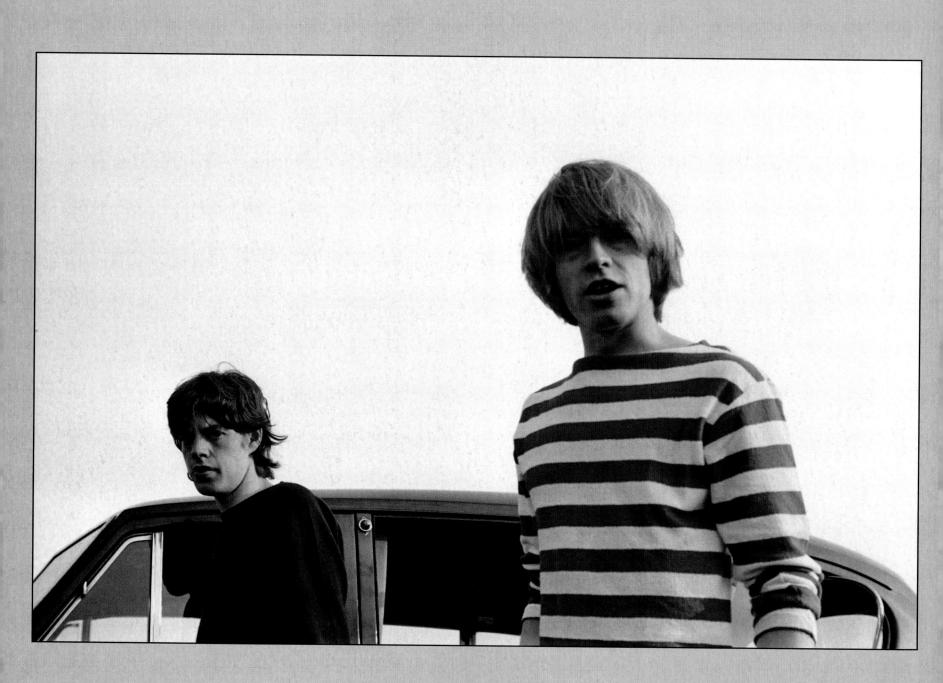

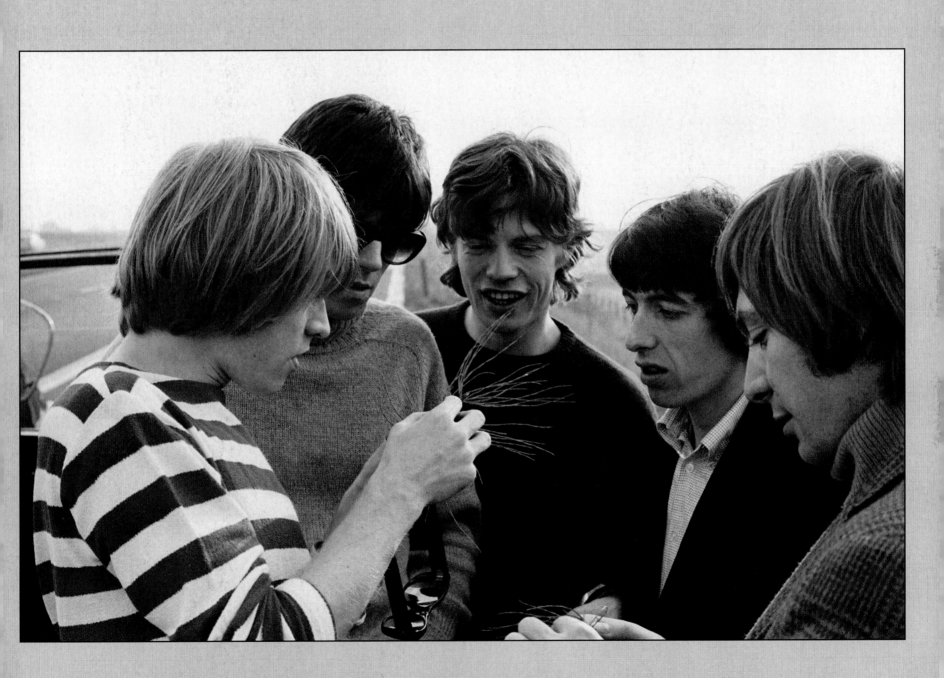

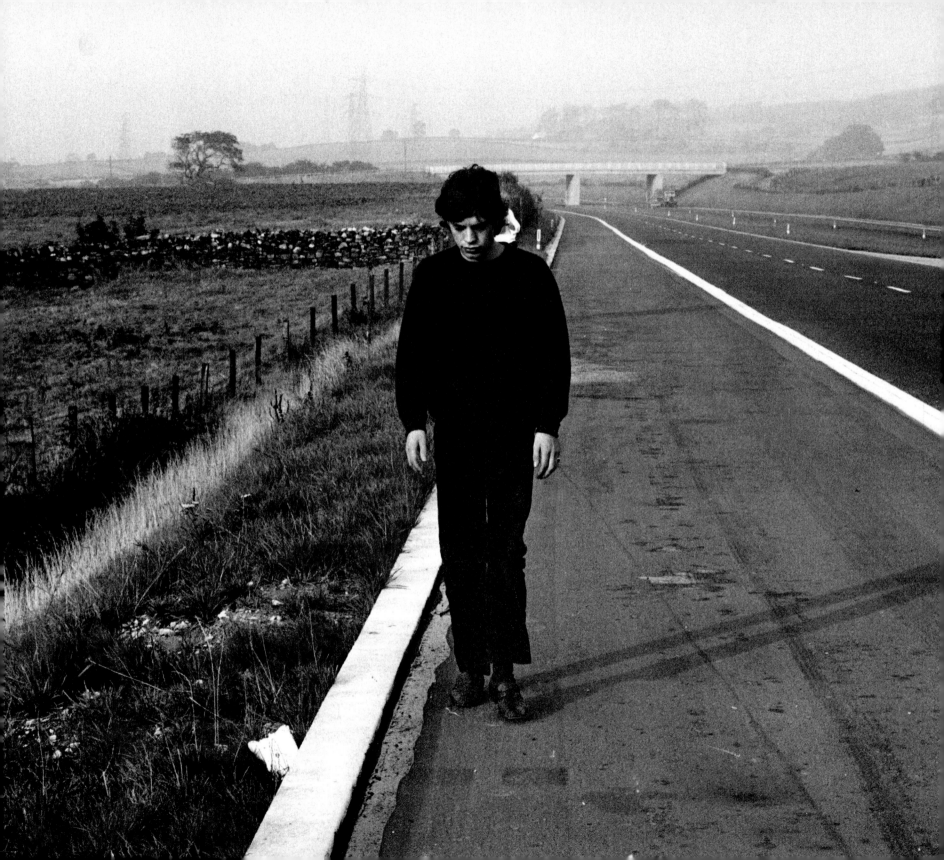

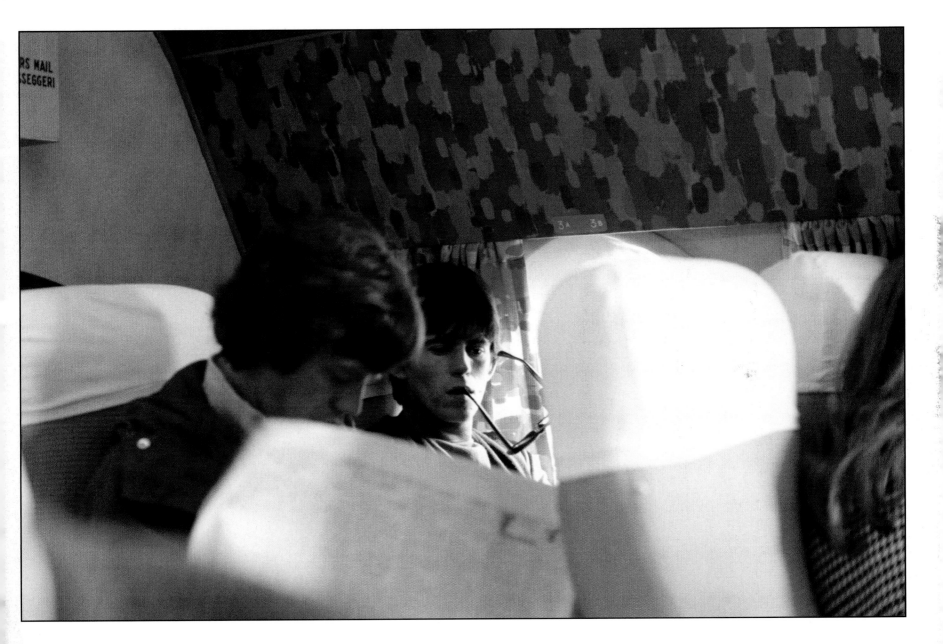

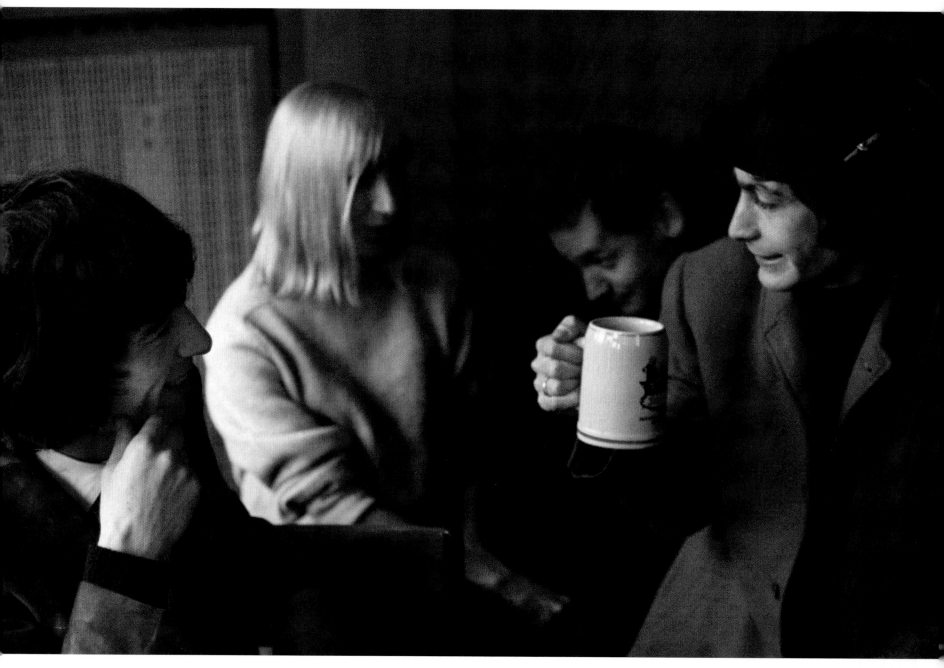

Munich, West Germany, September 14, 1965.

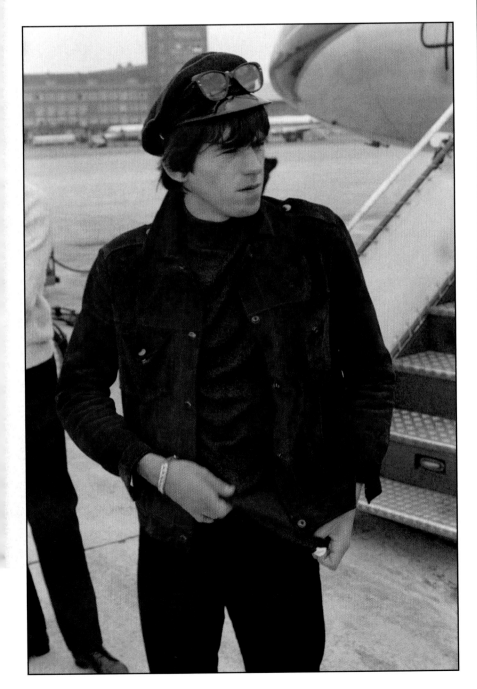

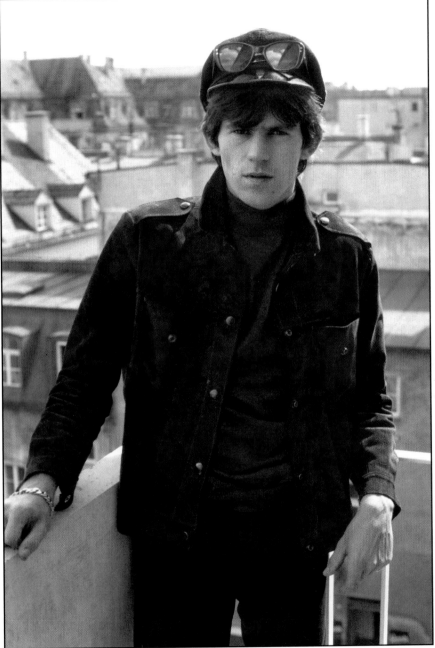

223

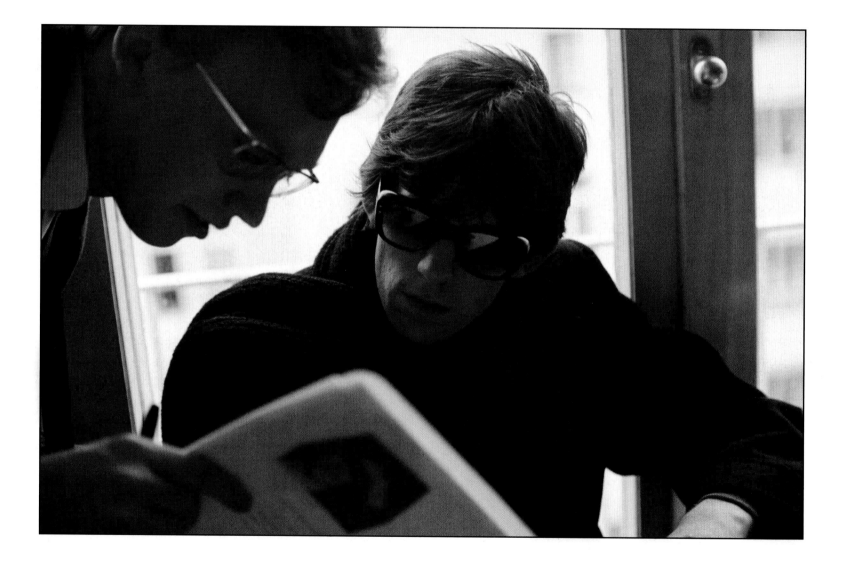

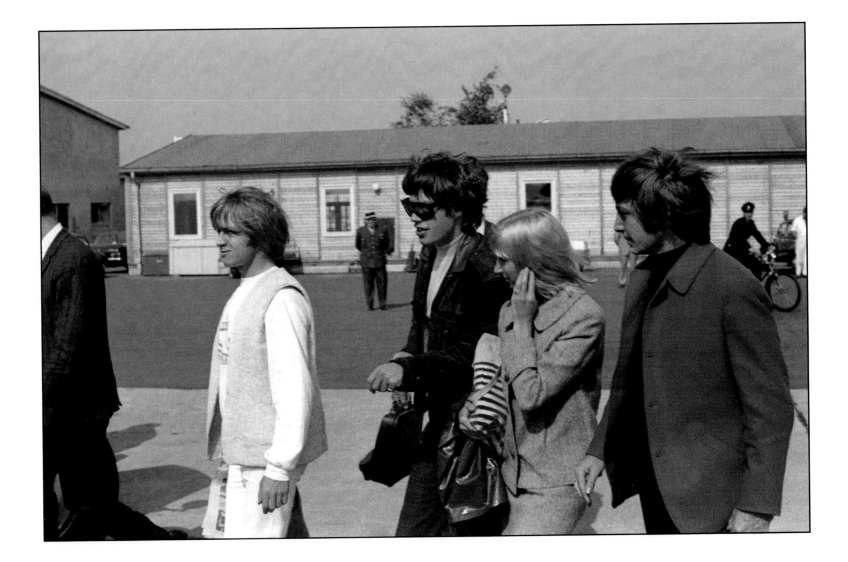

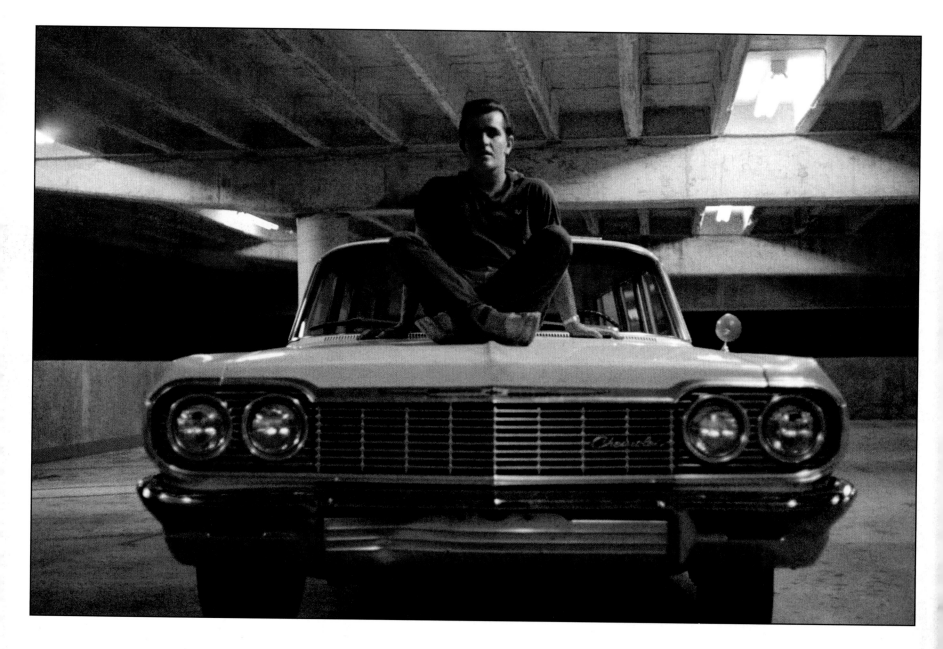

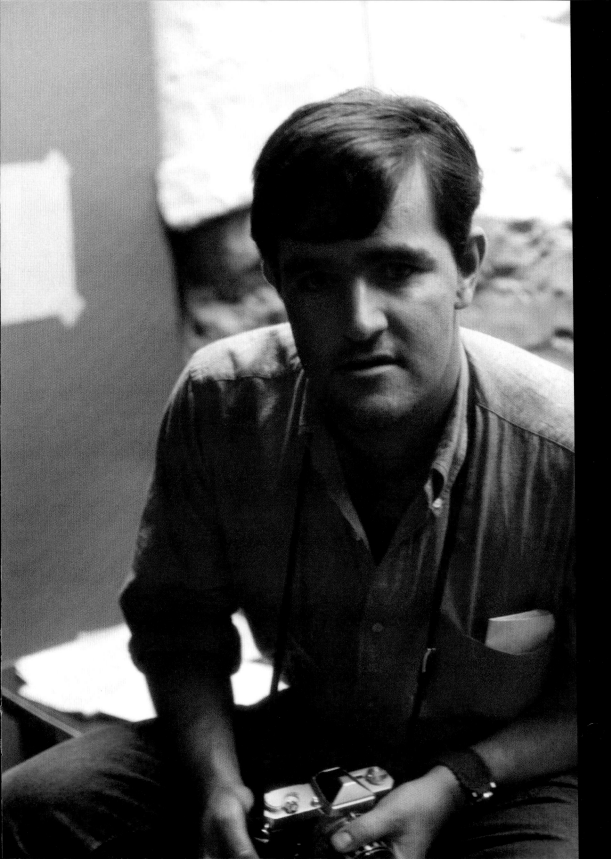

IAN "STU"
STEWART

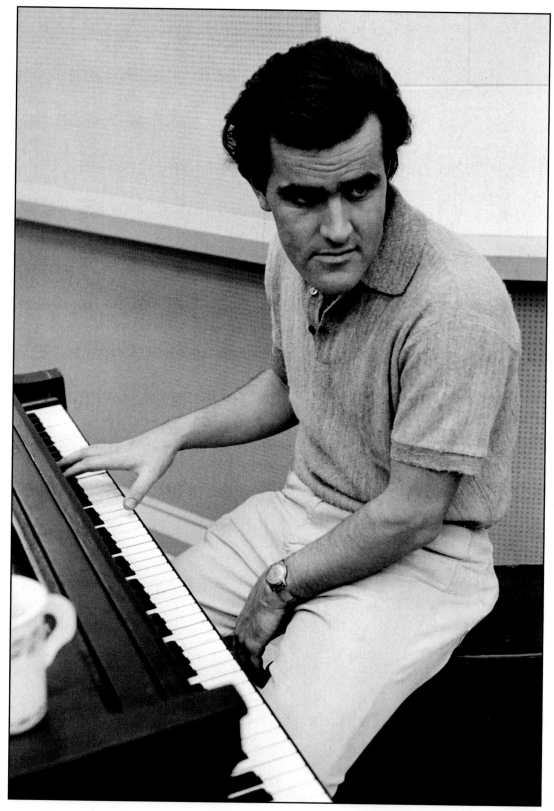

RCA Studios, Hollywood, California,
September 6–7, 1965.

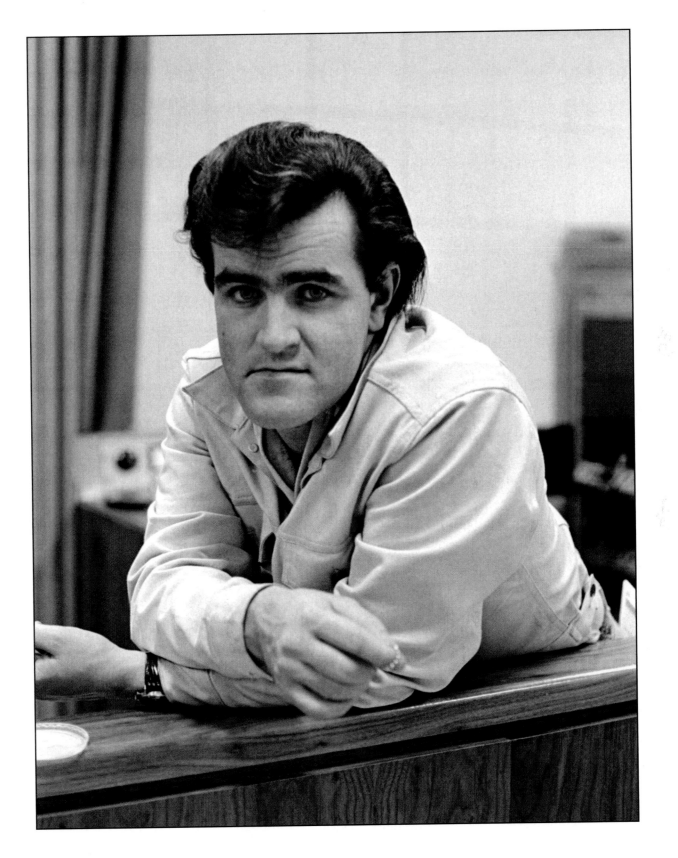

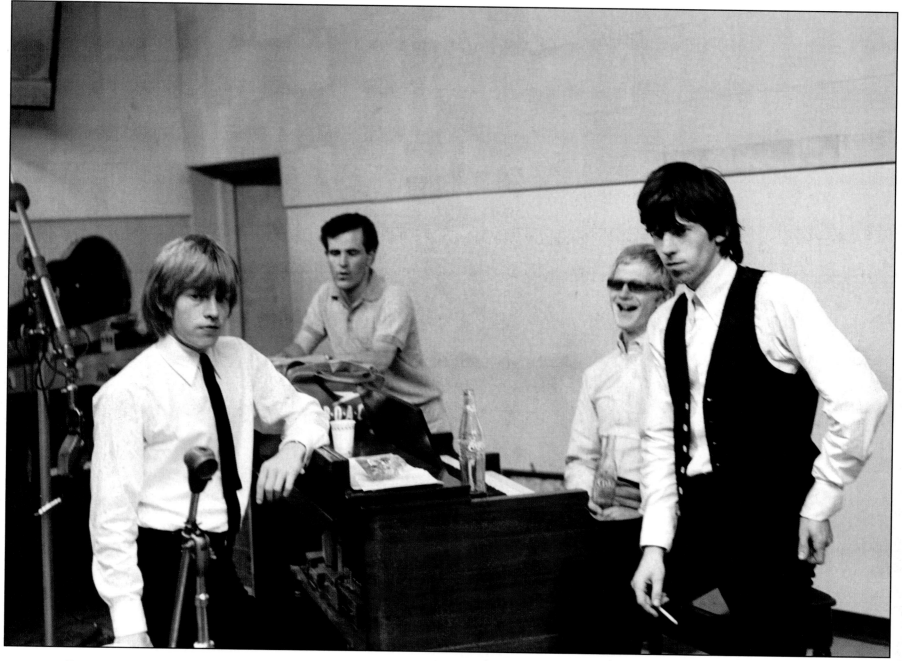

Chess Studios, Chicago, Illinois, June 1964.

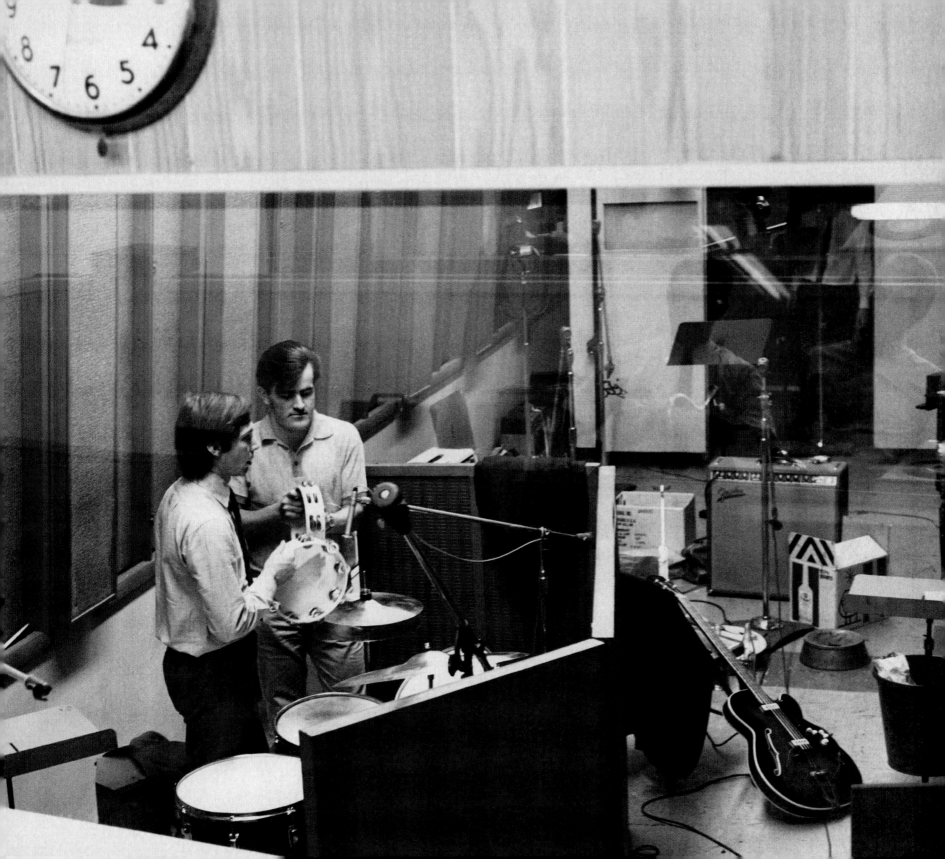

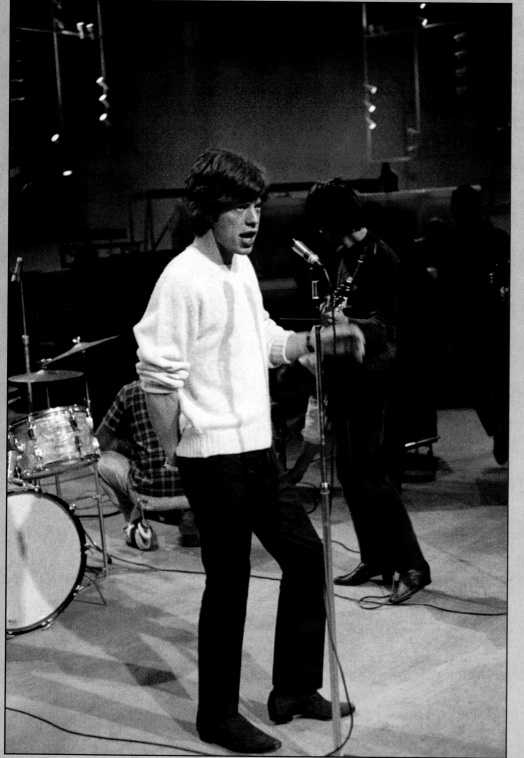
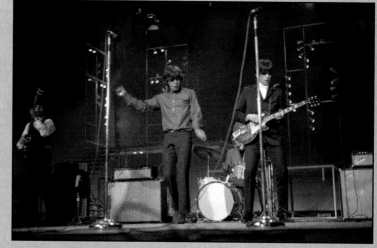
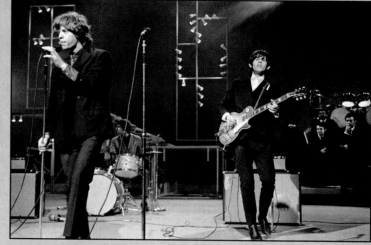
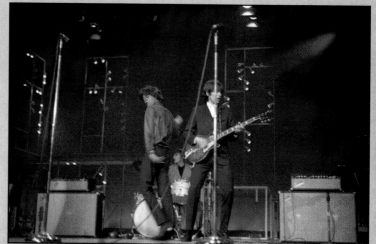

TELEVISION AND MOVIES

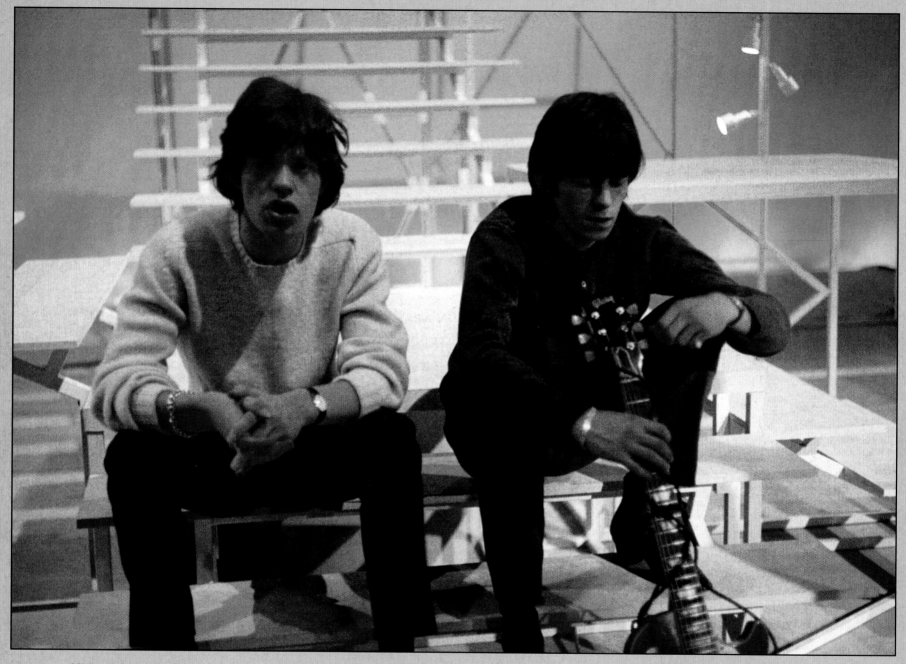

Mick and Keith take a break during *The T.A.M.I. Show* rehearsal.

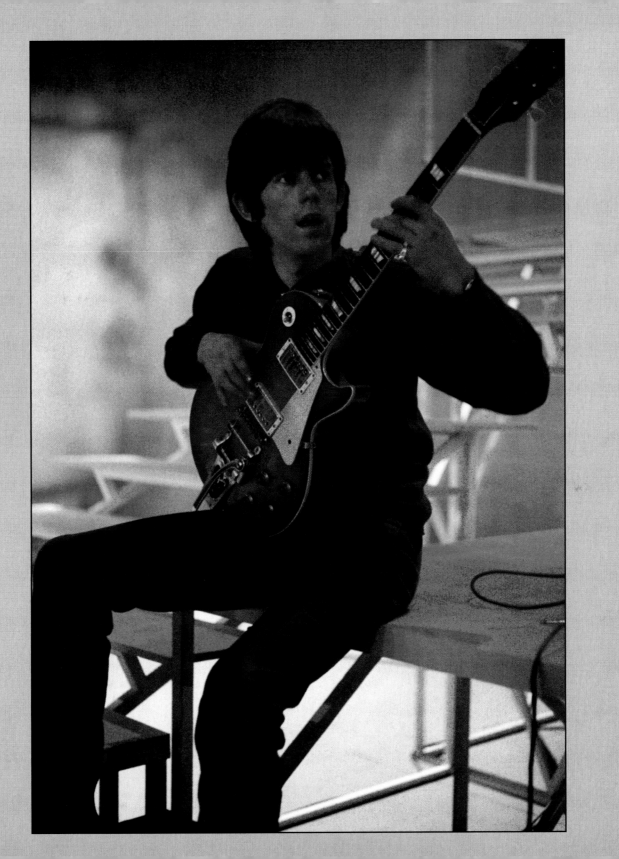

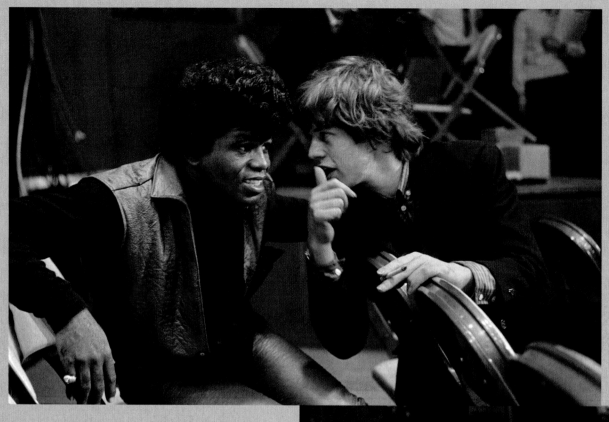

Mick, Keith, and Brian with James Brown
backstage at *The T.A.M.I. Show.*

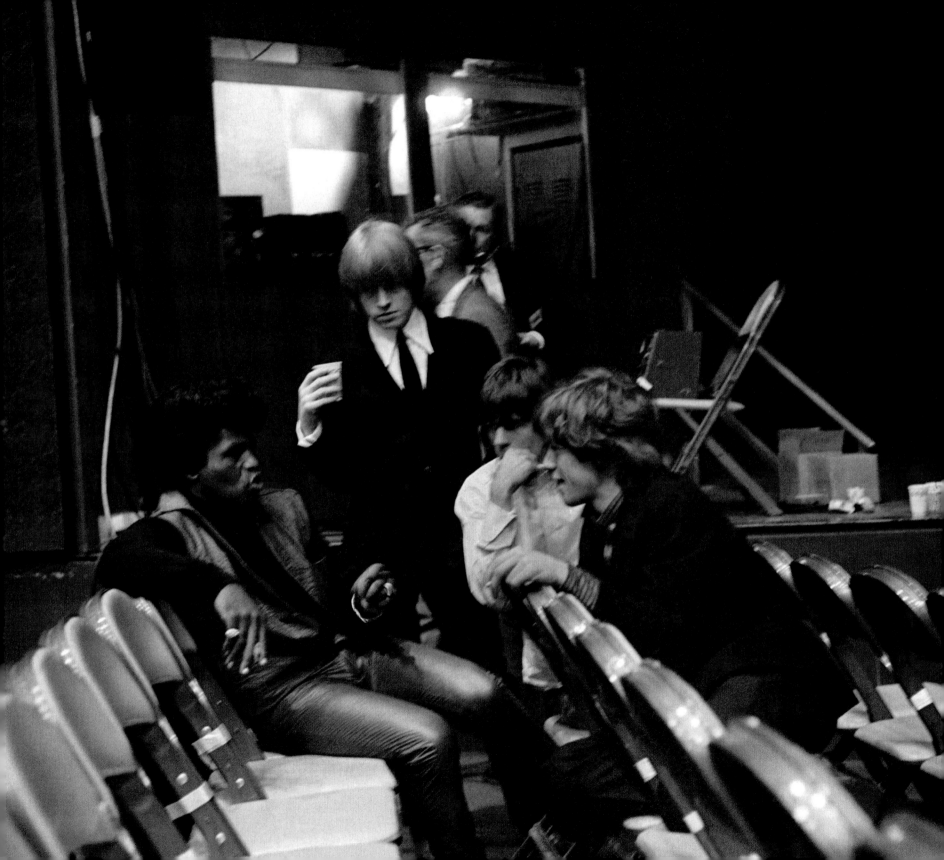

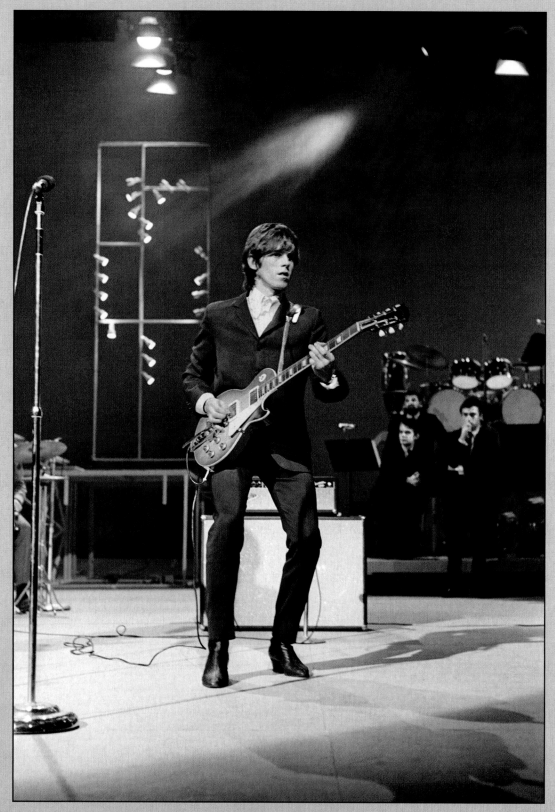

Keith performs
"Around and Around."

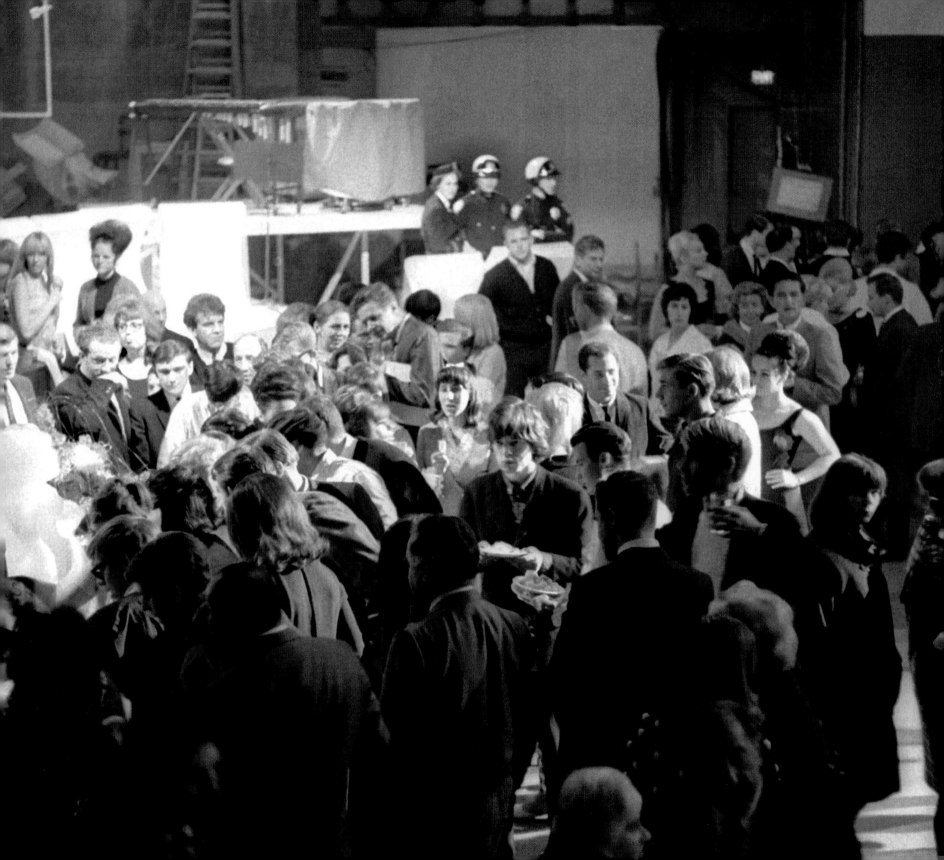

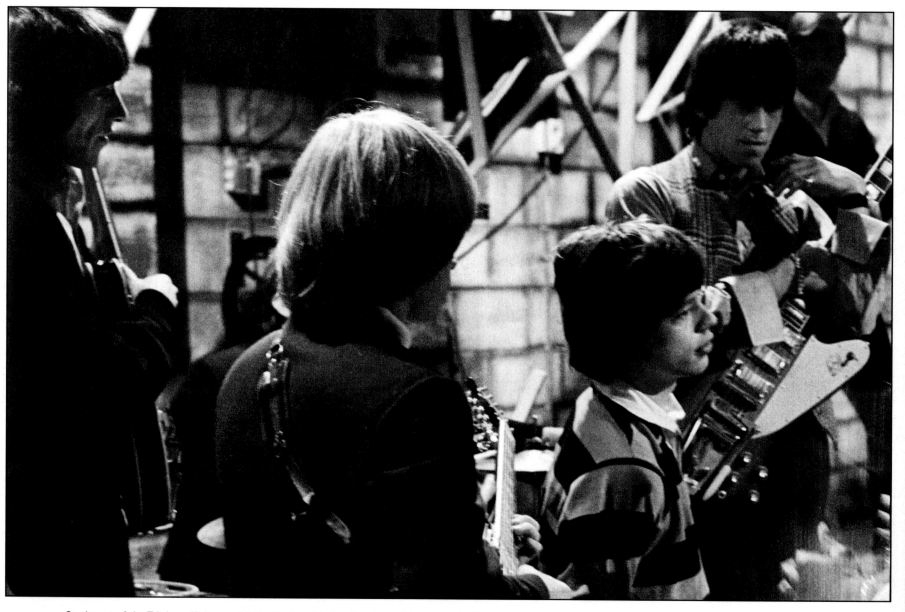

On the set of the TV show *Hollywood A Go-Go*, taped in Los Angeles on May 15, 1965. The Stones lip-synched "The Last Time," "Oh Baby (We Got a Good Thing Goin')," and "Play with Fire."

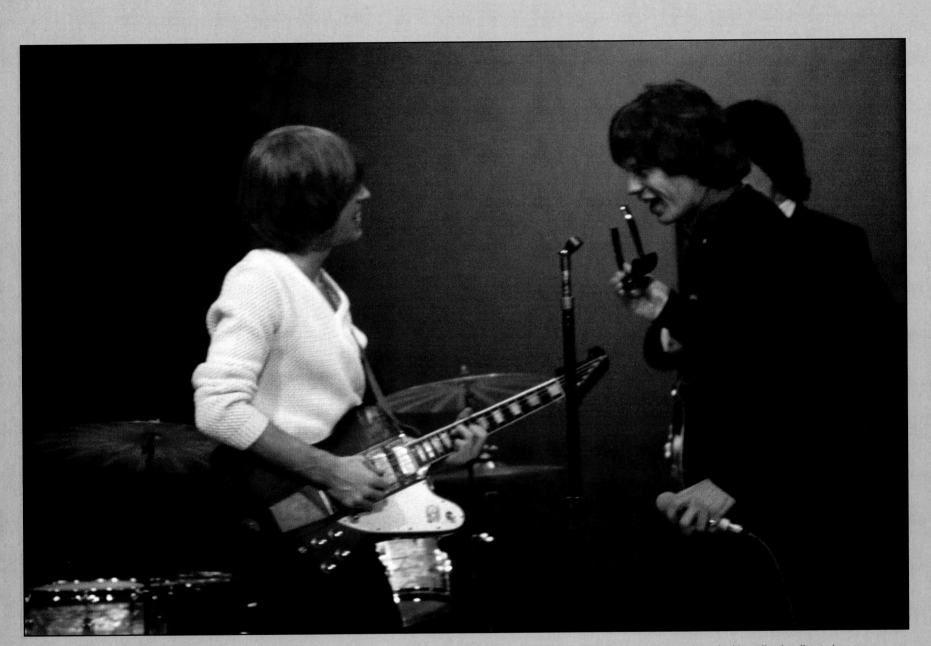

During The Stones' fourth North American tour they appeared on the NBC television show *Hullabaloo*, directed by Steve Binder, who coincidentally also directed *The T.A.M.I. Show*. Filmed in New York on November 11, 1965, and televised on November 15, The Stones performed two songs ("She Said Yeah" and "Get Off My Cloud") featuring live vocals over prerecorded backing tracks. Footage from the unreleased documentary *Charlie Is My Darling* was also shown overdubbed with the song "(I Can't Get No) Satisfaction" as performed by the *Hullabaloo* orchestra. *Charlie Is My Darling* is a documentary on The Stones touring in Ireland in 1965.

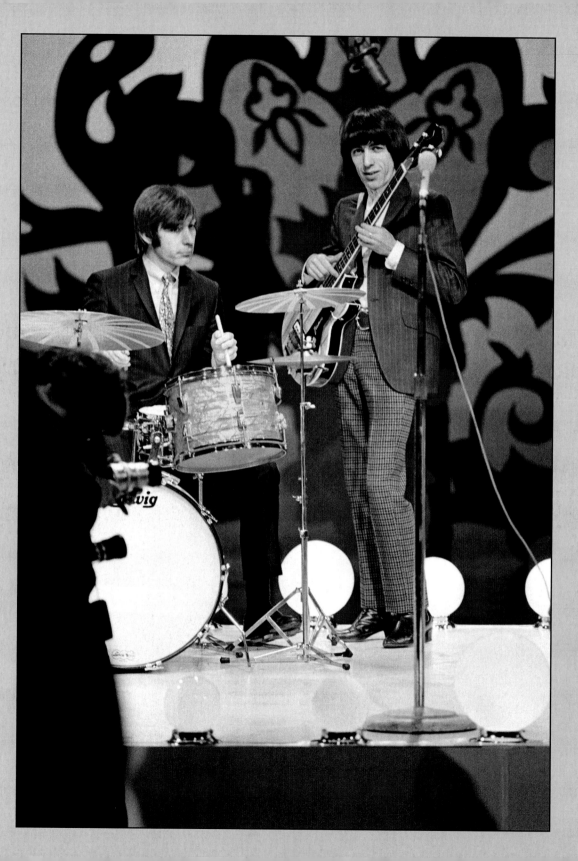

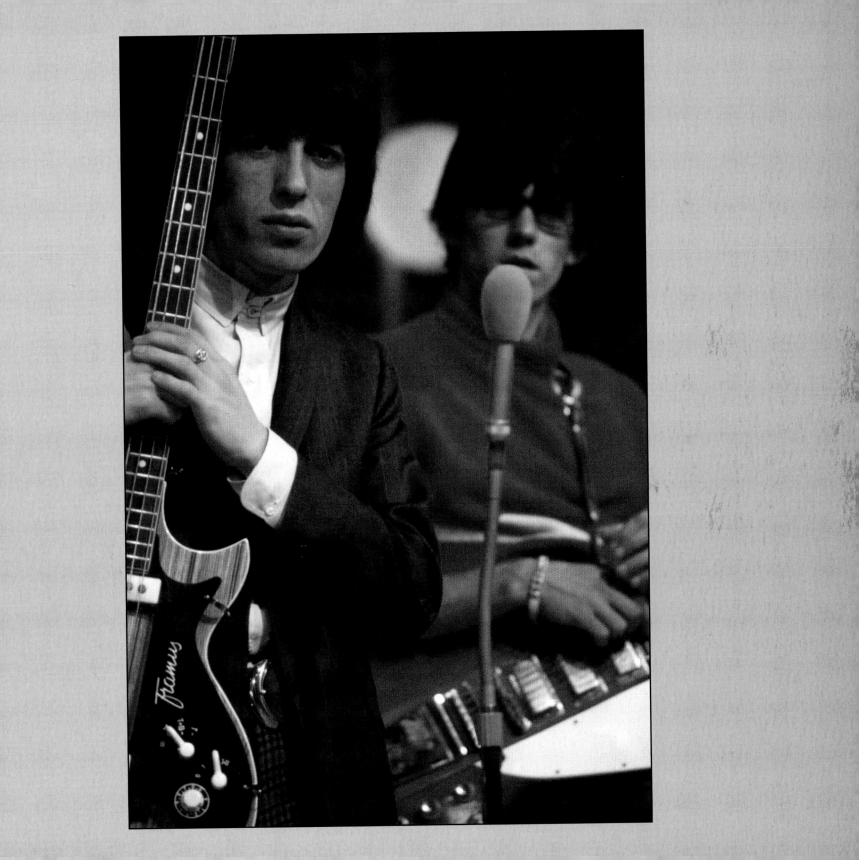

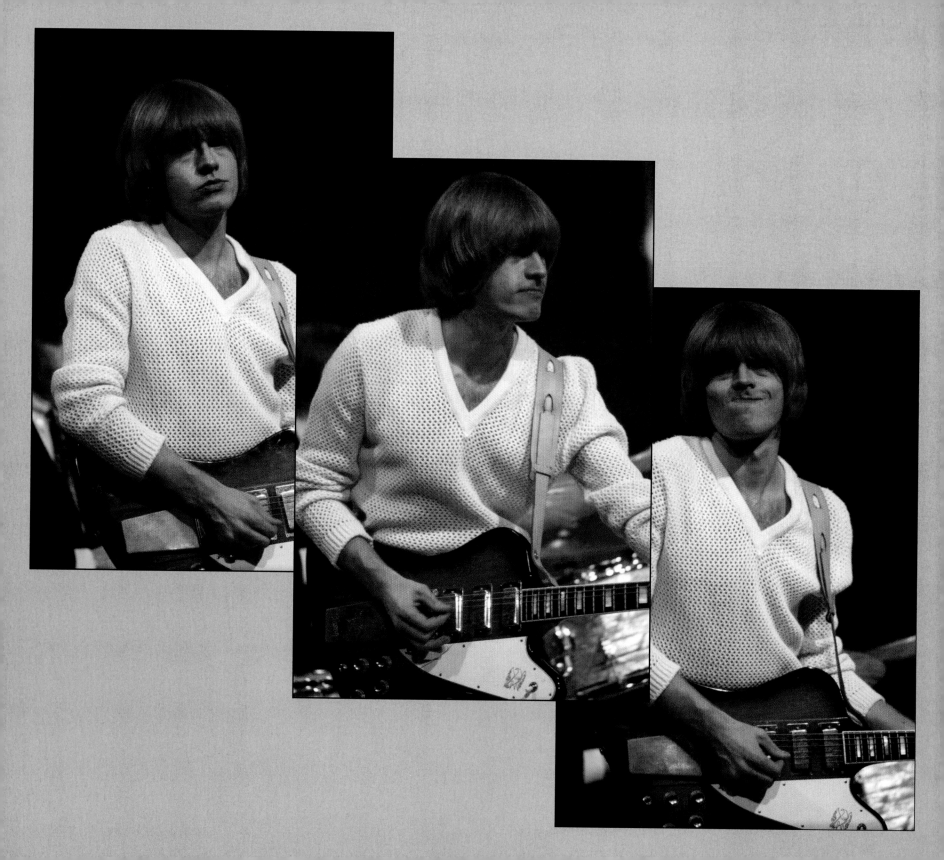

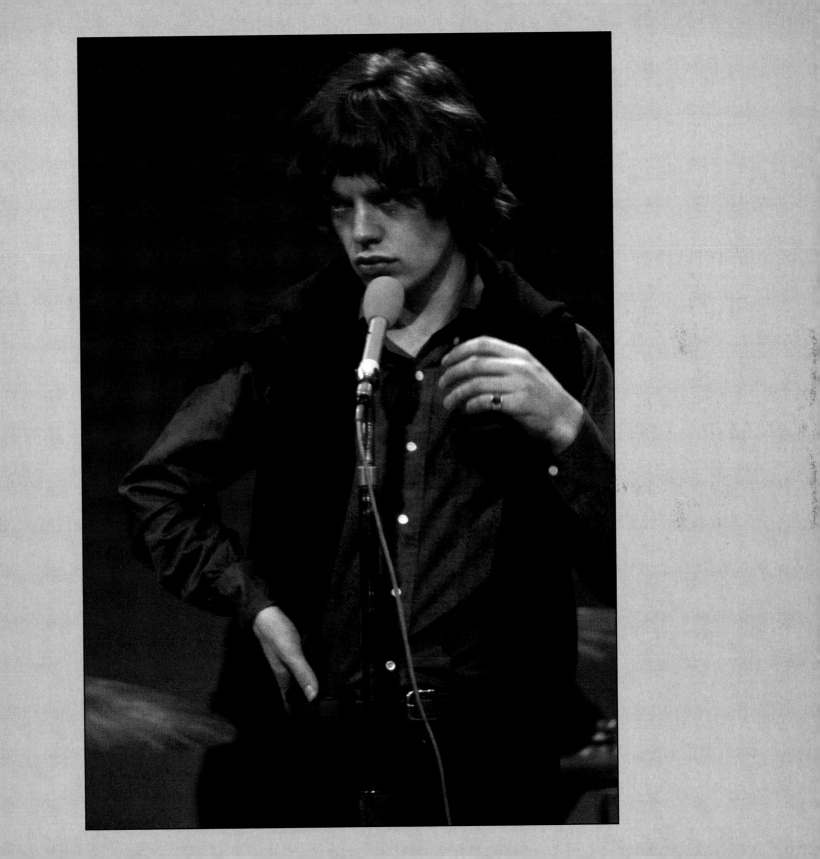

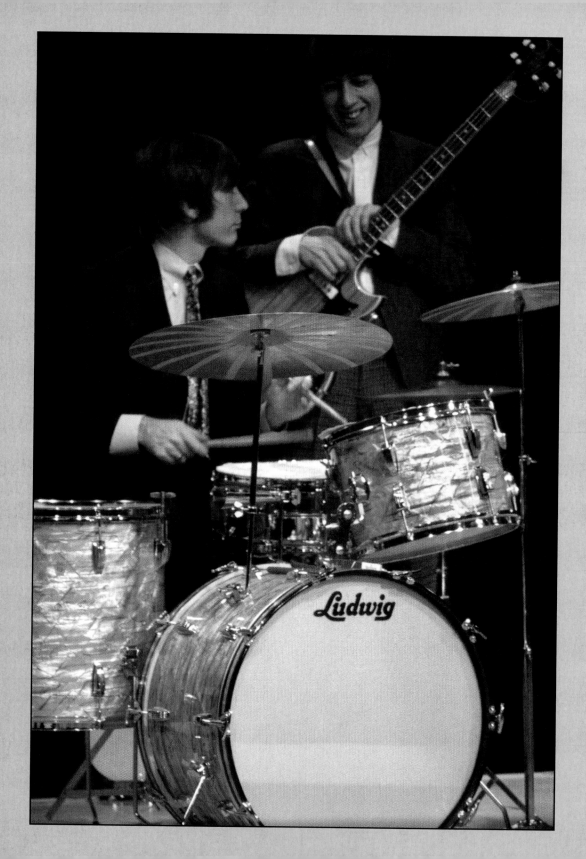

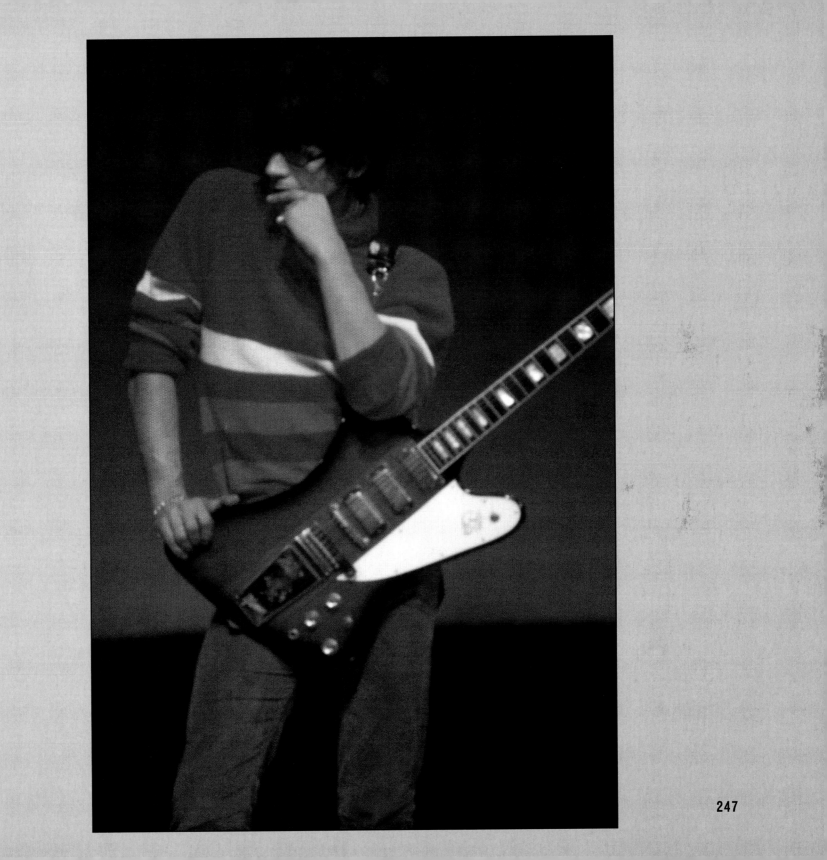

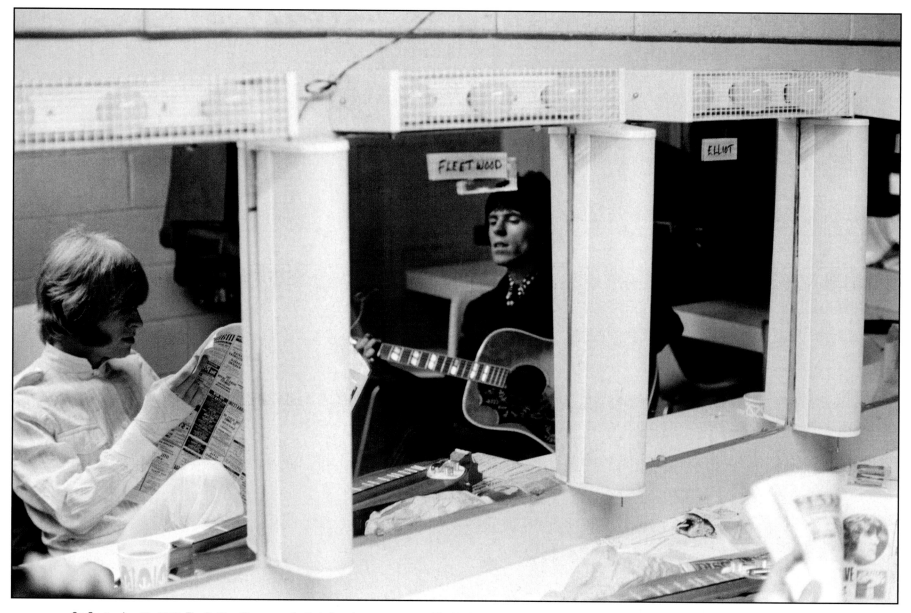

On September 11, 1966, The Rolling Stones made their fourth appearance on *The Ed Sullivan Show*. Shortly before this appearance Brian fractured his hand. Brian said that he slipped in the bathroom but according to antique dealer Christopher Gibbs, while in Morocco with then girlfriend Anita Pallenberg, Brian took a swing at her, missed, and hit the metal frame of a window. The injury meant that Brian was not able to perform the songs live that were scheduled for this appearance, so in a rare occurrence for *The Ed Sullivan Show*, The Stones recorded the music for the three songs they were to perform a few days earlier at a studio in Brooklyn, New York, and sang live to the prerecorded backing tracks on the show. Here, Keith is rehearsing "Lady Jane" on his Gibson Hummingbird guitar.

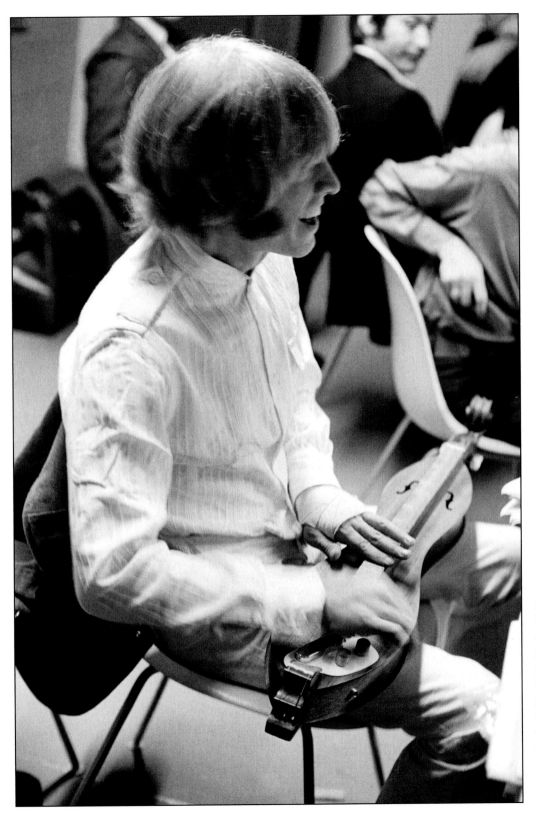

One of Brian's strong points was his ability to play a wide variety of instruments including sitar, autoharp, marimba, tamboura, mellotron, recorder, harmonica, keyboards, and guitar. Here he is seen rehearsing the song "Lady Jane" on his Vox Bijou electric dulcimer that was custom-built for him by Tony Diamond of Jennings Musical Instruments in England.

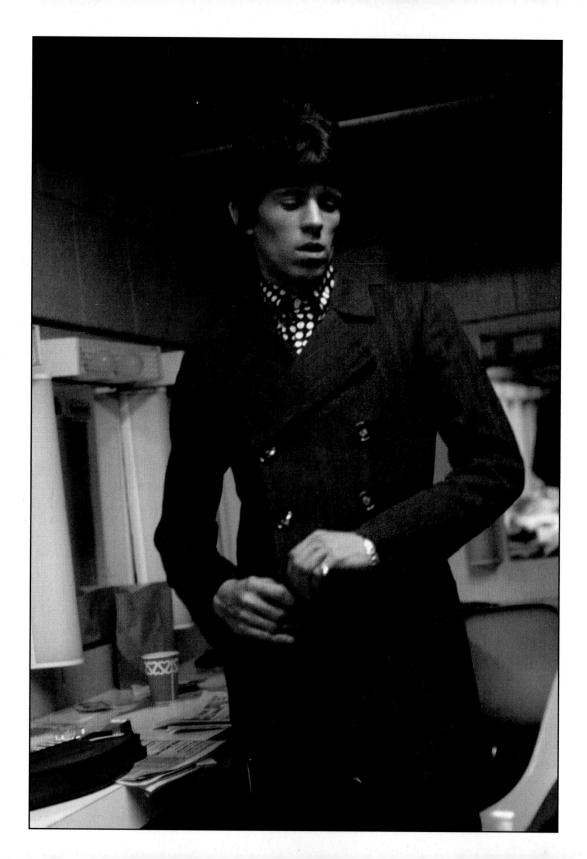

250

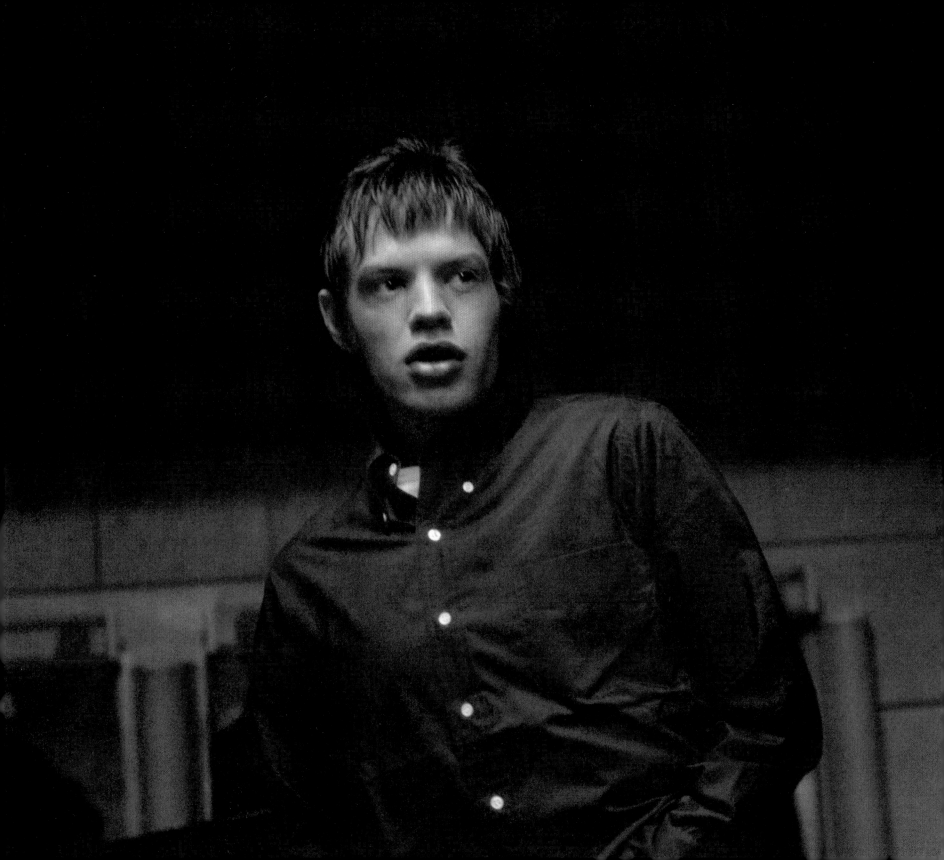

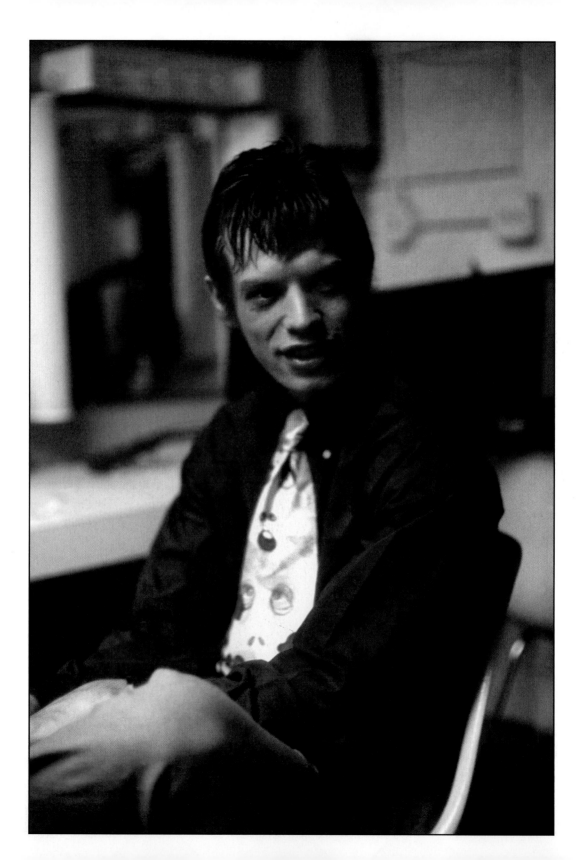

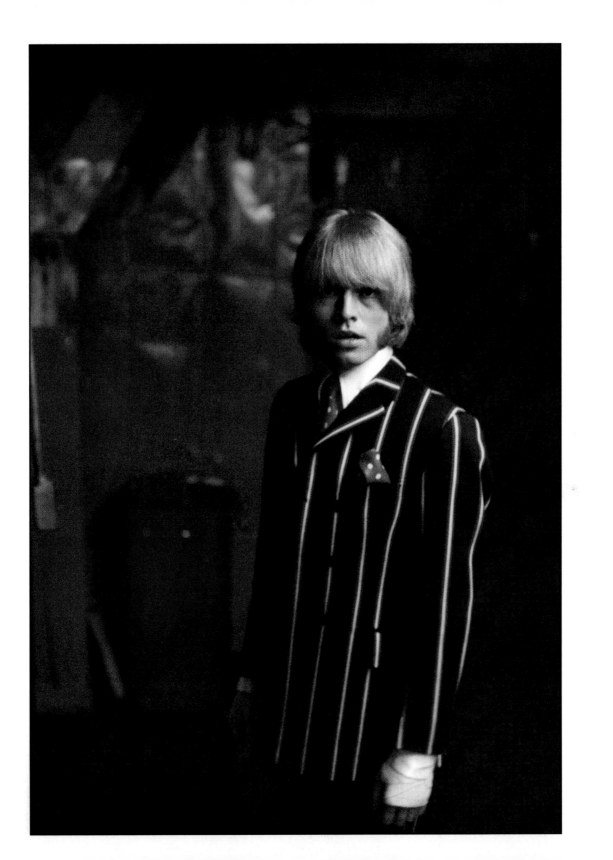

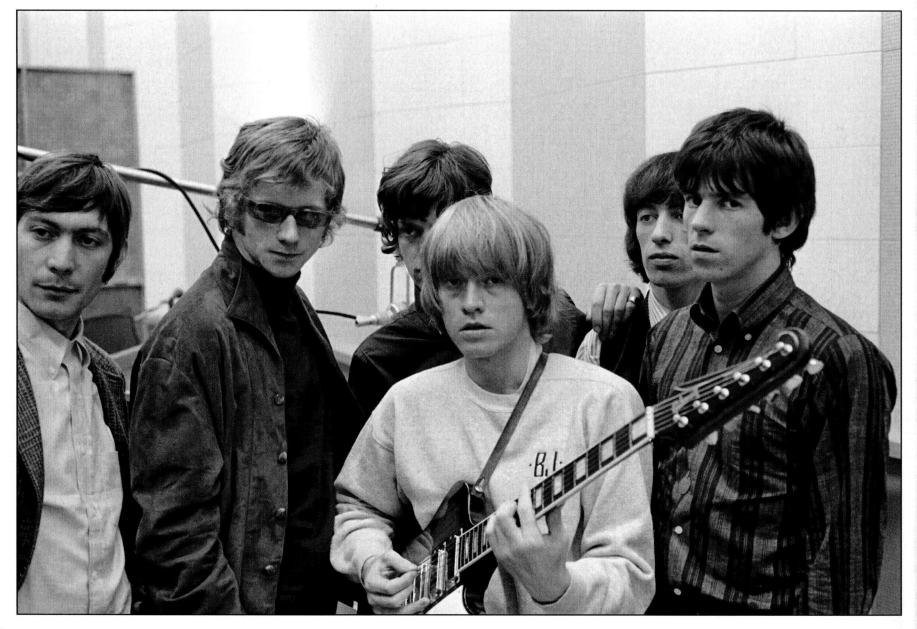

RCA Studios, Hollywood, California, September 6–7, 1965.

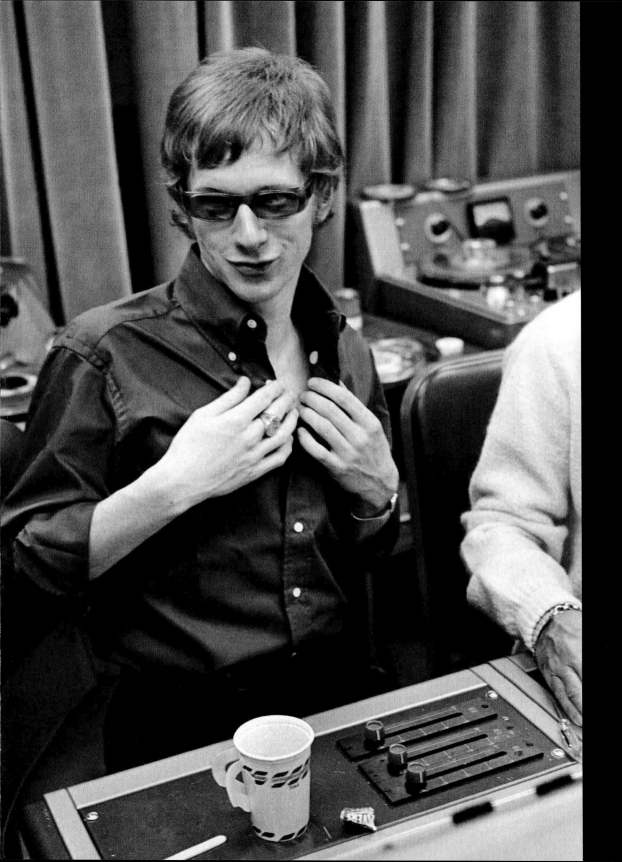

ANDREW LOOG OLDHAM

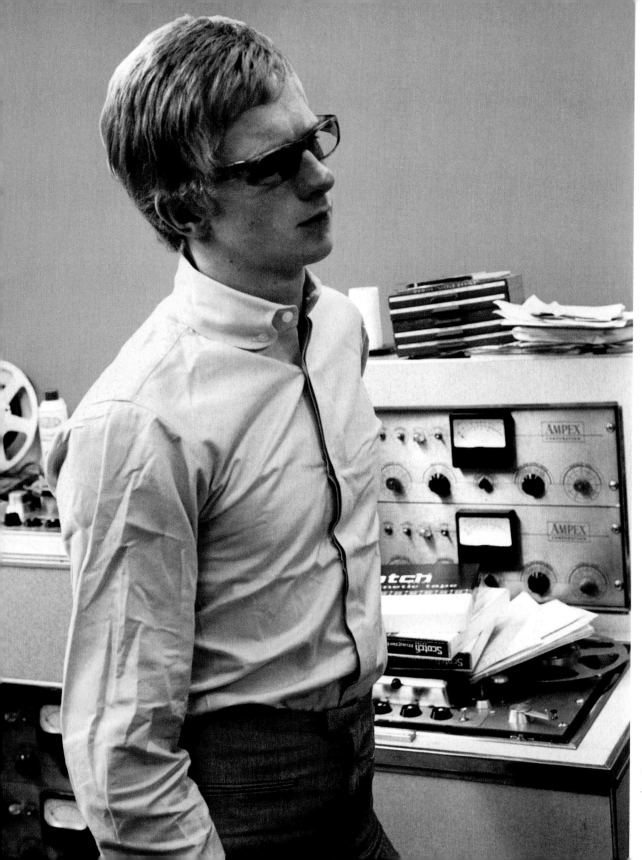

Chess Studios, Chicago, Illinois,
June 1964.

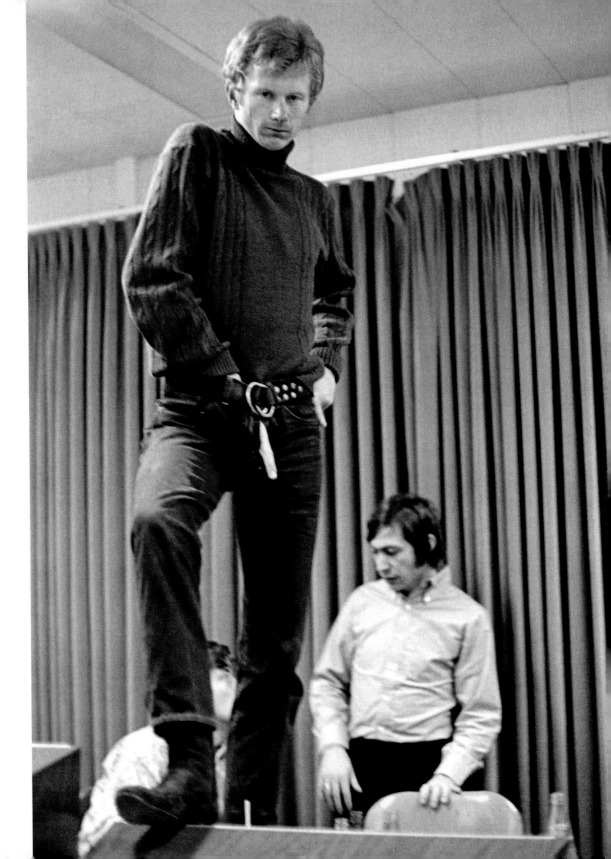

RCA Studios, Hollywood, California, December 1965.

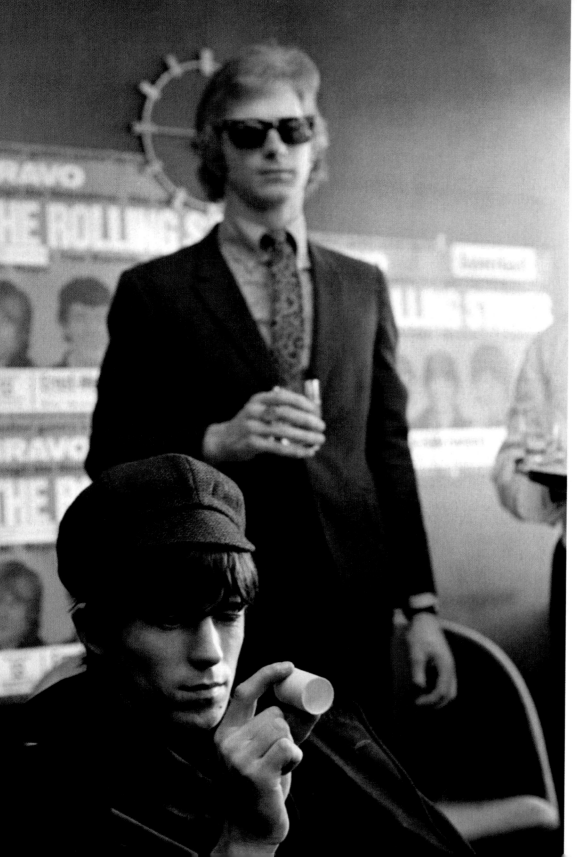

Hamburg, Germany, September 13, 1965.

German newspaper *Bild Zeitung* hosted a luncheon for
The Stones after running a story with a photograph
misidentifying Bill's girlfriend as Chrissie Shrimpton
(Mick's girlfriend at the time). The newspaper printed a
retraction when faced with The Stones canceling the rest
of the shows, which were sponsored by their publication,
Bravo. Note the posters on the wall advertising the
Hamburg stop on the tour.

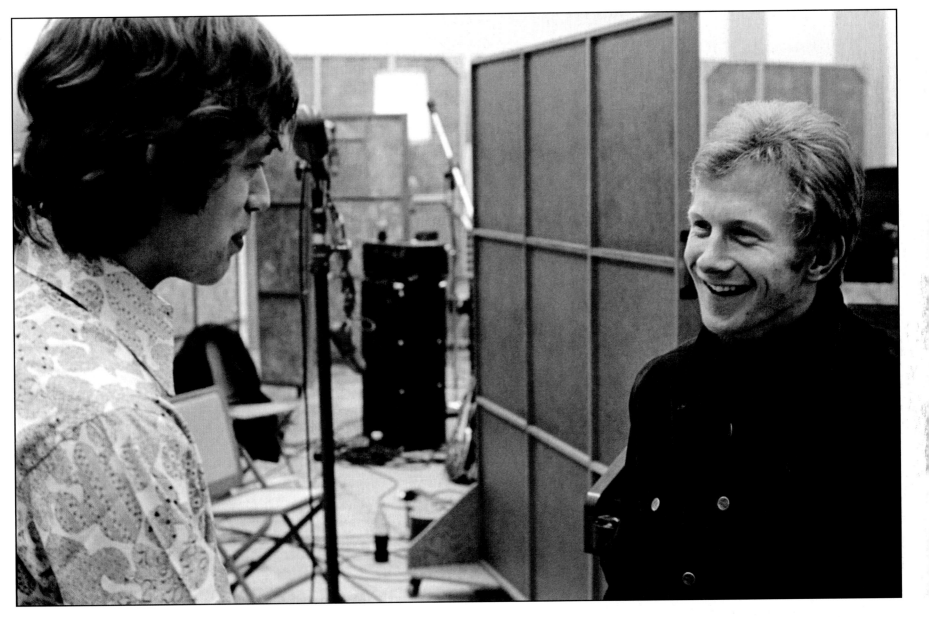

RCA Studios, Hollywood, California, December 3–8, 1965.

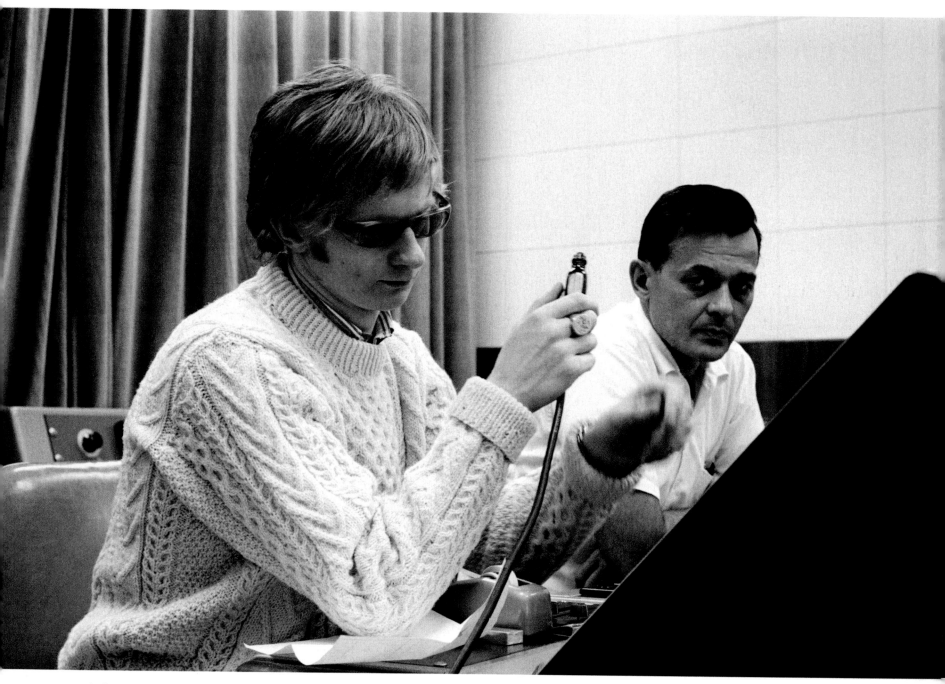

Andrew at the mixing board with RCA Studios engineer Dave Hassinger.

The Stones with Andrew Loog Oldham, Los Angeles, California, December 1965.

Bob served as tour manager for The Rolling Stones beginning with their first U.S. tour in June 1964 and continuing for their next four tours of the United States and North America through 1965. Additionally he traveled with them to West Germany for a brief tour in September 1965.

On their first tour The Stones arrived in New York on June 1 and flew back to London on June 22. While in the United States they appeared on TV shows and radio stations, held several press conferences, recorded at the historic Chess Studios in Chicago, and performed twelve concerts in nine cities. The tour included the following dates:

- June 5: San Bernardino, California, Swing Auditorium
- June 6: (two shows) San Antonio, Texas, State Fair, Joe Freeman Coliseum, San Antonio Teen Fair
- June 7: (two shows) San Antonio, Texas, State Fair, Joe Freeman Coliseum, San Antonio Teen Fair
- June 12: Minneapolis, Minnesota, Big Reggie's Ballroom, Excelsior Fair
- June 13: Omaha, Nebraska, Music Hall Auditorium
- June 14: Detroit, Michigan, Olympia Stadium
- June 17: Pittsburgh, Pennsylvania, West View Park
- June 19: Harrisburg, Pennsylvania, Farm Show Arena
- June 20: (two shows) New York City, New York, Carnegie Hall

Their second U.S. tour ran from October 24 through November 15, 1964, and in addition to TV appearances, radio interviews, and studio sessions, included the following concert appearances:

- October 24: (two shows) New York City, New York, Academy of Music
- October 26: Sacramento, California, Memorial Auditorium
- October 31: San Bernardino, California, Swing Auditorium
- November 1: Long Beach, California, Civic Auditorium
- November 1: San Diego, California, Balboa Park Bowl
- November 3: Cleveland, Ohio, Public Auditorium
- November 4: Providence, Rhode Island, Loews Theater
- November 11: Milwaukee, Wisconsin, Milwaukee Auditorium (without Brian Jones)
- November 12: Fort Wayne, Indiana, Memorial Coliseum (without Brian Jones)
- November 13: Dayton, Ohio, Wampler's Hara Arena (without Brian Jones)
- November 14: (two shows) Louisville, Kentucky, Memorial Auditorium (without Brian Jones)
- November 15: Chicago, Illinois, Arie Crown Theater

The Stones' third U.S./North American tour ran from April 23 through May 29, 1965, and included the following dates:

- April 23: Montreal, Canada, Maurice Richard Arena
- April 24: Ottawa, Canada, YMCA Auditorium
- April 25: Toronto, Canada, Maple Leaf Gardens
- April 26: London, Canada, Treasure Island Gardens
- April 29: (two shows) Albany, New York, Palace Theatre
- April 30: Worcester, Massachusetts, Memorial Auditorium
- May 1: New York City, New York, Academy of Music
- May 1: Philadelphia, Pennsylvania, Convention Hall
- May 4: Statesboro, Georgia, Southern College, Hanner Gymnasium
- May 6: Clearwater, Florida, Jack Russell Stadium
- May 7: Birmingham, Alabama, Legion Field Stadium
- May 8: Jacksonville, Florida, Coliseum
- May 9: Chicago, Illinois, Arie Crown Theater
- May 14: San Francisco, California, New Civic Auditorium
- May 15: San Bernardino, California, Swing Auditorium
- May 16: Long Beach, California, Civic Auditorium
- May 16: Los Angeles, California, Action Club
- May 17: San Diego, California, Convention Hall, Community Concourse
- May 21: San Jose, California, Civic Auditorium

- May 22: Fresno, California, Ratcliffe Stadium
- May 22: Sacramento, California, Memorial Auditorium
- May 29: New York City, New York, Academy of Music

Bob also traveled with and photographed The Rolling Stones on their September 1965 tour of West Germany. The tour included the following dates:

- September 11: (two shows) Muenster, West Germany, Muensterland Halle
- September 12: (two shows) Essen, West Germany, Grugahalle
- September 13: (two shows) Hamburg, West Germany, Ernst-Merck-Halle
- September 14: (two shows) Munich, West Germany, Zirkus Krone-Bau
- September 15: West Berlin, West Germany, Waldbühne
- September 17: Vienna, Austria, Stadthalle

Their fourth U.S./North American tour ran from October 29 through December 6, 1965, and included the following dates:

- October 29: Montreal, Canada, Forum
- October 30: Ithaca, New York, Barton Hall, Cornell University
- October 30: Syracuse, New York, War Memorial Hall
- October 31: Toronto, Canada, Maple Leaf Gardens
- November 1: Rochester, New York, Memorial Auditorium
- November 3: Providence, Rhode Island, Auditorium
- November 4: (two shows) New Haven, Connecticut, Loews State Theater
- November 5: Boston, Massachusetts, Gardens
- November 6: New York City, Academy of Music
- November 6: Philadelphia, Pennsylvania, Convention Hall
- November 7: (two shows) Newark, New Jersey, Symphony Hall/Mosque Theater
- November 10: Raleigh, North Carolina, Reynolds Coliseum
- November 12: Greensboro, North Carolina, War Memorial Auditorium
- November 13: Washington, D.C., Coliseum
- November 13: Baltimore, Maryland, Civic Center
- November 14: Knoxville, Tennessee, Civic Coliseum Auditorium
- November 15: Charlotte, North Carolina, Coliseum
- November 16: Nashville, Tennessee, Municipal Auditorium
- November 17: Memphis, Tennessee, Mid-South Coliseum
- November 20: Shreveport, Louisiana, State Fair Youth Center
- November 21: Fort Worth, Texas, Will Rogers Memorial Center
- November 21: Dallas, Texas, Memorial Auditorium
- November 23: Tulsa, Oklahoma, Assembly Center
- November 24: Pittsburgh, Pennsylvania, Civic Arena
- November 25: Milwaukee, Wisconsin, Arena Auditorium
- November 26: Detroit, Michigan, Cobo Hall
- November 27: Dayton, Ohio, Wampler's Hara Arena
- November 27: Cincinnati, Ohio, Gardens
- November 28: (two shows) Chicago, Illinois, Arie Crown Theater
- November 29: Denver, Colorado, Coliseum
- November 30: Phoenix, Arizona, unidentified venue
- December 1: Vancouver, Canada, Agrodome
- December 2: Seattle, Washington, Coliseum
- December 3: (two shows) Sacramento, California, Memorial Auditorium
- December 4: (two shows) San Jose, California, Civic Auditorium
- December 5: San Diego, California, Community Concourse, Convention Hall
- December 5: Los Angeles, California, Sports Arena

Their fifth U.S./North American tour ran from June 24 through July 29, 1966, and included the following dates:

- June 24: Lynn, Massachusetts, Manning Bowl

APPENDIX A: THE ROLLING STONES IN CONCERT

- June 25: Cleveland, Ohio, Arena
- June 25: Pittsburgh, Pennsylvania, Civic Arena
- June 26: Washington, D.C., Coliseum
- June 26: Baltimore, Maryland, Civic Center
- June 27: Hartford, Connecticut, Dillon Stadium
- June 28: Buffalo, New York, War Memorial Auditorium
- June 29: Toronto, Canada, Maple Leaf Gardens
- June 30: Montreal, Canada, Forum
- July 1: Atlantic City, New Jersey, Marine Ballroom
- July 2: New York City, Forest Hills Tennis Stadiums, Music Festival
- July 3: Asbury Park, New Jersey, Convention Hall
- July 4: Virginia Beach, Virginia, Under the Dome Theater
- July 6: Syracuse, New York, War Memorial Hall
- July 8: Detroit, Michigan, Cobo Hall
- July 9: Indianapolis, Indiana, State Fairgrounds Coliseum
- July 10: Chicago, Illinois, Arie Crown Theater
- July 11: Houston, Texas, Sam Houston Coliseum
- July 12: St. Louis, Missouri, Kiel Convention Hall
- July 14: Winnipeg, Canada, Stadium
- July 15: Omaha, Nebraska, Civic Auditorium
- July 19: Vancouver, Canada, Pacific International Exhibition Forum
- July 20: Seattle, Washington, Center Coliseum
- July 21: Portland, Oregon, Memorial Coliseum
- July 22: (two shows): Sacramento, California, Memorial Auditorium
- July 23: Salt Lake City, Utah, Davis County Lagoon
- July 24: (two shows): Bakersfield, California, Civic Auditorium
- July 25: Los Angeles, California, Hollywood Bowl
- July 26: San Francisco, California, Cow Palace
- July 28: Honolulu, Hawaii, Honolulu International Center

APPENDIX B The Rolling Stones in the Studio Rolling Stones U.S. Studio Sessions, 1964 to 1966

In 1964 The Rolling Stones recorded at the legendary Chess Records Studios in Chicago on three dates and recorded at RCA Studios in Hollywood, California, as well.

- June 10 and 11, Chess Studios, Chicago, Illinois. Producer: Andrew Oldham. Sound engineer: Ron Malo. Additional musicians: Ian "Stu" Stewart. Songs recorded: "I Can't Be Satisfied," "It's All Over Now," "Stewed and Keefed," "Time Is on My Side," "Around and Around," "Confessin' the Blues," "Down in the Bottom," "Down the Road Apiece," "Empty Heart," "High-Heel Sneakers," "If You Need Me," "Look What You've Done," "Reelin' and Rockin'," "Tell Me," and "2120 South Michigan Avenue."

- October 27 through November 2, RCA Studios, Hollywood, California. Producer: Andrew Oldham. Sound engineer: Dave Hassinger. Additional musicians: Jack Nitzsche (piano, tambourine, Nitzsche phone). Songs recorded: "Down Home Girl," "Everybody Needs Somebody to Love," "Heart of Stone," "Hitch Hike," "Oh Baby (We Got a Good Thing Goin')," and "Pain in My Heart."

- November 8, Chess Studios, Chicago, Illinois. Producer: Andrew Oldham. Sound engineer: Ron Malo. Additional musicians: Ian "Stu" Stewart (keyboards) and Howlin' Wolf (guitar) possibly. Songs recorded: "Fanny Mae," "Goodbye Girl," "Key to the Highway," "Little Red Rooster," "Mercy, Mercy," "Time Is on My Side," and "What a Shame." It is possible that The Stones rerecorded, overdubbed, or mixed "Little Red Rooster" on this occasion as well.

In 1965 The Rolling Stones recorded at RCA Studios in Hollywood, California, on the following dates:

- January 17 and 18, RCA Studios, Hollywood, California. Producer: Andrew Oldham. Sound engineer: Dave Hassinger. Without Brian Jones. Additional musicians: Phil Spector (zoom bass) and Jack Nitzsche (percussion and harpsichord). Songs recorded: "The Last Time," "Play with Fire," plus three old blues standards.

- February 17, RCA Studios, Hollywood, California. Producer: Andrew Oldham. Sound engineer: Dave Hassinger. Without Brian Jones, Bill Wyman, and Charlie Watts. Additional musicians: Jack Nitzsche. Song recorded: "The Last Time."

- May 10, Chess Studios, Chicago, Illinois. Producer: Andrew Oldham. Sound engineer: Ron Malo. Songs recorded: "That's How Strong My Love Is," "The Under Assistant West Coast Promotion Man," "Mercy, Mercy," "Try Me" (unverified), and "(I Can't Get No) Satisfaction."

- May 11 and 12, Los Angeles, RCA Studios, Hollywood, California. Producer: Andrew Oldham. Sound engineer: Dave Hassinger. Additional musicians: Jack Nitzsche (organ, percussion, piano) and Ian "Stu" Stewart (marimbas, backing vocals, organ). Songs recorded: "Cry to Me," "Good Times," "I've Been Loving You Too Long," "My Girl," "One More Try," "(I Can't Get No) Satisfaction," and "The Spider and the Fly."

- May 18 and 19, RCA Studios, Hollywood, California. Producer: Andrew Oldham. Sound engineer: Dave Hassinger. Preparing of backing tracks for *Shindig!* Songs recorded: "Little Red Rooster," "The Last Time," "Play with Fire," and "(I Can't Get No) Satisfaction."

- July 7 through 10, RCA Studios, Hollywood, California. Producer: Andrew Oldham. Sound Engineer: Dave Hassinger. Recordings and mixing for the UK version of the LP *Out of Our Heads*.

- September 6 and 7, RCA Studios, Hollywood, California. Producer: Andrew Oldham. Sound engineer: Dave Hassinger. Additional musicians: Ian "Stu" Stewart and James W. Alexander (percussion). Songs recorded: "Get Off My Cloud," "The Singer Not the Song," "Talkin' 'Bout You," "Blue Turns to Grey," "Gotta Get Away," "I'm Free," and "Looking Tired."

- December 3 through 8, RCA Studios, Hollywood, California. Producer: Andrew Oldham. Sound engineer: Dave Hassinger. Additional musicians: Ian "Stu" Stewart (piano, organ) and Jack Nitzsche (piano, organ). Songs recorded: "Aftermath" (unverified), "Doncha Bother Me," "Going Home," "Mother's Little Helper," "19th Nervous Breakdown," "Ride on Baby," "Sad Day," "Sittin' on a Fence," "Take It or Leave It," and "Think."

In 1966 The Rolling Stones recorded at RCA Studios in Hollywood, California, on the following dates:

- March 6 through 9, RCA Studios, Hollywood, California. Producer: Andrew Oldham. Sound engineer: Dave Hassinger. Additional musicians: Ian "Stu" Stewart (piano, organ) and Jack Nitzsche (piano, tambourine, harpsichord, percussion). Songs recorded: "Flight 505," "High and Dry," "I Am Waiting," "If You Let Me," "It's Not Easy," "Lady Jane," "Long Long While," "Out of Time," "Paint It, Black," "Stupid Girl," "The Tracks of My Tears," "Under My Thumb," and "What to Do" (and probably other new songs).

- August 3 through 11, RCA Studios, Hollywood, California. Producer: Andrew Oldham. Sound engineer: Dave Hassinger. Additional musicians: Ian "Stu" Stewart (piano, organ) and Jack Nitzsche (piano, harpsichord). Songs recorded: "All Sold Out," "Back Street Girl," "Complicated," "Connection," "Cool, Calm, and Collected," "Get Yourself Together," "Godzi," "Have You Seen Your Mother, Baby, Standing in the Shadow?" "Let's Spend the Night Together," "Miss Amanda Jones," "My Obsession," "Panama Powder Room," "Please Go Home," "She Smiled Sweetly," "Something Happened to Me Yesterday," "Who's Been Sleeping Here?" "Who's Driving Your Plane?" "Ya Bask Blues," and "Yesterday's Papers."

ACKNOWLEDGMENTS

Prints of the photographs are available at www.NFAgallery.com.

Many thanks and appreciations are extended to those who have made this book possible and who have been instrumental in preserving the Bob Bonis Archive for all to enjoy.

Thanks, first and foremost, go to Alex Bonis for preserving the extraordinary photographs taken by his father and for allowing me the privilege of working with him to bring them to the public's attention. It is my sincere hope that this book properly honors his father's legacy. Without Alex's help and cooperation none of this would have been possible.

Alex thanks Josie Wilson, Cayenne, and Wade.

Additionally we thank the following people, without whom the Bob Bonis Archive; 2269 Productions, Inc.; and Not Fade Away Gallery would not exist today: Martin Marion; Lawrence Wolfe; David Filler, Esq.; Tom Hansen; and John and Jordan DiPrato.

Without the following people's help and guidance this book would not have been possible:

Mauro DiPreta, Jennifer Schulkind, Lorie Pagnozzi, and Jeremy Cesarec at HarperCollins; Frank Weimann and Elyse Tranzillo (my agent and his assistant) at the Literary Group International; James Karnbach for his invaluable research assistance; Andy Babiuk and Greg Prevost—coauthors of the book *Stones Gear: All the Rolling Stones' Equipment from Stage to Studio*—for allowing me to use their extraordinary knowledge of the Stones' gear; Andrew Loog Oldham for his input; Jane Rose for her help; and especially Alison Graham for her assistance with the graphic design, editing, and work to restore and preserve the photographs.

For their help with creating the Bob Bonis Archive and Not Fade Away Gallery, and with the exhibition The British Are Coming: The Beatles and the Rolling Stones, thanks are due to the following: Andrew D. Epstein, Esq., for his legal advice; Bob Kapoor, Duggal Visual Solutions, and Jim Braden for their skill and talent in producing the prints for Not Fade Away Gallery and the Bob Bonis Archive; New Yorker Picture Frames for their excellent work framing the photos for exhibition; Christian Bies for hanging the show; Ron Higgins and Cogneato for creating and maintaining our Web site (NotFadeAwayGallery.com); Alexandra and Theodora Richards for hosting our opening night party; and Susan Blond, Carol Strauss Klenfner, Eric Wielander, and Alison Daulerio, publicists extraordinaire, for guiding us and for their help launching the show.

We also owe a debt of gratitude to the following: Jodi Okun, Michael Alfano, Gianluca Rizza, Rocco Pietrafesa, Stanley B. Burns, M.D., Steeve Henry, Margie Beck, Patrick McMullan, Shoshana Frishberg, and Marc and Deb Zakarin.

A very special thank-you to Marcie Frishberg, without whose support, advice, and love this book would not have been completed.